Nature and culture

MANCHESTER
1824

Manchester University Press

Nature and culture

Objects, disciplines and the Manchester Museum

Samuel J. M. M. Alberti

Manchester University Press

Manchester and New York

distributed in the United States exclusively by Palgrave Macmillan

Published by Manchester University Press
Oxford Road, Manchester M13 9NR, UK
and Room 400, 175 Fifth Avenue, New York, NY 10010, USA
www.manchesteruniversitypress.co.uk

Distributed in the United States exclusively by
Palgrave Macmillan, 175 Fifth Avenue, New York,
NY 10010, USA

Distributed in Canada exclusively by
UBC Press, University of British Columbia, 2029 West Mall,
Vancouver, BC, Canada V6T 1Z2

British Library Cataloguing-in-Publication Data
A catalogue record for this book is available from the British Library

Library of Congress Cataloging-in-Publication Data applied for

ISBN 978 0 7190 8114 9 *hardback*

First published 2009

18 17 16 15 14 13 12 11 10 09 10 9 8 7 6 5 4 3 2 1

Typeset in Arno Pro
by Servis Filmsetting Ltd, Stockport, Cheshire
Printed in Great Britain
by CPI Antony Rowe, Chippenham, Wiltshire

For Fay, Millie and Jacob

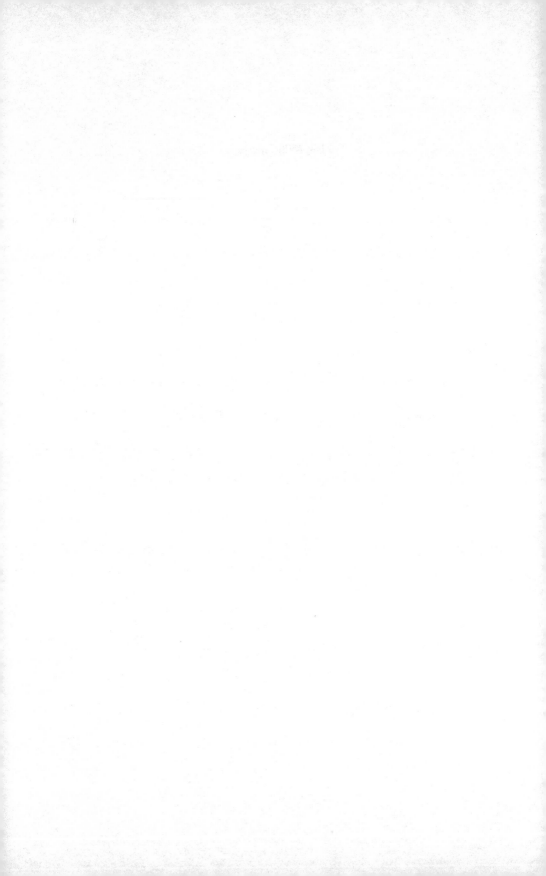

Contents

List of figures

Acknowledgements

For most of the three years spent preparing this book I was in and around the Manchester Museum, and my first debt of gratitude is to all my colleagues there, past and present, for their unstinting enthusiasm and tireless responses to my queries. Among those who were especially helpful and supportive were George Bankes, George Fildes (for his invaluable notes), Piotr Bienkowski, Pete Brown, Malcolm Chapman, Stephen Devine, Karen Exell, David Gelsthorpe, Andrew Gray, David Green, Suzanne Grieve, Dmitri Logunov, Maria Kostoglou, Lindsey Loughtman, Bernadette Lynch, Henry McGhie, Rebecca Machin, Phil Manning, Nick Merriman, John Miller, Irit Narkiss, Phyllis Stoddart, Joyce Tyldesley and Leander Wolstenholme. I would like to thank all the participants in the oral history project *Re-Collecting at the Manchester Museum*, including Roy Garner, Tom Goss, Keith Sugden and especially John and Kay Prag. Kostas Arvanitis, Louise Tythacott and the PhD students provided a warm and convivial environment at the Centre for Museology. Elsewhere in the University, I am grateful to Heather Birchall, Jane Naylor, John Rowcroft and especially John Pickstone. Tristram Besterman and Helen Rees Leahy believed in this project from its inception and have supported it ever since. The manuscript was completed while on research leave generously funded by the Wellcome Trust.

Further afield, I benefited from the help of David Allen, Sophie Forgan, Kate Hill, Andrew Schofield at the North West Sound Archive, Emilene Coventry (who read the whole thing) and Chris Whitehead. Thanks also to Manchester University Press and to six anonymous reviewers. My final and most heartfelt gratitude is to all the assorted Albertis, especially my parents and my brothers. But it is to my wife and children, Fay, Millie and Jacob, that I dedicate the book that they have lived with for so long.

List of abbreviations

BM(NH)	British Museum (Natural History), now the Natural History Museum
CNH	Manchester Natural History Society series, MMCA
GMC	Greater Manchester Council
HMSO	Her/His Majesty's Stationery Office
LEA	local education authority
Lit and Phil	[Manchester] Literary and Philosophical Society
MCL	Manchester Central Library
MMCA	Manchester Museum Central Archive
MMCM	Manchester Museum Committee Minutes, MMCA
MMR	*Manchester Museum Reports*, MMCA
MNHS	Manchester Natural History Society
NASA	[United States] National Aeronautics and Space Administration
NWSA	North West Sound Archive
RVUM	*Annual Reports of the Victoria University of Manchester*, UMA
UMA	University of Manchester Archives, John Rylands University Library
ZAC	Directors' correspondence, Manchester Museum Zoology Archive

Introduction: museum historiographies

There have been histories of museums for as long as there have been museums. Renaissance collectors described their cabinets of curiosities in print to augment their collections and enhance their own fame.[1] Together with narratives penned by travellers who visited them, these texts became intimately bound up with the collections. In the centuries that followed, curators of the museums that absorbed the *Wunderkammern* continued to account for their provenance. When the Glasgow bibliophile and archaeologist David Murray set out to list this literature at the turn of the nineteenth century, it took him seven years. His *Museums: Their History and Their Use* (1904) remains the most comprehensive work of its kind – the 'charter text' of museum history.[2]

Murray's timing was no accident. Museums in Europe and North America were then at their largest and most powerful. New buildings were bigger and more numerous than ever before; objects flooded into them at an unprecedented rate; and thanks to an increasingly public focus, more people visited them than ever before. In 1890, at the crest of this wave, the Manchester Museum opened its doors as the grand centrepiece of Owens College, later the University of Manchester. This book is an account of the Museum's first 100 years. As such, it follows the tradition of single-institution histories that Murray listed, which has blossomed in the intervening century.[3] However, *Nature and Culture* is also an experiment in museum historiography: using one particular institution as a methodological prism, I refract several distinct techniques in writing museum history to illuminate twentieth-century sites for display more generally.

Between 1950 and 1990, alongside the learned studies of individual museums, there emerged a number of different ways of studying collections more synthetically. The collections, staff and architecture all provided fruitful topics for historical analysis, often (but by no means always) written by those working within museums.[4] But it was from the emerging field of museum studies in the early 1990s that the history of museums reached a coherent maturity. Eilean Hooper-Greenhill, Susan Pearce and Tony Bennett replaced earlier progressive historiographies with accounts of the multiple genealogies of collecting and collections, variously informed by structuralism, post-structuralism and post-colonialism.[5] Museums were cast as political

instruments, machines for making meaning and imposing particular behaviours on their visitors. These approaches have been developed and refined by art historians, cultural theorists, anthropologists and historians of science.[6]

In the chapters that follow I apply existing museum historiographies to new territory, I enrol methods from elsewhere, and I propose novel techniques. These are adumbrated in this introduction, then applied to the Manchester Museum in the chapters that follow. But why choose this particular institution? And, indeed, why study a museum at all? Too often museologists take the latter for granted. It stands reiterating that museums play a very particular role in the production and consumption of Western knowledge, in the elucidation of identity and the organisation of material culture. We should always compare the museum as a site for the production of knowledge with the laboratory, the lecture hall and the field; and as a site for informal consumption with the theatre, the concert hall, the garden and the mass media. Furthermore, comparisons should be made not only between sites, but also across time. We have by now a clear understanding of the shifts in the function and role of the museum from its origins in the sixteenth century to its apogee at the end of the nineteenth, but we know far less about the fate of museums in the last eighty years or so.

The Manchester Museum is an ideal candidate for understanding cultures of display in twentieth-century Britain. Founded and articulated at the *fin de siècle*, as a sizeable urban museum it is big enough to be significant but not so large as to be unrepresentative. It is an accredited museum, indicating a professional level of collections management and public service. Its collections are designated, and therefore of international importance. And at the time of writing the Museum is part of the North-West England 'hub', demonstrating its history of political clout and regional leadership.[7] It boasts ancient mummies, exotic (dead) quadrupeds and spectacular (living) reptiles. The Manchester Museum is a treasure trove of some four million priceless objects. It is irreplaceable, unique.

And yet, the Museum is not unique in its uniqueness. By their very nature, every museum is inimitable, boasting distinctive collections with a singular history. Rather, the Manchester Museum is ripe for historical analysis because of its *similarities* with other institutions. It is a university collection, ranking with the Hunterian, the Pitt Rivers, the Ashmolean, the Sedgwick, the Hancock and the Petrie. It also functions as a provincial civic museum, alongside those in Glasgow, Birmingham, Sheffield and Leeds. And its collections are multi-disciplinary, like World Museum Liverpool, the Horniman and the original elucidation of the British Museum. Methodological light shone through the prism of the Manchester Museum will illuminate other collections.

Museums and disciplines

I return to this multi-disciplinarity throughout this book. My title, *Nature and Culture*, reflects the central theme – how nature and culture are constructed,

reinforced and differentiated with objects in museums.[8] This is especially explicit in the first half of the book, which looks at the history of the Manchester Museum through disciplinary construction and development. For the disciplines that we take for granted as units of knowledge production in Western academia are not stable, coherent and eternal, but rather they are fluid, contingent groupings.[9] They have commonly been studied as conceptual and political enterprises, but they are also material entities. As Simon Knell writes, 'Natural scientists, archaeologists and art historians, in some respects, share a similar engagement with objects: they build whole subjects from material things.'[10] Disciplines are constructed with buildings, tools, and objects of study; which fabric not only signals change but can also retard it. The investment in huge apparatus characteristic of twentieth-century physics, for example, is indicative of the maturing status of particular fields, but it also imbued them with a kind of inertia. Museums, with their massive collections, accumulate material culture like no other institution. The museum's role in the construction of disciplines, I will argue in the chapters that follow, is distinct in interesting ways.

The Manchester Museum opened as distinctions were being drawn between different sciences by men like Thomas Huxley, biologist, statesman and champion of Charles Darwin. Huxley's protégé, the geologist William Boyd Dawkins, was the first curator of the Manchester Museum, appointed by Owens College to transfer and arrange the collections of the Manchester Natural History Society (MNHS) that the College had acquired in 1868. Chapter 1 is devoted to the story of the Society and its collections, the Victorian prologue to the main feature. It traces the development of the collection from a private cabinet to its grand neo-Grecian premises in the centre of industrialising Manchester. It sketches out the different categories within the collection, laying the groundwork for chapters 2 and 3, and introduces those who worked in and visited it, whose stories are taken up in chapters 5 and 6.

William Boyd Dawkins's arrival in Manchester prompted an auction of many of the more exotic specimens in the Natural History Society's 'curiosities' gallery, an event that marked a gear shift in the disciplinary divisions within the collections. He replaced what he saw as an absurd miscellany with a continuous sequence, from palaeontology through archaeology to zoology and botany. Over the following decades, in Manchester as elsewhere, specialist disciplinary communities gradually crystallised around particular objects. For disciplines in museums were enacted not only in the material culture of the collections, but also through personnel and administrative structures. This specialist precipitation was contingent and uneven, and the disciplinary landscape did not necessarily match the divisions on the galleries. Rather, disciplines were contested, flexible and overlapping – one object could be claimed by different specialists. Chapter 2 maps out this gradual unravelling of Dawkins's continuous sequence within the Museum. It accounts for the ascendance of zoology as the Museum's driving political and intellectual force (cemented by developments in evolutionary thought and the significance of prominent endeavours

such as economic entomology). As museums generally declined in prestige as sites for the production of natural knowledge from the mid-century, I chart the increasing distance (conceptual and physical) between the Museum's collections and their cognate academic departments.

In studying disciplines within and outside museums, the historian reveals not only distinctions but also hierarchies. Just as there were shifting relations of prestige between laboratory, field and museum, so within museums, different collections were afforded particular status at different times – dependent not only on the wider intellectual climate but also on funding, staffing and modes of display. At the bottom of this hierarchy at the Manchester Museum's inception were the 'historical' collections, comprising a handful of artefacts that had survived Dawkins's auction and some ancient Egyptian material on loan. From such humble beginnings, chapter 3 reveals the emergence of distinct and valued collections of anthropology, Egyptology and archaeology. Although never quantitatively significant, anthropogenic material nevertheless came to dominate the Museum's practice and public face. Chapter 3 accounts for the disciplinary and material distinction between nature and culture, enacted through objects, specialist appointments and new buildings.

What emerges in the first half of this book, then, is a map. As Ken Arnold writes, museums were 'used to define where one discipline ended and another began, and indeed how they fitted together – which next to which'.[11] The language of territorialism pervades discussions of disciplinarity – we speak of 'fields', of provinces of knowledge, of 'charting' terrain.[12] *Nature and Culture* explores the place of different collections in the administrative and spatial layout of the museum. Where were different groups of artefacts and curators located, I ask – how were they arranged, and were such grammars of display shared between disciplines? The history of collections is a shifting intellectual topography involving both tangible and intangible factors: not only the location and classification of objects within the collection, but also the training and outlook of keepers. Just as on a political map nations build borders and sign treaties, so on the landscape of the museum curators construct boundaries and ally themselves with different disciplines. 'Cultural cartography is not idle play with Venn diagrams', argues its arch-proponent Thomas Gieryn, 'maps of science give definitions of situations real in their consequences, both for those who rely on them and those who draw them.'[13] The topography of knowledge is messy, contested and fragmented. To exploit the cartographical metaphor: disciplines have jagged borders, contingent cartographies and internal border disputes.

The lives of objects

The second half of this book shifts the focus from topography to objects. It draws on the work of sociologists, anthropologists and historians of science who have studied the social lives of things.[14] Moving on from disciplines, chapters 4, 5 and 6 explore the history of the Manchester Museum through the trajectories of objects

and, especially, the relationships they form with people and with other things. Material culture is thus afforded a metaphorical 'life' or 'career'. As Igor Kopytoff has suggested, we can ask of objects questions similar to those we raise when writing biographies of people.[15] What are the key moments in the career of these things? How has their status changed over the course of their lives – what have been their significant 'ages'? How has the political and social climate impacted on their trajectories? To study object biographies in this way is particularly fruitful in the museum context, not only because so many museum objects have exotic provenances, from far away or long ago, but also because we can learn so much from the lives of the most common of specimens.

Elsewhere I have asked these questions of specific objects from the Museum.[16] Here, by contrast, I explore the processes enacted upon objects and the communities that carried them out along the general lifespans of the Museum's things. They begin outside the collection, of course, at the point of collection, at which time objects are dislocated from their original contexts, whether South American jungle, Egyptian tomb, or Derbyshire cave. Chapter 4 traces the routes by which objects were taken from these sources and brought to the Manchester Museum, and the motives of those involved.[17] Whereas other studies have profitably analysed museum acquisition quantitatively and geographically, I use exchange theory to propose a fivefold typology of acquisition: by gift, purchase, fieldwork, transfer or loan.[18] In each case I discuss the kinds of objects that arrived by these routes and how the people involved changed over time. Wealthy amateur collectors bought exotic specimens at auction; a museum entomologist hurried insects out of Soviet-occupied Vienna; university archaeologists excavated local 'rescue' sites. This way of studying the history of museums firmly links them to other spaces for collecting and display, including zoos and menageries, even when curators were seeking to distinguish museums from such tawdry places. From there and elsewhere objects experienced multiple exchanges on their way to the collection. They were rendered (ostensibly) inalienable by gift or commoditised by purchase. They brought with them traces of those involved in their trajectory, different people's identities wrapped up in their meanings.

But the careers of objects did not terminate once they were absorbed into collections. Far from it: many specimens were subject to considerable change and movement subsequent to their arrival at the Museum. Too often, object biographers ignore these afterlives, and I want to correct this in chapter 5 with an innovative attention to the history of museum practice. For museum collections are organic: (mostly) growing, (sometimes) shrinking and changing over time through accession and de-accession, new buildings and gallery renewal. I focus here on the practices enacted upon objects within the Museum and the communities of practitioners responsible. Like its predecessor, chapter 5 is not arranged chronologically but rather thematically. From the range of different things that happen to museum objects I have identified three clusters of processes – physical, textual

and exhibitionary. Conservation and conservators, catalogues and cataloguers, exhibitions and their designers are the subject of this chapter, which also recognises the vast majority of items that were never displayed. Museum storage emerges as a surprisingly lively topic for historical analysis.

Those objects that were on display were viewed and used by diverse audiences, and the final chapter is devoted to the ways in which the Manchester Museum staff engaged with these visitors: who they were, and how they used and responded to the collections. Techniques for audience engagement and/or control ranged from guidebooks to lectures to temporary exhibitions, and served to construct the Museum's addressee, its ideal visitor. The Manchester Museum's ambiguous status as a university collection with civic responsibilities is made explicit in chapter 6, and the diversity of the audiences become apparent. Lofty museum directors and lowly conservators populate earlier chapters – here we meet the schoolchildren, university students and museum volunteers who consumed, justified and contributed to the fruits of their museological labours. For the meanings of things varied not only over time and between sites but also according to who was viewing them. An object on display had relationships not only with other items and with its collectors but also with its audiences. These relationships are historically and culturally contingent, and never one-way. However didactic and interpreted an exhibition, visitors brought their own meanings and reactions to the Museum, and engaged not only with sight but also by listening, talking and touching. Shifts in visitor constituencies and in the ways they viewed things meant that museum objects (and the distinctions between them) were never stable. This chapter contributes to the burgeoning study of museum audiences, both historical and contemporary, in an effort to explore not only collectors and curators but also visitors; to understand not only how objects arrived at the Manchester Museum and what happened to them within the collection but also their use.[19] Visitors breathed new life into objects.

These later chapters trace the processes enacted upon objects. They share with the first half of the book an attention to what material culture means to different people. *Nature and Culture* is a study of the distinctions drawn between different things, how different processes changed their meanings over time, and the diverse people who gave them these values. It is a study of the construction of nature and culture on display.

Notes

1 K. Arnold, *Cabinets for the Curious: Looking Back at Early English Museums* (Aldershot: Ashgate, 2006); P. Findlen, *Possessing Nature: Museums, Collecting, and Scientific Culture in Early Modern Italy* (Berkeley: University of California Press, 1994); A. MacGregor, *Curiosity and Enlightenment: Collectors and Collections from the Sixteenth to the Nineteenth Century* (New Haven: Yale University Press, 2007); K. Pomian, *Collectors and Curiosities: Paris and Venice, 1500–1800*, trans. E. Wiles-Portier (Cambridge: Polity, 1990).

2 R. Starn, 'A Historian's brief guide to new museum studies', *The American Historical Review*, 110 (2005), 68–98, p. 3; P. Findlen, 'Mr. Murray's Cabinet of Wonder', in D. Murray, *Museums: Their History and Their Use*, 2 vols, vol. 1 (Staten Island: Pober, reprinted edn, 2000), pp. i–xii; Murray, *Museums: Their History and Their Use*, 3 vols (Glasgow: MacLehose, 1904); cf. J. R. von Schlosser, *Die Kunst- und Wunderkammern der Spätrenaissance: Ein Beitrag zur Geschichte des Sammelwesens* (originally published 1908; Leipzig: Braunschweig, amended edn, 1978).

3 Volumes that have been especially useful here include C. Gosden and F. Larson, *Knowing Things: Exploring the Collections at the Pitt Rivers Museum 1884–1945* (Oxford: Oxford University Press, 2007); L. Keppie, *William Hunter and the Hunterian Museum in Glasgow, 1807–2007* (Edinburgh: Edinburgh University Press, 2007); S. Moser, *Wondrous Curiosities: Ancient Egypt at the British Museum* (Chicago: University of Chicago Press, 2006); W. T. Stearn, *The Natural History Museum at South Kensington: A History of the British Museum (Natural History) 1753–1980* (London: Heinemann, 1981); D. M. Wilson, *The British Museum: A History* (London: British Museum, 2002). Other valuable works in this expanding genre include E. Crooke, *Politics, Archaeology and the Creation of a National Museum of Ireland: An Expression of National Life* (Dublin: Irish Academic Press, 2000); N. Levell, *Oriental Visions: Exhibitions, Travel and Collecting in the Victorian Age* (London: Horniman Museum, 2000); C. Lewis, *The Changing Face of Public History: The Chicago Historical Society and the Transformation of an American Museum* (DeKalb: Northern Illinois University Press, 2005); R. Mason, *Museums, Nations, Identities: Wales and its National Museums* (Cardiff: University of Wales Press, 2007).

4 Important contributions to the history of museums in this period include E. P. Alexander, *Museums in Motion: An Introduction to the History and Functions of Museums* (Nashville: American Association for State and Local History, 1979); R. D. Altick, *The Shows of London: A Panoramic History of Exhibitions, 1600–1862* (Cambridge, Mass.: Belknap, 1978); N. Pevsner, *A History of Building Types* (London: Thames and Hudson, 1976); A. S. Wittlin, *The Museum, its History and its Tasks in Education* (London: Routledge, 1949).

5 T. Bennett, *The Birth of the Museum: History, Theory, Politics* (London and New York: Routledge, 1995); E. Hooper-Greenhill, *Museums and the Shaping of Knowledge* (London: Routledge, 1992); S. M. Pearce, *Museums, Objects and Collections: A Cultural Study* (Leicester: Leicester University Press, 1992); cf. P. Vergo (ed.), *The New Museology* (London: Reaktion, 1989).

6 J. Abt, 'Disciplining museum history', *Museums and Galleries History Group Newsletter*, 4 (2007), 2–3; e.g. B. J. Black, *On Exhibit: Victorians and Their Museums* (Charlottesville: University Press of Virginia, 2000); S. Conn, *Museums and American Intellectual Life, 1876–1926* (Chicago: University of Chicago Press, 1998); C. Duncan, *Civilizing Rituals: Inside Public Art Museums* (London: Routledge, 1995); J. V. Pickstone, 'Museological science? The place of the analytical/comparative in 19th-Century science, technology and medicine', *History of Science*, 32 (1994), 111–38; Pickstone, *Ways of Knowing: A New History of Science, Technology and Medicine* (Manchester: Manchester University Press, 2000).

7 The UK Museum Accreditation scheme is run by the Museums, Libraries and Archives Council (MLA), a non-departmental public body, to set standards in collections

management, governance and access. The Museum Designation Scheme, also run by MLA, identifies collections of international and national importance in non-national museums. Regional Museum Hubs coordinate the 'Renaissance in the Regions' funding scheme for English provincial museums. MLA, *The Museum Accreditation Scheme* (London: MLA, 2004); MLA, *A Pocket Guide to Renaissance* (London: MLA, 2006).

8 As such, it borrows from the chapter structure of R. E. Kohler, *All Creatures: Naturalists, Collectors, and Biodiversity, 1850–1950* (Princeton: Princeton University Press, 2006). Kohler, however, is differentiating between the subject and practice of natural history collecting. Cf. S. J. M. M. Alberti, 'Culture and nature: the place of anthropology in the Manchester Museum', *Journal of Museum Ethnography*, 19 (2006), 7–21; E. R. Leach, *Culture and Nature; or, La Femme Sauvage: The Stevenson Lecture* (London: Bedford College, 1969); and the journal *Nature and Culture* (2006–).

9 On the history of disciplines, see T. Becher and P. R. Trowler, *Academic Tribes and Territories: Intellectual Enquiry and the Culture of Disciplines* (Buckingham: Society for Research into Higher Education and Open University Press, 2nd edn, 2001); J. Ben-David, *Scientific Growth: Essays in the Social Organization and Ethos of Science* (Berkeley: University of California Press, 1991); N. Fisher, 'The classification of the sciences', in R. C. Olby *et al.* (eds), *Companion to the History of Modern Science* (London: Routledge, 1990), pp. 853–68; J. Golinski, *Making Natural Knowledge: Constructivism and the History of Science* (Chicago: University of Chicago Press, 2nd edn, 2005); G. Lemaine (ed.), *Perspectives on the Emergence of Scientific Disciplines* (The Hague: Mouton, 1976); E. Messer-Davidow *et al.* (eds), *Knowledges: Historical and Critical Studies in Disciplinarity* (Charlottesville: University Press of Virginia, 1993); J. V. Pickstone, 'Science in nine-teenth-century England: plural configurations and singular politics', in M. J. Daunton (ed.), *The Organisation of Knowledge in Victorian Britain* (Oxford: Oxford University Press, 2005), pp. 29–60; R. Stichweh, 'The sociology of scientific disciplines: on the genesis and stability of the disciplinary structure of modern science', *Science in Context*, 5 (1992), 3–15. On disciplines in art galleries and museums, see C. Gosden and F. Larson, *Knowing Things. Exploring the Collection at the Pitt Rivers Museum 1884–1945* (Oxford: Oxford University Press, 2007); Larson, 'Anthropological landscaping: General Pitt Rivers, the Ashmolean, the University Museum and the shaping of an Oxford disci-pline', *Journal of the History of Collections*, 20 (2008), 85–100; D. Preziosi, *Brain of the Earth's Body: Art, Museums and the Phantasms of Modernity* (Minneapolis: University of Minnesota Press, 2003); C. Whitehead, *Museums and the Construction of Disciplines: Art and Archaeology in Nineteenth-Century Britain* (London: Duckworth, 2009).

10 S. J. Knell, 'Museums, reality and the material world', in Knell (ed.), *Museums in the Material World* (London: Routledge, 2007), pp. 1–28, p. 7.

11 Arnold, *Cabinets for the Curious*, p. 239.

12 On the historical geography of science, see e.g. D. A. Finnegan, 'The spatial turn: geo-graphical approaches in the history of science', *Journal of the History of Biology* 41 (2007), 369–88; D. N. Livingstone, *Putting Science in its Place: Geographies of Scientific Knowledge* (Chicago: University of Chicago Press, 2003); S. Naylor (ed.), 'Historical Geographies of Science', special issue, *British Journal for the History of Science* 38 (2005), 1–100.

13 T. F. Gieryn, *Cultural Boundaries of Science: Credibility on the Line* (Chicago: University of Chicago Press, 1999), p. 12; see also Gieryn, 'What buildings do', *Theory and Society*,

31 (2002), 35–74; S. L. Star and J. R. Griesemer, 'Institutional ecology, "translations" and boundary objects: amateurs and professionals in Berkeley's Museum of Vertebrate Zoology, 1907–39', *Social Studies of Science*, 19 (1989), 387–420.

14 S. J. M. M. Alberti, 'Objects and the museum', *Isis*, 96 (2005), 559–71; A. Appadurai (ed.), *The Social Life of Things: Commodities in Cultural Perspective* (Cambridge: Cambridge University Press, 1986); L. Daston (ed.), *Biographies of Scientific Objects* (Chicago: Chicago University Press, 2000); Daston (ed.), *Things that Talk: Object Lessons from Art and Science* (New York: Zone, 2004); S. H. Riggins (ed.), *The Socialness of Things: Essays on the Socio-Semiotics of Objects* (Berlin: Mouton de Gruyter, 1994).

15 I. Kopytoff, 'The cultural biography of things: commoditization as process', in Appadurai (ed.), *The Social Life of Things*, pp. 64–91.

16 S. J. M. M. Alberti, 'Molluscs, mummies and moon rock: the Manchester Museum and Manchester science', *Manchester Region History Review* 18 (2007), 108–32.

17 N. Aristides, 'Calm and uncollected', *American Scholar*, 57 (1988), 327–36; R. W. Belk, *Collecting in a Consumer Society* (London: Routledge, 1995); J. Elsner and R. Cardinal (eds), *The Cultures of Collecting* (London: Reaktion, 1994); W. Muensterberger, *Collecting: An Unruly Passion: Psychological Perspectives* (Princeton: Princeton University Press, 1994); S. M. Pearce, *On Collecting: An Investigation into Collecting in the European Tradition* (London: Routledge, 1995).

18 N. Thomas, *Entangled Objects: Exchange, Material Culture, and Colonialism in the Pacific* (Cambridge, Mass: Harvard University Press, 1991); A. B. Weiner, *Inalienable Possessions: The Paradox of Keeping-While-Giving* (Berkeley: University of California Press, 1992). On the 'Relational Museum' project at the Pitt Rivers Museum, which employed a more quantitative approach, see Gosden and Larson, *Knowing Things*; Larson *et al.*, 'Social networks and the creation of the Pitt Rivers Museum', *Journal of Material Culture*, 12 (2007), 211–39.

19 On contemporary visitor studies, see e.g. E. Hooper-Greenhill, 'Studying visitors', in S. Macdonald (ed.), *A Companion to Museum Studies* (Oxford: Blackwell, 2006), pp. 362–76; on the history of visiting, see for example S. J. M. M. Alberti, 'The museum affect: visiting collections of anatomy and natural history', in A. Fyfe and B. Lightman (eds), *Science in the Marketplace: Nineteenth-Century Sites and Experiences* (Chicago: University of Chicago Press, 2007), pp. 371–403.

Prologue: the Manchester Natural History Society

Like many large European collections, the origins of the Manchester Museum are to be found in a private cabinet: that of John Leigh Philips (1761–1814; see figure 1.1). Philips was involved in textile manufacturing as a partner in his family-based firm, and served in the First Battalion of the Manchester and Salford Volunteers as Lieutenant Colonel.[1] The range of objects gathered by Philips and his contemporaries in the eighteenth-century provinces cannot be categorised using modern disciplinary parameters. He collected voraciously: paintings, prints, etchings, books and insects. He juxtaposed natural objects and antiquities, fine art and printed material, demonstrating the diversity of natural history. Philips set out his collections in his home at Mayfield near Manchester, there to welcome esteemed visitors, who in turn conferred status upon him and his cabinet.[2] He was well connected to regional and national-scale networks, joining the Manchester Literary and Philosophical Society (the 'Lit and Phil') upon its foundation in 1781, maintaining a lifelong friendship with Joseph Wright of Derby, and corresponding with the renowned botanist James Edward Smith.[3]

Philips's collection was to provide the seed of the Manchester Museum, and in this prologue I will trace the fate of his cabinet from his death in 1814. It draws to a close in the 1870s, by which time Philips's objects had been acquired by Owens College, the forerunner of the University of Manchester. In charting the biography of the collection, I begin to explore the spaces, people and objects involved in the Manchester Museum, whose narratives will be taken up in the chapters that follow. These stories are played out against the diorama of the bourgeois cultural sphere of industrial Manchester, in the context of museum development in Britain.

After his death, Philips's collection was sold at auction for a total of £5,474 15s 3d. His 'very extensive, valuable, and nearly perfect collection of insects' in three mahogany cabinets was purchased by the nonconformist merchant Thomas Henry Robinson.[4] Brother-in-law of the prominent banker Sir Benjamin Heywood, Robinson was a keen collector himself, having already gathered a considerable ornithological cabinet. By the early decades of the nineteenth century, however, the landscape of civic collecting in which Robinson moved was changing. Although learned groups such as the Lit and Phil had not been especially concerned with

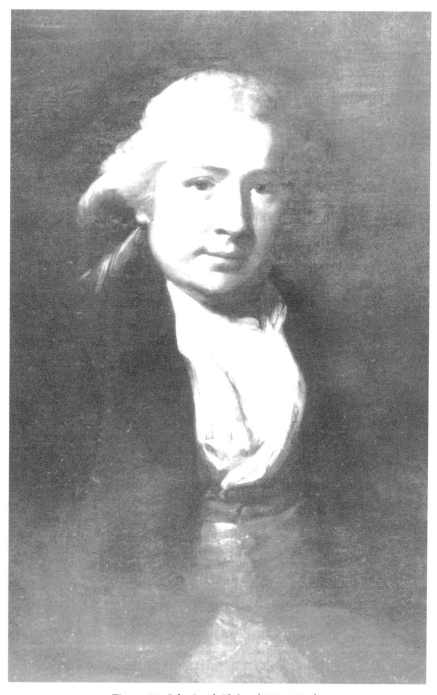

Figure 1.1 John Leigh Philips (1761–1814).

material culture during Philips's lifetime, voluntary associations in the 1820s were more interested in things.[5] Increased access to personal collections reflected the changing status of the home as new notions of 'private' and 'public' were fashioned.[6] The benefits of combined collecting and ownership in addition to (although by no means instead of) private collecting were apparent to the emerging middle classes in urban Britain. In other provincial centres such as Sheffield and Newcastle, literary and philosophical societies began to purchase sizeable private collections. And so it was to members of the Manchester Lit and Phil that Robinson turned when bankruptcy and lack of space prompted him to put the Philips's collection up for sale once more.

In June 1821 Robinson, by now a bookseller, met with nine other merchants and professionals in St Ann's Place in the centre of the city: each of them contributed £10 and, as the 'Manchester Society for the Promotion of Natural History', agreed to purchase the collections as the nucleus of a museum.[7] By the first formal meeting in August, nineteen others had joined, including the patrons of the new Society: Sir Oswald Mosley, lord of the manor of Manchester (and grandfather of the fascist leader), and Lord Stanley, later thirteenth Earl of Derby.[8] On 13 September 1821, shortly after the first meeting, Robinson died, and the following month, the remaining members of the Society paid his family £400 for the Philips cabinet.[9] But as their successors were to find out (see chapter 4 below), posthumous acquisition was rarely straightforward. Not until early 1822 did Robinson's father grudgingly hand over a number of duplicate specimens he had retained on the grounds that they were not intended to be transferred with the collection.[10]

As a small group without their own accommodation, the naturalists contemplated strategies to ensure their survival. Union with the Lit and Phil was considered and discounted; an amalgamation with the Royal Manchester Institution (founded in 1823) was also rejected, 'on the grounds of incompatibility of principles'.[11] Slowly, however, as the 'Manchester Natural History Society' (MNHS), the naturalists carved out a space in Manchester's cultural landscape, its remit bordering but not overlapping the Lit and Phil and the Royal Manchester Institution. From the 1830s, the MNHS was able to consider expansion rather than amalgamation. Briefly, in 1841 it declared itself the Manchester and Salford Natural History Society but in 1844 it adopted 'The Manchester Natural History Society and Museum', to emphasise the strength and grandeur of its new accommodation.

The Museum on Peter Street

Having initially housed the collections in St Ann's place, rented from Mr Winter, a member of the Society, in 1824 the MNHS had transferred to more spacious accommodation at the top of King Street, later the site of the Reform Club, rented for 150 guineas per annum.[12] These rooms were still too small for the growing collections, however, and members began a campaign to erect their own premises, following the

lead of the Royal Manchester Institution and other voluntary associations. Their ultimate success was by no means a foregone conclusion, as many civic collections elsewhere made do with adapted or shared quarters.[13] But after several years of lobbying and raising funds, in 1832 the Society secured a plot of 1,200 square yards on Peter Street where it adjoined with Mount Street, in part of the town whose quieter residential character was giving way to institutions that would comprise the cultural counterpoint to the industrial city (see figure 1.2).[14] Architectural tenders were invited the following year, and construction began.[15] The new building on Peter Street, 36 yards wide and 14 yards deep, opened on 18 May 1835 at a total outlay of around £4,000. The ground floor comprised two large rooms and an entrance hall, with nine smaller rooms and a gallery upstairs.[16]

The Peter Street Museum was a grand affair, replete with a pillared façade (see figure 1.3).[17] It was part of the Greek architectural revival in Manchester, echoing the original town hall on King Street. The Museum also resonated with the Royal Manchester Institution building on Mosley Street, designed by Charles Barry and opened in the same year. Both the town hall and the Royal Institution were within five hundred yards of Peter Street; the last great Grecian building in Manchester was even closer – the adjacent (indeed, overshadowing) Theatre Royal, completed in 1845. Thereafter, Gothic and Italianate styles dominated, as for example in the 1853 Free Trade Hall on the other side of the Theatre Royal. Juxtaposed with proliferating mills and the thousand warehouses in the city by 1830, Grecian and Gothic monuments alike emphasised the cultural sophistication of Manchester's elite. As elsewhere in the provinces – such as the royal institutions in Liverpool and Hull – such buildings proclaimed British cities as heirs of ancient and medieval city-states.

The MNHS building was to expand further in the middle of the century, as it incorporated the collections of the Manchester Geological Society.[18] Founded in 1838, the Geological Society owed its existence to the efforts of Edward W. Binney, then a young solicitor and keen geologist, who was to be closely involved with the Lit and Phil. Like the MNHS, a collection was part of the Geological Society's remit from the outset, and it soon boasted a considerable fossil cabinet. Its prize specimen, an ichthyosaurus found near Whitby, was purchased for the Society in part by the wealthy Unitarian reformer and philanthropist James Heywood, brother of Benjamin Heywood (see above) and brother-in-law of Robinson. Heywood also provided accommodation in his house on Mosley Street before the Geological Society and its collections moved to the nearby Royal Manchester Institution.

By the later 1840s, however, the geologists were declining in membership and attendance. Following Oswald Mosley's suggestion that there were too many different scientific societies in Manchester, the two organisations entered into an uneasy alliance in 1851.[19] During the two years it took to transfer the Geological Society specimens from Mosley Street to Peter Street and incorporate them into the MNHS geology series, the societies added three further rooms to the back of the museum building. Nevertheless, the two groups continued to govern themselves

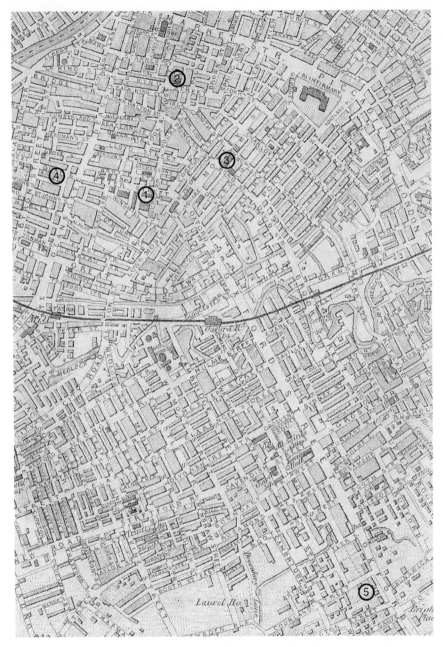

Figure 1.2 Victorian Manchester, showing (1) the Manchester Natural History Society's museum on Peter Street, (2) the original Town Hall, (3) the Royal Manchester Institution, (4) the original site of Owens College on Quay Street and (5) the site of the Owens College from the 1870s in Chorlton-on-Medlock.

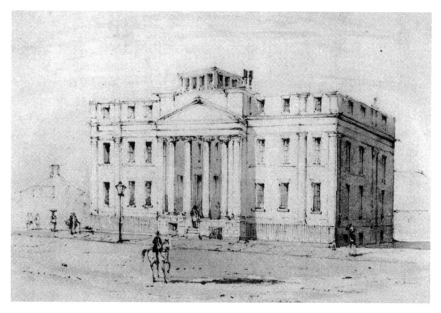

Figure 1.3 The museum of the Manchester Natural History Society, Peter Street, *c.*1865.

independently, and they made uncomfortable bedfellows.[20] Rows soon erupted over access to specimens, admission to the museum, and even charges for custody of umbrellas. They culminated in a bitter dispute over keys to the cases, during which MNHS Council accused Edward Binney of 'ungentlemanly and disgusting' conduct.[21] Sharing a space, it seems, did not entail sharing behavioural codes, and the spat rumbled on until the British Association for the Advancement of Science meeting in Manchester in 1861 prompted a truce.

The Manchester Geological Society's collection was only the largest of a series of acquisitions that extended the original core of Philips's cabinet to form a large (if uneven) natural history museum. The small revenue of the MNHS afforded some purchases, beginning with the bird collection of a local surgeon (which laid the groundwork for the collection's subsequent strength in ornithology) and 2,000 minerals and rocks from Joseph Strutt of Derby. According to the *Manchester Guardian*, the Society also bought the famed showman William Bullock's 'grand Mexican museum, consisting of birds, fishes, fruit, &c. &c.'[22] These early purchases spurred the generosity of the region's middle classes, and after the Society accepted its first donation – a South American Hammock from William Lever – gifts became the staple source of acquisition.[23] Donors included members of the Society or correspondents further afield. And as more specimens entered the collection, some began to leave. Duplicate specimens were sold or exchanged exploiting a network of individuals and institutions across the country including the Zoological Society of London, which promised the carcass of a kangaroo 'in case of its death, which

is expected to take place.[24] Such exchanges, gifts and purchases remained the principal modes of acquisition throughout the history of the Manchester Museum (see chapter 4 below). The collecting networks established by the MNHS in the nineteenth century provided a framework for acquisition in the twentieth.

Most items that arrived within the collection were incorporated within the ranks of taxonomically similar specimens, as the Society sought (vainly) to gather a 'complete' collection. But some specimens were so singular – either in their acquisition route, their characteristics, or their associations – that they remained distinct from the rest of the collection, their fame (or infamy) rendering them iconic. These included such notable quadrupeds as Mr Potter's cow, last individual of a herd of white polled cattle in Lancashire, and 'Vizier', Napoleon's Arabian charger.[25] The cotton merchants William and Robert Garnett donated sarcophagi housing the mummified remains of 'Asroni' (later 'Asru'), a royal maid of honour, thereby providing the Ancient Egyptian mummy that was ubiquitous in British collections from the seventeenth century onwards.[26] More unusually, the collection also included not only a Peruvian mummy but also the embalmed corpse of Hannah Beswick, a wealthy local woman who reputedly held such a fear of being buried alive that she had arranged for the surgeon Charles White posthumously to preserve her body.[27] White had then displayed her remains among the anatomical preparations at his house, which stood on the site that was later the town hall (see figure 1.2). Upon his death he had bequeathed the 'Manchester mummy' to a colleague, who in turn left it to the Society in 1828, together with the grandfather clock case in which Beswick's remains were kept. The presence of such curiosities reflected the expansive character of 'extended natural history' in Victorian Britain.[28] Antiquities and exotica were collected and used in the same way as local and foreign plants, animals and rocks. 'models of famous diamonds' and a 'large Burmese idol' sat alongside stalactites, turtle shells and a narwhal's horn.[29]

These charismatic objects occupied the 'curiosity' room on the ground floor of the 1835 building, the rest of which was given over to a more orthodox arrangement. By the time the Geological Society's collections arrived, some of the disciplinary lines that would shape the collection throughout the following century were evident, especially in the physical and conceptual position that earth sciences took as the basis of the Museum. Geology, mineralogy and vertebrate zoology were the foundation, while on the first floor the reptiles, birds, fish, crustaceans, insects and corals had coalesced into distinct parts of the collection. This gradual disaggregation reflected the emergence of distinct specialties within natural history literature and museums in the nineteenth century.[30] Naturalists in the British Museum and elsewhere carved out distinct areas of expertise not only in periodicals and monographs, but also in catalogues and with specimens: the material culture of natural knowledge. From 1836, the MNHS had embarked upon a series of catalogues of distinct faunal groups within the collection, which, although short-lived, reflected the divisions within the collection.[31] After the merger with the Geological Society,

the Manchester naturalists imposed the British Museum's taxonomic system across the collections.[32] But who was undertaking this rearrangement, and on whose behalf?

Visitors and staff

Like other bourgeois associations in the early nineteenth century, access to the rooms of the Manchester Natural History Society was limited to three categories of person. Gentlemen members or 'proprietors' paid a considerable sum upon joining (at first ten, later three guineas) and a guinea or two per annum thereafter. They had a proprietary stake in the collection, and were able to visit freely. Proprietors were permitted to bring guests, the second category, which included ladies, other family members and gentlemen visitors who resided more then six miles from the city. Finally, honorary membership was bestowed upon nobility and gentlemen 'residing some distance from Manchester' with scholarly merit, or else generosity in donating books, specimens or money.[33]

It was by the judicious employment of honorary membership that the MNHS connected itself to wider intellectual and political networks in Britain and beyond. The American ornithologist and bird artist John James Audubon exhibited his paintings in the Society's rooms while hawking his mammoth *Birds of America* (1827–38) around Britain.[34] The Society subscribed to the series (although the volumes were later sold by the Manchester Museum – see chapter 2 below) and granted Audubon honorary membership. He thereby benefited from the relationship financially, and the Society was afforded prestige in return as Audubon's star rapidly ascended. Closer to home, the patronage of Sir Oswald Mosley and Lord Stanley was critical: association with the landed gentry was a common tactic of the emerging urban bourgeoisie as they cemented their urban dominance.[35]

In the 1830s, however, the criteria for access to collections changed. Once the Peter Street building was open, other selected members of the middle classes were admitted, including from the mid-century professors from the nearby Owens College. Furthermore, the original bars to apprentices, servants and children were lifted. School groups could attend at 3d per pupil, ladies and strangers were permitted to enter on their own, non-subscribers were welcome (although often at the steep entrance fee of one shilling) and the working classes generally were granted entrance on certain days at 6d.[36] This apparent inclusivity was in response to a national tendency to provide cultural and educational opportunities for the 'lower orders' of society. Museums began to provide not only an uplifting pastime for the upper-middling ranks, but also rational recreation for the masses.[37] After the massive attendance at the Great Exhibition in 1851, reformers concluded that working people would flock to museums and galleries. Debates raged as to the desirability of gas lighting and Sunday opening to allow them to visit outside working hours (see chapter 6).[38]

Such endeavours met with mixed results. The MNHS Museum had been admit-
ting working men from 1838, but a year later not a single application had been made
for access.[39] More successful was a mutual admission deal with the Manchester
Mechanics' Institute: 188 mechanics attended in February 1840.[40] The MNHS later
reduced adult entrance to 3d, and gradually more use was made of the Museum.[41]
'No opportunity affords so effectual a means of elevating the tastes and pursuits of the
working classes and the young people of the district', the Council boasted, 'as frequent
and intelligent resort to an extensive, and, comparatively speaking, well-arranged
Museum of Natural History, such as that of the Society.'[42] Although total visits overall
peaked at over 50,000 in 1837, like comparable museums in Newcastle and Leeds,
the numbers were generally between 20,000 and 30,000 until the 1850s.[43]

In 1840, the Society experienced the ultimate test of the success of the Peter Street
Museum and other such institutions as instruments of working-class edification and
control. As the social reformer Edwin Chadwick reported,

> On the holiday given at Manchester in celebration of Her Majesty's marriage [10
> February], extensive arrangements were made for holding a Chartist meeting, and
> for getting up what was called a demonstration of the working classes, which greatly
> alarmed the municipal magistrates. Sir Charles Shaw, the Chief Commissioner of
> Police, induced the mayor to get the Botanical Gardens, Zoological Gardens, and
> Museum of that town, and other institutions, thrown open to the working classes at
> the hour they were urgently invited to attend the Chartist meeting. The mayor under-
> took to be personally answerable for any damage that occurred from throwing open
> the gardens and institutions to the classes who had never before encountered them.
> The effect was that not more than two or thee hundred people attended the political
> meeting, which entirely failed, and scarcely five shillings' worth of damage was done in
> the gardens or in public institutions by the workpeople, who were highly pleased.[44]

The civic elite rested assured that middle-class institutions were successful in luring
the lower orders from alcohol and, worse, radicalism. The symbolic location of the
Museum – built on the site of the Peterloo Massacre just a decade earlier – was
indicative of the confidence of the Manchester bourgeoisie in inter-class harmony.
Three successive free trade halls erected further down Peter Street reinforced the
assurance of the Manchester middle class and the centrality of the Natural History
Society within bourgeois culture.

The new building and visitor numbers in the 1830s prompted a shift in the manage-
ment of the collections. Originally, the specimens had been catalogued and cared for
by the core members of the Society, who appointed themselves 'honorary curators'.[45]
They were elected by ballot or council appointment according to their expertise (and
probably their ability to donate valuable or interesting specimens). Such naturalists
were not expected to get their hands dirty, however, and in the 1820s the Society had
engaged the weaver-turned-taxidermist Timothy Harrop to work for the honorary
curators as conservator, responsible for mounting and displaying the specimens. Upon
the erection of the Peter Street building, the Society also appointed William Crawford

Williamson 'Chief Curator, General Manager and Superintendent' at the tender age of nineteen.[46] The son of the curator of the Scarborough Museum, Williamson had come to Manchester to be apprenticed to Dr Charles Phillips, a prominent member of the Natural History Society. His appointment did not go well. 'If, before my acceptance of the curatorship of the Manchester Museum I had known all I subsequently learned,' wrote Williamson later in life, 'I should certainly have shrunk from taking the step.'[47] His frustration stemmed from a clash with Harrop, who he claimed was 'wholly ignorant of every branch of science except taxidermy, and . . . probably the worst bird-stuffer in Europe'.[48] Harrop too was disgruntled, and with good cause: he had once instructed Williamson's father in taxidermy, and Williamson Junior was then appointed over him, demanding a larger salary. The feud split the Council of the Society, pitting against each other those who advocated Williamson's 'scientific' approach to display, and those who favoured Harrop's more aesthetic methods. (Harrop was so concerned with appearance over all else that he installed only one glass eye in many of the birds, on the side that faced the audience.)[49] Exasperated, Williamson resigned in 1838 to complete his medical studies in London. He later returned to Manchester, where he was instrumental in establishing the Ear Hospital, and taught natural history at the new Owens College (see chapter 2 below).

Harrop also clashed with Williamson's successor, Captain Thomas Brown, and was eventually relieved of his duties after a long absence in 1848. Brown was an accomplished taxidermist himself, as well as a conchologist.[50] Brown had been stationed in Manchester as a militiaman in the 1810s, and after retiring from active service he made a living through scientific writing. He returned to Manchester and became involved in the fledgling Manchester Geological Society, succeeding as secretary Edward Binney (with whom he quarrelled bitterly). Continuing on the trajectory Williamson had started at Peter Street, Brown and his successor Thomas Alcock sought to establish the curators' role as that of expert naturalist rather than glorified janitor, and additional staff were appointed to assist them.[51] Like Williamson, Alcock was medically trained, and gave classes at Owens College and at the Museum. A keen naturalist, he kept a private museum at his home in Ashton-on-Mersey.[52] He had been a member of the Society for some years before his appointment in 1862, and so enjoyed an easier relationship with the honorary curators than his predecessors: he gave them new powers, and dismissed several of the salaried staff who were not pulling their weight. But there was little Alcock could do to stem the decline of the Society and its collections that was increasingly evident in the 1860s. Other associational organisations, such as the avowedly *haut bourgeois* Manchester Botanical and Horticultural Society, were also struggling for members and funds. The future looked bleak.

Transfer and dissolution

But there was legislative light at the end of the tunnel. The Public Libraries and Museums Act of 1845 gave local authorities the power to levy a penny rate to

maintain museums and libraries. Sunderland, Warrington, Leicester, Ipswich and (notably) Salford took advantage almost immediately. Over the following decades, many voluntary association collections in Britain either seeded or were absorbed by Corporation-run institutes, fuelling an exponential increase in public museums between 1850 and 1900.[53] These institutions were founded on the same wave of municipal reform as public libraries, parks and gardens. As the free library campaigner Thomas Greenwood wrote in 1888, 'a Museum and Free Library are as necessary for the mental and moral health of the citizens as good sanitary arrangements, water supply and street lighting are for their physical health and comfort'.[54]

Accordingly, when the Manchester naturalists began to struggle, they turned to the Corporation. The building had long been overcrowded; staffing was still inadequate. Members were dying off so subscriptions were down and attendance (and with it door income) was declining. The latter was exacerbated by competition from Salford's free museum at Peel Park less than two miles away, which had opened in January 1850. The Society's hopes were in vain. After four years, negotiations with the Corporation broke down – partly because the city bridled at the Society's demands for continued control over the collections, but no doubt also because of the financial circumstances of local government. The Society then considered offering the collections to Salford, but upon reflection anticipated similar problems to those encountered with Manchester. Salvation came from close to home in the form of Owens College, the first of the 'civic colleges' in provincial England.[55]

Founded in 1851, Owens had struggled through its first decade, but in the 1860s was beginning to thrive, with increasing students and the prospect of incorporating the Royal Manchester School of Medicine and Surgery. The naturalists were already familiar with the College, especially through Williamson's and Alcock's teaching.[56] The College authorities agreed to take the collections, together with the proceeds of the sale of the Peter Street building and its land. Space prohibited an immediate transfer, as the College operated in cramped accommodation on Quay Street (in Richard Cobden's old house), just west of the Museum. Larger premises were planned, however, on cheaper land in the suburb of Chorlton-on-Medlock a mile south of the city (see figure 1.2). They were designed by Alfred Waterhouse, a young Quaker architect trained and practising in Manchester, who had established his reputation with the Manchester Assize Courts and Strangeways Gaol, and was to cement it with the new Manchester Town Hall.[57] In the meantime, the MNHS appointed an interim commission to manage the collections, led by the Unitarian solicitor and collector Robert Dukinfield Darbishire, who features throughout this book. He supervised the disposal of the society's property and lands, and oversaw the running and maintenance of the collections in the meantime.

For advice on the reorganisation of the Museum in College hands, and how best fulfil its educational potential, the commission approached the biologist Thomas Huxley, 'Darwin's bulldog'. He advocated a 'public exhibition of a collection of specimens' *and* 'the accessibility of all objects contained in the museum to the curator

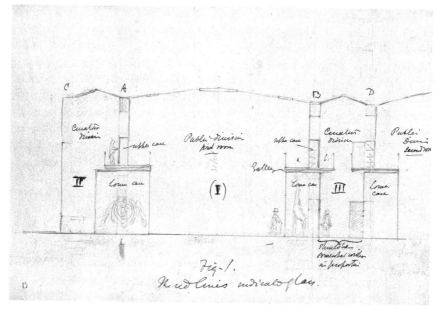

Figure 1.4 Thomas Henry Huxley's original sketch of the ideal arrangement of a natural history museum in the advice he gave to the Commissioners of the Manchester Natural History Society in 1868. The 'public division' (I) can be seen between 'curator divisions' (II and III); cases were accessible to staff and researchers, but not to the general visitor.

and to scientific students, without interference with the public or by the public'.[58] Huxley and museum practitioners such as William Henry Flower, later Director of the British Museum (Natural History), were seeking to distinguish between those collections for public display and those for serious study by promoting the notion of the 'new museum'. Research collections were to be kept in separate rooms in rows of densely packed cabinets, away from the select few specimens on public display (see figure 1.4).

> The cases in which these specimens are exhibited [Huxley advised the commission] must present a transparent but hermetically closed face, one side accessible to the public, while on the opposite side they are constantly accessible to the Curator by means of doors opening into a portion of the Museum to which the public has no access.[59]

Curators sought to construct self-consciously scientific collections, setting aside privileged space for the expert. Research collections were to 'be used only for consultation and reference *by those who are able to read and appreciate their contents*'.[60] And whereas Huxley's ideas were not strictly adhered to in the new Manchester Museum, the bifurcation of audiences, administratively and architecturally, was evident in its early years (see chapter 6 below).

To Alcock's disappointment, the commission did not see fit to continue his tenure as curator. Rather, on Huxley's advice, the commission appointed William Boyd Dawkins.[61] Born near Welshpool, Dawkins had studied geology at Oxford under John Phillips. As an undergraduate he undertook cave research, excavating at Kent's Hole, Torquay, and upon graduating, he worked for the Geological Survey under Huxley's tutelage. Although Dawkins went on to establish himself as an authority in palaeontology and archaeology, it is in his capacity as a curator and latterly a member of the Museum Committee that he is of interest here and in the chapters below. During his long career in Manchester, he developed very strong views on the arrangement and role of museums, and these influenced the Manchester Museum for decades – even after his formal departure from curatorial duties.[62]

On 29 January 1868 the Natural History Society formally dissolved, and the commission took control of its collections; the Manchester Geological Society, which survived, would transfer its collections the following year.[63] The new collection was to be purely scientific, comprising geology, zoology and botany, with no place for some of the more exotic specimens of the Society. Dawkins later complained that 'in very many museums, art is not separated from natural history, nor from ethnology, and the eye of the beholder takes in at a glance the picture of a local worthy, a big fossil, a few cups and saucers, a piece of cloth from the South Seas, a war club or two, and very possibly a mummy'. These 'articles which have no relationship with the rest . . . converted the whole into rubbish'.[64] And so in 1868, Darbishire arranged for the 'curiosities' to be auctioned – that is, all the anthropogenic material except Carthaginian and Egyptian antiquities. (Among the lots was the Burmese Buddha, bought by the Salford Museum but returned in 1969 as part of an exchange.)[65] The commission also sought to dispose of the some of the stranger items of the collection in an appropriate manner. After consultation with her surviving relatives, the Home Secretary and the Bishop of Manchester, Hannah Beswick's remains were finally buried in an unmarked grave in Harpurhey Cemetery to the north of the city.[66] The commission sent Napoleon's charger, Vizier, to the Louvre (where it remained unpacked for many years in a lumber room).[67]

Darbishire's law firm auctioned the Peter Street museum in July 1872.[68] From the proceeds of the sale, £5,000 was to fund a new building and the remainder (some £15,000) formed an endowment fund for salaries and collection maintenance. The collections themselves finally arrived at the College in 1873, a surprising sight as they trundled in carts down Oxford Road, many of the larger quadrupeds visible to the citizenry.[69] There they were stored in the College attics – ostensibly following Huxley's arrangement – with the exception of the giraffe and the elephant, which remained on the ground floor.[70] Dawkins used them on a limited basis 'in teaching in the College and in addresses to working men and to the general public' – students had to present a card signed by their professor to gain access.[71] But Dawkins was increasingly distracted from the collections. Failing to secure the Woodwardian Chair of Geology at Cambridge, he was appointed first to the lectureship and then

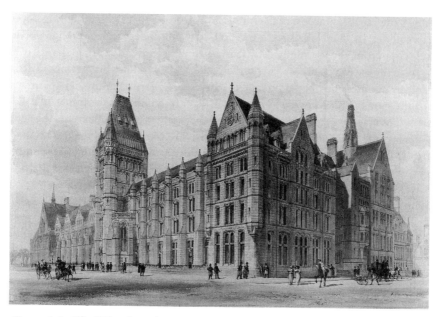

Figure 1.5 Alfred Waterhouse's conception of the Manchester Museum on Oxford Road, 1882. The building south of the tower (to the left of the picture) had yet to be completed: it would be designed by Alfred's son Paul as the Whitworth Hall (1902).

to the chair at Owens College (in addition to his curatorial duties), taking over Williamson's geology teaching.

In 1882, the first stone was laid for dedicated accommodation for the collections. The new building would form one side of the Owens quadrangle, the front face and gateway to the College. The building and its public aspect were timely. Further down Oxford Road, Darbishire and the other trustees of the estate of the engineering magnate Sir Joseph Whitworth secured a mansion and its parcel of land for a public park and art gallery, the Whitworth Institute. In the town centre, the corporation had recently adapted the Royal Manchester Institution to serve as the City Art Gallery. Liverpool, not to be outdone, boasted the new Walker Art Gallery.

To design a museum to rival these civic monuments, the College turned again to Alfred Waterhouse, who was becoming the favoured architect for the northern university colleges – his chosen building materials earned them their sobriquet 'redbrick'. His previous Owens building was an imposing but utilitarian non-historic Gothic sandstone pile. The Museum was even more monumental, with dense tripartite fenestration and full height buttresses (see figure 1.5). Steep red pyramidal roofs topped the façade, and a nine-storey tower provided the visual centre-point of the College. The popular conservatism demonstrated by this design was central to Waterhouse's reputation, as was his attention to practicality and his ability to work within limited budgets. Nevertheless, the proceeds of the Peter Street sale did

little to defray the total cost of the Museum. Together with the neighbouring Beyer laboratories, the final bill came to £95,000 – the remainder funded through public subscription and by the Whitworth Trustees.[72]

Waterhouse had been based in London since 1865, and since his previous Owens College commissions he had adapted Francis Fowke's design for new premises for the new British Museum (Natural History) in South Kensington.[73] The two museums may have shared an architect, but they were markedly different. The light Romanesque terracotta frontage of the BM(NH) contrasted with the imposing neo-Gothic edifice in Manchester. Rival conceptions of nature were built into the very fabric of the buildings. In South Kensington, the architecture reflected Richard Owen's commitment to comparative anatomy, with multiple galleries leading off from a central index collection. In Manchester, the galleries were arranged in a single continuous path up the building, allowing the collections to be displayed as an evolutionary sequence (explored in more detail in chapter 2). Dawkins's original idea was to present a few carefully selected specimens for public viewing, with the bulk in reserve storage; in South Kensington, Owen wanted an encyclopaedic collection with as much on display as possible.

Thus the Manchester Museum collections, like other aspects of Victorian natural history, emerged from the voluntary sphere into a new space and form of ownership as the twentieth century loomed. In the hands of the College they were controlled not by wealthy amateurs, but by a new community of professional men of science. Gathered by wealthy late-Enlightenment collectors, the material cultures of provincial natural history formed the core of museums of learned societies in the early decades of the nineteenth century that were among a range of activities designed to display provincial civic pride. By the 1860s, these palaces of middle-class science were bursting at the seams and were proving burdensome as the societies ran into financial difficulties under competition from other cultural and educational sites. They turned to their towns to pay for the transfer to new accommodation, and the collections then became the responsibility of one of the various forms of civic committee – in this case, the Council of Owens College. Their museums were increasingly removed from the less savoury aspects of Victorian cultures of display by an increasing emphasis (however unheeded) on education, shaping the twentieth-century understanding of the public museum.

Despite considerable changes during the nineteenth century, the influence exercised by the urban elite endured, and is evident throughout the chapters that follow. Members of the *haute bourgeoisie* managed personal collections as owners, society collections as proprietors, and university collections as committee members. Despite the apparent permeability of museums in the second half of the century, if anything, the local middle-class elite strengthened their grip during this time. Whereas the personal museum was explicitly exclusive, the public educational museum was potentially a more potent a tool of bourgeois hegemony, an attempt to impose middle-class definitions of culture and nature onto other sections of

society. Whether or not the 'lower orders' paid much heed is of course another matter.[74] Successful or not, natural history collecting and collections were one facet of middle-class cultural activities – art galleries, theatres, libraries – that served in part to educate the working classes, in part to reassure the urban bourgeoisie of the cultural sophistication of their town in contrast to other regions and to the capital. These functions and projected audiences feature throughout *Nature and Culture*, before becoming explicit again in chapter 6.

Notes

1 Manchester Central Library Local Studies Unit (hereafter MCL), Archives, M84, M84/ additional, 'Papers relating to the family of John Leigh Philips'; MCL, Biographical Newspaper Clippings, 'Philips, John Leigh'; S. J. M. M. Alberti, 'Placing nature: natural history collections and their owners in nineteenth-century provincial England', *British Journal for the History of Science*, 35 (2002), 291–311; F. J. Faraday and W. B. Faraday, 'Selections from the correspondence of Lieut.-Colonel John Leigh Philips of Mayfield, Manchester', *Memoirs and Proceedings of the Manchester Literary and Philosophical Society*, 3, 44, 45 (1890–1901), 13–56, 1–51, 1–59; J. L. Philips, *Instructions for Collecting and Preserving Insects, &c.* (Manchester: Wheeler, 1808); C. D. Sherborn, 'Memorandum on a catalogue of books and prints belonging to J. L. Philips', *Proceedings of the Manchester Literary and Philosophical Society*, 49 (1904–5), ii–iii. On eighteenth-century natural history collecting, see V. Jankovic, 'The place of nature and the nature of place: the chorographic challenge to the history of British provincial science', *History of Science*, 38 (2000), 79–113; A. MacGregor, *Curiosity and Enlightenment: Collectors and Collections from the Sixteenth to the Nineteenth Century* (New Haven: Yale University Press, 2007); on extended natural history, see J. V. Pickstone, *Ways of Knowing: A New History of Science, Technology and Medicine* (Manchester: Manchester University Press, 2000).

2 On country houses, see P. Mandler, *The Fall and Rise of the Stately Home* (New Haven: Yale University Press, 1997); A. Tinniswood, *A History of Country House Visiting: Five Centuries of Tourism and Taste* (Oxford: Blackwell, 1989).

3 On the Lit and Phil, see C. E. Makepeace, *Science and Technology in Manchester: Two Hundred Years of the Lit. and Phil.* (Manchester: Manchester Literary and Philosophical Society, 1984); A. L. Smyth, 'The Society's house, 1799–1840', *Memoirs and Proceedings of the Manchester Literary and Philosophical Society*, 126 (1986–87), 132–50; A. Thackray, 'Natural knowledge in cultural context: the Manchester model', *American Historical Review*, 79 (1974), 672–709.

4 *A Catalogue of the Valuable Collection of Paintings and Drawings, Prints and Etchings, Cabinet of Insects, &c. (The Property of the Late John Leigh Philips, Esq.)* (Manchester: Aston, 1814), p. 77; J. M. Chalmers-Hunt (ed.), *Natural History Auctions 1700–1972: A Register of Sales in the British Isles* (London: Sotheby Parke Bernet, 1976); L. H. Grindon, *Manchester Banks and Bankers: Historical, Biographical, and Anecdotal* (Manchester: Palmer and Howe, 1877).

5 On associational culture in provincial England, see P. Elliott, 'Provincial urban society, scientific culture and socio-political marginality in Britain in the eighteenth and

nineteenth centuries', *Social History*, 28 (2003), 361–87; S. Gunn, *The Public Culture of the Victorian Middle Class: Ritual and Authority in the English Industrial City 1840–1914* (Manchester: Manchester University Press, 2000); I. Inkster and J. Morrell (eds), *Metropolis and Province: Science in British Culture, 1780–1850* (London: Hutchinson, 1983); S. J. Knell, *The Culture of English Geology, 1815–1851: A Science Revealed through its Collecting* (Aldershot: Ashgate, 2000); R. J. Morris, *Class, Sect and Party: The Making of the British Middle Class, Leeds 1820–1850* (Manchester: Manchester University Press, 1990); Morris, 'Civil society and the nature of urbanism: Britain, 1750–1850', *Urban History*, 25 (1998), 289–301; J. Wolff and J. Seed, *The Culture of Capital: Art, Power and the Nineteenth-Century Middle Class* (Manchester: Manchester University Press, 1988).

6 E. P. Hamm, 'Unpacking Goethe's collections: the public and the private in natural-historical collecting', *British Journal for the History of Science*, 34 (2001), 275–300.

7 Manchester Museum Central Archive (hereafter MMCA), CNH1/1, 30 June 1821.

8 CNH1/1, 2 August 1822; C. Fisher (ed.), *A Passion for Natural history: The Life and Legacy of the 13th Earl of Derby* (Liverpool: National Museums and Galleries on Merseyside, 2002).

9 CNH1/1, 25 October 1821.

10 CNH1/1, 21 February 1822.

11 CNH1/1, 21 November 1822, 7 February 1823, 20 February 1823; S. MacDonald, 'The Royal Manchester Institution', in J. H. G. Archer (ed.), *Art and Architecture in Victorian Manchester: Ten Illustrations of Patronage and Practice* (Manchester: Manchester University Press, 1985), pp. 28–45.

12 CNH1/1, 11 October 1821, 20 February 1823; MMCA, Manchester Museum Committee Minutes (hereafter MMCM) vol. 4 (10 January 1921).

13 See e.g. P. Brears and S. Davies, *Treasures for the People: The Story of Museums and Art Galleries in Yorkshire and Humberside* (Yorkshire and Humberside: Yorkshire and Humberside Museums Council, 1989).

14 A. Kidd, *Manchester: A History* (Lancaster: Carnegie, 4th edn, 2006).

15 CNH1/2, 10 July 1832, 20 August 1833.

16 T. Ashton, *Visits to the Museum of the Manchester Natural History Society* (Manchester: Manchester Museum, 1857); J. Wheeler, *Manchester, its Political, Social and Commercial History, Ancient and Modern* (Manchester: Whittaker, 1836).

17 Archer, *Art and Architecture*; S. Forgan, 'Context, image and function: a preliminary enquiry into the architecture of scientific societies', *British Journal for the History of Science*, 19 (1986), 89–113; C. Hartwell *et al.*, *Manchester* (New Haven: Yale University Press, 2002); K. Hill, '"Thoroughly embued with the spirit of ancient Greece": symbolism and space in Victorian civic culture', in A. Kidd and D. Nicholls (eds), *Gender, Civic Culture and Consumerism: Middle-Class Identity in Britain 1800–1940* (Manchester: Manchester University Press, 1999), pp. 99–111; M. Howard, *Up Close: A Guide to Manchester Art Gallery* (London: Scala, 2002); Kidd, *Manchester*; J. J. Parkinson-Bailey, *Manchester: An Architectural History* (Manchester: Manchester University Press, 2000); S. M. Pearce, *Museums, Objects and Collections: A Cultural Study* (Leicester: Leicester University Press, 1992).

18 R. H. Kargon, *Science in Victorian Manchester: Enterprise and Expertise* (Manchester: Manchester University Press, 1977); Knell, *The Culture of English Geology*; J. Thompson,

The Owens College: Its Foundation and Growth; and its Connection with the Victoria University, Manchester (Manchester: Cornish, 1886); K. Wood, *Rich Seams: Manchester Geological and Mining Society 1838–1988* (Warrington: Manchester Geological and Mining Society Branch of the Institution of Mining Engineers, 1987).

19 CNH1/3, 7 November 1849.

20 Manchester Geological Society, *Annual Meeting* (1857) in CNH1/4, 2 December 1857.

21 CNH1/5, 5 October 1859; Wood, *Rich Seams*.

22 'Natural History Society', *Manchester Guardian* (25 October 1828), p. 2; W. Bullock, *A Descriptive Catalogue of the Exhibition, Entitled Ancient and Modern Mexico* (London: Egyptian Hall, 1824). I am grateful to William Costeloe for this information.

23 CNH1/1, 31 January 1822.

24 CNH1/2, 27 January 1841, p. 288.

25 CNH1/2, 1 November 1837; CNH1/3, 25 January 1843; L. Alderson, *Rare Breeds* (Aylesbury: Shire, 1984).

26 K. Arnold, *Cabinets for the Curious: Looking Back at Early English Museums* (Aldershot: Ashgate, 2006); S. Moser, *Wondrous Curiosities: Ancient Egypt at the British Museum* (Chicago: University of Chicago Press, 2006). On the Garnett brothers, see MCL newspaper cuttings, *Manchester City News* Notes and Queries, response from W. Hewitson, 5 November 1904.

27 *The Times*, 22 February 1864; *Evening News and Chronicle*, 13 February 1868; T. P. de Quincey, *Autobiographic Sketches 1790–1803* (Edinburgh: Black, 1862); G. Head, *A Home Tour through the Manufacturing Districts of England in the Summer of 1835* (London: Cass, facsimile edn, 1968); J. Ralston, *Views of the Ancient Buildings in Manchester*, ed. H. Broadbent (Salford: Printwise, facsimile edn, 1989).

28 Pickstone, *Ways of Knowing*.

29 Ashton, *Visits to the Museum*, part I, p. 41.

30 D. E. Allen, *The Naturalist in Britain: A Social History* (Princeton: Princeton University Press, 2nd edn, 1994); A. E. Gunther, *A Century of Zoology at the British Museum Through the Lives of Two Keepers, 1815–1914* (London: Dawsons, 1975); MacGregor, *Curiosity and Enlightenment*; G. R. McOuat, 'Species, rules and meaning: the politics of language and the ends of definitions in 19th century natural history', *Studies in History and Philosophy of Science*, 27 (1996), 473–519; McOuat, 'Cataloguing power: delineating "competent naturalists" and the meaning of species in the British Museum', *British Journal for the History of Science*, 34 (2001), 1–28.

31 Manchester Natural History Society (hereafter MNHS), *Aves Britannicæ. A Systematic Catalogue of British birds* (Manchester: Council of the MNHS, 1836); MNHS, *Catalogue of the Foreign Shells in the Possession of the Manchester Natural History Society* (Manchester: Council of the MNHS, 1837).

32 It replaced a somewhat piecemeal arrangement, some of which had been based on Cuvierian comparative anatomy. CNH1/4, 6 October 1852; Wheeler, *Manchester*.

33 CNH1/1, 25 October 1821, 11 May 1827.

34 CNH1/1, 23 September 1826, 11 May 1827, 22 August 1827. J. J. Audubon, *The Birds of America: From Original Drawings*, 4 vols (London: privately printed, 1827–38); J. Chalmers, *Audubon in Edinburgh: And his Scottish Associates* (Edinburgh: National

Museums of Scotland, 2003); D. Hart-Davis, *Audubon's Elephant: The Story of John James Audubon's Epic Struggle to Publish* The Birds of America (London: Weidenfeld & Nicolson, 2003); W. Souder, *Under a Wild Sky: John James Audubon and the Making of* The Birds of America (New York: North Point, 2004).

35 CNH1/2, 20 January 1839; Fisher (ed.), *A Passion for Natural History*.

36 CNH1/1, 2 May 1827; CNH1/2, 16 August 1837, 15 August 1838, 16 October 1838, 5 February 1840. The Manchester Geological Society collections were ostensibly open free to the public (a source of continued tension between the two societies). On nineteenth-century admission charges, see G. N. Swinney and D. Heppell, 'Public and privileged access: a historical survey of admission charges and visitor figures for part of the Scottish national collections', *Book of the Old Edinburgh Club*, 4 (1997), 69–84.

37 Alberti, 'Placing nature'; P. Bailey, *Leisure and Class in Victorian Britain: Rational Recreation and the Contest for Control, 1830–1885* (London: Routledge, 1978); A. Secord, 'Science in the pub: artisan botanists in early nineteenth-century Lancashire', *History of Science*, 32 (1994), 269–315.

38 K. Hill, '"Roughs of both sexes": the working class in Victorian museums and art galleries', in S. Gunn and R. J. Morris (eds), *Identities in Space: Contested Terrains in the Western City since 1850* (Aldershot: Ashgate, 2001), pp. 190–203; G. N. Swinney, 'The evil of vitiating and heating the air: artificial lighting and public access to the National Gallery, London, with particular reference to the Turner and Vernon collections', *Journal of the History of Collections*, 15 (2003), 83–112.

39 CNH1/2, 30 January 1839.

40 CNH1/2, 4 March 1840; CNH1/3, 5 April 1848.

41 Ashton, *Visits to the Museum*; CNH1/3.

42 MNHS, 'Report of the Council', in CNH1/4, 7 January 1857, p. 2.

43 Alberti, 'Placing nature'.

44 B. W. Richardson, *The Health of Nations. A Review of the Works of Edwin Chadwick*, 2 vols, vol. 2 (London: Longmans, 1887), p. 128; CNH1/2, 8 February 1840; T. Bennett, *The Birth of the Museum: History, Theory, Politics* (London and New York: Routledge, 1995).

45 CNH1/1, 22 November 1821.

46 CNH1/2, 18 March 1835, 29 July 1835; P. G. Moore, *Marine Faunistics in the Clyde Sea Area: Fieldworkers in Cultural Context Prior to 1850* (Isle of Cambrae: University Marine Biological Station Millport, 2007).

47 W. C. Williamson, *Reminiscences of a Yorkshire Naturalist* (London: Redway, 1896), p. 59.

48 *Ibid.*, p. 60.

49 CNH1/2, 7 August 1839.

50 CNH1/2, 15 August 1838, 3 October 1838; T. Brown, *Illustrations of the Fossil Conchology of Great Britain and Ireland, with Descriptions and Localities of all the Species* (London: Smith, Elder, 1837–49); Brown, *The Taxidermist's Manual; or the Art of Collecting, Preparing, and Preserving Objects of Natural History* (London: Fullarton, 8th edn, 1849); J. W. Jackson, 'Biography of Captain Thomas Brown (1785–1862), a former curator of the Manchester Museum', *Memoirs and Proceedings of the Manchester Literary and Philosophical Society*, 86 (1943–45), 1–28; Wood, *Rich Seams*.

51 CNH1/4, 4 February 1857.

52 'Dr Alcock's diary . . .', *Cheshire Archives and Local Studies Newsletter*, 27 (2005), 2.

53 Bennett, *Birth of the Museum*; D. Chun, 'Public display, private glory: Sir John Fleming Leicester's gallery of British art in early nineteenth-century England', *Journal of the History of Collections*, 13 (2001), 175–89; E. Frostick, 'Museums in education: a neglected role?' *Museums Journal*, 85 (1985), 67–74; K. Hill, *Culture and Class in English Public Museums, 1850–1914* (Aldershot: Ashgate, 2005); G. Lewis, *For Instruction and Recreation: A Centenary History of the Museums Association* (London: Quiller, 1989); Pearce, *Museums, Objects and Collections*.

54 T. Greenwood, *Museums and Art Galleries* (London: Simpkin, 1888), p. 389.

55 S. J. M. M. Alberti, 'Civic cultures and civic colleges in Victorian England', in M. J. Daunton (ed.), *The Organisation of Knowledge in Victorian Britain* (Oxford: Oxford University Press, 2005), pp. 337–56; S. Butler, 'A transformation in training: the formation of university medical faculties in Manchester, Leeds, and Liverpool, 1870–84', *Medical History*, 30 (1986), 115–32; D. R. Jones, *The Origins of Civic Universities: Manchester, Leeds and Liverpool* (London: Routledge, 1988). On Owens College, see H. Chaloner, *The Movement for the Extension of Owens College Manchester 1863–73* (Manchester: Manchester University Press, 1973); H. B. Charlton, *Portrait of a University, 1851–1951: To Commemorate the Centenary of Manchester University* (Manchester: Manchester University Press, 1951); E. Fiddes, *Chapters in the History of Owens College and of Manchester University, 1851–1914* (Manchester: Manchester University Press, 1937); C. Lees and A. Robertson, 'Early students and the "University of the Busy": the Quay Street years of Owens College 1851–1870', *Bulletin of the John Rylands University Library of Manchester*, 79 (1997), 161–94; Thompson, *The Owens College*.

56 CNH1/3, 4 March 1851; CNH1/4, 2 February 1853.

57 C. Cunningham, *The Terracotta Designs of Alfred Waterhouse* (London: Natural History Museum, 2001); Cunningham and P. Waterhouse, *Alfred Waterhouse 1830–1905: Biography of a Practice* (Oxford: Clarendon, 1992); Hartwell *et al.*, *Manchester*; N. Pevsner, *Lancashire: The Industrial and Commercial South* (Harmondsworth: Penguin, 1969).

58 T. H. Huxley – Commissioners of the Manchester Natural History Society, 25 May 1868, in T. H. Huxley, 'Suggestions for a proposed natural history museum in Manchester', *Report of the Proceedings of the Museums Association*, 7 (1896), 126–31, p. 126, also cited in L. Huxley, *Life and Letters of Thomas Henry Huxley*, vol. 1 (London: Macmillan, 1900), p. 135. See also A. Desmond, *Huxley: From Devil's Disciple to Evolution's High Priest* (London: Penguin, 1998).

59 Huxley, 'Suggestions for a proposed natural history museum', p. 128; cf. W. H. Flower, *Essays on Museums and Other Subjects Connected with Natural History* (London: Macmillan, 1898).

60 W. H. Flower, 'Address', *Report of the Meeting of the British Association for the Advancement of Science*, 59 (1889), 3–24, p. 14, emphasis added.

61 The commission's first choice, Mr W. Wallace, declined to take up the post. CNH/COM/1/1; MMCA, *Manchester Museum Report* (hereafter *MMR*) (1928–29); P. Lucas, 'Charles Darwin, "little Dawkins" and the platycnemic Yale men: introducing a bioarchaeological tale of the descent of man', *Archives of Natural History*, 34 (2007), 318–45; J. Morrell, *John Phillips and the Business of Victorian Science* (Aldershot: Ashgate, 2005); G. Tweedale, 'Geology and industrial consultancy: Sir William Boyd Dawkins (1837–1929) and the

Kent Coalfield', *British Journal for the History of Science*, 24 (1991), 435–51; Tweedale, 'Dawkins, Sir William Boyd (1837–1929)', in *Oxford Dictionary of National Biography* (Oxford: Oxford University Press, 2004), www.oxforddnb.com/view/article/62497, accessed 19 April 2005; A. B. van Riper, *Men among the Mammoths: Victorian Science and the Discovery of Human Prehistory* (Chicago: Chicago University Press, 1993).

62 W. B. Dawkins, 'On museum organisation and arrangement', *Report of the Proceedings of the Museums Association*, 1 (1890), 38–45; Dawkins, 'On the museum question', *Report of the Proceedings of the Museums Association*, 3 (1892), 13–24; Dawkins, *The Opportunity of Manchester* (Manchester: Cuthbertson & Black, 1903); Dawkins, 'The organisation of museums and art galleries in Manchester', *Manchester Memoirs*, 62 (1917), 1–10; Dawkins, 'The Manchester Museum: its place in education', *Old Owensian Journal*, 5 (1928), 142–4.

63 CNH1/6, 29 January 1868; Wood, *Rich Seams*.

64 Dawkins, 'On the museum question', p. 17. See also T. Bennett, *Pasts beyond Memory: Evolution, Museums, Colonialism* (London: Routledge, 2004).

65 'Sale of curiosities', *Manchester Guardian* (9 October 1868), p. 3.

66 CNH/COM/1/1, 16 June 1868, 23 July 1868.

67 CNH1/6, 8 January 1868; CNH/COM/1/1, 13 March 1868; *MMR* (1903–4).

68 CNH/COM/1/1, 19 April 1872; Darbishire, Barker, & Tatham, *Plan and Particulars of a Very Valuable Freehold Plot of Land, Having an Extensive Frontage to Peter-Street* (Manchester: privately printed leaflet, 1872). In December the remaining collections and property and of the Natural History Society were finally transferred by formal deed of gift to Owens College.

69 On similarly visible transfers of the British Museum and Hunterian collection animals see 'The zoological family removing from the British Museum to their new house in South Kensington', *The Comic News* (18 July 1863), p. 3; L. Keppie, *William Hunter and the Hunterian Museum in Glasgow, 1807–2007* (Edinburgh: Edinburgh University Press, 2007).

70 John Rylands University Library, University of Manchester Archives (hereafter UMA), Owens College, 'Report of the Council to the Court of Governors', 28 September 1874; G. H. Carpenter, *A Short Guide to the Manchester Museum* (Manchester: Manchester University Press, 1933).

71 MMCM vol. 4 (13 June 1927), p. 225; CNH/COM/1/1; UMA, Owens College Manchester, *Calendar* (1873–74).

72 H. Plummer and W. M. Tattersall, *Memorandum on the Manchester Museum* (Manchester: Manchester Museum, 1913).

73 M. Girouard, *Alfred Waterhouse and the Natural History Museum* (New Haven: Yale University Press, 1981); W. T. Stearn, *The Natural History Museum at South Kensington: A History of the British Museum (Natural History) 1753–1980* (London: Heinemann, 1981); C. Yanni, *Nature's Museums: Victorian Science and the Architecture of Display* (London: Athlone, 1999).

74 Secord, 'Science in the pub'; Secord, *Artisan Naturalists* (Chicago: University of Chicago Press, forthcoming).

Nature: scientific disciplines in the museum

In the autumn of 1887, the British Association for the Advancement of Science held its annual meeting in Manchester, a city at the forefront of the second industrial revolution. The meeting was packed with scientific celebrities, including the chemist Dmitri Ivanovich Mendeleev and the naturalists Sir William Thiselton-Dyer, E. Ray Lankester and Asa Gray. Owens College staff were energetic hosts, not least as they prepared their new museum for its first opening. William Boyd Dawkins, in his final act as curator of the collections, detailed the geology of the region for the delegates; he and other naturalists closely involved with the collection were pleased to announce 'the new natural history museum of The Owens College'.[1]

Their audience was especially discerning. Most were familiar with other new natural history museums: the British Museum (Natural History), Harvard's Peabody Museum, the new building of the Musée d'Histoire Naturelle in Paris, the Imperial Natural History Museum in Vienna, the Bohemian Museum in Prague and the California Academy of Sciences.[2] Colonial expansion flooded imperial centres with specimens from around the world, renewing the confidence of European and American naturalists in their efforts to catalogue nature's complete encyclopaedia. The decades around 1900 were considered by contemporaries and historians alike as the 'heyday' of natural history, and public appreciation of nature was demonstrated by new conservation movements.[3] Lay consumption for natural history publications, activities and exhibitions was unprecedented. In the academic realm in which the Manchester Museum now operated, there emerged new projects such as plant ecology, which drew upon and perpetuated natural history practices.[4] Thanks to the demands of medical education for life science instruction, zoology and botany were now firmly established in the syllabuses of British higher education establishments, which boasted chairs in life and earth sciences.[5] This was especially the case in the English civic colleges that were soon to be chartered as independent universities, of which Owens College was prominent. The combination of academic demand and popular interest fuelled natural history posts at institutions that were otherwise principally dedicated to professional and industrial topics.

Natural history museums thrived at the intersection of education, empire and leisure. On this historians agree, but few have turned their attention to the

subsequent fate of natural science collections in twentieth-century Britain. How did they fare in the century of the laboratory, mass media and the end of empire? To find out, I explore the cultural cartography and wider contexts of the Manchester Museum. I interrogate the shifting disciplinary boundaries within the natural history collections and between the Museum, the university, and the wider intellectual sphere. To do so one must assess not only the physical changes evident in buildings and galleries, but also intangible factors such as staff training. Material culture was employed in the physical space of the Museum to build disciplines and anchor communities of practice, whether academic, amateur or professional. To make sense of this complex system, this chapter takes three key moments of structural and administrative change as hinge points in the narrative: the opening of the museum in the 1890s; the 1910s, when new buildings and expansion were accompanied by shifts in emphases and hierarchies; and the years around 1950, when the collections became more remote from the other parts of the University even as the Museum's staff expanded considerably. What can these shifts tell us about the development of natural history museums in the twentieth century?

Unified nature 1887–1910

The galleries explored by the British Association delegates were the culmination of two decades' work on the part of William Boyd Dawkins, now firmly established as a national authority on Pleistocene (that is, relatively recent) palaeontology. His vision for the Museum was of a unified sequence based first on chronology, then on complexity. The displays were laid out first to demonstrate the passage of palaeontological time, then to illustrate the evolution of life in reverse, from complex to simple. This arrangement contrasted starkly with the taxonomic system built into the main galleries of Richard Owen's BM(NH).

The visitors' journey began on the ground floor with mineralogy, which was presented as the bedrock, literally, of the Museum and therefore of life on earth (see figure 2.1).[6] Guided by the numbering on the cases one started with the oldest rocks, embarking on a journey through stratigraphical time on the ground and first floors, finally arriving at Dawkins's principal interest, the Quaternary geological era.[7] Here he incorporated human prehistory, juxtaposing faunal and technological remains from his own cave finds. Dawkins thus effected a segue from geology to ethnology – humankind was the hinge between the lower displays devoted to time, and the upper galleries arranged by complexity. Human tools gave way to human and primate remains, the epitome of the animal world. Then began 'a systematic survey of the Animal Kingdom' arranged by decreasing sophistication of form.[8] 'Mr Potter's Cow', one of the few curiosities to survive the cull of the Natural History Society specimens, eyed the British Association delegates warily, unsure of her new role as an example of *Bos taurus*. Overlooking the fossils and large mammals from the second floor gallery the sequence ran from the marine and smaller mammals to

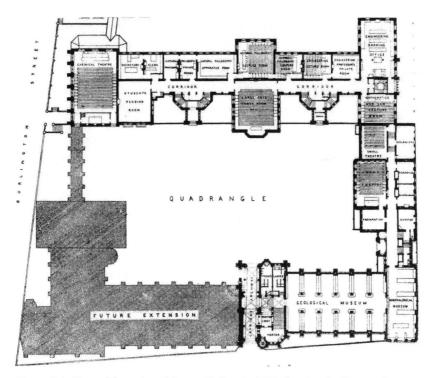

Figure 2.1 Ground floor plan of Owens College in 1890, showing the Museum bottom right. College staff entered the galleries directly from the Beyer Building immediately contiguous with the Museum, the public from under the arch on the left.

the 'lower vertebrates' – reptiles, amphibians and fish. On the east side Dawkins displayed the large ornithology holdings inherited from the Natural History Society, allegedly the finest outside the British Museum. They were soon to be arranged according to the classification of the Sheffield industrialist and ornithologist Henry Seebohm.[9] Descending in complexity as they ascended the stairs, visitors found the third floor devoted to invertebrates. Lying conceptually (if not physically) at the end of the sequence was botany, which occupied northern rooms on the second and third floors – almost an afterthought on Dawkins's part.[10]

Dawkins's series ran from mineralogy and palaeontology through archaeology to zoology and finally botany. Much as he had condemned the miscellany of the Peter Street Museum, however, the overall arrangement echoed that of the Natural History Society: rocks and mammals on the lower floors, with birds and lower zoological specimens in the upper rooms and botany fitted in wherever possible. And although in principle and in print the series ran smoothly in sequence, like his predecessors Dawkins had to contend with the practicalities of exhibitionary practice. Too often, museum historians fail to acknowledge that the sheer materiality

of galleries and objects constricted the enactment of theoretical arrangement. This was even the case in a building such as the Manchester Museum, in which Dawkins, architect of the arrangement, unusually had as much influence as Waterhouse, the architect of the structure.

Practicalities and contingencies abounded, and there were numerous concessions to the 'exigencies of space'.[11] As Dawkins's successor admitted, 'It has not always been possible to exhibit specimens in a strictly logical sequence', and at several points visitors had to double back on themselves.[12] Geology was suited to the ground floor not only because it was the foundation of life on earth and the conceptual progression of the displays, but also because of the sheer weight of the specimens. The enormous fossil tree stump the *Stigmaria ficoides* could only be housed on the ground floor.[13] Many parts of the series were under-represented or unsuitable for display, including swathes of palaeontology, invertebrate zoology and botany. To compensate for the pragmatics of displays, visitors were provided with the ideal arrangement in guides and handbooks (see chapters 5 and 6). Such publications could smooth over individual specimens or even cabinets out of physical place on the galleries, but in its realisation whole collections (such as mineralogy) sat outside Dawkins's ideal. Such irregularities would overwhelm his system in the decades that followed.

However compromised by pragmatic concerns, this original layout was the contrivance of a single individual – an unusually coherent vision – and betrayed Dawkins's training and outlook as a palaeontologist. Shortly after the Museum opened, however, Dawkins withdrew from the curatorship, devoting himself instead to the teaching and research duties associated with the Chair of Geology he had held since 1874. It would be nearly seventy years before another geologist was in charge of the Museum. For the next four decades, the Museum was run by a succession of zoologists, fundamentally shifting the disciplinary landscape of the Museum. Dawkins's immediate successor was William Evans Hoyle. Having grown up in the region, Hoyle trained as a surgeon, a common route to a zoological career for nineteenth-century zoologists, and in the early 1880s had worked as a demonstrator at the Owens College Medical School behind the Museum. He was an active marine zoologist, publishing extensively on molluscs and editing the *HMS Challenger* expedition reports while working in Edinburgh.[14]

Hoyle beat another 109 applicants for the post (including Dawkins's existing assistant keeper).[15] Directing a natural history museum was a prestigious appointment, but he was not omnipotent. In 1880, with the collections in the attic, Owens College had anticipated that that 'the Professors of Zoology, Botany and Anatomy, and the Lecturer in Mineralogy, [would] be Curators of the departments represented by the Museum, under the general direction of the Curator of the Museum', who formed the governing Manchester Museum Committee.[16] Once the Museum was open to the public, however, it became apparent that its management would require further staff. In addition to Dawkins's original assistant curator, a zoologist, the College appointed another zoologist and finally a geologist in 1890.[17] This small

Figure 2.2 The Museum staff in 1898. Left to right: Cecil B. Crampton (geology), Robert Standen (zoology), Freda C. Ede (printer), William Evans Hoyle (Director), Clara Nördlinger (secretary), J. Ray Hardy (entomology), Harold Murray (botany).

curatorial team remained in place for six years. By the turn of the century, there were ten staff in all (seven of whom are shown in figure 2.2) – compared with 143 at the BM(NH).[18]

These paid staff were by necessity polymathic, but there was evident a core of expertise concentrated around invertebrate zoology that was not reflected in the displays. This distinction, between practice and exhibition, would be overlooked in a history that presented museums only as visual culture. It also indicates the wide range of practitioners involved in the collections beyond the salaried staff – curators drew on an extensive network of advisers. They turned to the publications of prominent naturalists in their arrangements, including Henry Seebohm, George Bentham and Joseph Hooker. During the summer, staff travelled to other museums (such as the Hope collection at Oxford) to seek advice and keep abreast of the latest techniques.[19] Closer to hand, wealthy amateur collectors such as the merchant James Cosmo Melvill and the solicitor Robert Dukinfield Darbishire (see chapter 1 above) were closely involved with the collections.[20]

Melvill in particular brought about a significant disciplinary shift in the Museum. Not until the late 1890s did the Museum Committee see fit to appoint a member of staff with botanical expertise (see figure 2.2). By this time, however, Melvill was already a member of the Committee (he acted as chair). He arranged the Museum's herbaria and in 1904 donated his own collection of non-European pressed plants, as

we will see in see chapter 4.[21] The small space previously devoted to botany proved insufficient and the Committee set aside an additional room. This established the botany collection on a far firmer footing, demonstrating the power of donors to impact upon the disciplinary landscape of museums.

Melvill had not been working alone in the herbarium. The College's Department of Botany was a valuable source of expertise and specimens. William Crawford Williamson, who had been the first curator of the Peter Street Museum, was appointed Professor of Natural History in 1851.[22] By the 1880s he was formally based in the new Beyer laboratories next door and passed freely to and from the herbarium. There he worked on the palaeobotanical collection that he had given to the Museum on its opening, and which he considered to be his teaching collection. Younger members of staff also researched and arranged specimens in the Museum, including the palaeontologist Marie Stopes, later famous for her work on family planning.[23] William Boyd Dawkins also continued to be closely involved, donating his own material and overseeing the arrangement. He remained active in the Museum for the rest of his long life (even after his retirement in 1908), delivering popular lectures and actively participating in the Museum Committee. Knighted in 1919, he lived for another decade, attending his last Committee meeting four months before his death.[24]

The relationship between these 'scientific supervisors' and the full-time Museum staff was often tense. The Keeper answered formally to the Museum Committee, but the classification of the collections was the remit of the Owens College academics. Even before he took up the post, Hoyle had queried the authority of the Keeper over the assistant lecturers, at that time working on the arrangement of the collections. The Committee came down on the side of the professors and, further, authorised Owens College staff to remove specimens from the Museum for teaching purposes without consulting the curatorial staff. Still the academics were not satisfied, and complained when Hoyle and his assistants acquired and displayed specimens without consulting them.[25] Only gradually did the tension dissipate, principally because the junior academics withdrew to their teaching responsibilities as the displays were gradually finished.

The physical proximity of the Museum and the departments that facilitated interaction between museum and university echoed such juxtapositions in the built environment elsewhere.[26] Such boundaries were permeable, and curators, lecturers, students and objects pass to and fro. When the Museum opened it was intended to be the core site for science instruction at the Victoria University, like the 1860 University Museum at Oxford.[27] A major function of these collections was to provide material culture for the departments' teaching. 'New biologists' at Owens College were closely associated with the disciplinary programme that ostensibly privileged the laboratory as the key site for teaching and research in life science, and yet they were closely associated with museums throughout their careers. Any shift from 'natural history' to 'biology' in this period was complex and subtle.[28]

In presenting a unified view of nature linked by time and evolution, Dawkins wanted to smooth over disciplinary boundaries within the natural sciences. As a palaeontologist, however, Dawkins's concept of evolution was progressive and uni-linear, as opposed to a purely Darwinian model of fragmented and multi-directional development of species, which had fallen somewhat into the intellectual back-ground towards the end of the nineteenth century.[29] In particular, although he was one of Darwin's many correspondents, Dawkins was not convinced by man's place in Darwin's thought, publicly criticising *The Descent of Man*.[30] In the Manchester Museum, nature's story was one of perpetual progress rather than a messy branch-like trial and error.

The Owens College natural history chair originally held by Williamson was divided in the 1870s, first to allow a chair in geology for Dawkins and subsequently to establish positions in zoology, botany and mineralogy. There was a more differen-tiated disciplinary climate in the College by the time the Museum opened. Across the country, there was little unity in the earth or life sciences as the nineteenth century drew to a close. Even before it opened, clear boundaries were evident in the Museum, along the lines of the research interests of the College staff, the collections themselves, and the very built environment they inhabited. And so despite the advice of Thomas Huxley and the efforts of Dawkins, the Museum's organisation echoed that of the fragmented BM(NH). There, Huxley's arch-rival Richard Owen laid out four scientific departments that operated all but independently of each other.

As these disciplinary boundaries crystallised in the Manchester Museum, there became evident a clear hierarchy of disciplines. Thanks to Dawkins, vertebrate palaeontology was the foundation of the collection, spatially and intellectually. It was the first to be encountered by visitors as they entered the building, a crucial space for both public museums and the new department stores opening in the late nineteenth century with which they shared concerns and spatial strategies.[31] Palaeontology was the only part of the collection, Dawkins argued, that the Natural History and Geological societies had left in good order, the others having 'become dead' since their heyday in the second quarter of the century.[32] Even the zoologist Hoyle publicly acknowledged that he and his colleagues had much to learn from palaeontology when it came to museum display.[33] Upon replacing Dawkins, he immediately set about improving the animal displays, appointing more zoologists and shamelessly privileging the zoology collections in the allocation of duties. (Likewise at the BM(NH), there were thirty-four staff in the zoology department, compared with half that in geology and only six in botany.) The zoology collection occupied more than half of the cases in the Museum and pages in its guidebooks.[34] Disciplinary hierarchies were reflected in the very minutiae of museum practice: even the planned alphabetical lettering system employed in the accession registers privileged zoology.[35]

At the bottom of the pile – and the low-prestige top of the building – was botany, the Cinderella collection, in spite of Melvill's efforts and in stark contrast to the

enduring popularity of field botany. Unsuitable for display and difficult to store, plants offered little to the exhibition, and few visitors completed the long trek up the stairs to view them. Even at the BM(NH), the herbarium was under threat. It was housed on the second floor of the east wing – far from the entrance – and the Director, zoologist E. Ray Lankester, wanted to transfer it to Kew Gardens, run by his friend Sir William Thiselton-Dyer. In Manchester, even Williamson's involvement did little to promote the science, and he preferred to work away at the palaeobotany collection in the privacy of his rooms than to champion the herbarium generally. Not until the new century would botany find a firmer footing, in an era of significant changes in the disciplinary landscape of the Manchester Museum.

Expanding collections 1910–50

In 1912–13, the Manchester Museum was extended with two buildings to the north of the Owens College quadrangle (see chapter 3 below). Although they were largely intended to accommodate the Egyptology and anthropology collections, the extensions nevertheless impacted significantly on the natural history arrangement in a number of ways. Geology expanded and botany flowered, but zoology nevertheless reaffirmed its hegemonic place as top dog in the disciplinary hierarchy.

The most obvious consequence was the new gallery devoted to economic geology. Despite Dawkins's own industrial consultancy (he advised on an early channel tunnel venture), he had not originally considered economic geology to have a place in a museum intended for university-level education. Economic geology nevertheless became a staple of the Victoria University syllabus.[36] Its eleventh-hour inclusion in the new building was thanks to an injection of £700 from an old institutional friend of the Museum, the Manchester Geological and Mining Society – 'mining' now reflecting the renewed importance of industrial earth science at the turn of the century.[37] Although dwarfed by funding magnates such as the Carnegie Institute elsewhere, the geologists' support nevertheless demonstrated the significance of the industrial-scientific interface at the dawn of the century of oil and 'Big Science'.[38]

Across the collections, Dawkins's original stress on pure science in displays did not satisfy the Museum's stakeholders in the twentieth century. Not only did the University departments demand more applied approaches but so did schools, local industries (principally mining and cotton) and agricultural interests. Gradually, the displays began to reflect this demand. The botany exhibits were intended to emulate Kew in their utility for 'commercial men', illustrating crop disease, forestry and horticulture.[39] Economic aspects were even more evident in the entomology displays. Manchester became an unlikely centre for economic entomology in the wake of the 1909 Development Commission's decision to devote funding to the University for one of two centres for economic zoology: Birmingham received monies for helminthology (worms), and Manchester would concentrate on insects.[40] From the 1920s,

the Museum devoted several prominent cases on the first floor to 'aspects of animal life and behaviour in relation to their surroundings, including some aspects of their influence on human health and industry'.[41] The reserve collections were used for identification purposes for public health and warehouse pest control.

During the high colonial period between the founding of the Manchester Museum and the beginning of the First World War, economic entomology had been firmly established in Britain and the United States.[42] Together with exchanges of massive collections such as that of Baron Walter Rothschild and the key role later played by ants and *Drosophila* in the development of evolutionary theories, the emergence of economic entomology helped to consolidate the independent study of insects.[43] The Imperial Bureau of Entomology was established within the BM(NH), and entomology became a distinct department there in 1913. In Manchester, a role was established for a 'curator of entomology'.[44] This left a smaller portion of the disciplinary firmament for (the rest of) zoology, which nevertheless continued to dominate the staff and practice. When William Evans Hoyle left to direct the National Museum of Wales in 1909, it was the Professor of Zoology Sydney Hickson who oversaw the Museum for six months before a replacement could be appointed.[45] Permanent candidates for the position included the prominent palaeontologist D. M. S. Watson, who had worked in Manchester with Marie Stopes; but he was beaten to the post by the Liverpudlian Walter Medley Tattersall.[46] Like Hoyle a marine zoologist, Tattersall's academic background mirrored the recruitment to the directorship of the BM(NH), in which all but one of the directors in the period 1856–1927 had held chairs in zoology or comparative anatomy. In British museums, zoology reigned.

Slowly this dominance was reflected on the galleries. Against the backdrop of Dawkins's single progressive account of evolution, the zoology staff began to introduce specific displays devoted to single species.[47] As the evolutionist – but anti-Darwinist – Henry Fairfield Osborn, who was based at the American Museum of Natural History, became possibly the most influential museum palaeontologist in the world, these small displays reflected the revival of pure Darwinism within zoology (in the Manchester Museum and beyond) in the early twentieth century.[48] The pervasive influence of zoology was further cemented by the appointment of J. Wilfrid Jackson to the geology post.[49] Although he had worked in the cotton industry, Jackson's first interest, like so many others in Manchester, was in conchology. He secured a position at the Museum with the support of Hoyle and Melvill, both of whom knew him through their shared interest in molluscs. At Dawkins's suggestion, Jackson had taken up palaeontology, which qualified him for the vacant geology position. Soon after his appointment he married the Museum's printer Alicia Standen, who worked on the collections at the Museum with her father, the avid conchologist and Assistant Keeper for Zoology, Robert Standen. Jackson and his father-in-law worked and lived together for nearly two decades. Remaining at the Museum until 1945, Jackson turned his hand to a variety of areas, from fossil

molluscs to Egyptology, but came to concentrate on recent faunal remains in cave deposits, following Dawkins's lead. Nevertheless, a curator with a zoological outlook was responsible for the Manchester Museum rocks.

During the 1910s, the zoological interests of the Keeper, the acting keeper, and the long-standing staff cemented the supremacy of zoology at the Manchester Museum. This did not prevent the herbarium, so small at the Museum's inception, from finally flourishing. Cosmo Melvill's gift in 1904 was followed by two further large donations (see chapter 4 below), prompting considerable expansion in the resources devoted to botany.[50] Space was at such a premium that the Museum transferred some plants into the University's new botany building nearby (completed in 1911 and designed by the same architect as the Museum's extensions, Alfred Waterhouse's son Paul). Perhaps most importantly for botany, at the close of 1910, Grace Wigglesworth was appointed to the Museum's staff. A student of mosses and liverworts, Wigglesworth had trained at the University and previously catalogued the Museum's herbarium.[51] Her first act was to accession the Grindon collection, and over the next four decades she oversaw the consolidation of botany within the Museum.[52]

Already under strain, the uneasy unification of disciplines within the Manchester Museum broke down in the 1910s: zoology overcame palaeontology as the dominant discipline; botany secured a distinct status; and new sub-disciplines such as entomology and economic geology emerged. Tattersall's 1915 'scheme of general classification in the museum' nevertheless appeared to continue Dawkins's unifying approach (see figure 2.3):

> In this scheme the minerals are placed at the bottom, because they are the materials out of which the rocks are formed. The existing animals and plants stand at the top in their true relation to the geological record, and the various changes which they have undergone in becoming what they are, fix the geological age of the rocks in which they rest.[53]

In the same breath, however, he advocated separate guidebooks for the different collections, marking their autonomous status. Tattersall advised visitors to enter the economic geology gallery after viewing the stratigraphical series rather than continuing the journal through life up the stairs, thus breaking the direct passage from palaeontology to zoology. And, crucially, the new building established a division between the natural and cultural collections.

The status of natural history generally was also in flux. From the 1880s until the early 1920s, natural history thrived in Britain and America, and museums were hegemonic sites for its practice.[54] By the late 1920s, however, the Manchester Museum and other institutions erected at the end of the nineteenth century were no longer the obvious place for the production of life science (even as their popularity for its consumption continued). New disciplinary endeavours had no use for museums: Mendelian geneticists or geophysicists did not require large collections; ecologists retreated to the field, and no longer collected; and the great survey expeditions were running out of steam and funding.[55] In this climate, further expansion

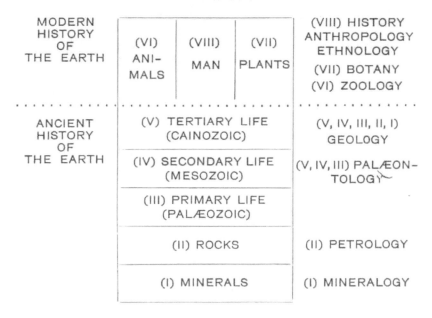

SCHEME OF GENERAL CLASSIFICATION IN THE MUSEUM

MODERN HISTORY OF THE EARTH	(VI) ANI-MALS	(VIII) MAN	(VII) PLANTS	(VIII) HISTORY ANTHROPOLOGY ETHNOLOGY
				(VII) BOTANY
				(VI) ZOOLOGY
ANCIENT HISTORY OF THE EARTH	(V) TERTIARY LIFE (CAINOZOIC)			(V, IV, III, II, I) GEOLOGY
	(IV) SECONDARY LIFE (MESOZOIC)			(V, IV, III) PALÆON-TOLOGY
	(III) PRIMARY LIFE (PALÆOZOIC)			
	(II) ROCKS			(II) PETROLOGY
	(I) MINERALS			(I) MINERALOGY

Figure 2.3 The Museum's classification scheme after the 1912–13 extensions, incorporating the expanded cultural collections.

of the Manchester Museum was once again effected on behalf of archaeology and anthropology rather than natural history.

A further extension to the Museum completed in 1927, as discussed in the next chapter, was built to house the still expanding cultural collections. The curators nevertheless saw opportunities for their natural science collections. The birds needed better accommodation, Wigglesworth wanted more space for the herbarium, and Jackson plotted to extend geology into the ground floor of the 1913 building. Tattersall was spared such adjudication, instead leaving Manchester to follow his predecessor Hoyle to Cardiff, where he took up the Chair of Zoology. His replacement was yet another zoologist, George H. Carpenter of the Dublin Museum.[56] Carpenter had briefly occupied the Chair of Zoology at the Royal College of Science in Dublin and was founder editor of the *Irish Naturalist*. Unlike his conchological predecessors, however, Carpenter's passion was insects, which would secure entomology's privileged status within the Manchester Museum.

Carpenter's first and most delicate task was to apportion the space liberated in the wake of the new building. Considerable tension centred on the proposal, popular with zoologists in the Museum and elsewhere in the University,

that the stratigraphical series of Tertiary fossils should be moved to the ground floor
so as to be continuous with the rest of the Palaeontological collections, thus leaving
the first floor and its galleries with adequate space for the Zoological and Botanical
collections.[57]

This would concentrate geology on the ground floor, and give over the first floor to
zoology. The plan was bitterly opposed by the indefatigable William Boyd Dawkins, who
was retired but still active on the Museum Committee. He clung to the coherence of his
original scheme, and in particular the continuity between nature and culture, insisting
that visitors should walk from fossils to simple tools to complex civilisations, whereas:

> The proposal now under discussion to remove the tertiary group from its place
> between Zoology and Egypt, will diminish the teaching value of the Museum to
> the University in Zoology and Palaeontology, and its attraction to the public. It will
> destroy the unique character of the Museum viz. – the proof of the continuity of
> Geology with History, and of the incoming of man in the Tertiary period, – resulting
> from recent discoveries.[58]

The Museum Committee voted Dawkins down, fourteen to one. Zoology con-
firmed its dominance of the galleries, and the conceptual bridge between nature and
culture was dismantled (even if the physical bridge remained intact).

Wilfrid Jackson accordingly brought the fossils down from the first floor, and
geology gained instead the 'north annexe' of the old building. Economic geology,
meanwhile, squeezed into the void left by ethnology.[59] Each displayed in its own way,
the different earth sciences now occupied almost the entire length of the Museum
(see figure 2.4). The interruption of Coupland Street between the buildings marked
a distinct change in emphases, however. To the north, mineralogy, petrology, geo-
physics and economic geology were somewhat isolated amongst the humanities; to
the south, palaeontology and stratigraphy became part of the science of life, 'living
and dead'. The zoology series had expanded to fill the entire first and second floors
of the old building. Dawkins's passage from complex to simple was now broken up,
with interspersed cases devoted to thematic displays on structure, classification, life
histories and more imaginative topics such as 'shells as jewellery'. Visitors could now
enter the Museum through the grand entrance in the 1927 building (see figure 2.5),
and did not come to natural history until the 'passage room' beyond the bridge, now
the boundary between nature and culture. Instead of encountering zoology as an
extension of palaeontology, the natural history building was prefaced with displays
devoted to the intellectual foundations of biology – 'a selection of exhibits to illus-
trate general zoological facts and principles'. They included life histories, the rules
of classification, biogeography and inheritance, reflecting Carpenter's Darwinism.[60]
Later, under the scientific supervision of neo-Lamarckian Herbert Graham Cannon
this emphasis waned and the displays were adapted in light of Henry Fairfield
Osborn's anti-Darwinist approach.[61]

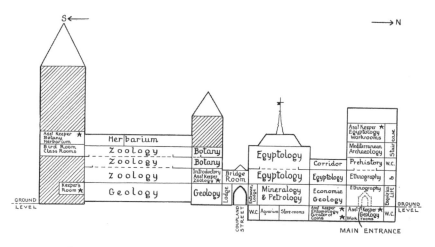

Figure 2.4 The arrangement of the Museum in 1941, as laid out in the late 1920s, showing the expansion of geology on the ground floor. The divisions between the cultural collection areas can be seen in the northern end of the building to the right.

Beyond, the majority of the gallery space was still devoted to zoology. Even though there was considerable behind-the-scenes activity in entomology and botany, Carpenter's museum was a predominately vertebrate collection built on top of some rocks.[62] The diversity of the earth sciences was well represented but, although he was respected, Jackson was not successful in his application for the keepership when Carpenter retired in 1934.[63] That the post was taken instead by an anthropologist, Roderick Urwick Sayce, as detailed in the following chapter, is indicative of the strength of the cultural collections and the changing status of natural history museums in the mid-twentieth century.

Nature dislocated 1950–90

Institutions dedicated to natural history struggled for status and funding in the decade after the Second World War.[64] In the restructuring of the British Civil Service, the Treasury even resisted the classification of museums as 'scientific' institutions, and the large national collections did not benefit from the injections of funding that universities enjoyed.[65] The 'evolutionary synthesis' of the early 1940s and the establishment of the structure of DNA in 1953 were manifestations of profound changes within the life sciences. These intellectual shifts, coupled with the development of new techniques, privileged laboratory-based fields as never before, particularly genetics and molecular biology.[66] This dynamic understanding of life appeared to threaten the notion of the static type specimen, and therefore the very underpinnings of taxonomy, with which the fate of museums was so intimately tied.

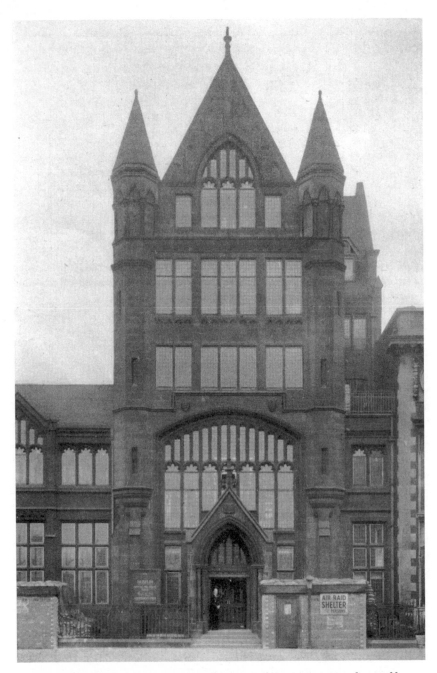

Figure 2.5 The front entrance of the Museum in the 1927 extension designed by Michael Waterhouse. This photograph, taken early in the Second World War, shows the Museum's air raid shelter.

Museums struggled to keep up with the changing face of science: not all cura-
tors were so involved with the evolutionary synthesis as Ernst Mayr (then at the
American Museum of Natural History), who in any case was accused by other
museum practitioners of betraying pure taxonomy in his enthusiasm to bring it
up to date.[67] The bulk of museum-based taxonomists, by contrast, were not inti-
mately concerned with the mechanics of evolution by natural selection, but rather
employed principally morphological techniques.[68] Laboratory geneticists, by con-
trast, were central to the new way of doing science. Field naturalists, meanwhile,
were called upon to solve a whole new set of problems, from ethology to ecology,
based on larger mathematical generalisations rather than detailed studies of particu-
lar species (and specimens). Professional field biologists in this period were more
interested in observing and recording system dynamics and population ecology
than they were in collecting an inventory of nature. Wildlife conservation and docu-
mentaries challenged urban museums as the principal popular engagement with
nature – the camera replaced the gun.

As Manchester Museum curators unpacked the key collections they brought
back from their wartime evacuation to various country houses, plans were afoot to
transform the built environment of the University around the Museum.[69] During
the 1940s the student population doubled, incorporating many returning service
personnel. In Manchester's post-war urban planning, the University was to expand
considerably at the expense of Chorlton-on-Medlock (see chapter 6).[70] With gov-
ernmental encouragement and increased student interest in technical subjects,
the science departments planned to expand to the east across Oxford Road. The
Museum Committee argued that the science collections should go with them,
rather than remaining on the west side of the road with the arts:

> if the future development of the Manchester Museum be considered, the Committee
> would favour a Natural History Museum associated with the new site allocated to the
> Faculty of Science which would leave the present building free for the expansion of the
> ethnological and archaeological collections.[71]

This would ensure that 'the several departments of the new Museum be closely con-
tiguous to the respective teaching Departments of Geology, Botany, and Zoology'.[72]
Such a move would also provide the opportunity for an overhaul of the older
galleries. The 'Natural History end is one of the most antiquated museums in the
whole country', complained the Committee, 'described by a leading member of the
Museums Association as a "museum piece"'.[73]

The Committee's hopes were in vain. New accommodation for the Museum
was relegated to 'the University's plans for the future', and the natural history col-
lections were dislocated from their cognate teaching departments. Starting with
engineering and the physical sciences, slowly the science faculties began to move to
new premises on the other side of the road in the 1950s. This development echoed
the removal of the Oxford University science departments from the museum block

on Parks Road, which included the natural history and Pitt Rivers collections. In Manchester, the Museum gained some scraps of space in the wake of the evacuating departments – and would eventually inhabit the old Dental School to its north – but its physical and conceptual position on campus was fundamentally altered.

How, then, did this dislocation impact upon the interaction of staff in the Museum and elsewhere in the University? Until the 1950s, Museum staff regularly taught in the University departments, whose staff and students in turn undertook research in the Museum.[74] The Professor of Zoology Herbert Graham Cannon in particular was an active and interested Museum Committee chair, securing major donations and insisting on the importance of gross morphology in the era of genes and proteins. However, after Cannon's death in 1963, his replacement was not as directly involved with the Museum as an academic site.[75] Some collections, especially botany, remained important resources for undergraduate teaching, but it was less common for the keepers to deliver the sessions. The Museum offered resources for the study of taxonomy and ecology, but these were no longer the strengths of the University department, which rather concentrated its expanding post-war resources on plant pathology and laboratory provision.[76] Whereas Wigglesworth had been so involved with the department that she appeared on their annual staff group photographs, her successors were conspicuous in their absence. By the 1960s, the status of the Museum within the University had declined to such an extent that its key location in the centre of the 'Manchester Education Precinct' (see chapter 6) outweighed the benefits of the collection, and a proposal circulated that the galleries move to the Arts Library away from Oxford Road.[77] Although the inertia of the University and the withdrawal of the funding for the Precinct saved it from this fate, that such a move was considered at all was indicative of the low priority by then given to the Museum.

Museum staff, too, felt the dwindling status. Cannon felt it was 'not sufficiently well-known . . . that we have by far the most distinguished scientific staff of any Museum outside London. It has, however, been a hard fight . . . to get these experts the salary they deserve, namely, the scale of their colleagues in the other University Departments.'[78] Students began to withdraw from museums generally, and as the University of Manchester life science departments prepared to cross Oxford Road, they also put intellectual distance between themselves and the Museum.[79] What were curators to do in museums, whose massive legacy of material culture denied them the flexibility of other institutions? The answer lay in orienting the Museum away from the University and towards other audiences.

Around 1950, partly as compensation for remaining on the west of Oxford Road, the Manchester Museum was awarded monies for a series of new posts. A technician was appointed to each collection, and as key long-serving members of staff such as Jackson and Wigglesworth retired, a new batch of curators arrived. Their generation was the first to have the opportunity to undertake museum-specific training (such as the Museums Association's new associateship scheme), and to subscribe to

emerging standards of practice, hallmarks of a maturing professional community.[80] In May 1958 the curatorial titles were re-cast: Sayce's successor, David Owen, was dubbed 'Director' and the specialist curator titles were changed from 'assistant keepers' to 'keepers'. Owen saw the Museum as a stand-alone public institution rather than a service department for the faculties, an effective survival strategy in an uncertain intellectual climate. He set about securing a series of new posts for each department, and by 1971 the number of curatorial and technical staff doubled (from six each in 1957).[81]

Academics from elsewhere in the University continued to be involved in the Museum, but generally by personal preference rather than formal requirements, as demonstrated, for example, by Cannon's interest in Japanese artefacts. Initiatives tended to come from within the Museum, as curators rather than academics led change. In recognition of this, their principal academic involvement in the Museum was no longer as scientific supervisors (which were by now more ex officio than active), but rather with a series of appointments of 'honorary curators', following an established practice in numismatics.[82] These practitioners were enrolled by the director and worked on the collections under the Museum's terms. The role of the amateur in museums had shifted in response to the increased status of curators, a key element of the emergence of the professional museum.

Another element characteristic of museums in this period, as in the construction of expert groups elsewhere, was professional closure to women.[83] Before the Second World War, the museum community had been notable for its gender balance. William Hoyle had 'considered museum work a suitable field for the employment of women' – although in his case this applied largely to the posts of secretary and printer.[84] In the inter-war period, female involvement in the Museum expanded from clerical into curatorial posts. By the mid-1930s, two-thirds of the Museum staff were female (see figure 2.6). Although this proportion included many subaltern roles, this nevertheless represented twice the national average of female involvement in the inter-war workplace. They were concentrated in the more acceptable female pursuits, especially botany, still considered a more feminine science as it had been in Victorian Britain: Marie Stopes, Irene Manton and Kathleen Drew were among the women who worked at the University.[85]

The new appointments in the 1950s, however, were largely male, with training and qualifications largely unavailable to women. From 1958 (when the assistant keepers became keepers) until 1990 (when the assistant keepership of archaeology was changed to the keepership of Egyptology) none of the main curatorial staff was female. All keepers of the natural science collections from 1958 were male; there has never been a female keeper of entomology or geology; and the Manchester Museum has never been directed by a woman. From the late 1960s, however, female museum professionals took advantage of the new assistant keeper positions to secure posts in the Museum, continuing the tradition of female involvement in the Museum in auxiliary roles, as female volunteers had undertaken before them. The education

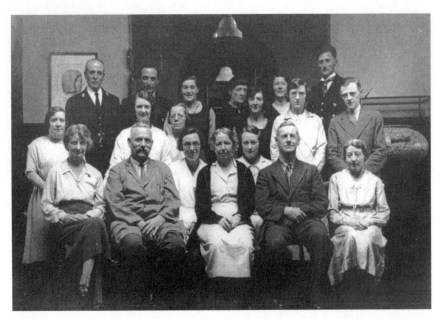

Figure 2.6 The Museum staff in 1934, showing the proportion of women employed. Front row, left to right: Mary Hodgson (secretary), Harry Britten (entomology), Cecilia Mirèio Legge (zoology), Grace Wigglesworth (botany), Mary Shaw (archaeology), Wilfrid Jackson (geology), Florence Hodgson (ethnology). Wiggleworth's assistant Annie Higginbotham is immediately behind Britten, whose assistant Mona Shields is behind Jackson. Long-serving technician and conservator Harry Spencer is on the far right of the middle row.

department (see chapter 6), which at the time was afforded considerably less status than other areas of the Museum, was also predominantly female. Even so, only around one quarter of the paid staff in the early 1970s were women.

The first – and ultimately longest serving – of the new (male) post-war curators was the geologist Michael Eagar.[86] He replaced Jackson in 1945 and remained in post until 1987. He studied the coal measures, and non-marine bivalves in particular, in order to understand better the correlation of different strata (geological layers). Unlike his predecessors, therefore, Eagar was interested in the deep past, in the earliest deposits rather than more recent eras. In contrast to the high-profile excavations and exotic fauna on which Dawkins worked, Eagar spent a painstaking career studying the least glamorous of creatures. His research focus led him to effect a subtle shift in the disciplinary topography of the Manchester Museum, an institution still small enough to be impacted upon by individual curators. For Dawkins, and to some extent Jackson, palaeontology served as an immediate prologue to modern zoology and botany, the first chapter in the continuous story of the history of life. Eagar, by contrast, was more interested in fossils in so far as they aided stratigraphy, and thereby 'the elucidation of the history of the earth'.[87] Eagar was

concerned with a huge timescale, and the bulk of the fossil record was only distantly connected to modern forms. There had been clear connections between Jackson's fossil mammals and those on the gallery above, whereas aeons separated Eagar's bivalves from the molluscs on the top floor. Dawkins and Jackson were palaeontologists who used some stratigraphy. Like many of his colleagues at the BM(NH), Eagar was a stratigrapher first and a palaeontologist second.[88] Accordingly, he dubbed the Manchester Museum fossil hall the 'stratigraphy gallery', setting up at its entrance a 'geological column' that graphically displayed the depth of time, unifying the geology collections and emphasising their grand scale.[89]

Zoology on the galleries was increasingly differentiated from geology.[90] This was especially evident in 1964, when the Herbert Graham Cannon Aquarium opened in what had been the upper botany gallery on the third floor.[91] The Museum had exhibited live animals and plants on the galleries since the Peter Street era, including wild flower displays, a rock pool and some small vivaria for reptiles.[92] These were dwarfed, however, by the breeding population of fish kept by Cannon in the University Department of Zoology next door. Used by both students and schoolchildren from the Museum's Education Service, the aquarium was a significant space of museum-university interaction. But in the mid-century the Department of Zoology was moving away from the study of whole organisms (like academic biology in the UK generally) and the fish were transferred to the Museum. The opening of the highly popular aquarium, named in Cannon's honour, emphasised reorientation of the Museum during Owen's tenure away from the University to a more general public. It soon included larger vivaria, and became famous for its large snakes and crocodiles (see figure 4.3).[93] Licensed as a zoo in 1984, the vivarium remained one of the most popular exhibits in the Museum, as live animals were in American science museums.[94]

This new-found popularity and the expansion in staff numbers of the individual 'departments' of the Museum served to isolate them from each other. During the 1960s there emerged within its cultural cartography a series of separate fiefdoms, comprising keeper, assistant keeper, technician and a community of volunteers. As the Museum gained more space in the basement of the neighbouring physics building for offices and stores in the late 1960s, they were also spatially disaggregated. They appealed to visitors separately with individual popular guidebooks, as we shall see in chapter 6. Each department engaged with other parts of the University separately – Eagar, for example, worked with the Department of Physics on a series of exhibitions about the moon.[95] They were staged in the new special exhibition space that replaced the economic geology gallery in the ground floor of the 1913 building, which finally broke down the spatial juxtaposition of nature and culture (see figure 4.2).

The Manchester Museum natural history staff survived the turbulent post-war years by establishing themselves not only as academics but as museum professionals. Spatially, administratively, and in their working communities, disciplines were

demarcated within the Museum. Such differences became even more pronounced in the final decades of the twentieth century. Divergent practices and relationships were concretised by an unprecedented stability in the staff, as keepers remained in the Museum for extraordinarily long tenures.[96] They were assisted by amateurs, both volunteers and honorary curators, and in the late 1970s by large cohorts of otherwise unemployed persons paid by the Manpower Services Commission.[97] These communities crystallised around particular collections and their keepers, further reinforcing separate fiefdoms within the Museum.

The long tenures of the paid staff benefited the collection, given the depth of expertise curators were able to develop over a period of decades and their combined institutional memory. In contrast to the turnover in the post-war period, however, long-term staff now presented a barrier to professional advancement for their assistants. This pressure was in part responsible for further disciplinary distinctions emerging within the collection areas as assistant keepers with distinct expertise were appointed and eventually promoted to keeper rank with responsibility for that particular part of the collection – invertebrate zoology, cryptogamic botany and mineralogy.[98]

Such distinctions within the collections were seldom evident on the galleries. Rather, this period was marked by a series of 'blockbuster' exhibitions. After a decade of dedication to expanding the public appeal of the Museum, David Owen's efforts paid off spectacularly in 1969 – but not through a carefully planned re-display, nor even one of the Museum's own objects. Keepers still mixed with other academics in the University's senior common room, where Michael Eagar had forged links with the mineralogist Jack Zussman, with whom he shared mutual college friends.[99] Zussman was one of the 300 principal investigators world-wide who were sent fragments of lunar soil gathered by Neil Armstrong on the Apollo 11 mission in 1969. Despite the restricted timetable dictated by NASA, Zussman and Eager wanted to put the 'moon rock' on display for the public. With the firm backing of David Owen, Zussman wrote to the Science Research Council, asking if they and NASA would permit a public display. Material from the early samples had been displayed, for example at the Smithsonian Institution in Washington, and Manchester was given the go-ahead. Eagar and fellow Museum staff frantically set to work preparing the exhibition, recycling material they had used in a lunar exhibition staged in 1964.[100] The dust was set in a glass dish within a locked case, with a microscope allowing scrutiny. Closed-circuit television cameras magnified the image onto a screen at the entrance to the exhibition. Despite the unimpressive appearance of the moon dust itself (see chapter 6), the exhibition attracted a staggering number of visitors.

Although itself serendipitous, the moon rock exhibition presaged a more strategic focus on display in the Museum over the following two decades (see also chapter 5). First to be redisplayed were the insect collections in 1978, better to illustrate 'the great diversity of form, size and colour of insects, and . . . their equally diverse biologies'.[101] But the lower floors would prove more challenging. By 1970, the bird gallery had become a 'public disgrace'.[102] After a decade of planning and fund-

raising, it was finally reopened in 1982, with new, themed displays (and even bird song).[103] Ornithology thus stood out from the other zoology displays, marking its disciplinary independence in this era, as echoed by the new BM(NH) sub-department at Tring. During the 1970s, botany also underwent a programme of rehousing and redisplay, culminating in 1985 in a new gallery that included a greenhouse and a live beehive (from which honey was sold in the Museum's new shop). Like the bird gallery, the botanists replaced traditional taxonomic exhibits with thematic displays, such as diet and medicine. After a decade of work, the mammals gallery was likewise relaunched in 1990.[104]

While change on the galleries was clear to see, the disciplinary hierarchies within the Museum changed more subtly. Zoology continued to dominate the science displays, especially with iconic beasts such as Maharajah the elephant in the centre of the old building and the huge spider crab displayed on the top floor. Spatial developments behind the scenes were rather more significant, as the Museum finally took over the old Dental School building to its north in 1977.[105] This allowed a rearrangement in offices and stores – geology, especially, was now consolidated on the second floor of the new building. This marked a subtle return to dominance within the Museum in the final decades of the century. From the success of the moon rock to the new Earth Science Collection Centre based in the Museum, geology was a force with which to be reckoned.[106] Owen had trained as a geologist – the first director to have done so since Dawkins a century before – and Eagar was appointed deputy director.

And yet even the geologists struggled in the later twentieth century to remain connected to the broader work of the university. The cognate university departments were now physically distant. The University Department of Geology had migrated east across Oxford Road in the 1960s, followed in the 1970s by Botany and finally Zoology.[107] When they needed museum objects, they now relied more on their own teaching collections rather than on the Museum's specimens.[108] The new School of Biological Sciences, typical of the rationalisation of life science in the UK, had few links with the Museum.[109] Across the country, taxonomists in particular and institutional naturalists generally considered themselves to be especially under threat in this period, as evidenced by funding crises at the BM(NH).[110] Even those scientific areas that fulfilled the new 'green' environmental Zeitgeist privileged fieldwork rather than collection-based research. Socially, too, museum-university links such as shared tea breaks were more difficult to maintain.[111] No longer did personnel so easily move from the departments to Museum, which now operated independently – conceptually, professionally, materially and socially.

The Museum was successful in its independence, proudly boasting the Museum of the Year Award for 1987, awarded on the strength of the new galleries. The Manchester Museum, once an integral part of the university's teaching and research with an auxiliary public display function, had experienced a century-long volteface from teaching collection to civic museum. The narrative of this complex and contingent shift will be taken up again in chapter 6.

Conclusion: cultural cartography and the museum

Three narratives have run through this chapter: the cultural cartography within the Museum; the relationship between the Museum and the rest of the University; and the status of the Museum profession(s). When it opened, the Manchester Museum presented a continuous, unified sequence, originally dominated by palaeontology. At least, that was the intention of its author, William Boyd Dawkins. But museum schemes are subject to pragmatics of the built environment, the availability and durability of specimens and the vagaries of institutional politics. Dawkins's conception of the Museum was never fully realised. The uniform strategy within the collection was slowly replaced by a more fragmented approach. The hegemonic status of palaeontology faded during the tenures of successive zoologists. The exclusive emphasis on pure science was supplemented by economic and applied approaches in a number of areas, especially entomology – which emerged as distinct in the early twentieth century.

Disciplinary distinctions were established not only by gallery arrangement but also in the very architecture of the Museum. Successive extensions to the Museum stretched and then broke the union of nature and culture in Dawkins's original evolutionary sequence. But the divisions did not result in the complete separation of natural and cultural collections into separate museums, as the Museum Committee proposed in the mid-century. Again, pragmatics prevented the implementation of the controlling philosophy of display. Instead, the individual collection areas emerged as separate fiefdoms under a new generation of curators.[112] Michael Eagar, who has served here as an example of the Museum's post-war personnel, employed a stratigraphical approach on the geology gallery that contrasted with the life science on the upper floors. Furthermore, as we shall see in chapter 3, the archaeologies in the newer buildings were also distinct from each other.

The explanation for this disciplinary development lies not in a single factor, but rather a contingent combination of collections, galleries and personnel. Especially in an institution of the Manchester Museum's size, the training and individual research interests of curators effected shifts in disciplinary shape as much as any new building. Chapter 4 will assess the role of donors in more detail, but their impact is already clear, for example in the gifts of the Manchester Geological Society and Herbert Graham Cannon. This combination of factors in the mapping of disciplines, and in particular the legacy of material culture, is unique to museums, and characteristic of particular institutions. The emphasis on different sciences and their place in any discernable hierarchy varies between sites and across time. In the nineteenth-century British Museum, for example, natural history played second fiddle to books and antiquities, in contrast to the dominance of science in the Manchester Museum, which had similar coverage (albeit on a much smaller scale). This disciplinary hierarchy is not only evident on the galleries, but in the apportion of staff, money and storage space. These resources were allocated unevenly – botany, the 'Cinderella collection', was taxon, for taxon always under-represented. Vertebrate zoology, by

contrast, enjoyed a staff-to-specimen ratio that was larger by several orders of magnitude than any other collection.

The Manchester Museum's development was profoundly affected by the history of the University in which it operated. In exploring this relationship, the distinctiveness of museum as site is helpfully thrown into relief. Museums demonstrate a particular configuration of built environment, material culture and practitioners that is characterised by a specific kind of inertia. As one prominent entomologist wrote in the 1970s in a sentiment that would apply to all taxonomic fields, 'A historical perspective is particularly important for entomology, being as it is a science which grows steadily by increments and numerous individual contributions, not by the great conceptual leaps characteristic of modern physics and biochemistry.'[113] And yet the relationship between the collections and the rest of the university was not a clear-cut story of the separation of museum and laboratory science. A complex web of relationships linked the Museum to its immediate administrative and physical locale. Not only a site for dissemination, the Museum was also a distinctive site for active research itself. Nevertheless, the university departments and the museum did part ways, especially from the 1950s, as the former began to move across Oxford Road. In Manchester the most telling shift in museum-lab relationship was not when molecular biology emerged nor the structure of DNA established, but rather when curators and professors ceased to share a tea room.

Late twentieth-century curators were a very different breed from their Victorian predecessors. The professionalisation of curators, evident from after the First World War, became marked after the Second. The construction of professional communities around museums, I have argued, was in part responsible for the exclusion of women in this period. And to professionalise is to construct boundaries, and define certain practitioners working on the same objects as 'amateurs'. The status of the unpaid communities that coalesced around the Museum shifted over the course of the century, from members of the Museum Committee (to whom the Keeper reported) to volunteers (who reported to keepers). Throughout, however, the involvement of amateurs in their various roles was vital, which will be even more evident in the story of the cultural collections of the Manchester Museum.

Notes

1 British Association for the Advancement of Science, *Handbook of Manchester. Prepared by the Local Committee for the Members of the British Association* (Manchester: Sowler, 1887), p. 31.

2 S. Conn, *Museums and American Intellectual Life, 1876–1926* (Chicago: University of Chicago Press, 1998); P. L. Farber, *Finding Order in Nature: The Naturalist Tradition from Linnaeus to E. O. Wilson* (Baltimore: Johns Hopkins University Press, 2000).

3 D. E. Allen, *The Naturalist in Britain: A Social History* (Princeton: Princeton University Press, 2nd edn, 1994); L. Barber, *The Heyday of Natural History 1820–1870* (London: Cape, 1980).

4 K. Benson, 'The emergence of ecology from natural history', *Endeavour*, 24 (2000), 59–62;
 P. D. Lowe, 'Amateurs and professionals: the institutional emergence of British plant
 ecology', *Journal of the Society for the Bibliography of Natural History*, 7 (1976), 517–35;
 J. Sheail, *Seventy-Five Years in Ecology: The British Ecological Society* (Oxford: Blackwell,
 1987); D. Worster, *Nature's Economy: The Roots of Ecology* (San Francisco: Sierra Club,
 1977).

5 S. J. M. M. Alberti, 'Civic cultures and civic colleges in Victorian England', in M. J.
 Daunton (ed.), *The Organisation of Knowledge in Victorian Britain* (Oxford: Oxford
 University Press, 2005), pp. 337–56; S. Butler, 'A transformation in training: the for-
 mation of university medical faculties in Manchester, Leeds, and Liverpool, 1870–84',
 Medical History, 30 (1986), 115–32; A. Kraft and Alberti, '"Equal though different":
 laboratories, museums and the institutional development of biology in the late-
 Victorian industrial North', *Studies in History and Philosophy of Biological and Biomedical
 Sciences*, 34 (2003), 203–36.

6 Much of the 'tour' presented here is based on W. E. Hoyle, *General Guide to the Contents
 of the Museum* (Manchester: Cornish, 1892).

7 The displays began with the most distant, non-fossil bearing Archaian (pre-Cambrian)
 strata. There followed Palaeozoic (or primary) periods, which included Cambrian,
 Silurian, Devonian and Carboniferous fossils, many of which had been the subject
 of heated geological debates within the lifetimes of the visitors. See D. R. Oldroyd,
 *The Highlands Controversy: Constructing Geological Knowledge through Fieldwork in
 Nineteenth-Century Britain* (Chicago: University of Chicago Press, 1990); M. J. S.
 Rudwick, *The Great Devonian Controversy: The Shaping of Scientific Knowledge among
 Gentlemanly Specialists* (Chicago: University of Chicago Press, 1985); J. A. Secord,
 Controversy in Victorian Geology: The Cambrian-Silurian Dispute (Princeton: Princeton
 University Press, 1986).

8 W. E. Hoyle, *Handy Guide to the Museum* (Manchester: Cuthbertson and Black, 1895),
 p. 27. On anthropology as a segue between zoology and geology, see T. Bennett, *Pasts
 beyond Memory: Evolution, Museums, Colonialism* (London: Routledge, 2004) and
 chapter 3 below.

9 Manchester Museum Central Archive (hereafter MMCA), Manchester Museum
 Committee Minutes (hereafter MMCM) vol. 1 (28 November 1890), (28 October
 1892); H. Seebohm, *Classification of Birds: An Attempt to Diagnose the Subclasses,
 Orders, Suborders, and Some of the Families of Existing Birds* (London: Porter, 1890).

10 Originally botany occupied only the second-floor room, and only after the removal of
 the Egyptian antiquities the room above it as well (see chapter 3). By 1892 the lower
 of the two rooms was devoted to a small systematic survey from fungi and lichens
 to flowering plants and grasses, arranged according to George Bentham and Joseph
 Hooker's scheme (by now rather outmoded) and in the upper room 'a collection of
 plants and drawings is exhibited, as to show their special morphological and biological
 peculiarities'. W. E. Hoyle, *General Guide to the Natural History Collections* (Manchester:
 Cornish, 1899), p. 66; MMCM vol. 1 (28 October 1892); G. Bentham and J. D.
 Hooker, *Genera Plantarum ad Exemplaria Imprimis in Herbariis Kewensibus Servata
 Definita*, 3 vols (London: Reeve, 1862–83); F. E. Weiss, 'The organization of a botani-
 cal museum', *Report of the Proceedings of the Museums Association*, 3 (1892), 25–38.

11 Hoyle, *General Guide* (1892), p. 24.

12 Hoyle, *General Guide* (1899), preface.

13 The stump was obtained by William Crawford Williamson, by now Professor of Natural History at Owens College, from the coal measures near Bradford. It remains in place to this day in the east bay of the 1880s building. See Hoyle, *General Guide* (1892); J. Morrell, Review of A. J. Bowden, C. V. Burek and R. Wilding (eds), *History of Palaeontology: Selected Essays*, Geological Society Special Publication 241 (London: The Geological Society, 2005), *British Journal for the History of Science*, 40 (2007), 447–8; W. C. Williamson, *A Monograph on the Morphology and Histology of Stigmaria ficoides* (London: Palaeontographical Society, 1887).

14 Hoyle took up the post in May 1889. R. Corfield, *The Silent Landscape: In the Wake of HMS Challenger 1872–1876* (London: Murray, 2003); W. H. Crompton, 'William Evans Hoyle, M.A., D.Sc., M.R.C.S. (founder of the Manchester Egyptian Association)', *Journal of the Manchester Egyptian and Oriental Society*, 13 (1927), 65–7; J. W. Jackson, 'Obituary notice: William Evans Hoyle', *Journal of Conchology*, 18 (1926), 33–4; E. E. Lowe, 'William Evans Hoyle, M.A., D.Sc.', *Museums Journal*, 25 (1926), 250–2; J. C. Melvill, 'List of molluscan papers (mostly dealing with the order Cephalopoda) by the late Dr. W. Evans Hoyle, D.Sc., F.R.S.E.', *Journal of Conchology*, 18 (1927), 71–4.

15 MMCM vol. 1 (8 March 1889). J. Ray Hardy, appointed in 1881, was an entomologist by inclination, but during his long career at the Museum turned his hand to most things zoological, including conchology and ornithology. J. R. Hardy, 'The macro-lepidoptera of Sherwood Forest', *Manchester Memoirs*, 45:12 (1901), 1–5; MMCM vol. 1 (24 March 1893), (27 October 1893); MMCA, *Manchester Museum Report* (hereafter *MMR*) (1902–3).

16 John Rylands University Library, University of Manchester Archives (hereafter UMA), Owens College, 'Report of the Council to the Court of Governors', 6 April 1880, p. 4.

17 There had been an 'assistant curator', Herbert William Oakley, while the collections were in the College attic in the 1870s; Percy Fry Kendall (later Professor of Geology at the Yorkshire College of Science) also briefly assisted Dawkins in the 1880s. Once the Museum opened, Frederick G. Pearcey was formally appointed second assistant keeper in July 1889; Herbert Bolton took up the post of third assistant keeper for geology in May 1890. Pearcey then left for Tasmania and Bolton departed for Bristol, the latter to be replaced by three geology assistants in rapid succession: Cecil B. Crampton (in post 1898–1900), who left to work of the Geological Survey of Scotland; E. Leonard Gill (1900–1901), who later worked at the Hancock Museum in Newcastle; and Walter J. Hall (1901–1907), who left due to ill health. Pearcey's successor as zoologist was Robert Standen, a keen amateur naturalist during his early working life at Swinton Industrial School. From 1887 he had been an assistant to Arthur Milnes Marshall in the Department of Zoology at Owens College, and had worked in the Museum during the summer during the early 1890s. Upon Milnes Marshall's untimely death in 1893, Standen transferred to the Manchester Museum as assistant and secretary. He then took up the post now designated assistant keeper for zoology in 1896, which he would keep until his death in 1925. Although like Hardy he turned his hand to much of the zoology collection, Standen was a keen conchologist (alongside Hoyle, a member of the Manchester Conchological Society). On staffing before the Museum opened, see UMA, Owens College *Calendars*

(1873–89); on early geology staff, see *MMRs* (1898–1907); R. M. C. Eagar and R. Preece, 'Collections and collectors of note 14: the Manchester Museum', *Newsletter of the Geological Curators Group*, 2:11 (1977), 12–40; on Standen, see S. J. M. M. Alberti, 'Molluscs, mummies and moon rock: the Manchester Museum and Manchester science', *Manchester Region History Review*, 18 (2007), 108–32; A. Jackson, Interview with the author, *Re-Collecting at the Manchester Museum*, disc V5, 2006, MMCA; J. W. Jackson, 'Obituary notice: Robert Standen', *Journal of Conchology*, 17 (1925), 41–5.

18 *MMRs* (1896–97), (1903–4). Unless otherwise noted, comparisons with the BM(NH) are drawn from W. T. Stearn, *The Natural History Museum at South Kensington: A History of the British Museum (Natural History) 1753–1980* (London: Heinemann, 1981).

19 E.g. *MMR* (1904–5).

20 On Melvill, see Alberti, 'Molluscs, mummies and moon rock'; J. M. Chalmers-Hunt (ed.), *Natural History Auctions 1700–1972: A Register of Sales in the British Isles* (London: Sotheby Parke Bernet, 1976); S. P. Dance, *A History of Shell Collecting* (London: Faber, 2nd edn, 1986); A. Trew, *James Cosmo Melvill's New Molluscan Names* (Cardiff: National Museum of Wales, 1987). On his work at the Museum, see for example J. C. Melvill and R. Standen, *Catalogue of the Hadfield Collection of Shells from Lifu and Uvea, Loyalty Islands*, 2 vols (Manchester: Cornish, 1895–97). On amateurs, see S. J. M. M. Alberti, 'Amateurs and professionals in one county: biology and natural history in late Victorian Yorkshire', *Journal of the History of Biology*, 34 (2001), 115–47; R. Ellis *et al.*, *Nature: Who Knows?* (Lancaster: English Nature, Lancaster University and the Natural History Museum, 2005); Lowe, 'Amateurs and professionals'; S. L. Star and J. R. Griesemer, 'Institutional ecology, "translations" and boundary objects: amateurs and professionals in Berkeley's Museum of Vertebrate Zoology, 1907–39', *Social Studies of Science*, 19 (1989), 387–420.

21 The botany collection largely comprised the prominent botanist Hewett Cottrell Watson's herbarium of European plants and a small British collection. *MMR* (1899–1900); J. W. Franks, *Herb. Manch: A Guide to the Contents of the Herbarium of Manchester Museum* (Manchester: Manchester Museum, 1973); W. E. Hoyle, *General Guide to the Contents of the Museum (Illustrated)* (Manchester: Cornish, 2nd edn, 1893). J. C. Melvill, *A Brief Account of the General Herbarium Formed by James Cosmo Melvill, 1867–1904: And Presented by him to the Museum in 1904* (Manchester: Sherratt & Hughes, 1904).

22 As successive appointments were made – firstly Dawkins as geology lecturer in 1872, then Arthur Milnes Marshall as professor of zoology in 1879 – Williamson's remit was narrowed to botany. Kraft and Alberti, 'Equal though different'; W. C. Williamson, *Reminiscences of a Yorkshire Naturalist* (London: Redway, 1896).

23 *MMR* (1908–9); S. Pain, 'Love among the fossils', *New Scientist* (22 December 2007), p. 74–5.

24 *MMRs* (1889–1929); G. Tweedale, 'Dawkins, Sir William Boyd (1837–1929)', in *Oxford Dictionary of National Biography* (Oxford: Oxford University Press, 2004), www.oxforddnb.com/view/article/62497, accessed 19 April 2005.

25 See e.g. MMCM vol. 1 (5 December 1889), (10 January 1890), (25 April 1890); vol. 2 (27 October 1899).

26 S. Forgan, 'The architecture of display: Museums, universities and objects in nineteenth-century Britain', *History of Science*, 32 (1994), 139–62; Forgan, 'Museum and university:

spaces for learning and the shape of disciplines', in M. Hewitt (ed.), *Scholarship in Victorian Britain* (Leeds: Trinity and All Saints, 1998), pp. 66–77.

27 A. MacGregor, *The Ashmolean Museum: A Brief History of the Institution and its Collections* (Oxford: Ashmolean Museum, 2001); C. Yanni, *Nature's Museums: Victorian Science and the Architecture of Display* (London: Athlone, 1999).

28 Alberti, 'Amateurs and professionals'; D. E. Allen, 'On parallel lines: natural history and biology from the late Victorian period', *Archives of Natural History*, 25 (1998), 361–71; Kraft and Alberti, 'Equal though different'; L. K. Nyhart, 'Natural history and the "new" biology', in N. Jardine *et al.* (eds), *Cultures of Natural History* (Cambridge: Cambridge University Press, 1996), pp. 426–43.

29 P. Bowler, *The Fontana History of the Environmental Sciences* (London: Fontana, 1992); cf. J. Adelman, 'Evolution on display: promoting Irish natural history and Darwinism at the Dublin Science and Art Museum', *British Journal for the History of Science*, 38 (2005), 411–36.

30 C. R. Darwin, *The Descent of Man, and Selection in Relation to Sex*, 2 vols (London: Murray, 1871); W. B. Dawkins, 'Darwin on the descent of man', *Edinburgh Review*, 134 (1871), 195–235; P. Lucas, 'Charles Darwin, "little Dawkins" and the platycnemic Yale men: introducing a bioarchaeological tale of the descent of man', *Archives of Natural History*, 34 (2007), 318–45.

31 T. Bennett, *The Birth of the Museum: History, Theory, Politics* (London and New York: Routledge, 1995); Forgan, 'The architecture of display'; T. A. Markus, *Buildings and Power: Freedom and Control in the Origin of Modern Building Types* (London: Routledge, 1993).

32 W. B. Dawkins, 'On the museum question', *Report of the Proceedings of the Museums Association*, 3 (1892), 13–24.

33 P. L. Sclater, 'On the typical forms of vertebrated life suitable for exhibition in local museums', *Report of the Proceedings of the Museums Association*, 4 (1893), 95–9.

34 Palaeontology punched above its weight in the first guidebook, but later occupied only one quarter to one third of the cases on display. Hoyle, *General Guide* (1892); Hoyle, *Handy Guide* (1895); Hoyle, *General Guide* (1899); Hoyle, *Handy Guide to the Museum* (Manchester: Cornish, 3rd edn, 1903); W. M. Tattersall, *General Guide to the Collections in the Manchester Museum* (Manchester: Manchester University Press, 1915); G. H. Carpenter, *A Short Guide to the Manchester Museum* (Manchester: Manchester University Press, 1933).

35 W. E. Hoyle, 'The registration and cataloguing of museum specimens', *Report of the Proceedings of the Museums Association*, 2 (1891), 59–67, p. 60. See also chapter 4 below.

36 G. Tweedale, 'Geology and industrial consultancy: Sir William Boyd Dawkins (1837–1929) and the Kent Coalfield', *British Journal for the History of Science*, 24 (1991), 435–51.

37 MMCM vol. 3 (22 January 1912); K. Wood, *Rich Seams: Manchester Geological and Mining Society 1838–1988* (Warrington: Manchester Geological and Mining Society Branch of the Institution of Mining Engineers, 1987).

38 Bowler, *The Fontana History*; P. Galison and B. Hevly (eds), *Big Science: The Growth of Large-Scale Research* (Stanford, Ca: Stanford University Press, 1992). On Carnegie

funding, see e.g. S. F. Markham, *A Report on the Museums and Art Galleries of the British Isles (other than the National Museums)* (Edinburgh: Constable, 1938).

39 *MMRs* (1904–5), p. 36; (1905–6).

40 A. Kraft, 'Building Manchester Biology 1851–1963: National Agendas, Provincial Strategies' (PhD dissertation, University of Manchester, 2000); Kraft, 'Pragmatism, patronage and politics in English biology: the rise and fall of economic biology 1904–1920', *Journal of the History of Biology*, 37 (2004), 213–58.

41 Carpenter, *Short Guide* (1933), p. 6.

42 J. F. M. Clark, *Bugs and the Victorians* (New Haven: Yale University Press, 2009); R. E. Kohler, *All Creatures: Naturalists, Collectors, and Biodiversity, 1850–1950* (Princeton: Princeton University Press, 2006).

43 M. Rothschild, *Walter Rothschild: The Man, the Museum and the Menagerie* (London: Natural History Museum, 2nd edn, 2008); M. A. Salmon, *The Aurelian Legacy: British Butterflies and their Collectors* (Berkeley: University of California Press, 2001).

44 A post held by J. Ray Hardy from January 1908. Hardy had been the first assistant and by this time senior assistant keeper. On Hardy's reluctant retirement in 1918, see S. J. M. M. Alberti, 'The status of museums: authority, identity and material culture', in D. N. Livingstone and C. W. J. Withers (eds), *Geographies of Nineteenth-Century Science* (Chicago: Chicago University Press, forthcoming).

45 On Hickson's involvement see S. J. M. M. Alberti, 'Culture and nature: the place of anthropology in the Manchester Museum', *Journal of Museum Ethnography*, 19 (2006), 7–21; J. S. Gardiner, 'Sydney John Hickson 1859–1940', *Obituary Notices of Fellows of the Royal Society*, 3 (1941), 383–94.

46 MMCM vol. 3 (6 December 1909); G. Anderson *et al.*, 'Biographical Information – Walter Tattersall', http://tidepool.st.usm.edu/mysids, accessed 19 April 2006; I. Gordon and S. W. Kemp, 'Walter M. Tattersall and Olive S. Tattersall: 7 decades of Peracaridan research', *Crustaceana*, 38 (1980), 311–20; W. M. Tattersall, 'On Mysidacea and Euphausiacea collected in the Indian Ocean during 1905', *Transactions of the Linnean Society of London – Zoology*, 15 (1912), 119–36; Tattersall, 'The Schizopoda, Stomatopoda, and non-Arctic Isopoda of the Scottish National Antarctic expedition', *Transactions of the Royal Society of Edinburgh*, 48 (1914), 865–94. When Tattersall's tenure was interrupted by war service, another zoologist on the Museum Committee, the ornithologist Thomas Alfred Coward (whose father, also Thomas, had been involved with the MNHS), took the helm, consolidating ornithology's distinct status within the Museum.

47 Tattersall, *General Guide*.

48 Bowler, *The Fontana History*; R. Rainger, *An Agenda for Antiquity: Henry Fairfield Osborn and Vertebrate Palaeontology at the American Museum of Natural History, 1890–1935* (Tuscaloosa: University of Alabama Press, 1991).

49 MMCM vol. 2 (10 June 1907); Jackson, Interview with the author; M. J. Bishop, 'Dr. J. Wilfrid Jackson (1880–1978): a biographical sketch', in Bishop (ed.), *The Cave Hunters: Biographical Sketches of the Lives of Sir William Boyd Dawkins and Dr. J. Wilfrid Jackson* (Buxton: Derbyshire Museum Service, 1982), pp. 25–48; D. M. Wilkinson *et al.*, 'A tale of two caves: the history of archaeological exploration at Haverbrack and Helsfell in Southern Cumbria', *Studies in Speleology*, 14 (2006), 55–7.

50 MMCM vol. 3 (13 March 1911), (November 1916); vol. 4 (24 March 1924); *MMRs* (1910–17); C. Bailey, 'On the contents of a herbarium of British and foreign plants for presentation to the Victoria University, Manchester', *Manchester Memoirs*, 61:5 (1917), 1–13; W. A. Charlton and E. G. Cutter, *135 Years of Botany at Manchester* (Manchester: University of Manchester, 1998).

51 *MMRs* (1903–11); Charlton and Cutter, *135 Years of Botany*; J. Watson, 'One hundred and fifty years of palaeobotany at Manchester University', in Bowden *et al.* (eds), *History of Palaeobotany*, pp. 229–57; G. Wigglesworth, 'A new Californian species of *Sphaerocarpus*, together with an annotated list of the specimens of *Sphaerocarpus* in the Manchester Museum', *University of California Publications in Botany*, 16:3 (1929), 129–37.

52 MMCM vol. 3 (21 January 1911).

53 Tattersall, *General Guide*, p. 8.

54 K. A. Rader and V. E. M. Cain, 'From natural history to science: display and the transformation of American museums of science and nature', *Museum and Society*, 6 (2008), 152–171.

55 Bowler, *The Fontana History*; Kohler, *All Creatures*.

56 *MMR* (1922–23). Thomas A. Coward once again stepped in to take up the reins of the Museum during the *inter regnum* as the Committee recruited a new director. On Carpenter, see Adelman, 'Evolution on display'; C. B. Moffat, 'Obituary: George Herbert Carpenter, B. Sc. (Lond.), D. Sc. (Q. U. B.)', *Irish Naturalist's Journal*, 7 (1939), 138–41. I am grateful to Juliana Adelman for information on Carpenter.

57 MMCM vol. 4 (7 March 1927), p. 213.

58 W. B. Dawkins, 'Memorandum on the history of the Manchester Museum', in MMCM vol. 4 (13 June 1927), pp. 225–7, p. 227.

59 The description here is based on Carpenter, *Short Guide* (1933).

60 *Ibid.*, p. 6.; *MMR* (1926–27); Adelman, 'Evolution on display'; G. H. Carpenter, 'On collections to illustrate the evolution and geographical distribution of animals', *Report of the Proceedings of the Museums Association* (1894), 106–44.

61 *MMR* (1943–44); H. G. Cannon, *The Evolution of Living Things* (Manchester: Manchester University Press, 1958); Cannon, *Lamarck and Modern Genetics* (Manchester: Manchester University Press, 1959); J. E. Smith, 'Herbert Graham Cannon 1897–1963', *Biographical Memoirs of Fellows of the Royal Society*, 9 (1963), 55–68.

62 The Committee dedicated a workroom for insect preparation adjoining the library on the first floor; entomology had gained status as a distinct sub-section in the Museum's publications; and the reserve collections were enormously popular with visiting groups and the University's Department of Entomology. MMCM vol. 4, 25 June 1928); *MMRs* (1923–35); Carpenter, *Short Guide* (1933); Carpenter, *A Short Guide to the Manchester Museum*, ed. R. U. Sayce (Manchester: Manchester University Press, revised edn, 1941). Wigglesworth, meanwhile, built up a significant herbarium but had little in the way of gallery space.

63 MMCM vol. 5 (7 May 1934).

64 Kohler, *All Creatures*; Rader and Cain, 'From natural history to science'.

65 A. P. Coleman and H. W. Ball, 'An era of change and independence 1950–1980', in Stearn, *The Natural History Museum*, pp. 333–85; K. Vernon, 'Desperately seeking

status: evolutionary systematics and the taxonomists' search for respectability 1940–60', *British Journal for the History of Science*, 26 (1993), 207–27.

66 For overviews, see Bowler, *The Fontana History*; Farber, *Finding Order in Nature*; E. Mayr, *The Growth of Biological Thought: Diversity, Evolution and Inheritance* (Cambridge, Mass: Harvard University Press, 1982).

67 Kohler, *All Creatures*; E. Mayr, *Systematics and the Origin of Species from the Viewpoint of a Zoologist* (New York: Columbia University Press, 1942).

68 W. T. Calman, 'A museum zoologist's view of taxonomy', in J. S. Huxley (ed.), *The New Systematics* (London: Oxford University Press, 1940), pp. 455–60; Vernon, 'Desperately seeking status'.

69 MMCM vol. 5 (20 January 1941); C. Pearson, 'Curators, Culture and Conflict: The Effects of the Second World War on Museums in Britain, 1926–1965' (PhD dissertation, University College London, 2008).

70 R. Nicholas, *City of Manchester Plan: Prepared for the City Council* (Norwich: Jarrold, 1945); B. Pullan and M. Abendstern, *A History of the University of Manchester*, 2 vols (Manchester: Manchester University Press, 2000–4).

71 MMCM vol. 5 (22 March 1948), p. 330.

72 MMCM vol. 5 (31 May 1948), p. 335; Pullan and Abendstern, *A History of the University*.

73 MMCM vol. 5 (7 June 1948), p. 336.

74 MMCM vol. 5 (21 October 1946), (16 October 1950); vol. 6 (19 October 1952); *MMRs* (1952–57).

75 Cannon was replaced by Ralph Dennell. MMCM vol. 8 (3 June 1974); J. G. Blower, 'Ralph Dennell (1907–1989)', *The Linnean*, 5:3 (1989), 35–8; Pullan and Abendstern, *A History of the University*.

76 *MMR* (1965–66); Charlton and Cutter, *135 Years of Botany*.

77 MMCM vol. 7 (18 January 1965); *MMR* (1964–65); H. Wilson and L. Womersley, *Manchester Education Precinct: Interim Report of Planning Consultants* (Manchester: Victoria University of Manchester, 1964).

78 MMCA box GB5, H. G. Cannon – A. P. Wadsworth, 20 May 1949.

79 Charlton and Cutter, *135 Years of Botany*; Standing Commission on Museums and Galleries, *Universities and Museums: Report on the Universities in Relation to their own and other Museums* (London: HMSO, 1968); D. Wilson and G. Lancelot, 'Making way for molecular biology: institutionalizing and managing reform of biological science in a UK university during the 1980s and 1990s', *Studies in History and Philosophy of Biological and Biomedical Sciences*, 39 (2008), 93–108.

80 G. Lewis, *For Instruction and Recreation: A Centenary History of the Museums Association* (London: Quiller, 1989). On communities of practice, see S. MacLeod, 'Making museum studies: training, education, research and practice', *Museum Management and Curatorship*, 19 (2001), 51–61; E. Wenger, *Communities of Practice: Learning, Meaning and Identity* (Cambridge: Cambridge University Press, 1998).

81 MMCM vol. 7 (16 March 1964), (12 October 1964); vol. 8 (24 May 1976); *MMR* (1964–66).

82 Cannon was given honorary care of the Japanese collections, for example, and in 1960, V. A. G. Brown was appointed 'honorary keeper of conchology'. *MMR* (1960–61).

83 A. Witz, 'Patriarchy and professions: the gendered politics of occupational closure', *Sociology*, 24 (1990), 675–90.

84 C. Nördlinger, 'A visit to Miss T. Mestorf, Directress of the Schleswig-Holstein Museum of National Antiquities at Kiel', *Report of the Proceedings of the Museums Association*, 7 (1896), 132–8, p. 137.

85 A. B. Shteir, *Cultivating Women, Cultivating Science: Flora's Daughters and Botany in England 1760 to 1860* (Baltimore: Johns Hopkins University Press, 1996); Charlton and Cutter, *135 Years of Botany*; P. N. Wyse Jackon and M. E. Spencer Jones, 'The quiet workforce: the various roles of women in geological and natural history museums during the mid-1900s', *Geological Society of London Special Publications*, 281 (2007), 97–113. Cf. R. Fortey, *Dry Store Room No. 1: The Secret Life of the Natural History Museum* (London: Harper, 2008); P. J. Smith, 'A Splendid Idiosyncrasy: Prehistory at Cambridge, 1915–50' (PhD dissertation, University of Cambridge, 2004). I am grateful to Jo Alberti for information on inter-war gender balance in the workplace.

86 'Eagar's endeavour', *Communication* (Victoria University of Manchester newsletter) (February 1977), p. 13; J. R. Nudds, *The R. M. C. Eagar Collection of Non-Marine Bivalves; Type and Figured Specimens of the Geological Department of The Manchester Museum* (Manchester: Manchester Museum, 1992); Nudds, 'Richard Michael Cardwell Eagar 1919–2003', *Geological Curator*, 7 (2003), 341–2.

87 G. H. Carpenter, *Guide to the Manchester Museum*, ed. R. U. Sayce (Manchester: Manchester University Press, revised edn, 1948), p. 6.

88 Fortey, *Dry Store Room No. 1*. The geology department at the BM(NH) had been re-dubbed 'palaeontology' in 1956, even though it included stratigraphy.

89 MMCM vol. 7 (25 October 1965); *MMRs* (1945–47), (1965–66); R. M. C. Eagar, *The Geological Column* (Manchester: Manchester Museum, 1965).

90 Zoology had been subject to a high turnover of staff in the post-war decade: P. M. Butler (in post 1946–47); B. M. Wilkinson (1948–49); Leslie Bilton (1950–53). Ted Seyd then remained in post for two decades. On Butler, see MMCM vol. 5 (5 March 1945); *MMR* (1944–45). On Bilton, see *MMR* (1952–53). On Seyd, see MMCM vol. 6 (30 October 1953); *MMR* (1953–54). In entomology, Walter Douglas Hincks was appointed in 1947 to replace Geoffrey Kerrich, who had spent much of his decade in post seconded to the war effort. See *MMRs* (1947–55); G. S. Kloet and W. D. Hincks, *Check List of British Insects* (Stockport: privately printed, 1945). Reflecting the career advancement possible within the expanded departments of the Museum, upon Hincks's death in 1964, he was succeeded by 'his' technician Alan Brindle, who was in turn succeeded by *his* technician Colin Johnson.

91 The aquarium's gain was thus botany's loss. Eventually confined only to one small gallery, botany experienced a lull in the two decades after Wigglesworth's departure. Neither her immediate replacement, Grant Roger, nor his successor, the Welsh taxonomist Effie Rosser, effected considerable change in the department. In this period, fewer botany graduates were interested in taxonomy, and it was difficult to attract qualified applicants to museum positions. In the pollen expert John Wilson Franks (who like Rosser had a PhD) the Manchester Museum succeeded in securing a qualified – if not prolific – scientist as Rosser's successor in 1958. The herbarium was further consolidated when the department was the first to host one of Owen's new assistant keepers: Susan

Amis (appointed 1964); Miss S. Hodges (1965); Judith Harrison (1970) and Giles Clark (also in 1970). MMCM vol. 7 (12 October 1964); *MMRs* (1969–70), (2000–1); MMCA, D. E. Allen – the author, 1 December 2004; Manchester Metropolitan University, North West Film Archive, RR 1005, Granada Television, 'From the North: Granada presents [the Manchester Museum]', television recording, 29 March 1968.

92 *MMRs* (1896–1940); T. Ashton, *Visits to the Museum of the Manchester Natural History Society* (Manchester: Manchester Museum, 1857); Tattersall, *General Guide*.

93 *MMRs* (1965–77); J. Whitworth, *The Cannon Aquarium* (Marple: Heap, 1968).

94 Rader and Cain, 'From natural history to science'.

95 MMCM vol. 5 (24 March 1947); MMRs (1946–47), (1962–64); R. M. C. Eagar, 'The moon in a geological gallery', *Museums Journal*, 64 (1964), 132–7.

96 Eagar in geology (over four decades); John Franks in botany (three decades); Ted Seyd and his successor Mike Hounsome in zoology (two decades each), Bill Pettitt and Sean Edwards, initially as assistant keepers in zoology and botany (three decades each), and Alan Brindle and Colin Johnson in entomology (respectively 24 and 32 years in total at the Museum).

97 Ellis *et al.*, *Nature: Who Knows?*; the Manpower Services Commission is discussed in chapter 5 below.

98 Bill Pettitt was appointed assistant keeper of zoology in 1968 with an interest in molluscs, whereas the keepers with whom he worked concentrated on mites and birds respectively; Sean Edwards, assistant keeper under the pollen expert John Franks from 1973, worked on bryophytes (mosses and liverworts). The assistant keepership in geology, established in 1965, was usually filled by a mineralogist to complement the stratigraphical expertise of Michael Eagar: Barbara Pyrah (appointed 1965); Derek Rushton (1968) and Rosemary Preece (1974). (The eventual creation of a new keepership specifically for mineralogy and petrology stemmed from the Earth Science Collection Centre, detailed below.) In entomology, by contrast, Alan Brindle's retirement from the keepership in 1982 prompted Colin Johnson's promotion to keeper after twenty years in the Museum. University funding cuts meant that neither the entomology nor the geology assistant keeper posts were re-filled after they fell vacant in the early 1980s. See MMCM vol. 7 (18 January 1965); *MMRs* (1965–69), (1981–86), (2002–3).

99 Alberti, 'Molluscs, mummies and moon rock'; J. Zussman, Interview with the author, *Re-Collecting at the Manchester Museum* disc S8, 2005, MMCA.

100 Eagar worked with the then assistant keeper Derek Rushton, and the Museum's chief technician Harry Spencer. Eagar, 'The moon in a geological gallery'; R. M. C. Eagar and D. E. Owen, 'Moon rock in Manchester', *Museums Journal*, 69 (1970), 159–60.

101 Manchester Museum, *The Manchester Museum* (Derby: English Life, 1985), p. 10; *MMR* (1976–77).

102 *MMR* (1970–71), p. 10.

103 *MMRs* (1980–82). North West Sound Archive 1982.7267; 1982.7287.

104 MMCM vol. 8 (23 January 1978), (24 May 1971), (29 January 1979); *MMRs* (1974–84); *Annual Reports of the Victoria University of Manchester*, UMA (hereafter *RVUM*) (1988–90).

105 Building Design Partnership (Manchester Group), *Brief for New Extensions to the Manchester Museum* (Manchester: Building Design Partnership, 1972); A. Warhurst, 'New extension', *Communication* (October 1977), 10.

106 After Eagar finally retired in 1987 he was replaced by John Nudds, formally curator at Trinity College Dublin. At this time the Universities Funding Council embarked upon what was intended to be the first in a series of disciplinary reviews, and began with geology. The intention was to rationalise earth science teaching into a small number of centres of excellence. In conjunction with staff in the University department, Nudds spent his first years in post campaigning on Manchester's behalf, and was eventually successful – the Manchester Museum was awarded special factor funding to establish an Earth Science Collection Centre, alongside Glasgow, Cambridge, Oxford and Birmingham. J. R. Nudds, Interview with the author, *Re-Collecting at the Manchester Museum*, disc S18, 2006, MMCA; *RVUM* (1989–91); P. Boylan, 'Universities and museums: past, present and future', *Museum Management and Curatorship*, 18 (1999), 43–56; Pullan and Abendstern, *A History of the University*.

107 Charlton and Cutter, *135 Years of Botany*; *MMR* (1970–71).

108 K. Arnold-Forster, *Held in Trust: Museums and Collections of Universities in Northern England* (London: HMSO, 1994); Eagar and Preece, 'Collections and collectors'; N. Handley (ed.), *Continuing in Trust: The Future of the Departmental Collections in the University of Manchester* (Manchester: Centre for the History of Science, Technology and Medicine, 1998); Standing Commission, *Universities and Museums*.

109 Within the school, created in 1986, botanists and zoologists were scattered among four new departments designed to underpin clinical medicine. Only environmental biology, with least resources, had much potential for links with the Museum and with whole-animal biology. Instead, resources and research were more commonly devoted to such areas as cell biology and genetics. D. Wilson, *Reconfiguring Biological Sciences in the Late Twentieth Century: A Study of the University of Manchester* (Manchester: University of Manchester, 2008); Pullan and Abendstern, *A History of the University*.

110 Natural Environment Research Council, *The Role of Taxonomy in Ecological Research* (London: NERC, 1976); Advisory Board for the Research Councils Review Group in Taxonomy, *Taxonomy in Britain* (London: HMSO, 1979). On the Natural History Museum, see D. Hencke, 'Severe blow dealt to museums policy', *Guardian* (20 April 1988); S. Pain, 'Scientists to desert a million bird's eggs', *New Scientist* (28 April 1988); T. Radford, 'Ornithologists' wings clipped', *Guardian* (27 April 1988); N. Williams, 'Museum's staff in cuts walk-out', *Guardian* (25 April 1990). For similar concerns in the earth sciences, see e.g. I. D. Wallace and P. W. Phillips, 'The function of local natural history collections', *Newsletter of the Geological Curators Group*, 2:11 (1977), 7–9.

111 Bill Pettitt, for example, had taken tea breaks with the University zoologists in the early years of his appointment. C. W. A. Pettitt, Interview with the author, *Re-Collecting at the Manchester Museum*, discs S9, S10, S15, 2005, MMCA.

112 On 'Science' as a federation of disciplines within a cultural cartography, see J. V. Pickstone, 'Working knowledges before and after *circa* 1800: practices and disciplines in the history of science, technology and medicine', *Isis*, 98 (2007), 489–516.

113 J. Waage, 'From the editor', *Antenna: Bulletin of the Royal Entomological Society*, 3 (October 1979), p. 121, cited in Clark, *Bugs and the Victorians*. On the limiting factor of materiality on the growth of collections, see S. Macdonald, *Behind the Scenes at the Science Museum* (Oxford: Berg, 2002).

3

Culture: artefacts and disciplinary formation

The Manchester Museum was founded as an institution devoted to natural history, but did not remain so for long. Even by the time it was fully opened in 1890, some man-made things were on display beside the natural specimens. The proliferation of these kinds of objects during its early decades was not planned by Museum staff, but rather expanded thanks to influential donors. Here I trace the differentiation of an intellectually and architecturally distinct portion of the collection devoted to Egyptology, archaeology and ethnology by the middle of the twentieth century. Like the last chapter, this is a study of relationships between objects and people, explored to better understand the construction of nature and culture in museums.[1] Again, my building blocks are disciplines – here the diverse communities of practice who studied elaborate works of art or plain stone tools, with theoretical approaches that illuminated both personal lives and complex civilisations. And like the natural sciences discussed above, these disciplines underwent considerable change over the course of the twentieth century, as different practitioners, from folklorists to classicists, came to work in and around the Museum. How did they come to be grouped together as 'humanities', or latterly, 'human cultures'? How did borders develop between disciplines – between prehistory and classical archaeology, Egyptology and ethnology? In Manchester, as elsewhere, the fortunes and purposes of such collections were deeply affected by their context as part of a multi-disciplinary museum. The shift over the century away from natural history was effected in Manchester for particular reasons, linked as much to changes in staffing and space as to the intellectual changes. Disciplinary allegiances are specific to time, to national academic communities, and even to institutions.[2]

As before, this story begins with William Boyd Dawkins. He has featured so far as a palaeontologist, but he was also an accomplished archaeologist, one of a distinct community of scholars concerned in the 1860s with prehistoric British archaeology, who used archaeological and palaeontological evidence together to debate the antiquity of man.[3] These 'prehistorians' – who included Augustus Henry Lane Fox (later General Pitt Rivers, and referred to as such throughout) and Dawkins's mentor Thomas Huxley – sought to establish the scientific study of culture, practised along the same lines as palaeontology. They were informed by the dynamic evolutionism

of Charles Darwin rather than by Johann Winckelmann's fixed Platonic concept of ideal beauty, which set the standard for the aesthetic study of ancient artefacts in the nineteenth century.[4] The prehistorians approached archaeology as a taxonomic and chronological enterprise, using stratigraphical techniques to date and classify artefacts in evolutionary sequences. And just as comparative anatomists used modern counterparts of extinct creatures to extrapolate from fossil bone fragments to complete organisms, so prehistorians used 'savage' or 'primitive' material culture to extrapolate from flints – the 'fossils of history' – to complete cultures. European exploration and colonial expansions allowed archaeologists to make sense of Europe's own ancient past.[5] For Dawkins, archaeology and anthropology were cognate enterprises bordered by history and by palaeontology; the Inuit, he argued, were the remnants of the Stone Age peoples of Europe.[6] The material culture upon which these disciplines were based could therefore be arranged in an uninterrupted sequence of development that encompassed both nature and culture; the geological eras segued into prehistoric, historic and, finally, contemporary 'savage' cultures. 'Man and his works', Dawkins therefore argued, 'must find a place in all Natural History Museums'.[7]

Culture precipitated 1890–1927

Upon arriving in Manchester, however, Dawkins found few ethnological objects in the Natural History Society collections that met his approval. He was seeking representative specimens rather than oddities, and the 'curiosities' in Peter Street were by definition were extra-ordinary. After the sale of most of them, only the Ancient Egyptian mummy Asru and a handful of ethnological pieces remained to be transferred to Owens College. Although few in number, these items nevertheless occupied the crucial hinge point of his planned arrangement of the Manchester Museum. In the 1870s Dawkins had advocated a universal series for museums that ran from geology (including prehistoric archaeology), to botany, zoology, then ethnology and finally to art. By the time the Museum opened, however, his ideas had shifted. In the final design of the Manchester Museum fine and decorative arts were eschewed, and cultural material was instead arranged between recent fossils and primates. The series in the Museum ran from geology through archaeology and ethnology to zoology, with the same evolutionary methodology applied throughout. Primitive culture, whether from prehistoric Europe or the modern Antipodes, was part of nature. Artefacts were not to be judged on aesthetic or functional lines, but rather as evidence of progress.

> [Dawkins's] justification for putting archæological specimens into the Tertiary section [was that] he had been compelled not only to deal with palæolithic man as a fossil, and as truly a fossil as the Pleistocene mammals by which he was surrounded, but also to place in the museum a small collection of implements, ornaments, and weapons and other articles representing the state of civilization in the Historic period.[8]

Artefacts were metonyms for cultures as individual plant and animal specimens represented species.

To reach this small collection, the visitor first passed through the ground-floor geology gallery then climbed upwards through geological time to the first floor. Reaching the Pleistocene epoch, they saw the first evidence of humans in the chipped flints of 'River-drift hunter'. There followed extensive material from Dawkins's British cave excavations, compared with flints from elsewhere in Europe, and with technology of contemporary 'Esquimaux'. Flints may not have been striking to view, but Dawkins did not present them as curiosities in themselves, but rather as snapshots of the development of culture. As such, the objects themselves were not as significant as the spaces between them – a novel way of displaying (and looking) in late Victorian museums developed by Pitt Rivers and others.[9]

The prehistoric period followed, which saw humankind 'attaining a gradually increasing degree of civilisation', illustrated by bronze axes and pottery.[10] Then, sitting uneasily in the overall sequence there was 'a miscellaneous collection of objects arranged on a Geographical basis'.[11] This medley, in a separate 'historic' room at the end of the geological series on the first floor (see figure 3.1), included ethnology and a small group of ancient artefacts intended 'to illustrate different phases in the development of the human race', a common method of displaying cultural collection in Britain at this time.[12] There was Cypriot pottery, Assyrian clay tablets and documents, some Romano-British material, Asru's remains and 'a number of Egyptian Amulets, Scarabs, and other small objects'.[13] The vestiges of European ancestors were to be found in ethnology collections – European cultures *then* were explicitly compared with savage cultures elsewhere in the world *now*. Dawkins selected material to reflect Huxley's evolutionary journey from Australasia (that 'palaeontological penal colony') via the Americas to Asia, the Middle East and finally to Europe (Africa's place in the scheme was ambiguous).[14] In other institutions without Dawkins's temporal basis for display, cultural items were displayed in picturesque arrangements, or else they were arranged chronologically, within the great chain of art rather than the naturalists' 'great chain of being'.[15] Similar objects in different arrangements generated very different knowledge.

Once the Museum opened, the staff devoted little attention to the small historic displays. But a number of prominent donors nevertheless began to add to them (see chapter 4), with gifts of coins, mummies and stone implements. This material was accommodated for a while within Dawkins's existing arrangement – but the overall scheme could not absorb the extensive Egyptian material loaned by the prosperous yarn merchant Jesse Haworth, who was to play such a significant role in the development of the Manchester Museum. Originally an avid collector of Wedgwood pottery, Haworth had become interested in Egyptology while reading Amelia Edwards's *A Thousand Miles up the Nile*. Having met the author, Haworth and his wife Marianne began to collect Egyptian antiquities during trips to Egypt, exhibiting pieces at the Jubilee Exhibition in Manchester in 1887. In that year, Edwards introduced the

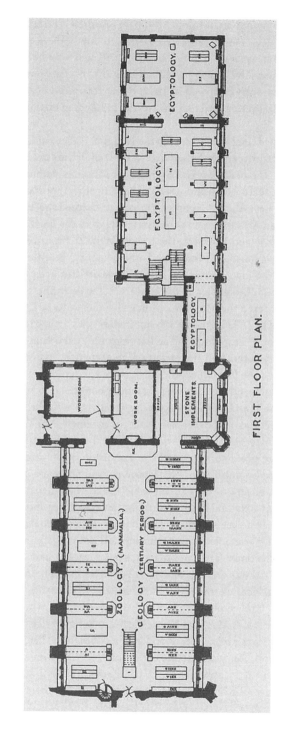

Figure 3.1 Plan of the first floor of the Museum after the 1912–13 extensions. The room in the centre labelled 'stone implements' was originally the 'historic' room.

Haworths to the prominent archaeologist William Matthew Flinders Petrie. Like Pitt Rivers and Dawkins, Petrie pioneered systematic methods in archaeological fieldwork. He had been excavating in Egypt since 1880, and was the first occupant of the Chair in Egyptian Archaeology and Philology at University College London that Edwards posthumously endowed in 1892. Petrie convinced Haworth and the London merchant Martin Kennard to fund the digs in Egypt in exchange for a third part of the finds each.[16]

Although they distributed some items to the National Gallery and to the British Museum, in 1890 Haworth and Kennard loaned most of Petrie's excavations in the previous two years to the newly opened Manchester Museum. Although there was no physical or conceptual space within Dawkins's arrangement for such a volume of material, the College nevertheless accepted the loan, and stored the 'Flinders-Petrie Collection of Egyptian Antiquities' in a room separate from the universal sequence. With advice from Petrie and Haworth, the Keeper William Evans Hoyle arranged it in fourteen cases in a loosely chronological arrangement.[17] But the Museum was uncomfortable with the loan, just as the British Museum had been disinclined to acquire Egyptian antiquities earlier in the century.[18] The scientific supervisors on the Committee considered the Museum's principal audience to be Owens College science students, and in 1892 formed a sub-committee with a view to disposing of the Egyptian collection.[19] Ethnology and archaeology only fell within the Museum's remit in so far as they completed the evolutionary sequence, and few items were needed for that beyond the flint collection. Nevertheless, Egyptology was massively popular in the late nineteenth century, and donations continued to arrive.[20]

Grudgingly, the Museum Committee agreed to accept more 'Anthropological and Archaeological Collections' and to set aside space accordingly.[21] In 1905, Haworth finally offered to donate his collection outright.[22] Still the Museum Committee, dominated by science professors, resisted the expansion of the Museum's remit, and finally they refused point blank: 'The Museum Committee are of the opinion that the [Egyptian] Collections are of great value and public interest, but in virtue of their constitution as a Natural History Museum, and the space and funds at their disposal, they feel themselves unable to take charge of the Collections.'[23] So the stalemate remained for some years. But museums do not operate outside society – even university collections shape and reflect popular tastes – and the popularity of the Egyptian material was difficult to ignore. When Sir Flinders and Lady Petrie delivered their annual lectures at the Museum (funded by Haworth), they attracted audiences twice the size of other speakers.[24] Another visitor who appealed to Manchester's townsfolk was Margaret Murray, lecturer in Egyptology at University College London, who was first a student and later a colleague of Petrie's. She came Manchester to teach and to catalogue the collection. In 1908, with an audience of 500 students, members of the public and local dignitaries, Murray and Museum staff unwrapped the remains of Khnum-Nakht, one of the 'Two Brothers' excavated by Petrie's team from the rock tombs of Deir Rifa (see figure 3.2).[25]

Figure 3.2 Margaret Murray of University College London and members of the Manchester Museum and Victoria University staff unwrap the remains of Khnum-Nakht in front of an audience of dignitaries and medical students, 6 May 1908.

In the new century, wider interest in Egyptian archaeology was not the only pressure to expand the remit of the Museum. Down the road, the Whitworth Institute's new building in 1908 expanded the cultural make-up of Chorlton-on-Medlock. 'Classical and Oriental Archaeology' was now taught at the newly chartered Victoria University of Manchester, and staff demanded space within or near the Museum. Encouraged, Haworth took the one course of action he knew the Museum Committee could not resist: he pledged £5,000 for a new building. A public appeal raised a further £3,000. The Committee capitulated, and construction began (see figure 3.3). The plans were provided by Alfred Waterhouse's son Paul, architect of the Whitworth Hall (erected in 1902 just south of the Museum). The demand for more space was so high that even before the building was finished, Haworth provided another £3,000 for a further, more modest extension.

The first new building was completed and opened in 1912, the second a year later. The expanded remit of the Museum would include,

> in addition to the collections illustrating . . . Botany, Geology and Zoology . . . (1) Ancient Egypt, its early religion, art and history including physical anthropology and ethnology. (2) Other ancient civilisations, particularly Assyrian. (3) General anthropology illustrating the primitive life of man. (4) Numismatics as applied to historical studies.[26]

Figure 3.3 Extensions to the Museum in 1913. The lower block on the right is still under construction.

Furthermore, the ground floor was largely given over to economic geology (see chapter 2); the University's schools of Classical and Oriental Archaeology were given space in the basement. The new building was to be connected to the old via a neo-Gothic bridge – an architectural feature linking nature and culture that was echoed in the extended museum and art gallery in Birmingham.[27]

The first floor, including this bridge, was devoted to Egyptian material. It was arranged chronologically for the most part, supplemented by further typological Egyptian and Assyrian displays on the gallery above. These galleries became an extension – tangential but nonetheless contiguous – to Dawkins's original scheme, in which Ancient Egypt sat at the overlap of (written) history and prehistoric archaeology.[28] Still under Dawkins's watchful eye, the new keeper Walter Tattersall accordingly ensured that the Egyptian galleries complemented, rather than challenged, the original displays:

> This arrangement connects up the Egyptian [and Near Eastern] Antiquities directly with those objects representing the Palæolithic and Neolithic History of Man, which are exhibited in that part of the old building immediately over the bridge connected the two Museum, and allows of the Egyptian Collections falling into their natural place (at the beginning of the Historic Period).[29]

The visitor was intended to follow the same path up through the old building, simply taking in the new galleries as a tangent. The continuity with the natural sciences was also emphasised in Petrie's very methods: 'The collection is particularly valuable

to students of archæology because, as it has been obtained almost entirely through scientific excavations, the place in which almost every article is found is known, and also the excavators' data for the period to which it should be assigned.'[30] Petrie was cast as a palaeontologist of Egyptian culture.

Ethnology, by contrast, was more removed from the general scheme. The few contemporary artefacts that had been scattered across the museum in drawers and cabinets were gathered together in the ground floor of the 1913 extension – beyond economic geology – with numismatics and what little classical archaeology there was. Thus the Manchester Museum, in a small way, reflected the emergence of anthropology as a distinct discipline within Anglophone scholarship.[31] In its wake, what had been the historic room was devoted largely to stone tools (both prehistoric and recent), which thereby remained in the temporal sequence. The result was a clearer series in the old building, connected to the Egyptian galleries, and 'The whole of the Ethnographical Collections . . . overhauled and segregated in one part of the Museum.'[32] Although the cultural collections were not therefore removed entirely (as in Oxford where the Pitt Rivers Museum had emerged from its original position as a department of the University Museum of Natural History), Manchester Museum ethnology was now displayed beside, rather than within, the natural sciences.

Slowly, the staffing structure began to reflect the expanded remit.[33] The Museum's printer, Winifred Crompton, had studied Egyptology at the University and took a keen interest in the Egyptian collections. On the eve of the extension, having worked at the Museum for eight years, she was formally appointed assistant-in-charge of Egyptology, with responsibility also for anthropology and classical archaeology.[34] University staff such as the prominent physical anthropologist Grafton Elliot Smith were involved in the supervision of the collection.[35] But for two decades it was Crompton who was the lynchpin of Manchester Egyptology, effectively running the Manchester Egyptian and Oriental Society, collaborating tactfully with both archaeologists and philologists, and liasing with Dawkins, the Petries and the Haworths.

Even if separately exhibited, other material remained within the conceptual domain of the natural sciences. Ethnology was absorbed into the remit of the zoologist Robert Standen, and his son-in-law, the geology assistant J. Wilfrid Jackson, took charge of prehistoric archaeology.[36] Although like Standen a conchologist by first passion, Jackson soon established himself as an authority on faunal cave deposits and began to study not only human remains but also accompanying artefacts. He was involved in British archaeology throughout his career, and in 1931–32 he also undertook excavations in Egypt. Taking the same approach to zoology, palaeontology and archaeology, Jackson used the Museum as a site for the combined study of these disciplines long after they had been separated elsewhere within the University. Prehistoric archaeology, for Jackson as it had been for Dawkins, was an extension of palaeontology. This methodology – archaeology as an extension of zoology and geology – governed the Museum's approach to arrangement and display of prehistory until Jackson retired in 1945.

By this time, however, prehistoric artefacts comprised only part of the Manchester Museum's archaeology holdings. Dawkins had shaped the collections during the brief spell at the end of the nineteenth century when – in Britain at least – prehistoric archaeology challenged its classical sibling, which had previously dominated European museums.[37] Under his successors in the early twentieth century, however, classical archaeology's star returned. With such an extensive Egyptology collection (which brought with it significant holdings of Semitic and Assyrian material), the lack of other Mediterranean material was striking. Shortly after the Great War, Tattersall as director reassessed the remit of the Museum in conjunction with the city's other galleries. He wrote to the Museum Committee:

> I would . . . recommend that the Museum Committee define as far as may seem desirable the scope of its activities and its policy for future developments. . . . For instance there are certain branches of Museum work which are not, up to the present, dealt with in any Manchester Institution but which must, sooner or later, be included in one or the other. I refer specially to the science of Anthropology and the nearly related subjects of Ethnology and to classical archaeology. Whether those subjects or any others legitimately come within the s[p]here of activities of the Manchester Museum should be decided.[38]

Although Dawkins was resistant to the inclusion of classical archaeology, Tattersall argued that the 1912–13 expansion had only partially fulfilled the central category in Dawkins's own plan for the Museum's scope, the complete historical and ethnological study of humankind. Tattersall advocated

> the completion of the Historical Series of Exhibits by the developments of collections illustrating Greek, Roman[,] Minoan (Mycenaean) archaeology and the civilization of Babylonia and Assyria. This will link up the Egyptian Collections with the contemporary and succeeding civilizations both East and West. Such collections are necessary in a complete Museum scheme and could be most easily and logically developed in connection with the Egyptian collection. . . . The end of the historic period marked by the fall of the Greek and Roman empires makes a very convenient point at which to stop, and our historical collections may well be finished off here.[39]

Together with the growing interest in classical and oriental archaeology elsewhere in the University, Tattersall's recommendation laid the foundation for a significant classical and oriental collection, and shifted the boundaries of knowledge within the Manchester Museum.

The reassessment of the Museum's remit had a considerable impact upon the place of ethnology. In 1924 Tattersall appointed Reverend Thomas G. Platten on a part-time basis, the first trained anthropologist in the museum. His post was created in the wake of the gift of Oceanic material from the Rochdale businessman Charles Heape, who preferred to give his collection to Manchester rather than his home town because the former was part of the University, then offering lectures on anthropology by W. H. R. Rivers and others.[40] Just as Pitt Rivers's gift to the

University of Oxford stimulated Edward Burnett Tylor's appointment to the new readership in anthropology, so the Manchester Museum was the first site for ethnographic instruction in Manchester. University museums were crucial sites for the establishment of anthropology and prehistoric archaeology in the early twentieth century.[41] Platten lectured extensively in Manchester, espousing the approach he had developed at Cambridge under the zoologist-turned-anthropologist Alfred Cort Haddon. Not only was Haddon significant in British anthropology in general, he also influenced the Manchester Museum, working with Standen and with Tattersall's successors as Keeper.[42] But it was during Thomas Platten's brief tenure that ethnology began to be practised as well as exhibited separately from zoology. Nature and culture were drifting apart, and would be further differentiated in the new building of 1927.

Nature and culture distinguished 1927–69

Tattersall's commitment to a more independent role for the cultural collections was timely. In the 1920s, the British public was mesmerised by all things archaeological. Massive digs began in Greece and Italy, and in 1922 Howard Carter excavated the tomb of Tutankhamun. In this climate the Manchester Museum Egyptian displays were enormously popular (see chapter 6). The prominence of the collection was such that the Museum warranted a visit from King Fuad of Egypt (although he was more impressed by the fossils than the mummies).[43] With this celebrity came a new-found self-assurance, as Crompton and Platten began to operate their collections separately from the other parts of the Museum. But this provoked tension in the Museum's resources. 'The Ethnology that has been done', grumbled the ageing Dawkins, 'is at the expense of the Geological and Zoological Collections'.[44] The 1912–13 extensions may have eased the accommodation demands of Egyptology, but the other humanities, if they were to fulfil Tattersall's vision, needed more dedicated space.

They had not long to wait. Already in 1918, an anonymous donor had offered to fund a further extension to the Museum to allow for the expanding cultural collections. The mysterious benefactor was none other than the Museum's old friend Jesse Haworth, who left a further £30,000 in his will.[45] The deliberations on the best purpose for such an extension dragged on until 1923, when

> it was finally agreed . . . that the basement of the new building be utilised as a store and workrooms for the Geological Department, and the ground-floor, first, second, and third floors for the exhibition of the Ethnographical, Egyptological, Semitic and Classical Archaeological Collections, and the top floor for the stores, offices and work rooms necessary for these Collections.[46]

Once again the University turned to a Waterhouse as designer – this time, Alfred's grandson Michael. Like his father's design for the earlier extension, Michael eschewed contemporary styles in favour of a building that matched the extant

Museum buildings, forming 'a homogenous and distinguished elevation to Oxford Road'.[47] Those who attended the opening of the new building in November 1927 found the ethnology collection on the ground and first floors dominated by massive cases containing artefacts in a 'geographical and racial scheme'.[48] Platten, who with advice from Haddon had designed the arrangement before he left, thereby bequeathed the museum a mixture of the Victorian typological ethnology of Pitt Rivers and the geographical displays typical of the British Museum.

Overlooking ethnology on the second-floor balcony were coins and medals – now separate from the other cultural collections as befitted the well-established independence of numismatics as a discipline in Britain. 'Pre-Classical and Classical Archæology' formed a new section on the third floor, including the archaeology of Europe and the western Mediterranean.[49] Like the ethnology below, this group of artefacts was generally arranged by place rather than time. They were separated by both geography and chronology from the Egyptian archaeology, which Crompton rearranged in the 1912–13 building. Mineralogy and petrology flooded into the void left by ethnology on the ground floor, severing the juxtaposition of earth and life science. Although prehistoric archaeology remained at the end of this expanded geological sequence, the four other cultural collections – now defined as Greek and Roman antiquities, numismatics, ethnography and Egyptology – achieved significant degrees of disciplinary independence in the new extension.[50] As discussed in chapter 2, however, this had not been without one last defence by Dawkins of his universal sequence. Overruled, his arrangement was replaced by two almost distinct museums, just as the British Museum (Natural History) finally became a separate administrative entity from its Bloomsbury cousin in 1930.

Operating independently, classical archaeology expanded considerably – thanks largely to the efforts of T. B. L. Webster, Hulme Professor of Greek at the University in the 1930s and 1940s. Webster had a strong interest in Greek vases, employing an art historical approach he learned from John Beazley at Oxford. Beazley had revolutionised the study of classical pottery by paying such close attention to minute details of style that he was able to assign pieces to particular artists or schools.[51] Webster arranged the Manchester Museum material in a chronological typology 'to illustrate the history of Greek vase painting' and he expanded the collection considerably (see also chapter 4).[52] His appointment to the Museum Committee as 'scientific' supervisor indicated the formalisation of classical archaeology as a discrete part of the collection.[53]

Whereas the interests of Beazley and Webster reflected a renewed interest in museum collections in classical archaeology, such an attitude was not evident in ethnology. For Haddon and his generation, anthropology had been distinct from zoology, but still practised with many of the same deductive methods in both field and museum. Their successors, especially Bronislaw Malinowksi and Alfred Radcliffe-Brown, replaced this approach with ethnographic field methods, distancing social anthropology not only from its natural science roots, but also from

material culture. These distinctions, Chris Gosden argues, were crucial in the construction of social anthropology as a discipline.[54] Already at the beginning of the century, the influential anthropologist Franz Boas chastised his former colleagues at the American Museum of Natural History:

> The strong tendency to accumulate specimens has often been a disadvantage to the development of anthropology because there are many aspects of this science in which the material objects are insignificant as compared with the actual scientific questions involved . . . Anthropology requires a broader point of view for its fieldwork than that offered by the strict requirements of the acquisition of museum specimens.[55]

But this left museum ethnography in a potentially ambiguous position with respect to both biology and the social anthropology.[56] Some museums sent their staff into the field, and some actively collected photographs as well as (or instead of) material culture. In Manchester, interest in ethnological objects was reignited from a different disciplinary direction altogether, by Roderick Urwick ('Rollie') Sayce, appointed to direct the Museum in 1935.[57] The first non-zoologist to hold the post, he had been lecturer in physical anthropology at the University of Cambridge, where he worked at the University Museum of Ethnology and Archaeology and edited the *Journal of the Anthropological Institute*.

Sayce's dedication to what he called 'British ethnology' – folklore or bygones, an expanding area in British museums – was far more akin to history and geography than to the natural sciences.[58] He had previously been head of the department of geography at Natal, and in Manchester Sayce worked on the collections with the social anthropologist, archaeologist and Professor of Geography Herbert John Fleure.[59] Acting as scientific supervisor for ethnology, Fleure shared Sayce's passion for folklore. His involvement marked a shift in the function of the ethnology collection from the natural to the human sciences, for although he had previously held a chair of zoology, he pioneered the independent study of both geography and anthropology. Sayce was the first to rename explicitly the Manchester Museum collection, 'ethnography', as befitted his emphasis on non-material culture and links with geography (see figure 2.4). His move effectively translated the discipline from prescriptive to descriptive (an '-ology' to an '-ography').[60]

Sayce also clarified the disciplinary divisions in the archaeological collections, as prehistoric (now 'general') archaeology was organised and staffed alongside ethnology.[61] By the time Wilfrid Jackson retired in 1945, prehistoric archaeology was disaggregated from its palaeontological roots, arranged instead in numismatics' former home on the gallery overlooking ethnography. Climbing up the 1927 building, the visitor moved from contemporary primitive cultures to their prehistoric equivalent in Europe, and finally to the pinnacle of ancient Mediterranean civilisation. This sequence was no longer chronological, but disciplinary, advancing in sophistication from the modern savage to the classical European. Three distinct archaeologies were now evident in the Manchester Museum: prehistoric British material; classical

artefacts; and the large holdings of ancient Egyptian grave goods. They had different staff, acquisition routes, arrangements and theoretical underpinnings. Overall, the cultural collections now mapped almost precisely onto the British Museum's departmental structure: Egyptology; Greek and Roman antiquities; numismatics; physical anthropology and prehistory; and ethnography.[62]

These 'humanistic' collections would have occupied the entire Museum complex had the Committee been successful in its bid to move natural history across Oxford Road with the University science departments after the Second World War (see chapter 2). Although this complete partition of nature and culture at the Manchester Museum did not come about, the post-war period was marked by more formal differentiation within the cultural collections. Sayce appointed two new curators whose remit was intended to span the collection more comprehensively than the ad hoc arrangements before the war. The Cambridge-trained specialist on Caucus archaeology Theodore Burton-Brown was given responsibility for Egypt, the Near East and the classical world.[63] Frank Willett, later an authority on African art and director of the Hunterian Museum in Glasgow, was appointed to care for ethnography and prehistoric archaeology.[64] His collections were connected not by geography but by methodology, as expounded by Sayce and other key curators such as Thomas K. Penniman at the Pitt Rivers Museum (which from 1958 comprised Oxford University's 'department of ethnology and prehistory').[65] This union reflected a widespread post-war rapprochement between archaeology and anthropology as the emphasis on material culture that had never left the former slowly returned to the latter.[66]

The differences between Willett's and Burton-Brown's territories were marked. With no classical archaeologists associated with the collection, after a wave of 'pilfering' just before the war, the third-floor gallery had been closed to the general public. Rather, even though Burton-Brown had little interest in Egyptology, the Egyptian galleries took on new significance in the 1950s in the aftermath of the Suez crisis, as Egypt and Britain sought to re-establish peaceful links through culture. They contrasted starkly with the prehistoric gallery next door. Willett later recalled,

> I decided that we needed a delineation between my ethnography gallery and the Egyptology gallery next door, so I painted the underneath side of the arch bright red. About six months later, Theodore Burton-Brown came raging at me, 'what did I mean doing that?' I said: 'so people would notice that they were crossing a boundary – it took you six months to find it, didn't it?'[67]

Willett expanded the scope of this adjoining room from prehistory to 'general archaeology', emphasising and adding more Bronze Age, Romano-British and Anglo-Saxon material.[68] On the other side of his disciplinary province, the increasing distance between ethnology and the natural sciences in Willett's time was evident in the displays themselves. He first displayed African sculpture as 'art' in 1952 at the nearby Whitworth Art Gallery (formerly the Whitworth Institute, soon to be taken

over by the University), and subsequently in the Museum itself, explicitly rejecting scientific classification for aesthetic criteria.[69] In 1958, as Willett left the museum to take up an archaeological post in Nigeria, the last spatial juxtaposition between ethnology and the natural sciences was broken. The economic geology gallery, next to the ground floor of ethnology, was replaced by a temporary exhibition space (see chapters 5 and 6). The first show featured Ife bronzes and terracottas that Willett excavated in Nigeria.

Under Willett, the links between ethnology and natural science were thus rivalled and finally eclipsed by continuities with archaeology and with art history. From the mid-twentieth century, when 'museum anthropology [was] stranded in an institutional, methodological and theoretical backwater', the museum began to draw on personnel trained in archaeology instead of zoology (as the Pitt Rivers Museum had in Penniman).[70] Willett was succeeded by James (Jim) Forde-Johnston, who had trained as an archaeologist and Egyptologist. Like Willett, he considered ethnology to be 'intimately connected with archaeology which is a technique of studying the same problems in past ages'.[71] The most significant front-end change during his twenty-four years at the Museum was in response to the massive donation of Japanese material by Robert Wylie Lloyd (see chapter 4), which he installed in the second floor of the 1927 building in place of general archaeology.[72] The last vestiges of Dawkins's evolutionary influence were removed from sight, and the archaeological displays were no longer presented in a progressive sequence. That this move finally came in 1960, long after academic archaeology and anthropology had moved away from universalist interpretations of material culture, demonstrates the inertia of the permanent exhibition in the museum context; one reason why scholars elsewhere in the academy had turned away from collections in the early twentieth century.[73]

Culture consolidated 1969–90

The domains into which the Manchester Museum was split in the middle of the century were not only determined by the interests of staff and the provenances of objects. They also reflected the very different disciplinary communities that were grouped around particular kinds of material culture. That prehistoric archaeology was curated alongside ethnography was in part because Sayce had an interest in both, but also, as discussed above, because prehistoric archaeology in Europe had a distinct intellectual pedigree from more recent Mediterranean archaeology. The alliance of classical archaeology and Egyptology in Manchester, by contrast, was more shaped by local factors, especially the void of expertise left in Webster's wake – elsewhere, the two fields were undertaken by very different communities of practice. Towards the end of the twentieth century, the organisational structure of the Museum would shift once again. Three factors were reflected in the changes: the formalisation of archaeology as a coherent discipline, practised in the UK separately from numismatics, anthropology and Egyptology; the independent

professionalisation of these disciplines; and finally the construction of the museum profession as a whole.

The fragmented character of archaeology and the neglect of the classical collections since the Second World War shaped the strategy of the Museum Committee in finding a replacement for Burton-Brown upon his retirement in 1969.[74] Setting out to appoint a classical archaeologist, the Committee found John Prag, a young Hellenist from the Ashmolean Museum.[75] Prag was among a new generation of archaeologists in the 1960s who had postgraduate training that had rarely been available to their predecessors.[76] The professional identity of archaeological curators, meanwhile, was consolidated by the formation of the Society of Museum Archaeologists in 1975, one of a series of specific bodies within the museum profession.

In the Manchester Museum, the consolidation of museum archaeology as a profession in this period was marked by the organisation of material culture as well as the training and approach of the staff. The Museum Committee transferred the general archaeology to Prag's remit as he was appointed, leaving Forde-Johnston only with ethnology. For the first time in the Manchester Museum, anthropology and archaeology were distinct conceptual entities. This was concurrent with the emergence from the British Museum of the Museum of Mankind, a satellite museum that was spatially, if not administratively, separate from the main site in Bloomsbury until the millennial rearrangement. John Prag's domain now encompassed 'archaeology' in its entirety, from 'the ancient world, from Northern Europe to Southern Africa and the Middle East, ranging in time from the Palaeolithic to the seventeenth century AD'. Nevertheless, as he acknowledged, 'within each broad area the museum has, for historical reasons, a slightly different approach'.[77] In particular, the intellectual rift between prehistoric and later archaeologies remained deep, as palaeolithic digs continued to be analysed according to typology, with little reference to context or human activity. Flints were categorised as tool-types, by parity with fossil type specimens.

Prag inherited an uneven collection, with considerable strengths in the areas that had been of interest to keepers and donors: particularly – even after nearly a century – Dawkins's flints and Petrie's Egyptian material. He set out to balance these with an emphasis on the ancient Mediterranean, thereby encompassing his own research interests and explicitly following Webster's footsteps.[78] The classical collections, however, remained in the closed upper gallery of the 1927 building, beyond the reach of the general public.[79] To rectify this, Prag displayed the Museum's holding in a series of temporary exhibitions, and slowly introduced more Mediterranean and Romano-British material into the open displays.[80] In these endeavours he worked with a large team of enthusiastic volunteers, from students to senior academics – a characteristic of UK archaeology collections in the 1970s – as well as staff employed by the Manpower Services Commission.[81] Beyond the Museum, Prag collaborated with the University departments of history (which included ancient history), Greek and Latin, and later with the Archaeology Department that emerged in the early 1970s.[82] Academic archaeology was in the throes of a series of theoretical turns that

shifted the attention of many archaeologists beyond museums, but in Manchester academic-museum ties were nevertheless vibrant. Such links were not mirrored in other areas: the University had no numismatist or Egyptologist outside the Museum, and the renowned Anthropology Department was more concerned with visual studies than material culture. But for archaeology, these scholarly and collaborative links contributed to a more coherent identity in the Manchester Museum than ever before. This was epitomised by plans for a new Mediterranean gallery, which encompassed the entire scope of the diverse collections that had operated independently for much of the previous century. On the map of knowledge in the Manchester Museum, archaeology was no longer a collection of city-states but a federal nation. Its authority was consolidated by the Lindow Man exhibition, the most popular the Museum ever staged (see chapter 6).

Forde-Johnston's ethnology, meanwhile, had occupied the entire 1927 building public exhibition space since the opening of the Lloyd Japanese gallery in 1960. The displays remained largely unchanged, although they were now explained in exclusively geographical terms, without any evolutionary undertones. There was no trace of Sayce's mid-century emphasis on folklore, as the bygones he collected had been exchanged for overseas material from the Salford Museum in 1969 (including the Burmese Buddha that Dawkins sold a century earlier).[83] In 1982 Forde-Johnston retired and his assistant keeper George Bankes replaced him. Like his predecessor, Bankes was trained in archaeology and continued to compare contemporary and archaeological artefacts in his work at the Museum.[84] And so although ethnology was a demarcated collection area, methodologically, it was closely linked to its neighbours.[85]

Egyptology, meanwhile, was relatively neglected in the early 1970s. As an unprecedented 1,600,000 visitors queued to attend the Tutankhamun exhibition at the British Museum in 1972 (including a trainload of Mancunians organised by Prag), the lack of a dedicated curator for the Manchester Museum's renowned collection was conspicuous.[86] Accordingly, when the archaeology assistant keeper position was eventually funded, the Museum appointed an Egyptologist, Rosalie David, who had a Liverpool PhD in Egyptology and experience at the Petrie Museum at University College London. She quickly set about raising awareness of the collection through a series of high-profile research projects and symposia. In 1975 she led a team in the autopsy of 'mummy 1770', explicitly echoing Murray's unwrapping in 1908.[87] These activities fuelled and were fuelled by the enormous popularity of a series of day schools and that David and Prag ran.[88]

The galleries David inherited had been refurbished in 1962, but their overall arrangement was still based on of Crompton's pre-war scheme. In the late 1970s David laid the groundwork for a complete re-display, which first bore fruit in 1979 in the successful 'O! Osiris, Live Forever' exhibition in the basement, laid out to emulate a tomb (see figure 3.4).[89] In 1986 the permanent galleries were finally re-displayed.[90] In light of such success, David demanded independence from

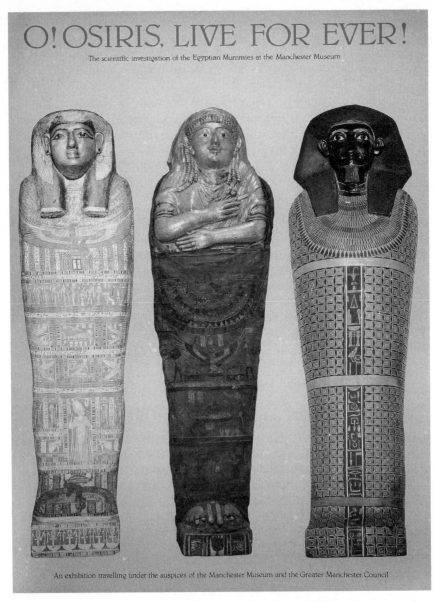

Figure 3.4 'O! Osiris, Live Forever' touring exhibition poster, 1980. The displays were first shown in the Museum basement in 1979.

archaeology. She began campaigning in earnest in the 1980s, lobbying the director and the vice-chancellor, and eventually succeeded in 1990 with a formal appointment as Keeper of Egyptology. She thereby regained the independent status held briefly at the beginning of the century by Crompton. Egyptology now sat in a very different disciplinary landscape, however, bordered by the fully formed departments that had emerged from the fledgling collections in 1912. By 1990 four consolidated collections – Egyptology, archaeology, ethnology and numismatics – operated as separate fiefdoms within the Museum, like the natural sciences in chapter 2.

Conclusion: shaping disciplines

The Manchester Museum humanities collections precipitated around the seed of Haworth's loan of Petrie's material in the period between the opening of the Museum in 1890 and the Great War. Originally sited within the wider natural science arrangement, the cultural collections expanded into a contiguous space in 1912–13 and were separated entirely in 1927. What had been a permeable boundary between nature and culture was concretised. There followed a period of differentiation, which resulted in a particular orientation in 1950 (after a failed bid for complete autonomy from natural history); a reorganisation around 1970 with the consolidation of the archaeology department; and a final schism in 1990 with the independence of Egyptology. In tracing these developments, this chapter has charted the changing disciplinary landscape of the Manchester Museum, as the humanities shifted from a province within the natural sciences to an adjoining dominion and finally to an independent federation.[91] The British Museum, the Smithsonian, and to some extent the Oxford University Museum, experienced large scale institutional differentiation of natural and cultural collections in the late nineteenth century. By contrast, the Manchester Museum (like the Horniman Museum), retained its original transdisciplinary remit, but drew the disciplinary boundaries within the institution, in policies and in the very fabric of the building. Treaties were formed between disciplines, boundaries constructed and, occasionally, wars waged. A range of factors, gradual or seismic, determined these shifts in intellectual topography: staff interests and training, donations, developments within the University and wider intellectual currents. The trajectory of culture in the Manchester Museum was as a result very different from that at other universities such as Cambridge, or other large museums in the north-west such as Liverpool.[92]

The particular interest of members of staff can impact upon a collection in obvious or subtle ways. Dawkins shaped the collection at the inception of the Manchester Museum not only in his overall arrangement, but also through his interest in cave deposits and particularly flints, which dominated the early displays. In the middle of the century, Sayce brought with him a keen interest in folklore, but this ultimately had no lasting impact on the topography of the Museum. The management and development of the 'general archaeology and ethnology' between 1950

and 1970 was dependent on the particular blend of anthropological and archaeo-
logical outlooks of Willett and later Forde-Johnston. As well as the interests and
training of the keepers, the external routes by which the material culture arrived at
the Museum influenced its internal mechanisms. While acquisition is discussed in
more detail in the following chapter, it is clear already that the arrival of particular
collections had an impact on the shape of the Museum. Not only did smaller dona-
tions expand extant collections, but Dawkins (qua flint collector), Petrie, Webster
and Lloyd all generated seismic changes in the shape of the Museum with key gifts.

Just as the shape and function of the cultural collections reflected their location
within a multi-disciplinary museum, their university context was also significant.
Compared with a municipal collection of a similar size, the Manchester Museum
in principle drew upon a greater pool of academic expertise, from scientific super-
visors and honorary curators. But the relations between museum and (the rest of
the) university depended on the standing of material culture within a discipline at
a particular time. Archaeology, for example, benefited from the interest of univer-
sity academics in later decades in a way that the ethnology collection did not. The
Manchester Museum reflected the confluence of different intellectual trajectories
in the study of material culture, and the development of what would become the
archaeology department emerged from two distinct traditions. The first, prehis-
toric archaeology, had its roots in Victorian palaeontology, and specifically in a
speleological enterprise that erected no boundary between cave finds of natural
and cultural origin. In 1969 this general collection joined the classical material that
had developed from art historical origins, its roots in the archaeological approach
of Beazley rather than that of Pitt Rivers. The same objects were used to very differ-
ent ends at different times and in variant disciplinary contexts. The ancient Greek
material, for example, began as a link in Dawkins's chain of development, was then
interpreted by Webster in aesthetic terms and still later employed by Prag to present
a rounded social and economic view of the Mediterranean world. The ethnology
collections, meanwhile, emerged from natural history to occupy the liminal space
between science and art. Anthropology as a discipline was built on museum collec-
tions, and objects told very different stories in this new intellectual locale than they
had as part of a taxonomic schema.

The collections and the galleries at the outset reflected state-of-the-art attitudes
to material culture, but soon became divorced from broader intellectual currents
elsewhere, and in some ways remained so until the exhibition redesigns of the
1980s. This did not necessarily reflect any conservatism on the part of the keepers,
but rather the inertia of the permanent museum display as a site for the produc-
tion of knowledge. Temporary exhibitions notwithstanding, a museum may retain
the same arrangement for decades, as ideas and the collections change. Thus, the
disciplinary landscape of the Museum's permanent galleries lagged some years
behind the broader intellectual cartography of British academia, and even the inter-
ests of the staff. Nevertheless, as we will see in the following chapter, acquisition

networks connected the Museum to broader developments, from debates around the antiquity of humankind to rescue archaeology. Galleries may be static, but a museum collection is a dynamic entity.

Notes

1 On the connotations of 'construction' and the distinctions (or lack thereof) between artefacts and specimens, see S. J. M. M. Alberti, 'Constructing nature behind glass', *Museum and Society*, 6 (2008), 73–97.

2 For complementary studies, see C. Gosden and F. Larson, *Knowing Things: Exploring the Collections at the Pitt Rivers Museum 1884–1945* (Oxford: Oxford University Press, 2007); L. Keppie, *William Hunter and the Hunterian Museum in Glasgow, 1807–2007* (Edinburgh: Edinburgh University Press, 2007).

3 T. Bennett, *Pasts beyond Memory: Evolution, Museums, Colonialism* (London: Routledge, 2004); A. H. Lane Fox, 'On the principles of classification adopted in the arrangement of his anthropological collection, now exhibited in the Bethnal Green Museum', *Journal of the Anthropological Institute of Great Britain and Ireland*, 4 (1875), 293–308; P. Lucas, 'Charles Darwin, "little Dawkins" and the platycnemic Yale men: introducing a bioarchaeological tale of the descent of man', *Archives of Natural History*, 34 (2007), 318–45; A. B. van Riper, *Men among the Mammoths: Victorian Science and the Discovery of Human Prehistory* (Chicago: Chicago University Press, 1993).

4 I. Jenkins, *Archaeologists and Aesthetes in the Sculpture Galleries of the British Museum 1800–1939* (London: British Museum, 1992); S. Moser, *Wondrous Curiosities: Ancient Egypt at the British Museum* (Chicago: University of Chicago Press, 2006); M. Shanks, *Classical Archaeology of Greece: Experiences of the Discipline* (London: Routledge, 1996).

5 C. Gosden, *Anthropology and Archaeology: A Changing Relationship* (London: Routledge, 1999); F. Larson, 'Anthropology as comparative anatomy? Reflecting on the study of material culture during the late 1800s and the late 1900s', *Journal of Material Culture*, 12 (2007), 89–112.

6 W. B. Dawkins, *Early Man in Britain and his Place in the Tertiary Period* (London: Macmillan, 1880), p. 3.

7 W. B. Dawkins, 'On museum organisation and arrangement', *Report of the Proceedings of the Museums Association*, 1 (1890), 38–45, p. 40.

8 Lancashire and Cheshire Antiquarian Society, 'Saturday, October 6th, 1888. Visit to the Manchester Museum', *Transactions of the Lancashire and Cheshire Antiquarian Society*, 6 (1888), 233–7, 233–4. See W. B. Dawkins, 'The organisation of natural history museums', *Nature*, 16 (1877), 137–8; Dawkins, 'On museum organisation', *Report of the Proceedings of the Museums Association*, 1 (1890), 38–45; Dawkins, 'The Manchester Museum: its place in education', *Old Owensian Journal*, 5 (1928), 142–4; W. E. Hoyle, *Handy Guide to the Museum* (Manchester: Cornish, 3rd edn, 1903). Cf. Gosden and Larson, *Knowing Things*.

9 Bennett, *Pasts beyond Memory*.

10 W. E. Hoyle, *General Guide to the Contents of the Museum* (Manchester: Cornish, 1892), p. 23.

11 Hoyle, *General Guide* (1892), p. 23. Manchester Museum Central Archive (hereafter MMCA) Manchester Museum Committee Minutes (hereafter MMCM) vol. 1 (26 October 1891).

12 W. E. Hoyle, *Handy Guide to the Museum* (Manchester: Cuthbertson & Black, 1895), p. 8; A. E. Coombes, *Reinventing Africa: Museums, Material Culture and Popular Imagination in Late Victorian and Edwardian England* (New Haven: Yale University Press, 1994); A. A. Shelton, 'Museum ethnography: an imperial science', in E. Hallam and B. Street (eds), *Cultural Encounters: Representing 'Otherness'* (London: Routledge, 2000), pp. 155–93; T. R. Trautmann, 'The revolution in ethnological time', *Man*, 27 (1992), 379–97.

13 W. E. Hoyle, *General Guide to the Contents of the Museum (Illustrated)* (Manchester: Cornish, 2nd edn, 1893), p. 25.

14 MMCM vol. 1 (2 February 1892); Bennett, *Pasts beyond Memory*; A. Desmond, *Huxley: From Devil's Disciple to Evolution's High Priest* (London: Penguin, 1998); T. Griffiths, *Hunters and Collectors: The Antiquarian Imagination in Australia* (Cambridge: Cambridge University Press, 1996); T. H. Huxley, *Evidence as to Man's Place in Nature* (London: Williams and Norgate, 1863).

15 Bennett, *Pasts beyond Memory*; Jenkins, *Archaeologists and Aesthetes*.

16 W. H. Crompton, 'Jesse Haworth: first president of the Manchester Egyptian Association', *Journal of the Manchester Egyptian and Oriental Society*, 9 (1921), 49–52; M. S. Drower, *Flinders Petrie: A Life in Archaeology* (London: Gollancz, 1985); A. B. Edwards, *A Thousand Miles up the Nile* (London: Longmans, 1877); D. Gange, 'Religion and science in late nineteenth-century British Egyptology', *The Historical Journal*, 49 (2006), 1083–103; J. Haworth, 'The progress of Egyptology in Manchester', *Journal of the Manchester Egyptian and Oriental Society*, 3 (1913), 12–18; W. M. F. Petrie, *Seventy Years in Archaeology* (London: Low, Marston, 1931); C. Riggs, 'Jesse Haworth and the Manchester Museum', *Bulletin of the Association for the Study of Travel in Egypt and the Near East: Notes and Queries*, 24 (2005), 11–12; P. J. Ucko, 'The biography of a collection: the Sir Flinders Petrie Palestinian Collection and the role of university museums', *Museum Management and Curatorship*, 17 (1998), 351–99.

17 MMCM vol. 1 (24 March 1893); Hoyle, *General Guide* (1892); Hoyle, *Handy Guide* (1895); W. M. F. Petrie, *Kahun, Gurob, and Hawara* (London: Kegan Paul, 1890); Petrie, *Illahun, Kahun and Gurob* (London: Nutt, 1891).

18 Moser, *Wondrous Curiosities*.

19 MMCM vol. 1 (28 October 1892). The natural sciences dominated, as the College had no humanities lecturers until Francis Llewellyn Griffith was appointed lecturer in Egyptology in 1898. Even then, this was largely a philological post – the study of Egyptian language did not always mesh with Egyptian archaeology. Griffith's sister Agnes compiled the first Egyptology catalogue. See M. A. Canney, 'Egyptology in Manchester', *Journal of the Manchester Egyptian and Oriental Society*, 18 (1933), 28–36; W. R. Dawson and E. P. Uphill, *Who Was Who in Egyptology*, ed. M. L. Bierbrier (London: Egypt Exploration Society, 3rd edn, 1995); A. S. Griffith, *Catalogue of Egyptian Antiquities of the XII and XVIII Dynasties from Kahun, Illahun and Gurob* (Manchester: Sherratt & Hughes, 1910).

20 Gange, 'Religion and science'; Moser, *Wondrous Curiosities*.

21 MMCM vol. 1 (17 March 1897), p. 365.

22 MMCM vol. 2 (16 January 1905); MMCA, *Manchester Museum Reports* (hereafter *MMR*) (1904–11).

23 MMCM vol. 3 (15 December 1908), p. 22; see also MMCM vol. 2 (15 January 1906), (13 January 1908).

24 E.g. *MMRs* (1899–1900), (1922–23). On Hilda Petrie, see Dawson and Uphill, *Who Was Who*.

25 S. J. M. M. Alberti, 'Molluscs, mummies and moon rock: the Manchester Museum and Manchester science', *Manchester Region History Review* 18 (2007), 108–32; A. R. David, *The Two Brothers: Death and the Afterlife in Middle Kingdom Egypt* (Liverpool: Rutherford, 2007); M. A. Murray (ed.), *The Tomb of Two Brothers* (Manchester: Sherratt & Hughes, 1910).

26 MMCM vol. 3 (8 February 1910), p. 71.

27 C. Wingfield, '(Before and) after *Gallery 33*: fifteen years on at the Birmingham Museum and Art Gallery', *Journal of Museum Ethnography*, 18 (2006), 49–62.

28 On Dawkins's attitude to Ancient Egypt, see W. H. Crompton, 'William Boyd Dawkins', *Journal of the Manchester Egyptian and Oriental Society*, 15 (1930), 12–13; Dawkins, *Early Man in Britain*.

29 Manchester Museum, *An Account of the Extension of the Museum* (Manchester: University of Manchester, 1912), p. 12; *MMR* (1910–11).

30 W. M. Tattersall, *General Guide to the Collections in the Manchester Museum* (Manchester: Manchester University Press, 1915), p. 42.

31 S. Conn, *Museums and American Intellectual Life, 1876–1926* (Chicago: University of Chicago Press, 1998); Gosden, *Anthropology and Archaeology*.

32 *MMR* (1912–13), p. 13. Tattersall, *General Guide*.

33 In the old building, the cultural collections had been cared for, if at all, by the natural science trained keepers and College staff. Ethnological and Egyptological classification and arrangement was undertaken by William Hoyle and Robert Standen (both zoologists) and by the entomologist J. Ray Hardy. Staffing connections between ethnology and natural sciences was also reinforced by the scientific supervisors drawn from the University, who included Sydney Hickson of the zoology department. But for all of them, the cultural collections were secondary to natural history. Tattersall, for example, barely looked at the Egyptian collections until the transfer to the new building. See e.g. Manchester Museum Egyptology Archive, W. Crompton – J. Haworth, 5 December 1912.

34 *MMR* (1911–12); G. Elliot Smith, 'Winifred M. Crompton', *Journal of the Manchester Egyptian and Oriental Society*, 18 (1933), 25–6; Dawson and Uphill, *Who Was Who*.

35 Elliot Smith was Professor of Anatomy at the Medical School 1909–19, during which time he was a stalwart of the Manchester Egyptian and Oriental Society. He worked on ancient Nubian and Egyptian human remains, embodying the close relationship between physical anthropology and anatomy in the early twentieth century. Other University staff who were involved with the Egyptian collections included the Egyptologists Francis Llewellyn Griffith, Alan Gardiner and T. Eric Peet. See G. Elliot Smith, *Catalogue Générale des Antiquités Égyptiennes du Musée du Caire: The Royal Mummies* (London: Duckworth, facsimile edn, 2000); T. E. Peet, *The Stela of Sebek-khu: The Earliest Record of an Egyptian Campaign in Asia* (Manchester: Sherratt & Hughes, 1914); J. S. B. Stopford,

'The Manchester period', in W. R. Dawson (ed.), *Sir Grafton Elliot Smith: A Biographical Record by his Colleagues* (London: Cape, 1938), pp. 151–65; H. A. Waldron, 'The study of the human remains from Nubia: the contribution of Grafton Elliot Smith and his colleagues to palaeopathology', *Medical History*, 44 (2000), 363–88.

36 Robert Standen was given charge of the ethnology in the 1913 building, and by the 1920s his involvement was such that his post was re-dubbed, 'assistant keeper for zoology and ethnology'. Although Wilfrid Jackson was a conchologist by passion he helped Crompton with the Egyptian collections and took part in Murray's unwrapping of Khnum-Nakht. See M. J. Bishop, 'Dr. J. Wilfrid Jackson (1880–1978): a biographical sketch', in Bishop (ed.), *The Cave Hunters: Biographical Sketches of the Lives of Sir William Boyd Dawkins and Dr. J. Wilfrid Jackson* (Buxton: Derbyshire Museum Service, 1982), pp. 25–48; J. W. Jackson, *Shells as Evidence in the Migrations of Early Culture* (Manchester: Manchester University Press, 1917).

37 Shanks, *Classical Archaeology of Greece*.

38 MMCA box CA5, typescript, W. M. Tattersall, 'Report by the Keeper of the Museum on the memorandum and resolution adopted at the Conference on Art Education held at the Art Gallery', 1920.

39 MMCM vol. 4 (10 January 1921), report facing p. 27, on p. 3.

40 'Mr. Charles Heape. Fine gift to Manchester University. Collection of which illustrates the development of man', *Rochdale Observer* (2 June 1923), p. 5; J. Edge-Partington and C. Heape, *An Album of the Weapons, Tools, Ornaments, Articles of Dress, etc., of the Natives of the Pacific Islands*, 3 vols (Manchester: privately printed, 1890–98); C. Heape and R. Heape, *Records of the Family of Heape, Staley, Saddleworth and Rochdale, from circa 1170 to 1905* (Rochdale: privately printed, 1905); J. W. Jackson, 'Genesis and progress of the Lancashire and Cheshire Antiquarian Society', *Transactions of the Lancashire and Cheshire Antiquarian Society*, 49 (1933), 104–12.

41 F. Larson, 'Anthropological landscaping: General Pitt Rivers, the Ashmolean, the University Museum and the shaping of an Oxford discipline', *Journal of the History of Collections*, 20 (2008), 85–100; P. J. Smith, 'A Splendid Idiosyncrasy: Prehistory at Cambridge, 1915–50' (PhD dissertation, University of Cambridge, 2004).

42 Robert Standen worked on specimens Haddon gathered during the first Torres Straits expedition; George Carpenter was Haddon's colleague at the Dublin Science and Art Museum; and Haddon in turn advised Carpenter's successor as Director, Roderick Sayce. See *MMR* (1934–35); J. Adelman, 'Evolution on display: promoting Irish natural history and Darwinism at the Dublin Science and Art Museum', *British Journal for the History of Science*, 38 (2005), 411–36; S. J. M. M. Alberti, 'Culture and nature: the place of anthropology in the Manchester Museum', *Journal of Museum Ethnography*, 19 (2006), 7–21; H. J. Fleure, 'Alfred Cort Haddon 1855–1940', *Obituary Notices of Fellows of the Royal Society*, 3 (1941), 448–65; N. Levell, 'Illustrating evolution: Alfred Cort Haddon and the Horniman Museum, 1901–1915', in A. A. Shelton (ed.), *Collectors: Individuals and Institutions* (London: Horniman Museum, 2001), pp. 253–79; J. C. Melvill and R. Standen, 'Report on the marine mollusca obtained during the first expedition of Prof. A. C. Haddon to the Torres Straits, in 1888–89', *Journal of the Linnean Society of London – Zoology*, 27 (1899), 150–206; R. U. Sayce, *Primitive Arts and Crafts: An Introduction to the Study of Material Culture* (Cambridge: Cambridge University Press, 1933); J.

Urry, *Before Social Anthropology: Essays on the History of British Anthropology* (Reading: Harwood, 1993).

43 *MMR* (1926–27).

44 MMCM vol. 4 (5 October 1925), p. 166.

45 He also bequeathed 'all Egyptian Antiquities belonging to me at the time of my death'. Cheshire and Chester Archives and Local Studies Service MF 91/67, manuscript ledger copy, Jesse Haworth, last will and testament, c.1920, paragraphs 10, 12, 37, here at paragraph 12.

46 MMCM vol. 4 (25 June 1923), p. 91.

47 Manchester Museum, *Guide to the Manchester Museum* (Stockport: Dean, 2nd edn, 1978), p. 1.

48 G. H. Carpenter, *A Short Guide to the Manchester Museum* (Manchester: Manchester University Press, 1933), p. 15.

49 *MMR* (1927–28), p. 8.

50 The distinction between nature and culture could be seen not only in architecture but also in staffing. Reverend Platten was replaced by Florence Hodgson, a former volunteer, who was the first full-time member of staff dedicated to ethnology. In 1931, Crompton formally took over responsibility for non-Egyptian archaeology as well, a role she had in practice undertaken for two decades; but she died suddenly the following year. Her unexpected vacancy was filled by Mary Shaw, a volunteer at the Museum who like Crompton had studied with Eric Peet and was closely involved with the Manchester Egyptian and Oriental Society. Shaw served until after the Second World War, when she was briefly – and unsuccessfully – succeeded by the German émigré Egyptologist Eliza (Elise) Baumgartel. Like her predecessors, Baumgartel was formally responsible for archaeology in general but was principally concerned with Egyptology. She clashed with the Museum Committee soon after her appointment in 1948 over permission for leave to lecture in the United States and other matters, and was relieved of her duties early in 1950 having failed to return to Manchester after Christmas 1949. The numismatics collections were cared for by a series of honorary curators (the first of this kind of position at the Manchester Museum): first Egbert Steinthal and later Harold Raby. Physical anthropology, under the care of the zoology staff, occupied a liminal conceptual space between the Museum's two parts. See MMCA, box GB5, typescript, E. Baumgartel, 'Memorandum on future work to be done in and for the Museum', 1948; box GB5, H. G. Cannon correspondence, 1949–63; MMCM vol. 5; *MMRs* (1931–32), (1946–48); R. Friedman, 'Elise Jenny Baumgartel 1892–1975', www.brown.edu/Research/Breaking_ Ground/, accessed 18 April 2006; J. F. Healy (ed.), *Sylloge Nummorum Graecorum*, VII, *Manchester University Museum: The Raby and Güterbock Collections* (London: Oxford University Press, 1986); F. C. Thompson, 'Obituary: Harold Raby, M.A.', *British Numismatic Journal*, 29 (1958–59), 196.

51 E. Handley, 'Thomas Bertram Lonsdale Webster', *Proceedings of the British Academy*, 120 (2003), 445–67; A. J. N. W. Prag, 'Acquisitions by the Manchester Museum 1970–1987', *Journal of Hellenic Studies*, 108 (1988), 290–4; Prag, Interview with the author, *Re-Collecting at the Manchester Museum* disc S19, 2006, MMCA, track 6; M. Robertson, 'Beazley, Sir John Davidson (1885–1970)', rev. D. Gill, in *Oxford Dictionary of National Biography* (Oxford: Oxford University Press, 2004), www.oxforddnb.com/

view/article/30664, accessed 26 Jan 2006; Shanks, *Classical Archaeology of Greece*. Webster published at length on Hellenic acquisitions of the Museum: see e.g. T. B. L. Webster, *Greek Vases in the Manchester Museum* (Manchester: Manchester University Press, 1933).

52 T. B. L. Webster, *Guide to the Greek Vases* (Manchester: Manchester Museum, 1946), p. 1; G. H. Carpenter, *A Short Guide to the Manchester Museum*, ed. R. U. Sayce (Manchester: Manchester University Press, revised edn, 1941).

53 *MMRs* (1932–37); MMCM vol. 5 (22 June 1936). T. Eric Peet held the corresponding post for Egyptology.

54 Gosden, *Anthropology and Archaeology*; Gosden and Larson, *Knowing Things*.

55 F. Boas, 'Some principles of museum administration', *Science*, 25 (1907), 921–33, p. 931; see also M. Bouquet (ed.), *Academic Anthropology and the Museum* (New York: Berghahn, 2001); G. W. Stocking, *The Ethnographer's Magic and Other Essays in the History of Anthropology* (Madison: University of Wisconsin Press, 1992).

56 Conn, *Museums and American Intellectual Life*; H. Kuklick, *The Savage Within: The Social History of British Anthropology, 1885–1945* (Cambridge: Cambridge University Press, 1991); G. W. Stocking (ed.), *Objects and Others: Essays on Museums and Material Culture* (Madison: University of Wisconsin Press, 1985); Stocking, *After Tylor: British Social Anthropology 1888–1951* (Madison: University of Wisconsion Press, 1995).

57 E. G. Bowen, 'Roderick Urwick Sayce', *Montgomeryshire Collections* (1969–70), 168–70.

58 Cf. F. M. Rodríguez, 'Consolidation and renewal: Otto Samson and the Horniman Museum', in A. A. Shelton (ed.), *Collectors: Individuals and Institutions*, pp. 85–109.

59 A. Garnett, 'Herbert John Fleure 1877–1969', *Biographical Memoirs of Fellows of the Royal Society*, 16 (1970), 253–78; P. Gruffudd, 'Back to the land: historiography, rurality and the nation in interwar Wales', *Transactions of the Institute of British Geographers*, 19 (1994), 61–77. I am grateful to Simon Naylor for the latter reference.

60 Carpenter, *Short Guide* (1933), p. 15, cf. Carpenter *Short Guide* (1941), p. 16. The collection reverted to 'ethnology' on Sayce's departure.

61 *MMRs* (1934–39); Sayce, *Primitive Arts and Crafts*; Sayce, *The Museums and British Ethnology* (Manchester: North Western Federation of Museums and Art Galleries, 1941).

62 *MMR* (1934–35). The British Museum at this time divided its (three-dimensional) collections into Egyptian and Assyrian Antiquities; Greek and Roman Antiquities; Coins and Medals; British and Medieval Antiquities; and Oriental Antiquities and Ethnography. D. M. Wilson, *The British Museum: A History* (London: British Museum, 2002).

63 After studying at Cambridge, Burton-Brown had excavated at Geoy Tepe in Azerbaijan (and there began to develop an unusual diffusionist position that privileged the Caucasus), bringing his region-specific expertise to the Museum. Although he added more material and reorganised the displays, the galleries retained the overall structure imposed by Winifred Crompton in the 1920s. Burton-Brown concentrated on publishing a series of diffusionist tracts. T. Burton-Brown, *Excavations in Azarbaijan, 1948* (London: Murray, 1951); Burton-Brown, *The Coming of Iron to Greece* (Wincle, Cheshire: the author, 1955); Burton-Brown, *The Diffusion of Ideas*, 3 vols (Wootton, Oxfordshire: the author, 1971–83); A. J. N. W. Prag, 'Larger-than-life scholar and archaeologist ', *Guardian* (14 June 1988), p. 39.

64 Willett had studied Anglo-Saxon English and Old French, but had developed an early interest in archaeology. He had visited the Manchester Museum as a schoolboy (and was shown around by Wilfrid Jackson), later developing his archaeological expertise working at the Portsmouth Museum. The archaeological and ethnological aspects of his remit in Manchester sat together happily: for Willett, 'prehistory does for the past by means of archaeology what ethnology does for the present'. F. Willett and G. Bridge, *Manchester Museum Ethnology* (Manchester: Bates, 1958), p. 3; Keppie, *William Hunter and the Hunterian Museum*; F. Willett, Interview with Emma Poulter, *Re-Collecting at the Manchester Museum* disc S11, 2005, MMCA.

65 F. Larson and A. Petch, '"Hoping for the best, expecting the worst": T. K. Penniman – forgotten curator of the Pitt Rivers Museum', *Journal of Museum Ethnography*, 18 (2006), 125–39.

66 Gosden, *Anthropology and Archaeology*; Stocking (ed.), *Objects and Others*.

67 Willett, Interview with Emma Poulter.

68 R. U. Sayce (ed.), *Guide to the Manchester Museum* (Manchester: Manchester University Press, revised edn, 1957).

69 *MMR* (1955–56); B. Pullan and M. Abendstern, *A History of the University of Manchester*, 2 vols (Manchester: Manchester University Press, 2000–4); A. C. Sewter and F. Willett, *Primitive Art from the Manchester Museum* (Manchester: Manchester University History of Art Department, 1952); F. Willett, *African Art: An Introduction* (London: Thames & Hudson, 1971).

70 Stocking (ed.), *Objects and Others*, p. 8; B. Blackwood, *The Origin and Development of the Pitt Rivers Museum* (Oxford: Pitt Rivers Museum, 2nd edn, 1991); Larson and A. Petch, 'Hoping for the best'.

71 Manchester Museum, *Guide to the Manchester Museum* (Stockport: Dean, 1970), p. 20. Forde-Johnston maintained his primary interest – the British medieval built environment – throughout his 24-year tenure at the museum: e.g. J. Forde-Johnston, *Great Medieval Castles of Britain* (London: Bodley Head, 1979).

72 MMCM vol. 6 (12 January 1959); J. Forde-Johnston and J. Whitworth, *A Picture Book of Japanese Art* (Manchester: Manchester Museum, 1965).

73 Gosden, *Anthropology and Archaeology*; S. M. Pearce, *Archaeological Curatorship* (London: Leicester University Press, 1990). Numismatics, by contrast, continued to be practised in museums throughout, and experienced a renaissance after the war as servicemen brought coins back from across the world. See R. A. G. Carson and H. Pagan, *A History of the Royal Numismatic Society 1836–1986* (London: Royal Numismatic Society, 1986); Pagan, 'The British Numismatic Society: a history', *British Numismatic Journal*, 73 (2003), 1–43; In Manchester, Harold Raby was replaced as honorary curator by the University's professor of metallurgy Frank Thompson, who was in turn succeeded by Roy Allen and latterly Keith Sugden.

74 MMCM vol. 8 (14 October 1968).

75 He was recently married to Kay Prag, a Near Eastern archaeologist also at the Ashmolean, who was to teach at Manchester University and be involved in the Museum. Both were undertaking doctoral research when they moved to Manchester. In Oxfordshire they had been neighbours of Burton-Brown, who originally invited Prag to apply for the assistant keepership in archaeology, a post that never materialised. Prag, Interview with the author.

76 Pearce, *Archaeological Curatorship*.

77 Manchester Museum, *The Manchester Museum* (Derby: English Life, 1985), p. 2.

78 A. J. N. W. Prag, 'Greek vases in the Manchester Museum', *Mamucium*, 24 (1976), 28–34.

79 A. J. N. W. Prag, 'Archaeology at the Manchester Museum', *Mamucium*, 14 (1970), 18–20, p. 18.

80 *MMR* (1983–84); Prag, 'Greek vases'; Manchester Museum *Guide* (1978); Manchester Museum, *The Manchester Museum* (1985).

81 *MMR* (1976–77).

82 Prag was honorary lecturer in history before a similar appointment in archaeology from 1984. From the early 1980s, Prag also worked extensively with Richard Neave of the Medical Illustration Unit of the University on facial reconstruction, most famously of Philip II of Macedon. *MMR* (1985–86); J. H. Musgrave *et al.*, 'The Skull from Tomb II at Vergina: King Philip II of Macedon', *Journal of Hellenic Studies*, 104 (1984), 60–78; R. A. H. Neave and A. J. N. W. Prag, *Making Faces: Using Forensic and Archaeological Evidence* (London: British Museum, 1997).

83 From this year, Forde-Johnston was supported by an assistant keeper, a post filled first by Kathleen Hunt, then Shelagh Lewis, and later by George Bankes. *MMR* (2002–3).

84 G. H. A. Bankes, 'Ethnology', in *The Manchester Museum* (Derby: English Life, 1985), pp. 11–13; Bankes, 'The manufacture and circulation of paddle and anvil pottery on the north coast of Peru', *World Archaeology*, 17 (1985), 269–77; Bankes, 'Photographing paddle and anvil potters in Peru', *Journal of Museum Ethnography*, 1 (1989), 7–14.

85 G. H. A. Bankes, 'Introduction to the ethnology collections at the Manchester Museum', *Museum Ethnographers Group Newsletter*, 20 (1987), 76–83.

86 Wilson, *The British Museum*; cf. M. McAlister, '"The common heritage of mankind": race, nation, and masculinity in the King Tut exhibit', *Representations*, 54 (1996), 80–103.

87 Alberti, 'Molluscs, mummies and moon rock'; A. R. David (ed.), *The Manchester Museum Mummy Project* (Manchester: Manchester Museum, 1979).

88 *MMRs* (1972–77); MMCA, box CA6/1.

89 MMCA, box CA5, leaflet guide, 'O! Osiris, Live Forever', 1979; North West Sound Archive (hereafter NWSA) 1982.3619; 'Finalists for the 1980 Museum of the Year award', *Illustrated London News*, June (1980), 47–9.

90 Manchester Museum, *The Manchester Museum* (1985), p. 5; Bankes, 'The ethnology collection of the Manchester Museum, 1900–2000', in A. A. Shelton (ed.), *Collectors: Individuals and Institutions* (London: Horniman Museum, 2001), pp. 311–21. *MMRs* (1983–86); NWSA 1992.1014.

91 On the power of the metaphor of a 'federation' for a group of knowledge practices, see J. V. Pickstone, 'Working knowledges before and after *circa* 1800: practices and disciplines in the history of science, technology and medicine', *Isis*, 98 (2007), 489–516.

92 Cf. N. Levell, *Oriental Visions: Exhibitions, Travel and Collecting in the Victorian Age* (London: Horniman Museum, 2000); Smith, 'A Splendid Idiosyncrasy'.

Acquisition: collecting networks and the museum

The Manchester Museum was based on the collections of the Manchester Natural History Society. Very soon after the transfer to Owens College, however, this founding collection made up only a fraction of the specimens housed within the Museum. Elsewhere, the Sloane collection at the British Museum and General Pitt Rivers's material at the University of Oxford accounted for only a tiny proportion of the museums they seeded. This chapter explores how the rest of the collection came to be in the Manchester Museum. Thus far I have been concerned with the use of objects once they have arrived in the collection; I now turn to the routes they travelled to get there. It is already clear that the Museum was a node in an extensive web of institutions, and it is the principal aim of this chapter to unpack the character, extent and mechanisms of this network. Disciplines in the Museum were constructed by collectors, dealers, excavators and donors who channelled material culture from field sites, monuments and auction houses into the collection. How did their collecting practices change over the century and how were they impacted upon by political factors such as colonialism? And, crucially, how did the meaning of objects change during the various processes of acquisition?

To answer these questions, my analysis is arranged not by type of object, nor by chronology per se, but rather by mode of acquisition: gift, purchase, fieldwork, exchange and loan. Separating these routes, however, proves challenging. In the complex journey to the museum, an object was often subject to different kinds of exchange: gathered in the field, sold to a collector, donated to one museum and exchanged with another. In its passage through the exhibitionary complex, a specimen could attain the purported inalienability of a gift through donation *and* be 'commoditised' by purchase.[1] It brought to the Museum traces of those who dug/sold/donated it: objects collected people on the way.[2] The collection thereby includes not only things in their material form, but also the legacy of their acquisition route, and of the people involved.

There is a significant body of literature on the history of collecting that details specific motives and psychologies of individual collectors.[3] Historians of science have likewise produced sophisticated analyses of scientific collectors and collecting.[4] In this chapter I seek to extend these bodies of literature by addressing the

institution as collector.[5] As Simon Knell writes of philosophical society museums, 'While many participants were collectors or knew collectors, the size, nature and socio-political make-up of these corporate bodies provided opportunities for collecting in new ways and on a new scale.'[6] Given the extent of any single museum's collecting activities, rather than detail every acquisition, or embarking upon a prosopographical survey, I seeks trends and patterns, illuminated by key acquisitions, from geological and Egyptological founding gifts (many of them in fact loans) to the botanical and archaeological fieldwork of the late twentieth century. This is thereby a qualitative analysis of museum acquisition, complementing recent studies that have assessed the history of collecting in quantitative terms.[7]

Foundation and empire[8]

The Manchester Museum and other civic collections expanded in their early years thanks to gifts. Owens College depended on the generosity of Manchester's citizenry to stock its collection. As the free library campaigner Thomas Greenwood wrote at the time of the Manchester Museum's opening, 'Private munificence has done a great deal for [museums]. It is a species of charity which is more than twice blessed, it blesses him that gives, and the recipients continue years after the donor's death.' However, he was also concerned that museums would be 'left stranded high and dry on the beach' should 'no private generosity . . . come their way'.[9] With the Natural History Society collections safely transferred to Owens College, William Boyd Dawkins set out to ensure that the Manchester Museum would not be left high and dry. Following the pattern set down by associational museums in the nineteenth century, Dawkins appealed to the civic spirit and scientific devotion of the townsfolk of Manchester.[10]

Not surprisingly, Dawkins was particularly active in soliciting palaeontological donations, but he also accepted ornithology, butterflies and minerals. For museums are passive recipients as often as they are active collectors. As discussed in chapter 3, the Committee members actively discouraged donations of anthropogenic material, but in vain. Numismatists in particular were stubbornly generous, especially Reuben Spencer, director of the large local business Rylands and Sons, who gave British and foreign coins in 1894 (as well as funds to provide cases and later electric lighting for the whole Museum). Spencer's son Baldwin, who went on to a successful career in anthropology and directed the National Museum of Victoria in Melbourne, was a school friend of the Manchester Museum's first keeper, William Evans Hoyle.[11] Accordingly, Hoyle found Spencer senior's coins difficult to refuse, even if they did not fit into the Museum's remit. Such gifts afforded the Museum a certain gravity in the collecting network, and others were sure to follow, including, as we shall see, antiquities from the architect William Sharp Ogden.[12]

The role of the gravity of donation can best be illustrated, however, by the expansion of the herbarium, and botany provides a useful illustration of the general

growth of collections by donation. The plants inherited from the Natural History Society were rather paltry, and for some decades the herbarium was the Museum's 'Cinderella collection' (see chapter 2). In 1904, however, Cosmo Melvill, Chair of the Museum Committee, gave to the Museum his 225,000-sheet collection of extra-European plants, among the three largest in the country.[13] 'Mr. Melvill's generosity', reported Hoyle, 'has therefore placed the Manchester Museum in the forefront of provincial institutions in respect of its botanical collections.'[14] Melvill, who had been involved with the Museum for over a decade, was an amateur naturalist who from his undergraduate days began to amass large collections of molluscs, insects and plants, mostly at auction.[15] Later he sustained and expanded his collections through an extensive web of collectors.

Melvill's collection attracted two further gifts that would set the herbarium on an international footing, from Charles Bailey and Leopold Grindon.[16] Bailey's donation was designed to complement Melvill's – he gave European plants (more than three thousand boxes and parcels) to match his friend's exotic collection. Bailey transferred the plants in 1917, but retained formal ownership until his death in 1924. A successful East India businessman, Bailey had embarked upon his collection after attending classes delivered by William Crawford Williamson, and, like Melvill, accumulated a massive herbarium through an extensive exchange network and by purchase. The specimens that arrived in the Museum, therefore, had already changed hands several times before the arrived. They had layers of meanings – as data, commodities and gifts.

By contrast, Leopold Hartley Grindon lacked the wealth of Bailey or Melvill, and picked most of his collection himself. Beginning in his teens, Grindon gathered a herbarium of some forty thousand specimens, accompanied by illustrations, publications and even poetry – forsaking his job as a cashier to devote his time entirely to collecting, publishing and teaching about natural history. He had been donating small numbers of specimens to the Manchester Museum since the 1890s, and after his death in 1904, his widow agreed to deposit his collection in the Museum.[17]

By the time the herbarium was established by these three benefactions, other donations large and small were arriving thick and fast. For three decades from the mid-1890s, the Manchester Museum was at the quantitative peak of growth by donation, which reflected natural history museum acquisition in Europe and North America generally.[18] These gifts augmented the museum's collection, both quantitatively and in the heraldic sense – to 'raise in estimation or dignity' or 'make an honourable addition to'. Through economic boom and bust, through peace and war, items continued to arrive at the Museum.[19] Probably the greatest number of these specimens were of local origin; others arrived from elsewhere in Northern England, sent to Manchester rather than elsewhere because of the gravity of donation. Qualitatively, however, the most significant routes to the Museum were those that ran the length and breadth of the empire.

It is widely acknowledged that museums benefited from and were complicit in

the colonial enterprise.[20] It may not have been initiated by the nature and culture of empire, but the Manchester Museum was certainly consolidated by colonial material. It was no accident that the late nineteenth-century imperial extension was matched by a massive expansion in metropolitan and provincial museums in Britain. The foundation stones of the Manchester Museum were laid as Gladstone's government hurled the nation into the 'scramble for Africa'. Many historical studies accordingly focus on this early colonial activity, and much of the literature is concerned with the nineteenth century. And yet the geographical and administrative peak of the British Empire was in the early twentieth century, which was reflected in the quantity and provenances of objects in British collections. They served to reinforce the appeal of museums on many fronts: education, entertainment and civic pride in British cities as hubs of empire. Housing objects in museums in turn legitimated colonialism.

The colonial agents who were a common source of gifts to Manchester and elsewhere performed a range of roles for Her Majesty in the outer reaches of her empire, often gathering material for exchange and sale in addition to their formal tasks. Four overlapping roles were particularly significant in terms of museum acquisition: the seaman, the missionary, the ethnologist and the hunter. Curators and museum advocates had long urged sailors to bring back with them examples of the flora, fauna and culture of the imperial periphery.[21] In the late nineteenth century, one such individual was First Officer Frederick W. Townsend, chief of telegraph staff for Eastern Telegraph Company and later commander of the steamship *Patrick Stewart*.[22] Townsend, once of Manchester, was an avid student of shellfish, and used his position to collect extensively the molluscan life of the Persian Gulf, the Gulf of Oman and the Arabian Sea. At the encouragement his friend, Alexander Abercombie, with whom he shared an interest in collecting the molluscs of Bombay, Townsend sent items back to Manchester to that most persuasive of collectors, Cosmo Melvill.

Together with the curators, Melvill exploited not only the maritime but also the missionary aspect of the empire. They were sent shells, for example, from Lifu and Uvea by the Reverend and Mrs James and Emma Hadfield of Ashton-under-Lyne.[23] The Hadfields and other missionaries offered autochthonous communities not only the Good Book, but also the material trappings of Christian civilisation, and in return – or in any case – they took away with them local cultural and natural objects.[24] They sent to Manchester crates of 'shell sand' via other conchologists, where some remained in private hands (especially Melvill's) and some entered the Museum. The conchologists eagerly mined the crates, and in return dubbed the new species they found after the donors, such as *Pleurotoma (drillia) hadfieldi*.

Specimens from the far reaches of empire were subject to numerous exchanges before they came to the Museum. The arrival of Hadfield's collection was partly thanks to the intermediary efforts of the indefatigable Robert Dukinfield Darbishire, whose importance to the development of the Museum we have already seen. Over

several decades Darbishire orchestrated and personally donated shells, books, rocks and antiquities. But it is for the 700 anthropological items that his contribution is most evident in the Museum. Although their sources stretched beyond the British empire (especially to Peru and to the Arctic), Darbishire was nonetheless making use of colonial exchanges to gather his collection, emphasising the imperial and commercial might of Manchester in the throes of the second industrial revolution.

The form and growth of the ethnology collections in this period, like that of Egyptology and archaeology, depended more on donors and patrons than on keepers or Owens College staff. Perhaps even more significant in this respect than Darbishire was the Rochdale businessman Charles Heape, who donated nearly three thousand artefacts, mostly from Oceania and North America.[25] Cultural material of colonial origin such as Heape's was crucial to the arrangement of the early anthropogenic displays, still based on Dawkins's notion of an evolutionary hierarchy of races.

Europeans engaged in the business of empire exercised their power over the natural world as well as colonised peoples. Nowhere was this more evident than on the hunt. Hunting and collecting have always been metaphorically associated, and in the inter-war period they were literally and practically connected. Just as the explorer and game hunter Frederick Courtney Selous's trophies came to the British Museum (Natural History) after the First World War, so in the 1920s the Manchester Museum was in receipt of a range of large mammals – or rather their heads – from Africa and India.[26] What Selous was to South Kensington, the Egerton family was to Manchester. Maurice, Lord Egerton of Tatton, was a keen traveller and hunter, whose uncle gifted the Cholmondeley collection of shells to the Museum at its foundation. From the 1920s Egerton junior began to donate large game such as antelope to the Museum.[27]

Like other natural artefacts, these hunting trophies outlive their original contexts and present reinvention challenges to the successors of those who acquired them. But their provenances proved stubbornly difficult to exorcise. Whole body mounts might be redisplayed in a diorama, but heads or antlers on shields are more challenging (see figure 4.1). Already by the late 1930s, the hunting mounts were proving difficult to store, and they were transferred to the University Department of Zoology to adorn the walls of the laboratory. After the Second World War, as the stores overflowed (and the empire crumbled), the Museum offered game heads to local schools. The relationship between museums and imperial collectors shifted, as agents' priorities changed and large scientific projects such as colonial geological surveys were discontinued.

The economy of donation

As well as gifts from across the globe, some of the most prolific donors were much closer to home – including many Owens College academics and curators. From

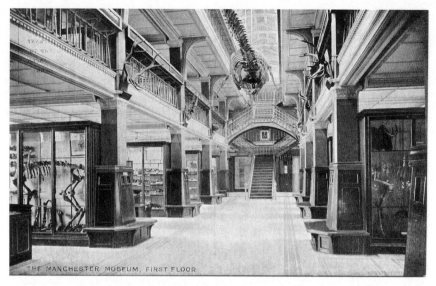

THE MANCHESTER MUSEUM, FIRST FLOOR

Figure 4.1 Postcard of the first floor gallery in 1911, with palaeontology on the left and zoology on the right. Game trophies can be seen on the pillars.

the outset, the keepers' own specimens formed an integral, if ambiguous, part of the collection. William Boyd Dawkins is especially important in this respect. He began to deposit rocks and fossils of all ages as soon as he arrived – in particular, his cave finds formed the basis of the prehistoric archaeology. While he was arranging the collection in the 1870s and 1880s there was little to distinguish the specimens he acquired for the collection and his own material, and upon his departure he 'gave' the University his own fossil collection.[28] He then continued to donate to the Museum, partly through loyalty to the collection, and partly no doubt because it was a convenient place to store the items, given that he had complete access to the collections. Many keepers continued to donate after retirement – or had even given objects before their appointments.

Not only did the Museum's own staff donate, but gifts also arrived from other parts of the University. Professor William Crawford Williamson, who had been the Natural History Society's first curator, gave his significant collection of fossil plants, and, as we have seen, discovered the huge *Stigmaria* fossil root that was built into the ground floor of the first building. Williamson's relationship with the Museum was turbulent, however, and towards the end of his life he contested the ownership of some of the fossils he gathered that were housed in the Museum. Over the century that followed, University members from lofty vice-chancellor to humble project students donated material to the Museum.[29] Although university personnel also deposited material in other kinds of museums, this acquisition route is – unsurprisingly – especially prevalent in higher education collections. Even when the Manchester

Museum was not the most research-active space in itself, it housed the results of work from elsewhere in the University.

Staff were important not only directly as donors, but also as donation brokers. As we have seen, T. B. L. Webster, Hulme Professor of Greek at the University, was instrumental in establishing the Classical archaeology collection in the inter-war period. He orchestrated gifts by persuading friends and associates (including members of the prominent Barlow family) to donate material in which he was interested – especially Greek vases. Likewise, Professor of Zoology and chair of the Museum Committee Herbert Graham Cannon not only transferred his eponymous aquarium, but also played a key role in securing Robert Wylie Lloyd's extensive Japanese ethnographic collections. Lloyd, an affluent manufacturer and printer based in London, was a consummate art collector (a director of Christie's), a keen mountaineer and entomologist.[30] Based in London, his generosity was prompted by Walter Hincks, the Keeper of Entomology. Hincks was skilled in securing dona-tions – the Museum Committee congratulated him on 'the efficient way in which he conducted the negotiations' – and he persuaded Lloyd not only to donate his own insect collection, cabinets and library, but also to pay for the significant acquisition of the Austrian lawyer Franz Spaeth's collection for the entomology department.[31] Hincks undertook the difficult mission of travelling to secure the collection in Soviet-occupied Vienna at a time when Austria's Cold War neutrality was especially tense. As he wrote to the Keeper, 'I underline the extreme delicacy of the transac-tion in respect to the Russian occupation of Vienna and their rigid censorship of all mail.'[32] It was Hincks who introduced Lloyd to Cannon, who in turn persuaded Lloyd to leave his Japanese art as well (a posthumous surprise).[33]

After Cannon and Lloyd, the third of the three major mid-century donations also comprised ethnological material. Ingo Simon, scion of a notable Manchester dynasty of engineers and politicians, was a keen and successful archer who held the world record for a flight shot for two decades. With leisure at his disposal, he devoted himself to toxophilic collecting. His gifts of bows and other material to the Museum in 1946 and 1950 were supplemented by his widow Erna, herself a keen archer, after his death in 1964.[34] Erna set up the Simon Archery Foundation in 1970 to oversee, fund and publish the collections, and provided a small honorarium for a part-time curator.[35]

The generosity of Cannon, Lloyd and Simon was most evident after their deaths (see figure 4.2). The Museum had benefited from such posthumous munificence from the outset, especially in bequests of coins. Having gifted in life, after Reuben Spencer's death his widow Martha donated the rest of his collection upon his death in 1901.[36] The Spencer bequest prompted William Smith Churchill and later William Sharp Ogden to follow suit.[37] This acquisition route was deemed so promising in the inter-war period that the Committee had bequest forms printed on the back of the Museum's *Annual Report*. And yet proceedings did not always run smoothly – Churchill's donation in particular was problematic. Having made a comfortable

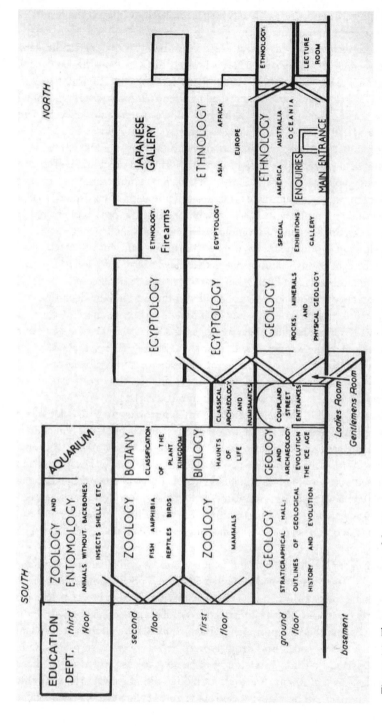

Figure 4.2 The arrangement of the Museum in 1970, showing the new special exhibitions gallery in the 1913 pavilion that had previously been devoted to economic geology. The results of major acquisitions in the post-war era can be seen in the aquarium (thanks to Herbert Graham Cannon) on the top floor of the southern building, the Japanese gallery (thanks to Robert Wylie Lloyd) on the top floor of the northernmost extension, adjacent to the firearms gallery (thanks to Ingo and Erna Simon).

enough living from the insurance business to amass a valuable collection of some thirty thousand continental coins, tokens and medals, Churchill transferred the bulk of his collection to the Museum in 1914. After his death two years later, however, there was some ambiguity over a codicil of the will regarding the status of the foreign coins that remained at his home. Fellow antiquarian William Sharp Ogden and the then Keeper Walter Tattersall were adamant that it had been Churchill's intention that *all* his coins come to the Museum; his family, knowing this cabinet was worth £700, disagreed.[38] Death duties were a considerable sum, which further complicated matters: if it could be proven that the coins had been a gift during Churchill's lifetime, then the Museum, as an institution 'for public or charitable purposes', would be exempt.[39] In a development redolent of *Bleak House*, the case sat in the Court of Chancery for a year. Ultimately, although Lord Eldon (presiding) was convinced that Churchill intended all his coins for the Museum, the codicil was sufficiently ambiguous to annul the will. 'I may add', wrote Ogden, who had been in attendance throughout, 'that the Law Courts here are not calculated to prolong life.'[40]

Nevertheless, Ogden was to live for another decade. The cost and ultimate futility of the 'Churchill affair' was a learning experience for the Museum Committee. When Ogden's health began to fail in the early 1920s, the Keeper George Carpenter was dispatched post-haste to ensure the collection Ogden had himself promised to the Museum was transferred with no further ado. Ogden also left the Museum a small amount of money in his will, but after finding that at the last Ogden had intended to change this in favour of relatives, the Council of the University, knowing the intransigence of donors' families, refused to accept it.[41]

That Churchill, Ogden and Spencer all sat on the Museum Committee for several years before they elected to donate their collections gives us a glimpse into the motivations of donors. Although some found sufficient the minor fame of a label mention or a line in the Museum's *Annual Reports* – acknowledging gifts was a major reason for publishing them – grand munificence especially was both encouraged and repaid with Committee seats.[42] This was also a common custom elsewhere: Baron Walter Rothschild, for example, was appointed a Trustee of the BM(NH) and subsequently bequeathed his massive collection.[43] Other rewards for donation included, as in Howarth's case, honorary degrees from the University. Particularly active donors enjoyed formal honorary appointments at the Museum, and such status often prompted further gifts and bequests. These well rewarded individuals were at the core of an acquisition network that translated patronage into material culture.[44]

Committee membership, honorary degrees and curatorships thereby rendered explicit the economy of donation. So too did named collections. Large gifts to museums, as Thomas Greenwood observed, 'will always have associated with them the name of the donor. Could a perpetuity of pleasure and instruction be secured by any better means?'[45] The King George III Collection of instruments in South Kensington, the Hunterian collections in London and Glasgow, or Marshall Field's eponymous museum in Chicago became 'donor memorials'.[46] So too in Manchester:

Walter Tattersall wrote shortly after William Smith Churchill's death, 'I am very glad indeed that his valuable collections have been deposited in this Museum, where they will serve as a memorial of the collector and take his place to a certain extent as a help and guide in matters relating to numismatics.'[47] The Judge presiding over Churchill's will similarly concluded that he gave 'his collection of foreign coins + medals to the University to perpetuate his name'.[48] Across the Museum, as we shall see, from the Simon archery collection to Henry Dresser's eggs, objects explicitly retained the identity of their donors.[49] In some cases, this fame extended beyond the Museum – an especially visible way of thanking donors was to name a species after them. *Pleurotoma (Drillia) hadfieldi* was mentioned earlier; Hincks acknowledged both Spaeth and Lloyd in dubbing a tortoise beetle *Spaethaspis lloydi*.

The relationship between the collector and the Museum thereby endured beyond the act of donation. As with any gift, donation to a museum constituted a reciprocal relationship between benefactor and recipient. As Mauss established, in gift exchange 'objects are never completely separated from the men who exchange them'.[50] This constituted what has recently been dubbed a 'vital contract' between amateur donors and the professional museum sector based on trust and data exchange.[51] Donors continued to communicate with Museum staff, and were afforded privileges such as the right to remove objects for study. A successful vital contract could endure for decades, prompting further donations and associating valuable expertise with the collection.

Museums tried not to be passive recipients in this system of exchange. Successfully or not, curators in Manchester and elsewhere sought to impose some strategy upon acquisition, to issue orders for particular items collected in particular ways, meeting their demands for standards in material and documentation quality.[52] From the outset, keepers had implicit or explicit lists of desiderata, gaps in the collection that they wished to fill. But collectors and donors would not be policed, especially in the early twentieth century. It was Charles Bailey and Cosmo Melvill who determined the strategy of botanical donation, carving up the world of plants between them. It was Webster who shaped the archaeology collection after Tattersall proposed plans for the scope of the Museum. Still other donations were the result of pure serendipity, especially local archaeology. Although the region's antiquities had been of increasing interest to provincial middle-class collectors in the late nineteenth century, the Manchester Museum did not include them in its original remit.[53] Nevertheless, chance finds arrived, such as a seventeenth-century pewter plate uncovered in the foundations of a house on Deansgate, and identifications for the public occasionally led to the donation of other noteworthy items.[54] Among the most significant local holdings were hoards of coins found at Knott Mill in Manchester and in the grounds of a school in Prestwich.[55] Chance finds like these increased in the 1970s with the spread of amateur metal detecting – but this quantity did not always translate into quality. As the numismatist Keith Sugden mused, 'just as the ordinary householder lives for the crock of gold in the back garden . . . so people in museums live for those days when something interesting will be brought in to show them that will actually add to scholarship'.[56]

Although there were considerable changes in the kind and volume of donation over the course of the twentieth century, similar motivations for donation remain evident. Collecting was a civilising activity, and subsequently to donate to a worthy museum ensured that it remained visible in perpetuity.[57] Relations between donors and museum, sometimes fraught, could be intimate and enduring. Surprisingly, as I will now explore, there is also evidence of strong bonds between museums and those who sold rather than gave to them.

Value for money?

Like other public collections, the bulk of the Manchester Museum's holdings were donated; but a small yet significant proportion of the collections were purchased. Different sorts of objects travelled along this acquisition route, and they were afforded different meanings. Unlike a gift exchange, when an object changes hands for money the relationship between vendor and recipient is usually considered concluded. Nevertheless, as we shall find, the associations with particular collectors often survived the commoditisation process that ostensibly erased them.[58]

Dawkins concentrated the Museum's earliest purchases once more on geology.[59] Thereafter, Hoyle's most visible purchase was that of a sperm whale skeleton for $300 (see chapter 5). This level of expenditure was not sustainable, however. For the Manchester Museum, as any other public institution, the greatest challenge to the curator seeking to expand the collection by purchase was the availability of funds. Although the Natural History Society had given Owens College a trust with the collections, what monies this generated were quickly swallowed up by general costs such as equipment purchase and conservation supplies. Hoyle set up a purchase budget early on, securing at first £150. But Council reduced even this small sum and what was left was hotly contested by the different assistant keepers and scientific supervisors.[60]

In light of this scarcity, University staff and keepers made good use of external grants. Such funds were difficult to win, however, and dependent on the remit of the awarding body. In order to generate monies that would be available at the Museum's own discretion, Hoyle appealed again to late Victorian philanthropy and set out to establish a subscription fund. As he impressed upon the townsfolk at the turn of the century, 'It is manifestly impossible for the College with its present resources to continue to support so serious a burden. If the Museum is to be maintained in a manner worthy of the City of Manchester, not only must the present rate of expenditure be continued, but a larger annual outlay will become necessary.'[61] Later, his tone became more urgent: 'A Museum behind the times is a useless and melancholy spectacle . . . It is for the public to decide whether the work shall be crippled or the funds provided.'[62] Individual subscribers began to commit an annual sum, and by July 1900, the Committee secured eighty subscriptions totalling £134 per annum, which was specifically dedicated to purchases. (Early subscribers included Winston Churchill, then a local MP.)[63] Although modest, this fund had other benefits – it rendered the

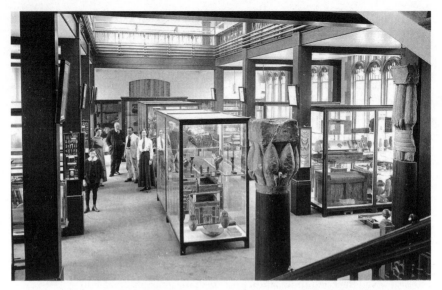

Figure 4.3 The Egyptology gallery under construction in the extension funded largely by Egyptophile Jesse Haworth, 1911.

Museum an organisation with voluntary members devoted to learning and thereby, according to the Literary and Scientific Institutions Act of 1854, exempt from rates.[64]

The subscribers, mostly local amateurs, constituted a 'friends' group that what would later become common in the UK heritage sector (although more often associated with art galleries), providing not only 'pecuniary help' but also 'valuable moral support'.[65] In return, they enjoyed privileged access to the collections, they were invited to dedicated social gatherings, they received all publications of the Museum (in which they were mentioned by name) and they had a formal hand in governance through two representatives on the Museum Committee. But after flowering in the early twentieth century the subscription fund dwindled. The character of civic pride, so lucrative in the nineteenth century, changed significantly after the First World War: cultural and educational institutions had to look elsewhere for revenue.

The Museum was more successful in attracting one-off sums. Museums were popular benefactors of philanthropy: to give money, and to enjoin other members of the elite to do so, was the mark of a cultured and estimable member of society.[66] The fame achieved by donating objects could also be gained by donating money for specific purchases. The Museum had Jesse Haworth to thank for its founding Egyptological collection, but his later pecuniary gifts of money were even larger, more than £50,000 in total (see figure 4.3). Others gave money alongside collections for their care or expansion.[67] In its early decades, a significant proportion of the Museum's income came from benefactions and financial bequests. But by the end of the century the Museum turned instead to corporate munificence to finance

large exhibitions and gallery re-displays, including Pilkington Glass, Book Club Associates and NatWest Bank.[68]

Other funds were donated for specific purchases. At the turn of the century, Hoyle managed to secure £1,000 in this way to purchase the bird skins collection of Henry Eeles Dresser, whose collection (and its mode of acquisition) is significant enough to warrant some attention here.[69] Originally from Yorkshire, Dresser travelled widely in connection with his family's timber firm in the 1850s and 1860s, and collected birds extensively from Northern Europe and North America. (He is also alleged to have trafficked arms for the confederate states.) Upon settling back in Britain, he published extensively and became closely involved in the British Ornithologists' Union.[70] In 1899 he announced his collection of skins for sale, which contained almost all species of European birds known at the time; Hoyle and an anonymous benefactor moved quickly and secured the skins for the Museum. Towards the end of his life, Dresser decided to sell his library and egg collection as well, and offered them to the Manchester Museum.[71] Although the Committee could not source sufficient funds immediately, Dresser nevertheless deposited the collection in Manchester.[72] A year later, as Mrs Dresser began to demand recompense, the Museum was forced to dip into the subscription account. This was not sufficient, however, and as a stop-gap measure Katharine Lucas Thomasson, widow of the MP for Bolton (and niece of John Bright), began to pay for the eggs in instalments. More drastic action was required in the end: rather than lose the collection, the Committee sold the copy of Audubon's *Birds of America* that the Museum had inherited from the Natural History Society to pay for the eggs.[73] This final resort would have been avoided had the appeal for funds been more successful, but by this time the Museum had exhausted its claim on the public purse. Sympathetic citizens had already signed up to the subscription account, and Hoyle had recently raised more than £500 in donations for Flinders Petrie's choice tomb group, the 'Two Brothers', one of whom was so famously unwrapped by Margaret Murray (see chapter 3).[74]

Like donations, purchases arrived at the Museum thanks to a web of patrons and collectors: a network in which a particularly significant part was played by dealers.[75] And yet they occupied an ambiguous place in the museum economy – in the nineteenth century, the boundary between museum and commercial spaces had not always been clear. Many dealers' businesses were showcases for natural knowledge, and by parity many collections were displayed with a view to sale.[76] In the twentieth century, the distinction was perhaps more explicit, but the role of the dealer was just as central to the traffic of museum pieces. In the sciences as in the arts, dealers and auction houses were regular sources of objects, channelling not only specimens but also books and associated documentation.[77] By the end of the century, although museums in the UK discouraged the trade in geological and archaeological collections, purchases of this kind were still made.

Different kinds of objects arrived via distinct, contingent purchase networks. The traffic in vertebrates, for example, involved not only dealers and auctions but

also taxidermists, menageries and zoological gardens. The latter were an especially reliable and plentiful source of exotic animals for provincial museums, connecting purportedly respectable educational institutions to the culture of the fairground, the circus and the show.[78] In particular, the Manchester Museum purchased deceased beasts from the nearby zoological gardens at Belle Vue, the most spectacular of which was Maharajah, the 'elephant who walked to Manchester'.[79] This iconic pachyderm spent his early years travelling the country as part of Wombwell's Royal Number One Menagerie, which was auctioned off in Edinburgh in 1872. Together with the services of his handler Lorenzo Lawrence, Maharajah was purchased by James Jennison, proprietor of Belle Vue, whose son and successor was later to sit on the Manchester Museum Committee. Upon being loaded onto a train to Manchester, however – possibly at Lawrence's instigation – the elephant objected strongly and kicked his way out of the horse box that had been customised for his transport. Beast and minder then set off on the long walk to Manchester, during which Lawrence made sizeable sums displaying his charge. Maharajah spent the rest of his living days giving rides to young Belle Vue visitors; upon his death from pneumonia, his remains were purchased by the Manchester Museum, where he took pride of place in the centre of the zoology gallery.

The acquisition route that brought the elephant to the Museum later worked in reverse, as the alligators that were fed so effectively in the Museum grew too large for their vivarium accommodation and were exchanged for smaller specimens from the zoo (see figure 4.4). After Belle Vue closed in 1977, the Museum was the only public display of live animals in the city. As one avenue of exotic fauna closed, however, another opened, thanks to the Endangered Species (Import and Export) Act of 1976. Although it prohibited the acquisition of some beasts for the vivarium, Manchester Museum zoologists were often called upon to identify creatures confiscated under its auspices, and were allowed to retain a choice few.[80]

Buying is often contrasted with giving in the principles of exchange – whereas a gift ostensibly constitutes an enduring relationship, a purchase is a one-off commodity transfer, leaving no trace beyond a receipt. And yet just as the examples discussed in the last section cast doubt on the inalienability of the gift, examining the Manchester Museum's purchases reveals the complex and enduring legacy of the provenance of bought specimens. Those who sold to the Museum were sometimes mentioned alongside those who gave and throughout the collection traces of sellers – which in a pure commodity exchange would have been obliterated – nevertheless remained with the specimens, as we see in the provenance of Maharajah or the Dresser birds.

The museum and the field

The Museum made most of its purchases in its first few decades, at which time only a small fraction of the new material in the Museum was the result of directed fieldwork. But this mode of acquisition, the third in the fivefold typology proposed here,

Figure 4.4 Vivarist Jim Whitworth and members of the Belle Vue Zoo staff transport a crocodile that had outgrown its quarters at the Museum, *c*.1970.

became much more significant later in the century. For curators were only able to purchase items that vendors wished to sell; and donation, as discussed above, left the selection up to the donor. In both gift and purchase, items were already circulating in the networks around which natural and artificial objects moved. If museums wanted specific items, they needed to go out into the field and get them.

The extent to which nineteenth-century natural history curators actively participated in field collecting varied.[81] Certainly William Boyd Dawkins was a prolific

fieldworker, replacing much of the Manchester Natural History Society material that was sold at auction with specimens he gathered himself. Refreshing collections in this way was a common endeavour in the decades around 1900, as large museums launched collecting expeditions on an unprecedented scale to satisfy the demands of a reinvigorated taxonomic enterprise that required more specimens and more data about their habitat.[82] This period also saw the beginning of a small but steady stream of archaeological material arriving at the Museum from the excavations of the museum staff, especially Wilfrid Jackson.[83] After the Second World War, the new generation of Manchester Museum keepers were even more active in the field. Post-war entomologists gathered enormous collections relating to their own research interests: during the 1950s the insect collection grew by 200,000 specimens.[84] The geologist Michael Eagar was an active collector for decades, building up the Museum's collection of fossil non-marine bivalves, and his colleagues in archaeology and ethnology were also prolific.[85] Theodore Burton-Brown, for example, undertook University-funded excavations in the Caucasus in the 1950s, and he continued to pass on material to the Museum (in exchange for grants towards publication) until the 1980s.[86] Significantly, Burton-Brown was also supported by the Hayter Fund, set up to encourage research in regions near the Iron Curtain.[87]

Post-war archaeological digs were increasingly rigorous and methodical. Just as William Boyd Dawkins's generation used Pitt Rivers's techniques, so mid-twentieth-century excavators employed methods advocated by the prominent archaeologist Sir Mortimer Wheeler. Furthermore, the increase in material direct from excavation relative to donations from collectors reflected a change in the standing and credibility of these activities. At the beginning of the century private collecting was prestigious and the armchair synthesiser had considerable intellectual clout; by the post-war period authority was to be gained through professional fieldwork, and private collecting was undertaken on a smaller scale. Museum objects were afforded status and meaning according to the relative hegemonic status of their acquisition route.

Fieldwork was not only undertaken by curators, but also by those indirectly funded by the Museum. Early in the century, for example, the Museum Committee funded Sheffield A. Neave, a naturalist with the British South Africa Company, which then controlled Rhodesia (Zambia/Zimbabwe), who sent 300 birds from the Luangwa River.[88] Funded fieldwork was particularly important for archaeology – the Museum and the University helped to fund an array of excavations over the century, including those of the Egypt Exploration Society and the British School of Archaeology in Egypt, those led by University archaeologists such as Alan Rowe and Charles Burney, and the digs of the doyenne of Palestinian Archaeology, Dame Kathleen Kenyon.[89] For a portion (often nominal) of the expenses of a dig, the Museum in return kept all or some of the finds – a mutually beneficial arrangement, as the field archaeologist gained the kudos of a respected repository. This was vital for oversees excavations – Near-Eastern countries would generally allow removal of up to half of excavated material, but only to a recognised museum.

Later in the century, the archaeological collection grew massively as a result of developments closer to home: the emergence of 'rescue' archaeology.[90] From the 1960s, with housing expansion, city centre development and the construction of the motorway network, archaeologists became increasingly alarmed at the potential for heritage destruction. First by persuasion and later by law, potential sites for development were excavated. The flood of new finds that resulted shifted the status of museums considerably. Any semblance of proactive collecting gave way to reactive archiving, as field archaeologists looked for places to deposit this flood of material. This was a mixed blessing for museum archaeologists, who did not always work in full coordination with their field-based colleagues. Not only that, but new recording techniques and attention to context increased dramatically the volume and complexity of excavation records. Archaeology collections were often swamped, and few finds were catalogued or published.

For the Manchester Museum, the most significant local material excavated in the 1970s came from excavations of the Roman fort in Castlefield directed by Barri Jones, an important figure in the emerging rescue movement, who worked at the University from 1964 until his death in 1999.[91] The digs were undertaken by the 'Greater Manchester Group' of volunteers, by University archaeologists and by staff paid by the Manpower Services Commission. Although not all of the 30,000 pieces of pottery came to the Museum and very few of those finds that did were 'worthy of display', they nevertheless included the renowned Manchester 'word square', taken to be evidence of very early Christianity in the British Isles.[92] Together with John Prag, Jones was also instrumental in the establishment of the Greater Manchester Archaeological Unit, one of a series of regional archaeology units set up by local government from 1973 as a way of coordinating rescue archaeology.[93]

Together with the activities of curators and other University fieldworkers, rescue archaeology generated a significant increase in the volume of material arriving at the Museum from the 'field'. Purchases and gifts, by contrast, proportionally diminished in this era. But whatever the quantity, all these objects were evidence of the passion and labour of the fieldworker.[94] Natural history collecting and archaeological excavations alike were (and are) combinations of study and leisure, and every specimen in a collection stands as a material reminder of this activity. From bivalve to potsherd, the dedication (or obsession) of the collector is embedded in the meanings of the objects, and they remain connected with those who found them, from Michael Eagar to Kathleen Kenyon.

Transfers and loans

The very basis of the Manchester Museum was not strictly a gift, purchase, or the result of fieldwork. Rather, the founding collection arrived via the fourth acquisition outlined in this chapter, that is, by transfer of material culture from one institution (the Manchester Natural History Society) to another (Owens College). The

historical mechanisms for this kind of movement are rarely addressed, and neither is the final mode of acquisition evident in the history of the Manchester Museum, the loan.

As Dawkins set out the Natural History Society collections in their new accommodation he secured further exchanges and transfers, such as plants sent from Kew Gardens. A steady flow of material arrived at the Manchester Museum as a result of small-scale 'swapping' with others public collections, punctuated by larger transfers as museums rationalised their material, or even closed down altogether. From the outset the Museum participated in the established system of natural history duplicate bartering. Overlaying the purchasing network was a well-oiled national and international exchange machine, especially in natural history as new ecological approaches stressed the need for well-recorded duplicates. London was very much an active centre in this respect, and the Manchester Museum's first duplicate exchanges were with the BM(NH), including 1,400 birds skins in 1895.[95] Among the early material that arrived from South Kensington were specimens from HMS *Challenger*, whose circumnavigation in the 1870s collectively took the British natural history establishment decades to record and publish.[96] Probably the greatest return in this respect was 2,289 butterflies from the collection of the politician and entomologist Thomas de Grey, Baron Walsingham, traded for just one of the Manchester Museum's pair of specimens of the extremely rare moth *Euclemensia woodiella*.[97]

Local institutions prompted the heaviest traffic, as specimens travelled to and fro from Stockport, Salford, and even closer, the medical museum in University; local schools also benefited from the Museum's duplicates.[98] Hoyle and his successors also participated in the thriving infra-provincial networks: after the Liverpool Museum suffered bomb damage during the Second World War, the Manchester Museum sent zoological material to help rebuild their collections.[99] Looking further afield, exchange routes stretched to Paris, Washington DC, Jerusalem, Calcutta and Tasmania.[100] Hoyle was particularly active in exchange with his aforementioned school friend, the anthropologist Baldwin Spencer at the National Museum of Victoria in Melbourne.[101] Museum publications, produced to be exchanged with other institutions, oiled these networks: the Manchester Museum *Notes* and *Annual Reports* travelled along the same paths as material culture, so that its activities were in principle at least known world-wide, and the Museum's own library was stocked with the catalogues of dozens of international museums regardless.[102] Print and material culture together constituted a system of obligation and patronage that locked institutions together.

Small exchanges of material culture maintained collections and filled in taxonomic gaps. At other times, large volumes were transferred as institutions effected major changes in the shape and scope of their collections. In Manchester and its environs, the lack of a dedicated city museum prompted a number of exchanges in this vein.[103] As Walter Tattersall expanded the Museum's classical archaeology in the 1920s he sent the local antiquities to Queen's Park Museum. His successor Roderick

Sayce, by contrast, was keen to include 'local ethnology' in the collections, and actively collected in the area. When David Owen then replaced Sayce the Museum's remit shifted yet again to exclude bygones. Owen effected the most significant transfer in the Museum's history when he oversaw the exchange of the Manchester Museum's local anthropology for Salford's exotica. 'This form of rationalisation of collections', he argued, 'allows both museums to concentrate their efforts and it cuts down the number of visits that scholars must make.'[104] Ironically, this returned to Manchester the Burmese Buddha that the Salford Museum has purchased when William Boyd Dawkins auctioned the material from the Natural History Society.[105]

A boost to the Manchester Museum and many other UK collections came from the dispersal of Sir Henry Wellcome's Historical Medical Museum. Wellcome, who had funded Wilfrid Jackson's fieldwork in Egypt, not only collected artefacts related to health and medicine, but he also voraciously (and uncritically) amassed archaeology and ethnology. These 'surplus' non-medical items were gradually sold and transferred, beginning shortly after Sir Henry's death in 1936 until a final dissemination in 1978–83 when the bulk of the medical collection was removed to the Science Museum. The Manchester Museum had already received a small number of items over the years, and in 1980, John Prag travelled to the Wellcome Institute in London to select choice artefacts including 16 terracottas and 500 ancient bronzes.[106]

At the end of the chronological scope of the present study, George Bankes and the director Alan Warhurst quietly undertook a small but important transfer.[107] While preparing for an exhibition in 1990 to mark the sesquicentenary of the treaty of Waitangi, Bankes and the Keeper of Design Andrew Millward approached Warhurst on the subject of the skeleton of a Maori chief that had been transferred from the zoology to the ethnology collection in 1988. With the backing of Warhurst and the Museum Committee, they offered to return the remains to New Zealand. Furthermore, while visiting the Museum, Maui Pomare, then Chair of the Trustees of the National Museum of New Zealand in Wellington (later Te Papa), also requested the return of two *toi moko* (tattooed heads). One of these had come from Salford Museum during the 1969 exchange, but after agreement with Salford, both were returned. All the remains were transferred to a consecrated store. Although it did not 'open the floodgates' as some in the ethnographic museum community feared, this repatriation marked a reversal of the imperial acquisition routes that brought so many of the Museum's collections to Britain.

The complex trajectory of the *toi moko* is a helpful reminder that museum objects do not follow a simple path from the outside world into the Museum. In particular, if one looks closely it transpires that many significant items in the collection did not technically belong to the Museum, but were loans. A discussion of their ambiguous status will conclude my typology of acquisition routes. And last is by no means least, for loaned objects included for years the Egyptian collection, so iconic and beloved by the Museum's visitors. Jesse Haworth, aware that the Museum Committee was not committed to archaeology as part of the collecting remit, was emphatic at first

that he was simply loaning the results of Petrie's excavations in Egypt (see chapter 3). This stalemate persisted for fifteen years, and the Egyptian material sat in an uneasy conceptual and logistic place in the collections, outside Dawkins's grand scheme (the latter's Egyptophilia notwithstanding). Finally, in 1905, Haworth conceded that

> He would be willing to give absolutely to the Museum at Owens College all his Egyptian antiquities subject to an undertaking being given that they shall be suitably and permanently exhibited, say in a room with good light, and of not less dimensions than the upper room on the second floor which faces Coupland Street and Oxford Road. . . . He would also require on the ticket describing the object, his name should appear as the contributor.[108]

Still the material was displayed in the inaccessible 'Flinders-Petrie Room', and the scientific supervisors on the Museum Committee remained loath to expand the Museum's scope to include archaeology and anthropology.[109] In the end, as we have seen, Haworth took matters into his own hands, pledging money for an extension to the Museum. Finally, the cultural collections had a permanent place in the Manchester Museum.

Many loans were even more problematic and ambiguous.[110] Some were removed from the Museum; others shifted from loan to gift simply through the weight of time or the death of the lender.[111] The shells and ethnological artefacts sent by missionaries James and Emma Hadfield were technically only lent; three decades after they arrived in the collection, they offered to sell them to the Museum (which the Committee claimed was beyond its pocket).[112] To prevent instances such as these, keepers preferred outright gifts; but some specimens were too enticing to refuse, such as the huge tiger initially only lent to the Museum by the local hunter Keith Quas-Cohen, 'one of the finest specimens most of us have ever seen', which he no longer had room to display in his new home.[113]

Over the years, however, thousands of small loans passed to and from the Museum without incident, for research or display.[114] Museum and galleries, collectors and dealers constituted an active and dynamic system along which channels objects of nature and culture travelled. The volume of sampling and study requests increased over the century as the collections grew, and more staff were on site to process these loans. Such quotidian practices, rarely featured in the history of museums, were quietly in process as the high-profile gifts, purchases and fieldwork spoils arrived and departed. A museum collection is a dynamic, organic conglomeration – which mutable character will be the subject of the next chapter.

Conclusion: the politics of acquisition

In common with other public institutions devoted to the preservation and display of culture and nature, the Manchester Museum acquired objects by gift, purchase,

fieldwork, exchange and loan. In exploring these different routes, this chapter has thrown light upon the networks that propelled specimens to the Museum, the politics of acquisition and the meanings of objects. In closing, I want to discuss these three issues in turn, with a particular eye on how they changed over the course of the twentieth century.

Objects travelled complex paths to arrive at the Museum, often changing hands several times in different modes of exchange. Lucas and Lucas consider such routes to be 'the supply chain from the wild/the field to the cabinet/herbarium/garden/zoo/ spirit store/gallery', with numerous middle-men between the initial and the ultimate collector, who add value and create new meanings with and around the specimens.[115] Their scheme is a useful classification of these diverse channels. Many of the plants, for example, were collected in the field, given to a collector, compiled in herbaria, sold at auction, then donated en masse to the Museum. Objects would commonly pass through the hands of a number of private collectors and dealers. Like General Pitt Rivers and Henry Wellcome elsewhere, in Manchester Cosmo Melvill and Robert Dukinfield Darbishire built up their own collections through a variety of methods and modes of exchange, then passed them on to an institution. Objects were propelled through this web of overlapping and intersecting channels not only by money, but also by patronage, trust and collaboration. There has been space here to tell only a sample of the stories that could be told: every museum object has the potential for a rich life history. And some objects' journeys did not end once they arrived in the collection, as the loans, transfers and deaccessions detailed above reveal.

Difficult as it is to make general claims about this complex network, it is clear that a small minority of items were collected by curators. Rather, most were first gathered by diverse individuals with varied reasons for being where they were, and different motivations for collecting. And for every famous named collector there were countless unthanked individuals.[116] Take for example the remains of the 'Two Brothers'.[117] Haworth donated them and paid for the building that surrounds them; but it was Petrie who excavated them. Or rather, Petrie was responsible for their excavation: the dig supervisor was Ernest MacKay, a young field archaeologist from Bristol who assisted in Petrie's British School of Archaeology in Egypt. MacKay had in turn been taken to the find by Erfai, an Egyptian casual worker on the dig. Even then, the chain does not end: Erfai had been alerted to the tomb by a local boy. This young man's name is now lost to history, while Petrie and Haworth are indelibly associated with the objects the boy found. A more equitable history of museums must address not only the published accounts of collections, but also the complex lives of objects and those all those who played a part.

Part of the reason for this iniquity is that even for those specimens gathered by collectors like Melvill who were careful to record their debts to other collectors and dealers – in catalogues or in the very names of the specimens – it is Melvill's name that lives on in the collection. (However, although Melvill may have obscured other botanists, even he was outshone by the renown of Sir James Edward Smith, founder

of the Linnean Society, whose duplicates he acquired.) As Hugh Torrens observes, even famous specimen hunters like Mary Anning were rarely afforded a mention in acquisition records: 'it was not the discoverer who got recorded but those who patronized the discoverer'.[118] At the beginning of the twentieth century, finders were rarely keepers, hunters remained anonymous, and it was the gatherers who achieved fame. Later, the subtle power differential between patron and curator shifted; large gifts were less frequent and more in keeping with the objectives of those who worked in the Museum. Benefactors by this time were more likely to be prominent members of the University rather than civic grandees – what Melvill was to the Museum in the 1890s, Cannon was in the 1940s. Early donation to the Manchester Museum was similar to that of civic collections, whereas later in the century acquisition routes were more reflexive of its university status.

The relationship between curator and patron brings into relief the importance of both amateurs and professionals in museum acquisition throughout the twentieth century. Initial collectors might be gathering for passion (as Townsend) or for profit (as Erfai), their booty then passed on to wealthy amateurs like Melvill or Haworth. Museum specimens acted as cultural capital that lubricated patronage networks that shaped the parameters of collections, especially evident in the introduction of cultural material in the Manchester Museum. And even as the influence of the wealthy amateur on the Committee waned, other collectors were enrolled – especially those in clubs and societies, or involved in conservation movements. As professional communities cemented their hegemonic grip on the practice of science generally, museum donation was one way that amateurs could continue to participate in the natural science enterprise. Museum staff were often closely involved with learned societies in the region, as we shall find in the next chapter. From ethnology to entomology, amateurs in the field and professionals associated with the Museum were engaged in a system of mutual enrolment.[119] Donors and fieldworkers needed the authority of the Museum to validate their practice, and the museum practitioners needed the specimens to build their collections. Curators by necessity became expert at securing and managing these complex exchanges, but they were dependent on amateur associates. They implored sailors and collier men alike to gather specimens for museums as they went about their professional business.

Chapters 2 and 3 have already demonstrated the extent to which acquisition generally and donation in particular shaped the disciplinary landscape of the Museum. That the collection spanned nature and culture reflected how closely the paths along which natural and artificial objects travelled were entwined. In the Museum's early decades, most donations were a combination of natural and artificial, print and material culture.[120] Two of the three most significant post-war donors, Robert Wylie Lloyd and Herbert Graham Cannon, both gave material that spanned the remit of the collections. Collectors did not respect the disciplinary boundaries that museums and other institutions sought to erect in the twentieth century, and the cultural economy of donation encompassed both nature and culture.

The routes by which natural and cultural objects arrived at the Museum reflected not only the character of twentieth-century museums (and scholarship), but also the wider social context. The paths of objects reveal much about the politics, local and international. Wars shifted, blocked or enabled particular channels. Here I explored, as other museum historians have, the significance of empire on collecting and vice versa. But what of the flow of material after the decline of empire? Certainly the reduction in export of antiquities from Egypt and the Near East affected the flow of material to European museums. But other objects continued to move between Britain and its former colonies, and a wider study of such relations as enacted in material culture is wanting. So too the impact of the Cold War, which loomed over museums as it did over all aspects of life in this period, awaits analysis. In rare cases the Soviet threat facilitated acquisition, such as the availability of funding for Theodore Burton-Brown's fieldwork in Azerbaijan. But otherwise, as in Walter Hincks's efforts to extract the Spaeth collection from occupied Vienna, the Iron Curtain hindered the movement of material. The moon rock displayed in the Museum only weeks after the Apollo 11 mission, attracting the largest number of visitors in any year to that date, was powerful evidence of the Cold War funding of the space race.

As they travelled along acquisition routes, imperial or otherwise, museum objects enabled scientific and other collaborations. In doing so, they were not stable entities over time and space. Their meanings (and physical integrity) shifted as they changed hands, and as different actors impacted upon their trajectories. The first significant shift was in the moment of collecting, when the pre-museum life of the object abruptly ended. Natural objects became material culture; artificial objects were removed from their use. But this was not the last change in meaning. As Donald Preziosi writes of works of art, 'The act of collecting and exhibiting artefacts, of passing them across an exhibitionary threshold, is much more than an act of removal from some prior place, context, or condition. The object is not simply transported but *transformed*.'[121] Objects not only carried meaning with them, but in their incorporation into the collection, they brought meaning into being.[122]

Notes

1 On gifts and commodities, see A. Appadurai (ed.), *The Social Life of Things: Commodities in Cultural Perspective* (Cambridge: Cambridge University Press, 1986); on scientific collecting networks, see for example H. Torrens, 'Mary Anning (1799–1847) of Lyme; "the greatest fossilist the world ever knew"', *British Journal for the History of Science*, 28 (1995), 257–84. On the exhibitionary complex, see T. Bennett, *The Birth of the Museum: History, Theory, Politics* (London and New York: Routledge, 1995).

2 C. Gosden and C. Knowles, *Collecting Colonialism: Material Culture and Colonial Change* (Oxford: Berg, 2001); Gosden and F. Larson, *Knowing Things: Exploring the Collections at the Pitt Rivers Museum 1884–1945* (Oxford: Oxford University Press,

2007); Gosden and Y. Marshall, 'The cultural biography of objects', *World Archaeology*, 31 (1999), 169–78; J. Hoskins, *Biographical Objects: How Things tell the Stories of People's Lives* (New York: Routledge, 1998); F. R. Myers (ed.), *The Empire of Things: Regimes of Value and Material Culture* (Oxford: Currey, 2001).

3 J. Elsner and R. Cardinal (eds), *The Cultures of Collecting* (London: Reaktion, 1994); S. Macdonald, 'Collecting practices', in Macdonald (ed.), *A Companion to Museum Studies* (Oxford: Blackwell, 2006), pp. 81–97; W. Muensterberger, *Collecting: An Unruly Passion: Psychological Perspectives* (Princeton: Princeton University Press, 1994); S. M. Pearce, *On Collecting: An Investigation into Collecting in the European Tradition* (London: Routledge, 1995); A. A. Shelton (ed.), *Collectors: Expressions of Self and Other* (London: Horniman Museum, 2001).

4 I have assessed this literature elsewhere: see S. J. M. M. Alberti, 'Constructing nature behind glass', *Museum and Society*, 6 (2008), 73–97.

5 A. A. Shelton (ed.), *Collectors: Individuals and Institutions* (London: Horniman Museum, 2001).

6 S. J. Knell, *The Culture of English Geology, 1815–1851: A Science Revealed through its Collecting* (Aldershot: Ashgate, 2000), p. 115.

7 Gosden and Larson, *Knowing Things*; F. Larson, 'Anthropology as comparative anatomy? Reflecting on the study of material culture during the late 1800s and the late 1900s', *Journal of Material Culture*, 12 (2007), 89–112; Larson, 'Anthropological landscaping: General Pitt Rivers, the Ashmolean, the University Museum and the shaping of an Oxford discipline', *Journal of the History of Collections*, 20 (2008), 85–100; Larson *et al.*, 'Social networks and the creation of the Pitt Rivers Museum', *Journal of Material Culture*, 12 (2007), 211–39; C. Loughney, 'Colonialism and the Development of the English Provincial Museum, 1823–1914' (PhD dissertation, University of Newcastle, 2005); A. Petch, 'Counting and calculating: some reflections on using statistics to examine the history and shape of collections at the Pitt Rivers Museum', *Journal of Museum Ethnography*, 18 (2006), 149–56. While useful and revealing, as its advocates acknowledge, a quantitative history of acquisition is subject to the vagaries of recording and documentation practices between and within collections, and it affords equal weight to massive, expensive and iconic things as it does to the tiny, cheap and mundane.

8 I have borrowed this subtitle from I. Asimov, *Foundation and Empire* (New York: Doubleday, 1952).

9 T. Greenwood, *Museums and Art Galleries* (London: Simpkin, 1888), p. 153.

10 S. J. M. M. Alberti, 'Placing nature: natural history collections and their owners in nineteenth-century provincial England', *British Journal for the History of Science*, 35 (2002), 291–311; Knell, *The Culture of English Geology*.

11 D. J. Mulvaney and J. H. Calaby, *'So Much that is New': Baldwin Spencer, 1860–1929; A Biography* (Melbourne: University of Melbourne, 1985).

12 On the gravitational pull of museums, see R. W. Burkhardt, 'The leopard in the garden: life in close quarters at the Muséum d'Histoire Naturelle', *Isis*, 98 (2007), 675–94.

13 Manchester Museum Central Archive (hereafter MMCA), Manchester Museum Committee Minutes (hereafter MMCM) vol. 2 (19 October 1903); MMCA *Manchester Museum Report* (hereafter *MMR*) (1903–4); J. C. Melvill, *A Brief Account of the General*

Herbarium Formed by James Cosmo Melvill, 1867–1904: And Presented by him to the Museum in 1904 (Manchester: Sherratt & Hughes, 1904).

14 *MMR* (1903–4), p. 4.

15 E.g. MMCM vol. 1 (28 October 1892); *MMR* (1899–1900). On Melvill as a collector, see J. M. Chalmers-Hunt (ed.), *Natural History Auctions 1700–1972: A Register of Sales in the British Isles* (London: Sotheby Parke Bernet, 1976); S. P. Dance, *A History of Shell Collecting* (London: Faber, 2nd edn, 1986); A. Trew, *James Cosmo Melvill's New Molluscan Names* (Cardiff: National Museum of Wales, 1987).

16 MMCM vol. 2 (13 January 1908); vol. 3 (13 March 1911), (22 March 1909), (20 November 1916); vol. 4 (24 March 1924); *MMR* (1916–17); C. Bailey, 'On the contents of a herbarium of British and foreign plants for presentation to the Victoria University, Manchester', *Manchester Memoirs*, 61:5 (1917), 1–13; W. A. Charlton and E. G. Cutter, *135 Years of Botany at Manchester* (Manchester: University of Manchester, 1998); F. E. Weiss, 'James Cosmo Melvill (1845–1929)', *North Western Naturalist*, 5 (1930), 150–6; Weiss, *Three Manchester Botanists: Leopold Hartley Grindon, Charles Bailey, James Cosmo Melvill* (Manchester: Manchester University Press, 1930).

17 The collection was eventually accessioned in 1911. Manchester Museum Herbarium, Accession Register KK, 1906–2006, L. H. Grindon, 'History and description of my herbarium', 1885–86, p. 39; MMCM vol. 1 (4 April 1892); vol. 3 (21 January 1911); *MMR* (1910–11); S. J. M. M. Alberti, 'Leopold Grindon', in B. Lightman (ed.), *Dictionary of Nineteenth-Century British Scientists*, 4 vols, vol. 2 (Bristol: Thoemmes, 2004), pp. 852–3; R. H. Kargon, *Science in Victorian Manchester: Enterprise and Expertise* (Manchester: Manchester University Press, 1977); D. Q. King, 'A checklist of sources of the botanical illustrations in the Leo Grindon Herbarium, The Manchester Museum', *Archives of Natural History*, 34 (2007), 129–39.

18 Gosden and Larson, *Knowing Things*; R. E. Kohler, *All Creatures: Naturalists, Collectors, and Biodiversity, 1850–1950* (Princeton: Princeton University Press, 2006).

19 For the endurance of acquisition and other museum activities during the First World War see e.g. MMCM vol. 3 (10 December 1915); G. Kavanagh, *Museums and the First World War: A Social History* (Leicester: Leicester University Press, 1994) and chapter 6 below.

20 T. Barringer and T. Flynn (eds), *Colonialism and the Object: Empire, Material Culture, and the Museum* (London: Routledge, 1998); B. J. Black, *On Exhibit: Victorians and Their Museums* (Charlottesville: University Press of Virginia, 2000); A. E. Coombes, *Reinventing Africa: Museums, Material Culture and Popular Imagination in Late Victorian and Edwardian England* (New Haven: Yale University Press, 1994); C. Gosden, *Anthropology and Archaeology: A Changing Relationship* (London: Routledge, 1999); Gosden and C. Knowles, *Collecting Colonialism*; Gosden and Larson, *Knowing Things*; T. Griffiths, *Hunters and Collectors: The Antiquarian Imagination in Australia* (Cambridge: Cambridge University Press, 1996); S. Hall (ed.), *Representation: Cultural Representations and Signifying Practices* (London: Sage, 1997); S. Sheets-Pyenson, *Cathedrals of Science: The Development of Colonial Natural History Museums during the Late Nineteenth Century* (Kingston, Ontario: McGill-Queen's University Press, 1988); Shelton (ed.), *Collectors: Expressions of Self and Other*; Shelton (ed.), *Collectors: Individuals and Institutions*.

21 Greenwood, *Museums and Art Galleries*; Loughney, 'Colonialism and the Development of the English Provincial Museum'; J. Owen, 'Collecting artefacts, acquiring empire: a maritime endeavour', *Journal of Museum Ethnography*, 18 (2006), 141–8.

22 S. J. M. M. Alberti, 'Molluscs, mummies and moon rock: the Manchester Museum and Manchester Science', *Manchester Region History Review*, 18 (2007), 108–32.

23 MMCM vol. 1 (24 March 1893); J. C. Melvill and R. Standen, *Catalogue of the Hadfield Collection of Shells from Lifu and Uvea, Loyalty Islands*, 2 vols (Manchester: Cornish, 1895–97); Trew, *James Cosmo Melvill*.

24 A. Henare, *Museums, Anthropology and Imperial Exchange* (Cambridge: Cambridge University Press, 2005); N. Levell, 'The translation of objects: R. and M. Davidson and the Friends' Foreign Mission Association, China, 1890–1894', in Shelton (ed.), *Collectors: Individuals and Institutions*, pp. 129–61; Loughney, 'Colonialism and the Development of the English Provincial Museum'; N. Thomas, *Entangled Objects: Exchange, Material Culture, and Colonialism in the Pacific* (Cambridge, Mass: Harvard University Press, 1991).

25 MMCM vol. 4 (25 June 1923); *MMR* (1922–23); 'Mr. Charles Heape. Fine gift to Manchester University. Collection of which illustrates the development of man', *Rochdale Observer* (2 June 1923), p. 5; J. Edge-Partington and C. Heape, *An Album of the Weapons, Tools, Ornaments, Articles of Dress, etc., of the Natives of the Pacific Islands*, 3 vols (Manchester: privately printed, 1890–98); C. Heape and R. Heape, *Records of the Family of Heape, Staley, Saddleworth and Rochdale, from circa 1170 to 1905* (Rochdale: privately printed, 1905).

26 *MMR* (1922–23); J. M. MacKenzie, *The Empire of Nature: Hunting, Conservation, and British Imperialism* (Manchester: Manchester University Press, 1988); J. A. Mangan and C. C. McKenzie, *'Blooding' the Martial Male, Militarism, Hunting, Imperialism* (London: Routledge, 2009); R. I. Pocock and N. Etherington, 'Selous, Frederick Courteney (1851–1917)', in *Oxford Dictionary of National Biography* (Oxford: Oxford University Press, 2004), www.oxforddnb.com/view/article/35017, accessed 14 Dec 2007; W. T. Stearn, *The Natural History Museum at South Kensington: A History of the British Museum (Natural History) 1753–1980* (London: Heinemann, 1981).

27 *MMR s* (1924–40), (1957–58). Manchester Museum Zoology Archive ZAC/1/40.

28 MMCM vol. 1 (5 December 1889); J. W. Jackson, 'Sir William Boyd Dawkins (1837–1929): a biographical sketch', in M. J. Bishop (ed.), *The Cave Hunters: Biographical Sketches of the Lives of Sir William Boyd Dawkins and Dr. J. Wilfrid Jackson* (Buxton: Derbyshire Museum Service, 1982), pp. 5–17.

29 For example, specimens came from Sir Henry Miers, who before his appointment as Vice-Chancellor of the University of Manchester (and chair of the Museum Committee) had worked as a mineralogist at the BM(NH). See H. T. Tizard, 'Miers, Sir Henry Alexander (1858–1942)', in *Oxford Dictionary of National Biography* (Oxford: Oxford University Press, 2004), www.oxforddnb.com/view/article/35017, accessed 14 Dec 2007.

30 A. M. Cain, 'Lloyd, Robert Wylie (1868–1958)', *in Oxford Dictionary of National Biography* (Oxford: Oxford University Press, 2004), www.oxforddnb.com/view/article/62497, accessed 19 April 2005; J. Forde-Johnston and J. Whitworth, *A Picture Book of Japanese Art* (Manchester: Manchester Museum, 1965); K. Sloan, *J. M. W.*

Turner: Watercolours from the R. W. Lloyd Bequest to the British Museum (London: British Museum, 1998).

31 MMCM vol. 5 (20 March 1950), 380; *MMR* (1957–58); W. D. Hincks, 'Dr. Franz Spaeth and the Cassidinae', *Coleopterists' Bulletin*, 5 (1951), 55–7; C. L. Staines, 'Franz Spaeth: publications and proposed taxa', *Zootaxa*, 1035 (2005), 1–49.

32 MMCA box GB5, W. D. Hincks – R. U. Sayce 16 February 1950, p. 1.

33 MMCM vol. 6 (2 June 1958); *MMR* (1958–59).

34 MMCM vol. 5 (11 March 1946); vol. 7 (18 January 1965), vol. 7 (10 May 1965), vol. 7 (11 October 1965); *MMRs* (1945–49), (1965–66).

35 From shortly after the Second World War, the bows had been displayed in the top corridor of the 1913 building that connected the upper galleries in the two extensions. The Foundation also funded a dedicated store and study room opened in the basement of the Coupland building in 1973 (refurbished in 1988), which cemented archery's autonomy. MMCA Simon Archery Foundation Trustee Meeting Minutes, 1983–2004; MMCM vol. 8 (16 March 1970), (21 May 1973); *MMRs* (1970–74); G. H. Carpenter, *Guide to the Manchester Museum*, ed. R. U. Sayce (Manchester: Manchester University Press, revised edn, 1948); W. Hodkinson, Interview with the author, *Re-Collecting at the Manchester Museum*, disc S5, 2006, MMCA.

36 MMCM volume 1 (22 June 1894), 254. *MMRs* (1890–98); K. F. Sugden, 'The Department of Numismatics at the Manchester Museum', *Compte rendu*, 32 (1986), 41–4; F. C. Thompson, 'The coin collections in the Manchester Museum', *Spink and Son's Numismatic Circular*, 73 (1965), 1–2.

37 'William Smith Churchill', *Transactions of the Lancashire and Cheshire Antiquarian Society*, 32 (1914), 306–7; On Ogden, see Manchester Museum Archaeology Archive William Sharp Ogden File, typescript, G. H. Carpenter, 'Memorandum on the Sharp Ogden Collection', 1924, and 'The W. Sharp Ogden collection of pottery', 1936; *MMR* (1927–28); 'Obituary. Mr. W. S. Ogden', *Manchester City News* (1 May 1926), p. 12g; 'Wills and bequests: Mr. William Sharp Ogden', *The Times* (13 September 1926), p. 15c; M. Girouard, *Town and Country* (New Haven: Yale University Press, 1992); H. Pagan, 'The British Numismatic Society: a history', *British Numismatic Journal*, 73 (2003), 1–43; J. M. Turfa, 'The Etruscan and Italic collection in the Manchester Museum', *Papers of the British School of Archaeology at Rome*, 50 (1982), 166–95.

38 MMCA box GB5, W. M. Tattersall correspondence, 1914–16; MMCM vol. 3 (29 February 1916).

39 MMCA box GB5, Barker, Ayre & Milne (solicitors) – W. M. Tattersall, 26 November 1914.

40 MMCA box GB5, W. S. Ogden – H. Plummer, 11 December 1916.

41 MMCM volume 4 (18 October 1926).

42 MMCM vol. 1 (2 February 1894).

43 M. Rothschild, *Walter Rothschild: The Man, the Museum and the Menagerie* (London: Natural History Museum, 2nd edn, 2008); Stearn, *The Natural History Museum*; cf. Knell, *The Culture of English Geology*.

44 Knell, *The Culture of English Geology*; H. McGhie, 'Contextual research and the postcolonial museum: the example of Henry Dresser', *Annalen des Naturhistorischen Museums Wien* (forthcoming); Shelton (ed.), *Collectors: Individuals and Institutions*.

45 Greenwood, *Museums and Art Galleries*, p. 154.

46 S. J. M. M. Alberti, 'Objects and the museum', *Isis*, 96 (2005), 559–71; Alberti, 'Owning and collecting natural objects in nineteenth-century Britain', in M. Berretta (ed.), *From Private to Public: Natural Collections and Museums* (New York: Science History Publications, 2005), pp. 141–54; C. Duncan, *Civilizing Rituals: Inside Public Art Museums* (London: Routledge, 1995); L. Keppie, *William Hunter and the Hunterian Museum in Glasgow, 1807–2007* (Edinburgh: Edinburgh University Press, 2007); S. G. Kohlstedt and P. Brinkman, 'Framing nature: the formative years of natural history museum development in the United States', in A. E. Leviton and M. L. Aldrich (eds), *Museums and Other Institutions of Natural History, Past, Present, and Future* (San Francisco: California Academy of Sciences, 2004), pp. 7–33; A. Q. Morton and J. A. Wess, *Public and Private Science: The King George III Collection* (Oxford: Oxford University Press, 1993).

47 MMCA box GB5, W. M. Tattersall – M. Churchill, 27 November 1914.

48 MMCA box GB5, W. S. Ogden – H. Plummer, 11 December 1916.

49 T. Fish, *The 'Behrens' Collection of Sumerian Tablets in the Manchester Museum* (Manchester: Manchester University Press, 1926); McGhie, 'Contextual research and the postcolonial museum'.

50 M. Mauss, The *Gift* (New York: Norton, new edn, 1976), p. 31.

51 R. Ellis *et al.*, *Nature: Who Knows?* (Lancaster: English Nature, Lancaster University and the Natural History Museum, 2005).

52 *MMR* (1937–38); S. J. M. M. Alberti, 'Culture and nature: the place of anthropology in the Manchester Museum', *Journal of Museum Ethnography*, 19 (2006), 7–21; Greenwood, *Museums and Art Galleries*; Knell, *The Culture of English Geology*; Kohler, *All Creatures*; Loughney, 'Colonialism and the Development of the English Provincial Museum'.

53 Y. S. S. Chung, 'John Britton (1771–1857) – a source for the exploration of the foundations of county archaeological society museums', *Journal of the History of Collections*, 15 (2003), 113–25; S. M. Pearce, *Archaeological Curatorship* (London: Leicester University Press, 1990); B. Sitch, 'Thomas Sheppard, the Morfitts of Atwick and Allen coin number 223', *Yorkshire Archaeological Journal*, 65 (1993), 11–19. E.g. North West Sound Archive (hereafter NWSA) 1999.3640.

54 W. E. A. Axon, 'On a pewter plate, with figures of Christ and the twelve apostles, in the Manchester Museum', *Transactions of the Lancashire and Cheshire Antiquarian Society*, 25 (1907), 79–80; cf. J. W. Jackson, *Contributions to the Archaeology of the Manchester Region* (Manchester: Manchester Museum, 1936).

55 *MMRs* (1962–63), (1973–74).

56 NWSA 1999.3361.

57 Duncan, *Civilizing Rituals*; on the culture of philanthropy more generally, see F. Ostrower, *Why the Wealthy Give: The Culture of Elite Philanthropy* (Princeton: Princeton University Press, 1995).

58 Knell, *The Culture of English Geology*; I. Kopytoff, 'The cultural biography of things: commoditization as process', in Appadurai (ed.), *The Social Life of Things*, pp. 64–91.

59 MMCM vol. 1 (13 May 1889); vol. 2 (15 May 1907); R. M. C. Eagar and R. Preece, 'Collections and collectors of note 14: the Manchester Museum', *Newsletter of the Geological Curators Group*, 2:11 (1977), 12–40.

60 MMCM vol. 1 (5 December 1889); vol. 1 (9 March 1894).

61 Manchester Museum, *General Statement of the Work of the Museum* (Manchester: Manchester Museum, 1900), p. 1; MMCA box GB2, Manchester Museum Subscribers' Minute Book, 1900–30; MMCM vol. 2 (20 July 1900).

62 *MMR* (1904–5), p. 4.

63 Churchill College Churchill Archive Centre CHAR 1/49/48, CHAR 1/62/48–49.

64 MMCA box DO1, H. W. Freston – A. Hopkinson, 6 November 1917.

65 Manchester Museum, *General Statement*, p. 1.

66 Ostrower, *Why the Wealthy Give*.

67 On the fiscal bequests of Thomas Barker and Randal Mundy, see MMCM vol. 5 (14 June 1937); *MMRs* (1907–8), (1943–44); Charlton and Cutter, *135 Years of Botany*.

68 E.g. *MMR* (1982–83).

69 MMCM vol. 2 (10 May 1899); McGhie, 'Contextual research and the postcolonial museum'.

70 See e.g. H. E. Dresser, *Eggs of the Birds of Europe, Including all the Species Inhabiting the Western Palæarctic Area*, 2 vols (London: Royal Society for the Protection of Birds, 1905–10); Dresser and R. B. Sharpe, *A History of the Birds of Europe, Including all the Species Inhabiting the Western Palaearctic Region*, 9 vols (London: published by the author, 1871–96).

71 MMCM vol. 3 (26 May 1911).

72 MMCM vol. 3 (23 October 1911).

73 Asking £500, the Committee secured only £310 from its sale. MMCM vol. 3 (13 February 1912), (24 June 1912); J. J. Audubon, *The Birds of America: From Original Drawings*, 4 vols (London: privately published, 1827–38).

74 Alberti, 'Molluscs, mummies and moon rock'; M. A. Murray (ed.), *The Tomb of Two Brothers* (Manchester: Sherratt & Hughes, 1910). This was not technically a purchase: rather, Petrie offered Hoyle the tomb group, as well as first claim on next season's work, if only £500 might be secured to fund the continuing excavations of the British School.

75 E.g. C. H. W. Johns, 'Some Babylonian tablets in the Manchester Museum', *Journal of the Manchester Egyptian and Oriental Society*, 3 (1913–14), 67–72.

76 On dealers, see M. V. Barrow, 'The specimen dealer: entrepreneurial natural history in America's gilded age', *Journal of the History of Biology*, 33 (2000), 493–534; M. Cooper, *Robbing the Sparry Garniture: A 200 Year History of British Mineral Dealers* (Tucson, Ariz.: Mineralogical Record, 2006); McGhie, 'Contextual research and the postcolonial museum'.

77 Chalmers-Hunt (ed.), *Natural History Auctions*; C. D. Sherborn, *Where is the --- Collection?* (Cambridge: Cambridge University Press, 1940).

78 E. Baratay and E. Hardouin-Fugier, *Zoo: A History of Zoological Gardens in the West*, trans. O. Welsh (London: Reaktion, 2002); R. J. Hoage and W. A. Deiss (eds), *New Worlds, New Animals: From Menagerie to Zoological Park in the Nineteenth Century* (Baltimore: Johns Hopkins University Press, 1996).

79 MMCM vol. 2 (15 January 1906), vol. 5 (22 March 1948), vol. 6 (16 June 1952), (26 October 1964); D. Barnaby, *The Elephant who Walked to Manchester* (Plymouth: Basset, 1988); J. L. Middlemiss, *A Zoo on Wheels: Bostock and Wombwell's Menagerie*

(Burton-on-Trent: Dalebrook, 1987); R. Nicholls, *The Belle Vue Story* (Manchester: Richardson, 1992).

80 *MMRs* (1979–81).

81 Knell, *The Culture of English Geology*; cf. Kohler, *All Creatures*.

82 E.g. *MMR* (1905–6).

83 M. J. Bishop, 'Dr. J. Wilfrid Jackson (1880–1978): a biographical sketch', in Bishop (ed.), *The Cave Hunters*, pp. 25–48; e.g. J. W. Jackson, 'Preliminary report on the exploration of "Dog Holes" Cave, Warton Crag, near Carnforth, Lancashire', *Transactions of the Lancashire and Cheshire Antiquarian Society*, 27 (1909), 1–32; Jackson, 'The prehistoric archaeology of Lancashire and Cheshire', *Transactions of the Lancashire and Cheshire Antiquarian Society*, 50 (1934–35), 65–106.

84 *MMRs* (1947–48), (1954–55), (1963–64).

85 *MMR* (1967–68); Eagar and Preece, 'Collections and collectors'; G. H. A. Bankes, 'The manufacture and circulation of paddle and anvil pottery on the north coast of Peru', *World Archaeology*, 17 (1985), 269–77; Bankes, 'Photographing paddle and anvil potters in Peru', *Journal of Museum Ethnography*, 1 (1989), 7–14; J. Forde-Johnston, 'The excavation of a round barrow at Gallowslough Hill, Delamere Forest, Cheshire', *Transactions of the Lancashire and Cheshire Antiquarian Society*, 70 (1960), 74–83; F. Willett and T. Seddon, 'Excavations in Everage Clough, Burnley, 1951', *Transactions of the Lancashire and Cheshire Antiquarian Society*, 63 (1952–53), 194–200.

86 *MMR* (1980–1); T. Burton-Brown, *Excavation at Kara Tepe 1957* (Wootton, Oxfordshire: the author, 1979); Burton-Brown, *Barlekin* (Wootton, Oxfordshire: the author, 1981).

87 W. G. Hayter, 'The Hayter Report and after', *Oxford Review of Education*, 1 (1975), 169–72; J. Ure, 'Sir William Goodenough Hayter', in *Oxford Dictionary of National Biography* (Oxford: Oxford University Press, 2004), www.oxforddnb.com/view/article/62497, accessed 21 January 2008.

88 MMCM vol. 2 (14 February 1905), (15 October 1906), (12 November 1906); *MMRs* (1903–6); McGhie, 'Contextual research and the postcolonial museum'.

89 MMCM vol. 4 (20 June 1921). That Kenyon's finds came to the Museum was thanks to the involvement of Kay Prag in the British School of Archaeology in Jerusalem (for which she acted as honorary secretary 1972–82). From 1987, the Museum also took finds from Kay Prag's own work at Iktanu and Hammam, Jordan.

90 G. W. Dimbleby (ed.), *The Scientific Treatment of Material from Rescue Excavations: A Report by a Working Party of the Committee for Rescue Archaeology of the Ancient Monuments Board for England* (London: Department of the Environment, 1978); *Dust to Dust? Field Archaeology and Museums* (n.p.: Society of Museum Archaeologists, 1986); S. Frere, *Principles of Publication in Field Archaeology* (London: Department of the Environment, 1975); B. Jones, *Past Imperfect: The Story of Rescue Archaeology* (London: Heinemann, 1984); N. Merriman and H. Swain, 'Archaeological archives: serving the public interest?' *European Journal of Archaeology*, 2 (1999), 249–67; I. Narkiss, 'Pass the Parcel: Archaeological Archives, Creators, Keepers and Beyond' (MA dissertation, Nottingham Trent University, 2003); *Planning and Policy Guidance 16: Archaeology and Planning* (London: HMSO, 1990).

91 *MMR* (1971–72); A. Birley, 'Barri Jones', *Guardian* (23 July 1999), p. 22; B. Jones and P. Reynolds, *Roman Manchester: The Deansgate Excavations 1978* (Manchester: Greater Manchester Council, 1978); B. Pullan and M. Abendstern, *A History of the University of Manchester*, 2 vols (Manchester: Manchester University Press, 2000–4).

92 Manchester Museum, *The Manchester Museum* (Derby: English Life, 1985), p. 2; R. Goodburn *et al.*, 'Roman Britain in 1978', *Britannia*, 10 (1979), 267–356; M. E. Raybould, *A Study of Inscribed Material from Roman Britain: An Inquiry into Some Aspects of Literacy in Romano British Society* (Oxford: Archaeopress, 1999).

93 *MMRs* (1979–86); NWSA 1982.8854; P. Holdsworth, 'The Greater Manchester Archaeological Unit', *Mamucium*, 28 (1981), 3–4; A. J. N. W. Prag, 'Archaeology alive at the Manchester Museum', *Museums Journal*, 83 (1983), 79; Prag, Interview with the author, *Re-Collecting at the Manchester Museum* disc S19, 2006, MMCA.

94 Kohler, *All Creatures*; Ellis *et al.*, *Nature: Who Knows?*

95 MMCA box GB3, Ledger of specimens 1890–1903; MMCM vol. 1 (20 January 1893); vol. 4 (5 October 1925); McGhie, 'Contextual research and the postcolonial museum'.

96 MMCM vol. 2 (7 July 1899); *MMR* (1976–77); R. Corfield, *The Silent Landscape: In the Wake of HMS Challenger 1872–1876* (London: Murray, 2003).

97 Manchester Museum Entomology Archive, Walsingham Collection correspondence 1899–1918; *MMR* (1927–28); K. G. V. Smith, 'Grey, Thomas de, sixth Baron Walsingham (1843–1919)', in *Oxford Dictionary of National Biography* (Oxford: Oxford University Press, 2004), www.oxforddnb.com/view/article/35017, accessed 17 January 2008; Stearn, *The Natural History Museum*.

98 MMCA Ethnology loans documents box; MMCM vol. 1 (12 July 1895); vol. 3 (11 October 1909), (15 October 1911); *MMRs* (1897–98), (1915–16), (1983–84).

99 MMCM vol. 5 (4 December 1950).

100 MMCA box GB3, Ledger of specimens 1890–1903; box OMR5, Manchester Museum directors' correspondence 1906–33; MMCM vol. 4 (26 January 1925).

101 Mulvaney and Calaby, *'So Much that is New'*.

102 *MMRs* (1895–96), (1904–5); W. E. Hoyle, *A Catalogue of the Books and Pamphlets in the Library Arranged according to Subjects and Authors* (Manchester: Cornish, 1895).

103 MMCM vol. 4 (10 January 1921). Successive curators tried to lobby for a separate Museum of Manchester; see *MMR* (1985–86); J. W. Jackson, 'Genesis and progress of the Lancashire and Cheshire Antiquarian Society', *Transactions of the Lancashire and Cheshire Antiquarian Society*, 49 (1933), 104–12; A. J. N. W. Prag, 'The Mediterranean in Manchester', *Minerva*, 5:3 (1994), 40–3.

104 *MMR* (1968–69), p. 1; MMCM vol. 8 (15 March 1971); MMCA Ethnology loans documents box, 'Material sent *to* Salford' file.

105 'Sale of curiosities', *Manchester Guardian* (9 October 1868), p. 3.

106 *MMR* (1980–81); R. M. de Peyer and A. W. Johnston, 'Greek antiquities from the Wellcome Collection: a distribution list', *Journal of Hellenic Studies*, 106 (1986), 286–94; A. J. N. W. Prag, 'The Wellcome Collection and the Manchester Museum', *Mamucium*, 28 (1981), 4–6; G. Russell, 'The Wellcome Historical Medical Museum's dispersal of non-medical material, 1936–1986', *Museums Journal*, 86: supplement (1986), 3–15, appendices B and C.

107 My thanks to George Bankes for this information. See also G. H. A. Bankes, *Aotearoa: The Maori Collections at the Manchester Museum* (Manchester: Manchester Museum, 1990); C. McCarthy, *Exhibiting Maori: A History of Colonial Cultures of Display* (Oxford: Berg, 2007).

108 MMCM vol. 2 (16 January 1905), p. 326; *MMR* (1904–5); W. H. Crompton, 'Jesse Haworth: first president of the Manchester Egyptian Association', *Journal of the Manchester Egyptian and Oriental Society*, 9 (1921), 49–52; Manchester Museum, *An Account of the Extension of the Museum* (Manchester: University of Manchester, 1912).

109 MMCM vol. 3 (15 December 1908).

110 On the complexities of Max Robinow's loan, for example, see MMCM vol. 3 (15 May 1912); vol. 5 (7 October 1935); vol. 6 (12 January 1959); W. R. Dawson and E. P. Uphill, *Who Was Who in Egyptology*, ed. M. L. Bierbrier (London: Egypt Exploration Society, 3rd edn, 1995).

111 E.g. *MMRs* (1900–1), (1937–38), (1963–64).

112 MMCM vol. 4 (22 March 1926).

113 MMCM vol. 8 (9 February 1976), 143; my thanks to Roy Garner for this information.

114 E.g. MMCA box A4, Keeper's correspondence 1924–35.

115 A. Lucas and P. Lucas, '"Collectors" and "collections": resolving the ambiguities', unpublished conference paper delivered at 'Nature behind Glass', University of Manchester, 2007, by kind permission of the authors.

116 Gosden and Larson, *Knowing Things*; Shelton (ed.), *Collectors: Individuals and Institutions*.

117 Alberti, 'Molluscs, mummies and moon rock'; Dawson and Uphill, *Who Was Who*.

118 Torrens, 'Mary Anning', pp. 280–1.

119 S. J. M. M. Alberti, 'Amateurs and professionals in one county: biology and natural history in late Victorian Yorkshire', *Journal of the History of Biology*, 34 (2001), 115–47; Griffiths, *Hunters and Collectors*; Knell, *The Culture of English Geology*.

120 E.g. MMCM vol. 1 (24 March 1893); *MMRs* (1890–99), (1903–4), (1911–12); Melvill and Standen, *Catalogue of the Hadfield Collection*; L. Tythacott, 'Trade, travel and trophy: a biography of the Ridyard collection at Liverpool Museum: 1895–1916', in A. A. Shelton (ed.), *Collectors: Expressions of Self and Other* (London: Horniman Museum, 2001), pp. 157–79.

121 D. Preziosi, 'Art history and museology: rendering the visible legible', in Macdonald (ed.), *Companion to Museum Studies*, pp. 50–63, p. 50, original emphasis.

122 S. Moser, *Wondrous Curiosities: Ancient Egypt at the British Museum* (Chicago: University of Chicago Press, 2006).

5

Practice: technique and the lives of objects in the collection

The history of museums is rich in biographies of collectors, in accounts of the content of collections, and in analyses of the architecture of the buildings that housed them. Within art history and visual studies, the historiography of display is increasingly sophisticated. Sociological approaches are informing a budding history of visitors and visiting. But at the intersection of these fruitful approaches there is a lacuna, in the 'black box' of the collection: after they arrive in the museum, and before they are seen by the public (if at all), what happened to objects behind the scenes at the museum? Contrary to analyses of collecting that consider an object's career terminated once it arrived in the museum, objects did not stagnate, and this chapter charts the fate of specimens and artefacts within the collection.

Museum objects were subject to physical processes to render them stable, a series of textual practices to order them, a range of spatial techniques to store them, and a variety of exhibitionary strategies to make them intelligible. All these methods were intended to extract knowledge from objects. This is not to deny the many other ways visitors engaged with collections (see chapter 6 below), but in university museums in particular, whether as research tools or as instruments of public education, objects were deployed in the production and consumption of knowledge. Intellectualist histories of museums tend to focus on high-profile research projects. For the Manchester Museum, these have been studied elsewhere; here, instead, I explore other object-knowledge practices.[1]

By 'practice', I mean an everyday individual or group activity, rather than a macroscopic socio-cultural enterprise. For disciplines operated not only as networks of concepts and beliefs, but also as contingent sets of empirical and textual techniques, many of which fall outside what is usually termed 'research'.[2] Historians and sociologists of science who exercise the concept of practice in this way have applied it to experimental and field science.[3] As Robert Kohler writes, historians of science 'have produced a voluminous literature on the conceptual and philosophical aspects of species without paying much attention to taxonomists' actual practices. This is unfortunate, since intellectual changes cannot be understood without reference to collecting and sorting practices.'[4] By studying what happened to objects

in collections, this chapter contributes to a constructivist history of science, embedding the study of scientific practice in material culture.[5]

This chapter addresses what naturalists, archaeologists, curators and technicians actually did on a day-to-day basis, and how they learned to do it. Studying museums in practice encourages us to look beyond exhibitions and texts to instruments, to specimens, to techniques. We find that the classificatory schema advocated by museum authorities were subject to compromises and pragmatic adaptations in practice. While unpacking the black box of the collection, we meet the 'invisible technicians' who kept museums afloat: curators' assistants, conservators, volunteers and cleaners.[6] Almost by definition, many of their practices were crafts or implicit skills that were reproduced by the transfer of tacit knowledge and never recorded. The historian must look beyond the scant written traces to the outcomes of these practices: among them ledgers, taxidermic mounts and cupboards.[7] Museum products reveal much about museum processes.

Here I will use these traces and products to track the pathway of objects within the collection in order to understand museum practices in their historical context. Objects were first prepared, then conserved; their details recorded in registers and card indexes; they were stored or else displayed and labelled. What tools and techniques were used during these processes? Where were they undertaken, and by whom? To answer these questions, I have selected examples of practices – generally from the Museum's early years – and grouped them into three sections below, devoted (loosely) to physical, textual and spatial techniques. In each section, I then trace shifts in staffing, training and spaces for these practices over the century, concentrating in particular on the emergence of professional communities in the 1970s. From conservators to designers, specialised groups clustered around particular museum practices. By juxtaposing them we gain insights into the development of the UK museum sector more generally and the importance of practices to the shaping of disciplines. Most of all, we appreciate the dynamism of museum objects, as observed by Chris Gosden and Chantal Knowles:

> [Objects] are always in a state of becoming, and this is true not just when produced and used in their original context, but once collected and housed in the museum. The physical circumstances of the object change continuously, but so also do its sets of significances as it accumulates a history. It is possible, when records are made, to reconstruct this history, which carries with it the lives of those involved with the object. An object is best viewed as indicative of a process, rather than static relations, and this process is ongoing in the museum as elsewhere, so that there is a series of continuous social relations surrounding the object connecting 'field' and 'museum'.[8]

Preparing and conserving

Very few objects would survive long-term retention in the state in which they were found, killed or unearthed. Early in its life in the collection, an artefact or specimen

was subject to a series of processes intended to render it stable. However futile, the ultimate aim was to enable it to survive indefinitely.[9] Not only did museum staff spend a significant amount of time preparing specimens as they arrived at the Museum, there was also the continuous cleaning and conserving – ongoing and labour-intensive activities. Several million specimens attracting mould and insects pests, and generally responding to the entropic urge to deteriorate, kept the Museum staff on their toes.

The technical challenges of preservation began even before the specimen arrived in the museum. First, it had to survive the journey, often arduous, from point of collecting to arrival. Transport arrangements varied, but many relied on the post. Insects and plants arrived in envelopes; conchological specimens in crates of 'shell sand' (see chapter 4 above), that needed to be painstakingly sifted.[10] The vagaries of the customs process was a frequent challenge for the Museum, such as the crate in 1929 that was held at port for the duty on the preservative spirits.[11] Other specimens were considered too valuable for such routine avenues. One precious insect collection was flown by British Empire Airways from Vienna to Northolt.[12]

Most objects arrived safely at the Museum, there to be subject to a complex set of processes to stabilise and secure them, that is, 'conservation' – the umbrella term that according to the Manchester Museum's Keeper of Conservation encompassed 'both the preservation and enhancement of information embodied in the chemical, physical and biological make-up of the object'.[13] We have already seen how different intellectual approaches clustered around particular kinds of object; so too preparation and conservation methods were highly variable. Some techniques were idiosyncratic to particular staff or institutions, others differed between nations. In the 1890s, fiery debates raged between British and continental entomologists over the appropriate method of pinning Lepidoptera – with flexible European pins or stout, reliable English pins?[14] Part of the challenge of pinning, as with many other techniques, was standardisation. In the herbarium, for example, a great deal depended on the dimensions of the specimen sheets. Donors selected their own sizes to suit their needs, which, to the frustration of curators, did not always match. Of the three major botanical donors first encountered in chapter 2, Charles Bailey based his sheets on those of the British Museum (Natural History), but Cosmo Melvill and Leopold Grindon did not.[15] The gravity in standardising museum techniques exerted by major institutions was significant, but not absolute.

To further illustrate the craft-based contingency of museum practice, I want to turn to the location and personnel of three particular practices developed to care for collections in the Museum's early years: articulation, spirit preservation and cleaning. The taxidermist took the remains of a dead creature and sought to render it as life-like as possible.[16] Given the cost and specialist nature of this skill, some animals were mounted even before they arrived, for example by Rowland Ward's renowned taxidermy company in London – the BM(NH)'s firm of choice.[17] For those specimens that arrived unmounted in Manchester, the Museum at first contracted Harry

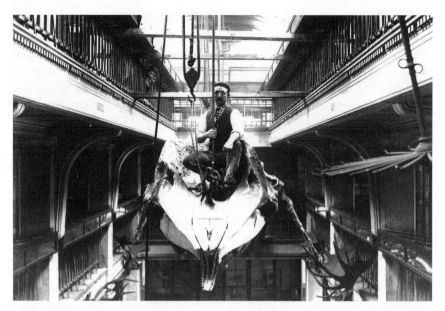

Figure 5.1 An unidentified man (probably the taxidermist Harry Brazenor) riding the newly-installed sperm whale, 1898.

Brazenor, a taxidermist in nearby Stockport. It was Brazenor who articulated the largest single specimen in the Museum (see figure 5.1). In February 1896, a sperm whale had beached on the coast of Massachusetts.[18] The fisherman who found the dying beast secured its remains for Henry Ward's Natural Science Establishment in Rochester, New York, a powerful centre for the study and trade of natural history that specialised in supplying museums.[19] The Manchester Museum's keeper, William Evans Hoyle, visited the Establishment while touring North America the following year and, much taken with the skeleton, purchased it for $300. The bones were shipped to Manchester in three cases via the newly opened ship canal. It took Brazenor three weeks, and finally the whale was suspended from the ceiling of the mammal gallery, where it became an iconic specimen, emblematic of the Museum as a whole.

For those vertebrates that arrived untreated, maceration was required – the flesh wasted away to leave only the skeleton. In the Museum's early years, the assistant keeper J. Ray Hardy macerated specimens in a room on the quadrangle, favouring traditional liquid vat techniques.[20] This stood in contrast to 'dry' maceration, used in Dublin and at the BM(NH), in which specimens were buried; later methods used bacteria or insects to eat away the flesh.[21] Other skills demanded of Hardy were equally unpleasant – applying boric acid to bird skins, for example.[22] Reptiles, fish and invertebrates tended to be preserved as 'wet' specimens: a technique developed in the seventeenth century in which organic material was preserved in 'spirit of

wine'.[23] This method presented its own peculiar challenges. Wet specimens retained many of the features that mounts did not; but they did suffer some shrinkage and considerable loss of colour.[24] And although the common habit of museum staff purloining the alcohol did not seem to trouble the Manchester Museum, it was nevertheless dangerous and expensive.[25]

Across the collection, from vertebrates to potsherds, objects were picked clean, pieced back together and fixed. But after the labour of preparation, this work was then concealed, 'ironed out'.[26] Perhaps the least visible museum skill – but most fundamental of all – was cleaning. That most mundane of activities, cleaning is not surprisingly almost entirely overlooked in the history of museums. And yet the question of appropriate methods vexed museum professionals of all eras. Cleaning ranged from the careful preparation undertaken by keepers – such as buffing a fossil with a dental engine – to the 'humbler sphere of the charwoman, the pail, the duster, and the broom'.[27] Dust was a particular bugbear of the urban museum. But dust in the case was the problem of the curator or conservator; dust on the floor was not. Rather, the latter was the responsibility of three charwomen the Museum employed. The interface between these two realms was an important boundary, the outer parameter of the museum profession, and those who overstepped the mark in either direction were subject to censure.[28]

On the spectrum of status (and remuneration) of museum workers from char-woman to director, the care of the collections tended to fall to those on the subaltern end of the scale. 'The constant attention which large collections require to protect them from moth and rust and other troubles', proclaimed the Manchester Museum's *Report* in the middle of the twentieth century, 'normally involves a considerable amount of unspectacular work.'[29] This was often unpleasant circumstances: tech-niques such as maceration were nasty, smelly tasks.[30] The environment itself was often challenging – the herbarium in particular was an extremely cold place to work. (In the winter of 1978–79, the east corridor was so cold that the specimens themselves began to disintegrate).[31]

For the rest of this section, we shift our attention from these unspectacular prac-tices to the practitioners who undertook them. In the Museum's early years, assist-ant keepers such as Hardy cared for the collections. But as the staff expanded, more porters (or 'attendants') became involved in peripheral conservation duties. One junior porter-attendant appointed shortly after the First World War, Harry Spencer, became so closely involved with conservation work that from 1931 he worked exclusively with the expanding archaeology collections, a post that became the blueprint for department-specific 'technicians' (see figure 5.2). Like school-leavers appointed to work in other scientific laboratories, Spencer learned on the job, ini-tially acquiring tacit skills from colleagues, as an apprentice would.[32] Later, along with other museum staff, he attended formal courses in care and restoration.[33]

The availability of such training signalled the emergence of conservation as a dis-tinct set of professional skills. 'Conservation is, in fact, a preventative and curative

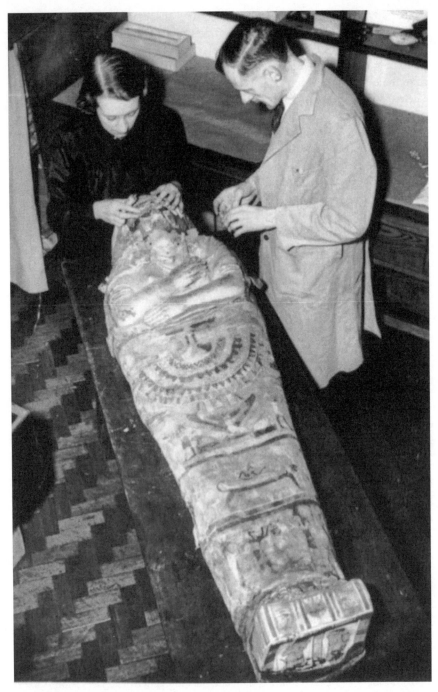

Figure 5.2 Archaeologist Mary Shaw and technician Harry Spencer at work, *c.*1937.

science', argued Frank Markham in his 1938 report on museums in Britain, 'and it requires a thorough training and proficiency in it.'[34] Whereas previously many of the skills of the conservator remained tacit, techniques began to be published in the *Museums Journal* and elsewhere, and new methods were imported, first from Germany and later from the United States. As befitted an emerging professional community, the staff who learnt these skills set out to wrench conservation away, in Markham's words, from 'elderly honorary curators . . . or paid caretakers' who were 'entirely ignorant . . . of the many new methods that have been tried out and proved successful.'[35]

Newly professionalised skills required dedicated spaces. Two members of Manchester Museum staff trained at the British Museum's conservation laboratory (established in 1919), and eventually, after the Second World War, the director Roderick Sayce set aside space for a 'laboratory' for the humanities collections with tanks and work benches.[36] The laboratory reflected the new prestige afforded to technicians, as they enjoyed more training opportunities and stronger unionisation in the aftermath of a war effort that relied heavily on technical skills.[37] The new facilities enabled the Manchester Museum technicians to undertake more thorough preventative conservation and, for example, to give electrolytic treatment to various metal items in the collections. The Museum became a regional centre of expertise as staff advised other institutions on conservation processes. After the staff expansion of 1950, assistant keepers and technicians began a systematic restoration and stock-take of the reserve collections, especially in zoology, where annual inspections of all specimens for insect attack and fluid evaporation took place; interventive collection care took precedence over changes in public display.[38] Technical staff salaries improved after national-level public sector agreements, attracting more qualified personnel to the emerging profession.[39] The new Area Museum Councils took advantage of them, promoting conservation skills and planning centralised laboratories.

By the time Harry Spencer retired in 1970 after half a century, most Manchester Museum departments had their own technician – like the BM (NH), individual departments were responsible for their own collection care. They undertook the bulk of the conservation work, as well as joinery, and assisted the curatorial staff. Keepers, nevertheless, continued to undertake particular specialist practices: the entomologist Harry Britten, for example, was expert in mounting the tiniest of insects.[40] In the decade that followed, however, this disaggregated approach would be replaced by a centralised department, as conservation's status as an autonomous profession was consolidated.

When the archaeologist John Prag arrived at the Museum in 1969 he found 'every department had its technician', but that by this time 'people realised this was not actually a terribly good use of skills.'[41] The factors driving this change of heart were both external and internal. During the 1970s in the UK there emerged professional sub-communities in museum design and education. The rise of 'rescue'

excavation prompted an influx of archaeological material. New professional bodies in conservation pressed for more conservation posts to cope with the backlog of untreated material, a sentiment echoed by both the Wright Report on museums and the Dimbleby report on archaeology.[42] They met with some success – the Manchester Museum would be one of around half of UK museums and galleries by the 1980s with in-house dedicated conservators.[43] By this time, conservation techniques had proliferated to the extent that autonomous sub-disciplines in art restoration, archaeology and zoology were clearly evident (if only in woefully small numbers compared with the number of museum requiring their services).[44]

It was the lack of archaeological conservation that precipitated change in the Manchester Museum. Horrified at the state of the collection, John Prag lobbied vigorously for greater conservation resources and facilities, backed by Barri Jones, Professor of Archaeology at the University, and Keith Priestman, Keeper of Conservation at the City of Liverpool Museums.[45] Furthermore, Prag was keenly aware of national developments; the Pitt Rivers Museum, for example, established a new conservation laboratory in 1972. Convinced, the Museum Committee established a dedicated Department of Conservation, under a new keeper of conservation, Frank Goodyear. The post was formally of equivalent rank to the other keepers, marking the independence and professional status of collection care. Goodyear, a firm advocate of professional training for conservators, had himself trained as a chemist and authored a volume on archaeological conservation.[46]

Goodyear worked with a small team assembled to provide centralised conservation services for the Museum as a whole. The director David Owen secured a new technician post specifically for conservation, first filled by Muriel Whittaker. From within the Museum, Don Ashton was recruited from archaeology and Roy Garner from zoology; Bill Hutchinson transferred from the exhibitions department when Whittaker departed. They set up a new conservation laboratory in the basement of the old physics building next door to the Museum, funded partly by the North Western Museum and Art Gallery Service on the condition that the Manchester Museum resume its role as a centre for advice and support for other collections. The laboratory, while not overly sophisticated, centralised conservation for the whole museum rather than just the humanities collections, especially with the appointment of Garner, who had previously worked in medical laboratories (see figure 5.3).[47]

In 1978 Goodyear retired, to be succeeded by Velson Horie, who like Goodyear had studied chemistry and archaeological conservation before his appointment. With the technicians he undertook conservation research and expanded the department's focus from physical manipulation to environmental conservation, controlling light and humidity levels.[48] As the economic climate changed, however, so did the nature of conservation appointments. In 1980, Julie Vint was appointed to a fixed-term archaeological conservation post funded first by the Department of the Environment and later by the new body, English Heritage. Meanwhile, the

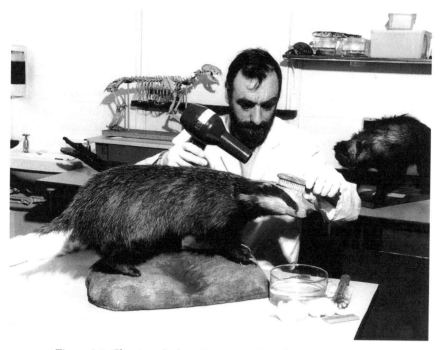

Figure 5.3 Cleaning a badger. Conservator Roy Garner at work, 1988.

Manpower Services Commission funded temporary posts to undertake natural history conservation.[49] As graduate chemists, Goodyear and Horie's background was indicative of the shift in emphasis from technical skills to a self-consciously scientific approach. The new conservators considered themselves dedicated conservation professionals, tackling the welfare of the collections as a whole, and removing these responsibilities from the curatorial staff. Their new status transgressed the firm social boundaries of an institution in which technicians worked *for* collection-based keepers within distinct fiefdoms. Conservators set out to incorporate and formalise the craft practices inherited from their predecessors, but their main emphasis endured: to preserve the collection in perpetuity in order to glean information from the objects. But having rendered them stable, how was such knowledge extracted?

Recording and cataloguing

Objects in museums were subject not only to material manipulation but also to practices intended to order them, interpret them and trace them. The principal remnant of these practices is the museum catalogue, which historian of science Paula Findlen considers 'the most important object produced from a collection'. Together with other collection documents, they acted as 'repositories of multiple

intersecting stories that textualized and contextualized each object'.[50] With a few important exceptions, the catalogues themselves, rather than their content, have not been the focus of scholarly attention.[51] Here I focus on cataloguing as a process rather than product; not detailed exegeses of the texts, but rather an exploration into the practices that produced them. After reflecting on the nature of cataloguing, I explore the different textual encounters from registration to publication, concentrating on the Museum's early history and on the system set out by William Evans Hoyle. Many of these remained in place until the advent of computer cataloguing, a discussion of which closes this section.

Museum cataloguing was not a neutral process: it was highly contingent, specific to era, discipline, institution, and even to individual. But some common characteristics nevertheless emerge. All cataloguing involved a certain amount of sleight of hand: specimens were tidied up, their defects and deterioration disguised.[52] Line drawings often rendered imperfect specimens pure types. The catalogue gave the illusion of finality, of completeness (later addenda notwithstanding), and was imbued with considerable authority. This apparent objectivity masked the cultural assumptions and specific ways of knowing that were enacted in museum ordering and understanding. In principle, objects could be catalogued in any number of ways: by donor, by species, by morphology, by gallery; but the choices made in cataloguing and arrangement reflected contemporary concepts of rationality and in turn contributed to the construction of taxonomies. Cataloguing defined and delimited collection-based disciplines as firmly as the gallery spaces and administrative structures analysed in earlier chapters.

As Ken Arnold observes, whereas collections were subject to considerable physical inertia – given the time and effort it took to reorder displays – successive editions catalogues could be more responsive to expanding collections and to changes in taxonomic thought.[53] At the Manchester Museum, for example, whereas the zoological displays changed little in its first two decades, the pamphlet *Outline Classification of the Animal Kingdom* that accompanied them was adapted in successive editions between 1891 and 1924 to accommodate changes in taxonomy and nomenclature.[54] Cataloguing itself comes with a particular kind of inertia, however, for once a particular system has been set up, and it is difficult and time-consuming to change it.

In order to facilitate published catalogues, Hoyle set up a system of registration that was modelled, like many of the techniques he established, on library practice. Every specimen was registered as soon as it entered the Museum (in principle at least – some were recorded in groups, especially plants). As Helen Southwood observes, although published accounts of objects ordered and illuminated them, such registers reveal the messy acquisition processes behind the ordered displays.[55] Each item was noted with its date of arrival, name, locality, and whatever provenance details were available. Objects that shared an acquisition route were categorised, reordered and isolated. Details were recorded in one of a series of folio ledgers

that acted as accession registers.[56] As we have seen, the overall scheme privileged zoology in general (nine of fourteen ledgers) and Hoyle's invertebrate interests in particular (five of those nine) – yet remained in use for decades.

The choice of lettering and numbering systems had an enduring impact upon collections, and was the subject of heated debate in many museums. The main problem, of course, was that a system needed to be flexible enough to allow for expansion of the collection, but not so complex as to become unwieldy. Hoyle had each register printed with numbers up to 12,500, prefixed with the alphabetical code. Any subsequent renumbering – an enormous exercise – cut the objects adrift from any work, published or otherwise, that referred to their previous numbers. And as the Egyptologist Flinders Petrie lamented, 'Whenever a collection has been catalogued anew, and all the numbers are in the order of the specimens, the placing of additions at the end . . . always seems a melancholy collapse of the order just established.'[57] For in contrast to the apparent adaptability of print representations of the collection, the selection of a particular method of ordering objects as they arrive in a collection can lock an institution into a particular way of knowing. Many ethnographic museums, for example, were bound into imperial modes of classifying artefacts well into the post-colonial era.[58] At the Manchester Museum, various attempts by Hoyle and his successors to impose a universal system of numbering across the collections made little headway.[59] Aside from the endemic problem of backlog, the main challenge to his scheme as the decades wore on was the emergence of new collections. The staff later responsible for Egyptology and archaeology adopted their own accessioning systems, collection-specific practices that had proliferated to the point of confusion by the time John Prag imposed a unified recording and numbering system in the 1970s.[60] Prag implemented a uniform scheme (down to the very paper of the registers) based on that at the Ashmolean, where he had previously worked.

Accession registers, complex in themselves, did little to order the items, and beyond attributing each specimen to a broad class, involved no classification. Most institutions complemented an accessions register with a card catalogue.[61] It was at this stage that the object was named and classified. And whereas accession books often recorded such quotidian details as price or donor, the card catalogue wrenched the object from its fiscal and social contexts, the first step in what scholars have termed the 'museum effect', whereby an object is radically dislocated from its point of origin, and rendered a frozen work of art in the surrounds of the museum.[62] On his trusty Hammond typewriter, Hoyle detailed specimens on 5-inch cards. In the zoology collections, the species cards were interspersed with taller genus cards, and family cards that were more prominent still; these were also on different coloured card for clarity. Thus new specimens were recorded onto extant species cards, or new species were added to extant genera. Stationery imposed and reflected classification.

The preparation of the card catalogues involved intense scrutiny of the object, visual and haptic, to squeeze out information – very different way of engaging

with material culture than collecting or conservation. All parts of this process were contingent on discipline: the characteristics of the data that the cataloguer sought to extract from the object; its accompanying documentation; and the body of reference works used (one did not sit down and start classifying from scratch). Nevertheless, the information generally included the species or type, format, some intrinsic properties (such as dimensions), accession number, geographical location and relevant published references. The object was thus described, situated and implicitly compared with others. Subsequent efforts to re-catalogue could involve going back to the specimen and re-examining it; with new eyes and new contexts, a second scrutiny could produce very different results. The flexibility of a card system was crucial – elsewhere, curators and collectors used similarly flexible schema such as slip catalogues.[63] Objects could float between categories and even transgress classifications.

Whether registers or card catalogues, the textual products of these processes were unique, and did not leave the Museum. In parts of the collection curators used them to compile typescript handlists, especially of type specimens, many of which were produced with a view to publication.[64] For although a complete catalogue was never produced, some groups of objects were the subject of published catalogues. Rather than fulfilling the inventory function of registers, such publications purported to interpret and to order the objects. Although they were more fixed than card or slip catalogues, those with indexes or multiple ways of listing offered differing ways of ordering and understanding their contents. Contrary to Werner Hüllen's claim that 'catalogues repeat the spatial arrangement of exhibits in the sequence of entries', on the contrary, in a printed catalogue, unlike items on display and in store, the order was pure – there were no pillars or shelves in the way, no constraints of size or medium.[65]

Crucially, published catalogues were reproducible, taking advantage of cheap late nineteenth-century printing technology. They were distributed to the Museum Committee, University staff, local grandees and prominent donors; sold to visitors (first by one of the Museum's boys from a table on Saturdays, later from the Museum's shop), and, as we have seen, distributed to museums and libraries outside Manchester as part of an extensive exchange system. Intended 'to popularise the arrangements of the Museum and its contents', catalogues afforded prestige to the institution, to collectors and to donors.[66] 'These publications', proclaimed the *Museums Journal*, 'will enhance the reputation of the Manchester Museum and also of their authors.'[67] They reached places and people that the Museum could not. In setting out taxonomic principles and introducing the topic in question, they acted not only as ambassadors for the Museum, but also as textbooks, essential reference tools. In the century between the Great Exhibition and the Second World War, museum catalogues were larger, more plentiful and more authoritative than at any other time. In archaeology, for example, the catalogues were the major form of publication, building histories out of material culture with chronological sequences, as

Webster's studies of the Manchester Museum vases did.[68] To publish new items in a catalogue was to publish the specimen, to claim priority, indelibly to stamp the author's identity on the item. Rather than publishing *about* the object, museum-based scholars *published the object*.

Despite the illusion of authority and finality, catalogues dated quickly, and subsequent additions or published addenda were common. The keepers themselves had copies bound with interleaved blank pages – a common practice in Victorian museums – and their notes and marginalia speak volumes about changing collections and ideas. As much as the preserving jar or the scalpel, the catalogue was an essential museological working tool, part of the material culture of science. Its physicality impacted upon keepers' practice, and reflected their approaches. Font sizes and styles gave subtle indicators as to classificatory levels and emphases.

Aiding in the publication of the 1970s published catalogues, but possibly contributing to their discontinuation, was the computer catalogue. The Manchester Museum Keeper of Botany John Franks had been investigating methods of electronic information retrieval from the late 1960s, designing a computer recording form for botanical specimens that aroused the interest of the Information Retrieval Group of the Museums Association (from 1977 the Museums Documentation Association).[69] Bill Pettitt, Zoology assistant keeper, then began to work with the University of Manchester Regional Computing Centre, the Museum Documentation Advisory Unit at Cambridge and the North Western Museum and Art Gallery Service to develop full computer-aided cataloguing. The Manchester Museum, he declared, 'intends to play a leading role in this modern approach to the problem of retrieving and using data about museum collections'.[70]

Institutions in the United States and the United Kingdom had been considering digital recoding of collections data for over a decade when in May 1979 the 'Computer Cataloguing Unit' became operational.[71] The Unit was located in the space that had once housed the first conservation laboratory, staffed by Manpower Services Commission-funded personnel and managed by Pettitt.[72] Running for seven years, at its peak the Unit had twenty-eight staff processing 75,000 entries per annum.[73] The techniques of data capture and processing changed rapidly. From 80-column punch cards in the first year, through paper-tape to early floppy discs; processed first by a FAMULUS package and later by other software; operated on a dizzying variety of hardware, often supplied by the University as part of computer enhancement on campus. The final databases were stored on half-inch magnetic tapes. The location of the Museum in Manchester was crucial, given the University's pioneering role in the development of computing and the resources thereby made available – although the Museum had its own terminals, much of the work took place over Oxford Road in the University's Computing Centre.

In principle, the computer catalogue offered some seductive advantages over its paper-based cousin. It was flexible, and could be rearranged to suit a range of queries. Data could be entered by unskilled personnel, and in great numbers. The

product was ostensibly democratic and adaptable. There were, however, significant disadvantages. While unskilled cataloguers entered data in unprecedented volume, maintaining accuracy was a challenge, and such large teams required considerable management. Uniformity in data fields and quality of information was difficult to maintain across the collections, as was curatorial staff interest and commitment: as Pettitt later reflected, his colleagues had 'different reactions to the museum computer system, ranging from enthusiastic through apathetic to decidedly opposed'.[74] As new software was introduced, staff encountered difficulties of incommensurability; on one occasion, a thousand unique archaeology records were lost altogether.[75] Nevertheless, the system was adapted and updated (not always easily) over the following decades, ultimately to replace paper cataloguing entirely.

Manpower Services Commission personnel undertook not only computer cataloguing, but also natural history site recording and archaeology cataloguing.[76] They continued an established tradition of semi-skilled staff undertaking the drudgery of base-level documentation; originally the responsibility of curators, over the course of the twentieth century more of the cataloguing was undertaken by volunteers. Others who worked on specific aspects of the collections were experts, including Museum Committee members, University staff and visitors.[77] The sheer labour involved prevented Museum staff from publishing comprehensive catalogues. The geologist Wilfrid Jackson, for example, began to update his predecessor's catalogue records when he arrived at the Museum in 1907, but did not publish the results until 1952.[78]

Storing and displaying

Whether on screen or on paper, once registered, described and catalogued it may be tempting to assume that the object might be left in peace. And yet its museum journey was not yet complete. Having been rendered stable and ordered, the vast majority of specimens were stowed away, subject to a range of environmental processes according to size, classification and mode of preservation. The remainder of this chapter is devoted to these storage techniques, and to tools and staff involved in exhibiting the select few items deemed suitable for display.

The gallery space in the Museum barely doubled over the Museum's history. The collections, however, grew eightfold between 1890 and 1990. Almost all the Museum's specimens, it follows, were out of sight. In the early modern cabinet of curiosities, everything had been on display; in the Victorian 'new museum' there had been separate public displays and reserve collections for research; and by the twentieth century exhibited objects constituted only a fraction of a museum's holdings. Museum visitors were often unaware of the volume of material in store, or of its existence at all. 'Museum collections, like icebergs, keep a great proportion of their mass out of sight', David Owen argued. 'Such large collections are essential for study, scholarship and research and a very small proportion is displayed for the general

public. Yet these hidden reserves need constant examination and treatment – the more because they are in closed drawers out of sight.'[79] This material was frozen in time (preservative practices and the decay they were designed to combat notwithstanding). Considered by some scholars the material basis of a collective societal memory, stored collections were by contrast forgotten, in repose, only to be woken by use, conservation (or insect attack).[80]

In the original building, William Boyd Dawkins displayed as much of the collection as he could, and stored the rest in drawers underneath the display cases, a practice continued during the Museum's early decades.[81] The collection thus remained in one continuous sequence, and students could study the reserve collections in direct juxtaposition with the exhibited material. As the collections expanded, however, it became rapidly clear that off-gallery storage would be necessary, first located in the tower and later in the basement. The Museum's guidebooks, in light of calls from museum professionals generally for greater accessibility to stored collections, advertised the existence and accessibility of large donated 'reserve' collections that were not on display.[82] Storage was a major driver for each new building, as it was at the BM(NH), which erected a sizeable spirit store in the 1920s.[83]

Like the other museum practices explored in this chapter, storage techniques demonstrated disciplinary differences, a diversity that was perpetuated by the habit of donors of gifting material in furniture that was often valuable in its own right (especially in entomology). Particular donations warranted – and demanded – special storage arrangements. At great expense, Cosmo Melvill's herbarium was stored in a dedicated room with electric light and heating to ensure it remained dry. Effective storage of the Dresser bird collections likewise vexed the zoologists for decades.[84] The idiosyncrasies of donors notwithstanding, curators sought to store items in sequences as intelligible as those on display. Even more so than on the galleries, however, practicalities dominated. Like most museums, the Manchester Museum had a 'large object' store to accommodate items from across the collection. Taxonomically diverse 'wet' specimens were stored together in the tower.[85] Other practical challenges included the supply of storage vessels: rectangular glass jars became scarce after the First World War disrupted the supply route from Germany.[86] The Second World War brought different problems, as the stores were broken up and many collections were removed to various country estates for safe keeping, the remainder protected *in situ* by sandbags.[87]

The return of the collections after the war prompted a series of rearrangements, and it became clear that the stores were full to brimming.[88] Upon his appointment as director, David Owen set about a long campaign to render the extant storage space more effective, for example, with extra shelving and Dexion racking.[89] Even so, it was apparent that any plans for new exhibitions would be hampered by lack of space to store the material to be taken off displays.[90] As the Chair of the Museum Committee Herbert Graham Cannon had already complained, 'as regards space, we are liked the psalmist who was "closed in on every side by the fat

bulls of Basan" – we are completely surrounded by University Departments and unable to expand.'[91] After considerable lobbying, the Museum eventually secured the space underneath the neighbouring Schuster Building on Coupland Street for Egyptology and archaeology storage.[92] Although this was rather far from the galleries, the plans were drawn up during a period in which many other museums were opting for storage facilities that were entirely off-site.[93] Secured in 1967, the resulting collection movement took over a decade to complete, by which time the Museum had also taken over the neighbouring metallurgy building for further stores, offices, working spaces and photographic darkrooms.[94] Not until 1985 was John Prag finally able to occupy the last of the basement storage areas for archaeology.

In most museums in the last 150 years, then, the majority of objects in collections were never put on display. The techniques employed on those that were, however, were subtle and not-so-subtle methods of extracting meanings, telling particular stories with objects. As Stephanie Moser writes, in the study of display techniques 'we see how a new "life" emerges for objects once they are placed in an exhibitionary setting'.[95] Art historians and museologists take it for granted that exhibitions endorse and generate particular theoretical viewpoints, but rarely are we shown precisely how. For the meanings of an object are impacted upon not only by its arrangement and place in the overall classification, but also by its immediate display environment, the shelves and drawers, labels and lights.[96] Such techniques and their political implications are chronologically and geographically contingent, and so to track one object through the decades and centuries of changing modes of exhibition is to present a rich history of the cultures of display. Turning first to the fixtures and fittings used to display museum collections, the final passages of this chapter will address display furniture, lighting, colour and labelling in the Museum's early years, before finally turning to the professionalisation of museum design in the later century.

As they did in many other respects, nineteenth-century museums borrowed furniture ideas from the library sector.[97] Most provincial museums adopted a combination of library-style vertical wall-cases and horizontal table cases (see figure 5.4). The wall-cases either lined the edges of the room closely, or jutted out from the walls to create bays, as in the Manchester Museum.[98] The aim of display furniture in this period was to present the object in ostensibly as clear a fashion as possible, to let the specimens 'speak to the eyes'.[99] Transparent shelves and unobtrusive fittings were visible through large plate glass, made possible and cheap by advances in glass-making technology (also employed in department stores). No longer was it necessary or desirable to remove objects from the cases in order to examine them closely. Objects in the Manchester Museum were arranged 'to tell their own tales'.[100] The campaign for clarity in casing continued during the twentieth century, as electric polishing techniques developed during the First World War rendered plate glass even clearer.

Figure 5.4 Electric lighting in the Museum, 1898, showing table cases with uprights.

As cases became larger, so too the modes of displaying objects within them changed. Although habitat groups and dioramas never dominated the zoological displays in the Manchester Museum as they did elsewhere, elements of these innovative display methods were evident from the outset.[101] In Europe and America, the family group replaced serried ranks of the systematic display with carefully arranged specimens of the same species in ostensibly characteristic positions (often with the male predominant).[102] Such arrangements were later supplemented with appropriate scenery demonstrating 'their natural haunts and habitats', which faded into painstakingly-painted backgrounds.[103] Such 'habitat cases' involved complex collaboration between naturalist and artist, and tensions between scientific 'truth' and aesthetic appeal.[104] Despite objections that these tableaux were redolent of the dime museum and the waxwork display, dioramas were common in Scandinavia, Germany and the United States in the early twentieth century in natural history and in folklore museums, as museums began to appeal to a mass audience. Except for ornithology, British museums were rather slower on the uptake, but such display techniques were employed for example in Norwich and the Science Museum from the 1930s.[105] Whether or not Manchester Museum staff were in favour of them, however, the prohibitive cost and space taken up by dioramas prevented their widespread use.[106]

The Manchester Museum may not have been at the forefront of museum fur-
niture or display techniques, but it was pioneering in the lighting of the cases and
galleries. Even more so than case design, the lighting of museums and galleries was
the subject of vigorous debate in the late nineteenth century.[107] Victorian museum
architects had favoured lusciously top-lit galleries, but as the pressure to admit
the public during the evening mounted, natural light was complemented or even
replaced by gas light. The potential and actual damage to art, objects and people
alike rendered this solution unpalatable to many, however. The Manchester Museum
was originally lit by gas, with 'the result that the cases were badly illuminated and
the upper galleries rendered useless by vitiated air'.[108] Local businessman Reuben
Spencer, who was to donate his numismatics collection, agreed to finance electric
lighting, allowing the Museum to follow the example of the Manchester Art Gallery.
After experiments on the gallery powered by the generator of the nearby physics
lab, 206 lamps were installed in the first three floors, and switched on in November
1898 (see figure 5.4).[109] Artificial light presented new problems for curators, includ-
ing reflections, shadows and glare. Hoyle's solution was to use 'inverted arc' lamps
with reflectors that threw the light towards the ceiling of the galleries, as well as
individual incandescent spotlights on the upright cases. This system remained
largely unchanged, save for adapting the voltage to the grid, until the 1950s, when
the Museum was finally rewired. Over the next three decades, electric light became
the sole source of illumination, as curators and conservators alike agreed on the
undesirability of sunlight, and blinds were installed.

The advent of electric lighting brought fresh emphasis to the problem of colour
in cases and on galleries. Already in the early nineteenth century, curators and
museum trustees argued that colour, like cases and lighting, was an integral part
of the mechanics of display. As the museum profession matured at the turn of the
century, so they sought control over this aspect of museum design, rather than
leaving it to architects or decorators.[110] Colour was a key component in the early
twentieth-century quest for clarity, and many curators argued for as unobtrusive a
background as possible within cases – but judgements as to what constituted such
neutrality ranged from buff to warm red. In Manchester a blue-grey was adopted.
Later in the century, however, the climate of colour opinion changed: around the
Second World War blue-grey gave way to 'oyster' and 'light stone'; the mammal
cases were painted primrose yellow and the bird cases blue. The cases themselves
were transformed in the early 1960s as David Owen engaged polishers to remove
the ebony stain that rendered the mahogany black. With an emphasis on light and
space, the austere Victorian galleries gradually brightened.[111] Although their means
of achieving it had changed, nineteenth-century and post-war curators alike advo-
cated clarity in display.

This clarity came not only from the display environment, but also from the
information provided. Cases, lighting and colour rendered displays eye-catching,
but not necessarily intelligible. A museum object in isolation was considered useless

– it either had no meaning, or, worse, the visitor was too free to bring their own. 'A museum without labels', concluded one of several late-Victorian committees convened on the subject, 'is like an index torn out of a book; it might be amusing, but it teaches very little.'[112] More than any other exhibitionary device, the label rendered the object accessible, shaped the audience, and extracted particular kinds of information. 'Effective labelling is an art to be studied,' proclaimed the British Association committee, 'it is like a style in literature . . . the reader grasps the thought with the least possible effort.'[113]

Accordingly, by the turn of the century, every specimen on display in the Manchester Museum had a label, and in some cases, additional wax models, 'sketches, notes, and brief descriptions'.[114] Early texts were rather abrupt. With little of the description that could be found on other institutions' panels, they were unashamedly scientific, written in conjunction with Owens College staff and aimed at their students. Colours and font size were themselves lessons in taxonomy, and the labels included:

> Printed names in block type, of a bright red colour for the different groups of animals, the principal Divisions of the Animal Kingdom being in large letters, and the orders and sub-orders in a smaller but conspicuous type; individual specimens in black, the Geological labels having a red border, and the Zoological black; locality in the left-hand corner, and the donor's name on the right.[115]

Labelling was a laborious and expensive business, and so justified not only a printing press but also a dedicated member of staff as printer. This position, one of the few available to women in this period, was essential to the running of the museum until it was discontinued on grounds of economy during the First World War. Its incumbents included Alicia Standen, daughter of the zoology assistant keeper Robert Standen, who left upon marrying her colleague Wilfrid Jackson; and Winifred Crompton, later assistant keeper for archaeology. They issued not only labels for the Museum, but also pamphlets with complete lists of particular phyla for other museums and collectors to purchase.[116] By disseminating them, the Museum sought to standardise labelling and collecting practices according to Hoyle's scheme, and thereby to establish itself as an authoritative site for systematic biology.

The label sets were available well into the inter-war period. By this time, however, the Museum was reassessing its own labelling practice. Museum professionals across the country acknowledged that their texts, many unchanged since the Victorian labelling campaign, were ineffective and unread.[117] Gradually, heeding continued calls for clarity, dense Latin gave way to simpler English, and the sparse information was complemented with typewritten guides attached to the cases. These changes in labelling were part of a post-Second World War shift in attitude to display at the Manchester Museum, and across the museum sector. During the 1950s, prompted by the increase in funding from the corporation, Manchester Museum staff, like many of their peers, set about 'modernising' the galleries. This

was especially urgent for the ageing natural history displays, which as we have seen was considered 'hopelessly out of date from all aspects'.[118] One keeper complained that the 'cases are not only old fashioned and extremely ugly in appearance but difficult to adapt to modern display techniques'.[119] Curators set about gearing their displays to their visitors, for example, through increased use of models and images. Cabinets and their contents were spaced out, Perspex mounts employed and internal case lighting was installed as staff set out to render 'showcases more attractive to the general public'.[120]

These systematic redisplays and new temporary exhibitions reflected an increasing concern within the profession with museum design, clearly evident in the United States and emerging in the United Kingdom.[121] Concurrent with the consolidation of professional communities of educators and conservators, the role of the gallery designer was disaggregated from other museum duties.[122] In larger institutions, fittings, colours, labels and the exhibition 'script' would no longer be the domain of the curator.[123] In 1970, as the redesign of the galleries stretched into its third decade, Owen set about to secure funding for dedicated display staff.[124] With funds from the new Greater Manchester Council (GMC), Owen was finally successful in 1975, when Andrew Millward was appointed the Museum's first keeper of display. Together with the new keeper of conservation, this post marked the increasing status of generic museum practitioners alongside specialist curators. Millward worked with a small team of technicians in the workshop, which had been centralised in 1969 in the person of Harry Rowcroft, previously senior technician for geology. Rowcroft had come to the Museum having worked as a fitter for British Rail (laid off during Richard Beeching's reorganisation). His colleague, the display technician Trevor Trueman, brought with him to the Museum skills he honed building theatrical sets.

At the GMC's behest, much of the display team's time was taken with exhibitions that would travel elsewhere within the region.[125] Beginning with 'Nature in the Town' in April 1975, travelling exhibitions drew from all collections, ranging from 'The World Inside Out: Shells, Corals, and Other Marine Creatures (1976) to Fort, Vicus, Town' (1978–79). After a decade of these peripatetic shows, Millward's post and those of the display technicians were seriously threatened by the loss of funding when the Conservative government abolished the GMC in 1986. The posts were only continued thanks to monies direct from the Office of Arts and Libraries. No longer responsible for the Greater Manchester area, the team concentrated on in-house productions and redisplays. In twenty-five years at the Museum, Millward would supervise the overhaul of seven permanent galleries, working with (and sometimes against) the collection-based staff. He brought about a significant change of style to the Museum's front end, opting for 'fuller interpretation' to render the galleries 'an exciting and stimulating environment'.[126] His team's work on the Egyptology and botany galleries was decisive in the Museum's success as 'Museum of the Year' in 1987.

Conclusion: towards a history of museum practice

Much of the work of these technicians, designers and conservators has been over-looked by museum historians, and there are few historical accounts of the mundane activities undertaken by museum staff every day. Paying attention to these processes shows clearly that the biography of an object did not halt when it reached a museum, and nor was its meaning frozen – rather, it was subject to considerable work while in the collection. The museum was not a static mausoleum but a dynamic, mutable entity where specimens were added and preserved, discarded and destroyed. Preservation, preparation and, especially, taxidermy are all abundant avenues of study. Objects were catalogued, cleaned, stored and researched, not only by curators, but by volunteers, assistants, technicians and charwomen. This chapter has explored these museum activities and people in their historical contexts, demonstrating how museum objects enabled a series of actions and relationships between museum personnel. Jars, cata-logues, cases and labels were the tools of the curator's trade, and enabled the consid-erable work necessary to reveal the 'true' nature of museum objects. As much as the discipline building and acquisition of previous chapters, the techniques outlined here reveal how nature and culture were constructed in the museum.

These intimate details were the day-to-day concerns of museum personnel, con-suming their time and attention as much as grand taxonomic schemes and universal collections. A study of museum practice must reflect this, the work of the museum. In doing so we can track the development of distinct professional communities in museums, in conservation, documentation and design. Despite the formalised training that marked these groups, staff continued to rely on tacitly-reproduced techniques. Even as technical staff increasingly operated in central units within the museum with graduate professionals in their midst, they relied heavily on the craft skills they brought with them. And these backgrounds fundamentally shaped the social operation of the Museum. Different sets of staff were clearly demarcated, in their operation and in the spaces in which they worked – lab, workshop, office – and in the very social space of the Museum, as technicians and keepers drank tea separately.[127] Working in the museum for decades, technical staff developed skills and familiarity with the collection and the building that were distinct from, and therefore invaluable to, their curatorial colleagues.[128]

Although a different historiography has been employed in this chapter, these con-clusions nevertheless complement arguments found earlier in this book concerning the disciplinary development within museums. Disciplines are constructed not only with ideas and networks, but also material culture, I argued above. But further, as John Pickstone claims, they were characterised by different 'ways of working'.[129] These practices, combined in different ways at different times, were not only experi-mental and analytical, but also museological. Conservation, cataloguing and exhi-bitionary techniques were specific to collection areas as the Manchester Museum developed into a feudal collection of collections; these skills were then rearranged

as generic groups emerged within the museum sector. On an institutional level, like other large museums, the Manchester Museum exported some of these techniques, from label style to herbarium sheet size. Pan-sector standardisation tended to be defeated, however, in the face of discipline-specific traditions.

Of course, we need a detailed and contextualised history of collecting and collections, but this is only part of the story. The history of museums is also the history of people, the history of relationships, and a history of practice.

Notes

1 S. J. M. M. Alberti, 'Molluscs, mummies and moon rock: the Manchester Museum and Manchester science', *Manchester Region History Review*, 18 (2007), 108–32; A. Kraft and Alberti, '"Equal though different": laboratories, museums and the institutional development of biology in the late-Victorian industrial North', *Studies in History and Philosophy of Biological and Biomedical Sciences*, 34 (2003), 203–36.

2 On disciplines and techniques, see J. V. Pickstone, *Ways of Knowing: A New History of Science, Technology and Medicine* (Manchester: Manchester University Press, 2000); Pickstone, 'Working knowledges before and after *circa* 1800: practices and disciplines in the history of science, technology and medicine', *Isis*, 98 (2007), 489–516.

3 H. Collins, *Changing Order: Replication and Induction in Scientific Practice* (London: Sage, 1995); J. Golinski, 'The theory of practice and the practice of theory', *Isis*, 81 (1990), 492–505; H. Kuklick and R. E. Kohler (eds), *Science in the Field* (Chicago: Chicago University Press, 1996); B. Latour and S. Woolgar, *Laboratory Life: The Construction of Scientific Facts* (Princeton: Princeton University Press, 2nd edn, 1986); A. Secord, 'Science in the pub: artisan botanists in early nineteenth-century Lancashire', *History of Science*, 32 (1994), 269–315.

4 R. E. Kohler, *All Creatures: Naturalists, Collectors, and Biodiversity, 1850–1950* (Princeton: Princeton University Press, 2006), p. 229.

5 J. Golinski, *Making Natural Knowledge: Constructivism and the History of Science* (Chicago: University of Chicago Press, 2nd edn, 2005).

6 S. Shapin, 'The invisible technician', *American Scientist*, 77 (1989), 554–63; S. G. Kohlstedt, '"Thoughts in things": modernity, history, and North American museums', *Isis*, 96 (2005), 586–601.

7 M. Patchett, 'Tracking tigers: recovering the embodied practices of taxidermy', *Historical Geography*, 36 (2008).

8 C. Gosden and C. Knowles, *Collecting Colonialism: Material Culture and Colonial Change* (Oxford: Berg, 2001), pp. 4–5. On the dynamism of the collection see also C. Gosden and F. Larson, *Knowing Things: Exploring the Collections at the Pitt Rivers Museum 1884–1945* (Oxford: Oxford University Press, 2007).

9 W. Lindsay, 'Time perspectives: what "the future" means to museum professionals in collections-care', *The Conservator*, 29 (2005–6), 51–61.

10 See for example the correspondence cited in S. R. Edwards, 'Spruce in Manchester', in M. R. D. Seaward and S. M. D. FitzGerald (eds), *Richard Spruce, 1817–1893: Botanist and Explorer* (London: Royal Botanic Gardens, 1996), pp. 266–79.

11 Manchester Museum Central Archive (hereafter MMCA) box OMR5, directors' correspondence 1906–33.

12 On the Spaeth Collection, see MMCA box GB5, W. D. Hincks – R. U. Sayce, 16 February 1950, and chapter 4 above.

13 C. V. Horie, 'Conservation and the specimen', *Newsletter of the Natural History Group of the ICOM Committee for Conservation* (1986), 4–5, p. 4.

14 E. B. Poulton, 'The methods of setting and labelling Lepidoptera for museums', *Report of the Proceedings of the Museums Association*, 8 (1897), 30–6; cf. A. S. Douglas and E. G. Hancock, 'Insect collecting in Africa during the eighteenth century and William Hunter's collection', *Archives of Natural History*, 34 (2007), 293–306.

15 Manchester Museum Herbarium, Accession Register KK, 1906–2006, L. H. Grindon, 'History and description of my herbarium', 1885–86, p. 39; C. Bailey, 'On the contents of a herbarium of British and foreign plants for presentation to the Victoria University, Manchester', *Manchester Memoirs*, 61:5 (1917), 1–13; D. Q. King, 'A checklist of sources of the botanical illustrations in the Leo Grindon Herbarium, The Manchester Museum', *Archives of Natural History*, 34 (2007), 129–39; J. C. Melvill, *A Brief Account of the General Herbarium Formed by James Cosmo Melvill, 1867–1904: And Presented by him to the Museum in 1904* (Manchester: Sherratt & Hughes, 1904).

16 There is a burgeoning literature on taxidermy, which I review in S. J. M. M. Alberti, 'Constructing nature behind glass', *Museum and Society*, 6 (2008), 73–97.

17 See e.g. MMCA, Manchester Museum Committee Minutes (hereafter MMCM) vol. 3 (1 June 1908), vol. 4 (20 October 1924); C. Frost, *A History of British Taxidermy* (Lavenham: Lavenham Press, 1987); P. A. Morris, *Rowland Ward: Taxidermist to the World* (Ascot: MPM, 2003); W. T. Stearn, *The Natural History Museum at South Kensington: A History of the British Museum (Natural History) 1753–1980* (London: Heinemann, 1981).

18 Manchester Museum Zoology Archive ZAC/1/146/3, H. A. Ward – W. E. Hoyle, 8 February 1898; ZAC/1/146/4, Ward – Hoyle, 11 January 1898.

19 On Ward's, see M. A. Andrei, 'Nature's Mirror: How the Taxidermists of Ward's Natural Science Establishment Reshaped the American Natural History Museum and Founded the Wildlife Conservation Movement' (PhD dissertation, University of Minnesota, 2006); M. V. Barrow, 'The specimen dealer: entrepreneurial natural history in America's gilded age', *Journal of the History of Biology*, 33 (2000), 493–534; S. G. Kohlstedt, 'Henry A. Ward: the merchant naturalist and American museum development', *Journal of the Society for the Bibliography of Natural History*, 9 (1980), 647–61; R. H. Ward, *Henry A. Ward: Museum Builder to America* (Rochester, NY: Rochester Historical Society, 1948).

20 MMCM vol. 1 (1 October 1890), (24 March 1893).

21 A. C. Western, Interview with Kay Prag, 2006, abstract in MMCA; R. F. Scharff, 'On a dry system of macerating bones', *Museums Journal*, 10 (1911), 196–8.

22 See e.g. MMCM vol. 1 (28 October 1892); H. H. Higgins, 'Life history groups. Suggestions on the desirability of exhibiting in museum drawers of unmounted skins of birds', *Report of the Proceedings of the Museums Association*, 2 (1891), 49–56; R. Newstead, 'The use of boric acid as a preservative for birds' skins, &c.', *Report of the Proceedings of the Museums Association*, 4 (1893), 104–6; cf. S. L. Olson,

'Correspondence bearing on the history of ornithologist M. A. Carriker Jr. and the use of arsenic in preparation of museum specimens', *Archives of Natural History*, 34 (2007), 346–51.

23 R. Down, '"Old" preservative methods', in C. V. Horie (ed.), *Conservation of Natural History Specimens: Spirit Collections* (Manchester: University of Manchester, 1989), pp. 33–8; J. J. Edwards and M. J. Edwards, *Medical Museum Technology* (London: Oxford University Press, 1959).

24 MMCA, *Manchester Museum Report* (hereafter *MMR*) (1890–94); P. Rainbow and R. J. Lincoln, *Specimens: The Spirit of Zoology* (London: Natural History Museum, 2003).

25 Cf. M. G. Rhode and J. Connor, 'Curating America's Army Medical Museum', in A. Levin (ed.), *Defining Memory: Local Museums and the Construction of History in America's Changing Communities* (Lanham, MD: AltaMira, 2007), pp. 177–96.

26 *MMR* (1950–51). Only later did archaeologists value the associated matter on finds: see M. Corfield, 'The reshaping of archaeological metal objects: some ethical considerations', *Antiquity*, 62 (1988), 261–5; E. Pye, *Caring for the Past: Issues in Conservation for Archaeology and Museums* (London: James and James, 2001); United Kingdom Institute for Conservation of Historic and Artistic Works, *Guidance for Conservation Practice* (London: Tate Gallery, 1983). On the 'silencing' of museum practice see Alberti, 'Constructing nature behind glass'; S. Macdonald (ed.), *The Politics of Display: Museums, Science, Culture* (London: Routledge, 1998); S. L. Star, 'Craft vs. commodity, mess vs. transcendence: how the right tool became the wrong one in the case of taxidermy and natural history', in A. E. Clarke and J. H. Fujimura (eds), *The Right Tools for the Job: At Work in Twentieth-Century Life Sciences* (Princeton: Princeton University Press, 1992), pp. 257–86.

27 C. Nördlinger, 'The cleaning of museums', *Report of the Proceedings of the Museums Association*, 9 (1898), 108–11, p. 108; *MMR* (1896–97); F. A. Bather, 'How may museums best retard the advance of science?', *Report of the Proceedings of the Museums Association* (1896), 92–105.

28 On professional boundary work, see T. F. Gieryn, 'Boundary work and the demarcation of science from non-science: strains and interests in professional interests of scientists', *American Sociological Review*, 48 (1983), 781–95; Gieryn, *Cultural Boundaries of Science: Credibility on the Line* (Chicago: University of Chicago Press, 1999).

29 *MMR* (1947–48), p. 4.

30 Western, Interview with Kay Prag; Kohler, *All Creatures*; Scharff, 'On a dry system'.

31 *MMR* (1978–79).

32 T. Tansey, 'Keeping the culture alive: the laboratory technician in mid-twentieth-century British medical research', *Notes and Records of the Royal Society*, 62 (2008), 77–95.

33 *MMRs* (1945–54); MMCM vol. 5 (6 December 1948); vol. 7 (29 October 1964).

34 S. F. Markham, *A Report on the Museums and Art Galleries of the British Isles (Other than the National Museums)* (Edinburgh: Constable, 1938), p. 64.

35 *Ibid.*, p. 66.

36 The laboratory was initially located on the fourth floor of the 1927 building. *MMRs* (1948–51); MMCM vol. 5 (13 June 1949); A. J. N. W. Prag, Interview with the author, *Re-Collecting at the Manchester Museum* disc S19, 2006, MMCA, track 8; Western,

Interview with Kay Prag; D. M. Wilson, *The British Museum: A History* (London: British Museum, 2002).

37 Tansey, 'Keeping the culture alive'.

38 *MMRs* (1950–71).

39 MMR (1954–55); C. Horie (ed.), *Conservation of Natural History Specimens: Spirit Collections* (Manchester: University of Manchester, 1989). J. D. Thomas, *Fifty years of Whitleyism in the Inland Revenue, 1920–70* (London: Somerset House, 1970).

40 H. Eltringham and H. Britten, *Histological and Illustrative Methods for Entomologists* (Oxford: Clarendon, 1930).

41 A. J. N. W. Prag, Interview with the author, *Re-Collecting at the Manchester Museum* disc S1, 2004, MMCA, track 8.

42 Department of Education and Science, *Provincial Museums and Galleries*, ed. C. W. Wright (London: HMSO, 1973); G. W. Dimbleby (ed.), *The Scientific Treatment of Material from Rescue Excavations: A Report by a Working Party of the Committee for Rescue Archaeology of the Ancient Monuments Board for England* (London: Department of the Environment, 1978). The UK group of the International Institute for Conservation formed in 1958; it was succeeded by the United Kingdom Institute for Conservation of Historic and Artistic Works in 1979.

43 S. M. Pearce, *Archaeological Curatorship* (London: Leicester University Press, 1990).

44 Department of Education and Science, *Provincial Museums and Galleries*.

45 C. V. Horie, Interview with the author, *Re-Collecting at the Manchester Museum*, disc S6, 2004, MMCA, track 2; Prag, Interview with the author, 2004, tracks 4–5; *MMR* (1971–72); MMCM vol. 8 (12 October 1970).

46 F. H. Goodyear, *Archaeological Site Science* (London: Heinemann, 1971).

47 *MMR* (1970–71); R. Garner, Interview with the author, *Re-Collecting at the Manchester Museum*, disc S3, 2004, MMCA, track 1.

48 MMRs (1980–85); C. V. Horie, *Materials for Conservation: Organic Consolidants, Adhesives and Coatings* (London: Butterworths, 1987); C. Horie (ed.), *Conservation of Natural History Specimens*; Horie, Interview with the author.

49 MMCM vol. 8 (20 October 1980); *MMRs* (1981–84).

50 P. Findlen, *Possessing Nature: Museums, Collecting, and Scientific Culture in Early Modern Italy* (Berkeley: University of California Press, 1994), p. 36.

51 K. Arnold, *Cabinets for the Curious: Looking Back at Early English Museums* (Aldershot: Ashgate, 2006); A. Cooper, 'The museum and the book. The *Metallotheca* and the history of an encyclopaedic natural history in early modern Italy', *Journal of the History of Collections*, 7 (1995), 1–23; R. Harbison, 'Contracted world: museums and catalogues', in *Eccentric Spaces* (New York: Avon, new edn, 2000), pp. 140–62; W. Hüllen, 'Reality, the museum, and the catalogue, a semiotic interpretation of early modern German texts of museology', *Semiotica*, 80 (1990), 265–75; A. MacGregor, *Curiosity and Enlightenment: Collectors and Collections from the Sixteenth to the Nineteenth Century* (New Haven: Yale University Press, 2007); H. Southwood, 'The history and wonder of the Marischal Museum's catalogues, 1900–2000', *Journal of Museum Ethnography*, 15 (2003), 94–107; M. Thompson and C. Renfrew, 'The catalogues of the Pitt-Rivers Museum, Farnham, Dorset', *Antiquity*, 73 (1999), 377–93.

52 On the practice of drawing as taxonomic skill, see A. Secord, 'Botany on a plate:

pleasure and the power of pictures in promoting early nineteenth-century scientific knowledge', *Isis*, 93 (2002), 28–57.

53 Arnold, *Cabinets for the Curious*.

54 A. M. Marshall, *Outline Classification of the Animal Kingdom* (Manchester: Cornish, 1891); Marshall, *Outline Classification of the Animal Kingdom* (Manchester: Cornish, 2nd edn, 1892); Marshall, *Outline Classification of the Animal Kingdom*, ed. S. J. Hickson (Manchester: Cornish, 3rd edn, 1897); Hickson, *Outline Classification of the Animal Kingdom* (Manchester: Manchester University Press, 4th edn, 1911); Hickson, *Outline Classification of the Animal Kingdom* (Manchester: Manchester University Press, 5th edn, 1924).

55 Southwood, 'History and wonder'; see also E. E. Lowe, 'The registration and numeration of museum specimens', *Museums Journal*, 2 (1903), 258–66; R. Parry, *Recoding the Museum: Digital Heritage and the Technologies of Change* (London: Routledge, 2007).

56 Hoyle originally planned: A. Mammalia; B. Aves; C. Reptilia; D. Amphibia, Pisces; E. Mollusca; F. Insecta; G. Crustacea, Arachnida, Myriapoda; H. Vermes, Echinodermata; I. Cœlenterata. Porifera. Protozoa; J. Botany; K. Palæontology; L. Petrology; M. Mineralogy; N. Anthropology. In practice, botany was split into two ledgers, one for cryptogams (spore-producing plants) and the other for spermatophytes (which reproduce with seeds). See W. E. Hoyle, 'The registration and cataloguing of museum specimens', *Report of the Proceedings of the Museums Association*, 2 (1891), 59–67, p. 60; 'Report of the Museum Catalogue Committee', in MMCM vol. 1. (24 February 1893).

57 Cited in Hoyle, 'Registration and cataloguing', p. 64.

58 Southwood, 'History and wonder'.

59 W. E. Hoyle and H. Bolton, 'Classified cataloguing, as applied to Palæozoic fossils', *Report of the Proceedings of the Museums Association*, 5 (1894), 167–77.

60 *MMR* (1969–70); Prag, Interview with the author, 2004, track 8.

61 Hoyle, 'Registration and cataloguing'; Lowe, 'Registration and numeration'; Parry, *Recoding the Museum*.

62 S. Alpers, 'The museum as a way of seeing', in I. Karp and S. D. Lavine (eds), *Exhibiting Cultures: The Poetics and Politics of Museum Display* (Washington, DC: Smithsonian Institution Press, 1991), pp. 25–32; W. Benjamin, 'The work of art in the age of mechanical reproduction', in *Illuminations*, ed. H. Ardent, trans. H. Zorn (London: Pimlico, 2nd edn, 1999), pp. 211–44; S. Vogel, 'Always true to the object, in our fashion', in Karp and Lavine (eds), *Exhibiting Cultures*, pp. 191–204.

63 G. R. McOuat, 'Cataloguing power: delineating "competent naturalists" and the meaning of species in the British Museum', *British Journal for the History of Science*, 34 (2001), 1–28; S. Müller-Wille, 'Linnaeus' herbarium cabinet: a piece of furniture and its function', *Endeavour*, 30:2 (2006), 60–4; Parry, *Recoding the Museum*.

64 MMCM vol. 4 (6 May 1929), (25 June 1929); H. Bolton, *Catalogue of the Types and Figured Specimens in the Geological Department* (Manchester: Cornish, 1893); Bolton, *Supplementary List of Type and Figured Specimens in The Geological Department, Manchester Museum, Owens College* (Manchester: Cornish, 1894); J. W. Jackson, *Catalogue of Types and Figured Specimens in the Geological Department of the Manchester Museum* (Manchester: Manchester University Press, 1952); W. H. Pearson, *Catalogue of Hepaticæ (Anacroynæ) in the Manchester Museum. Arranged according to Stephani's 'Species Hepaticarum'* (Manchester: Sherratt & Hughes, 1910).

65 Hüllen, 'Reality, the museum, and the catalogue', p. 272; see also Arnold, *Cabinets for the Curious*; W. E. Hoyle, *General Guide to the Natural History Collections* (Manchester: Cornish, 1899).

66 *MMR* (1890–94), p. 8. On the periodical exchange system, see *MMRs* (1895–96), (1925–26); S. G. Kohlstedt, 'Exhibiting colonial science', in D. Livingstone and C. Withers (eds), *Geographies of Nineteenth-Century Science* (Chicago: University of Chicago Press, forthcoming). On catalogues as travelling ambassadors, see Findlen, *Possessing Nature*; Hüllen, 'Reality, the museum, and the catalogue'; e.g. A. S. Griffith, *Catalogue of Egyptian Antiquities of the XII and XVIII Dynasties from Kahun, Illahun and Gurob* (Manchester: Sherratt & Hughes, 1910).

67 F. R. Rowley, 'Books and papers', *Museums Journal*, 10 (1911), 234–6, p. 235.

68 M. Shanks, *Classical Archaeology of Greece: Experiences of the Discipline* (London: Routledge, 1996); see e.g. T. B. L. Webster, *Greek Vases in the Manchester Museum* (Manchester: Manchester University Press, 1933).

69 *MMRs* (1972–76).

70 *MMR* (1977–78), p. 2.

71 E. Orna and C. W. A. Pettitt (eds), *Information Handling in Museums* (London: Bingley, 1980); R. Parry, *Museums in a Digital Age* (London: Routledge, 2006); Parry, *Recoding the Museum*.

72 MMCM vol. 8 (30 May 1978). C. W. A. Pettitt, 'The Manchester Museum Computer Cataloguing Unit: a STEP in the right direction?' *Museums Journal*, 80 (1981), 187–91; Pettitt, Interviews with the author, *Re-Collecting at the Manchester Museum*, discs S9, S10, S15, 2005, MMCA.

73 *MMRs* (1978–86).

74 C. W. A. Pettitt, 'People and data: managing the less predictable aspects of a museum computer system', in *Management of the Use of Automated Data* (Cambridge: Museum Documentation Association, 1988), pp. 12–19, p. 16.

75 Prag, Interview with the author, 2004, track 9.

76 *MMRs* (1976–78).

77 E.g. Griffith, *Catalogue of Egyptian Antiquities*; J. C. Melvill and R. Standen, *Catalogue of the Hadfield Collection of Shells from Lifu and Uvea, Loyalty Islands*, 2 vols (Manchester: Cornish, 1895–97); J. M. Turfa, 'The Etruscan and Italic collection in the Manchester Museum', *Papers of the British School of Archaeology at Rome*, 50 (1982), 166–95; T. B. L. Webster, *Guide to the Greek Vases* (Manchester: Manchester Museum, 1946).

78 Jackson, *Catalogue of Types and Figured Specimens*.

79 *MMR* (1962–63), p. 1.

80 D. Ross, 'Storage and repose', unpublished seminar paper, at the Manchester Art Gallery, 2005, by kind permission of the author; S. A. Crane (ed.), *Museums and Memory* (Palo Alto, CA: Stanford University Press, 2000); M. Halbwachs, *On Collective Memory*, trans. L. A. Coser (Chicago: University of Chicago Press, 1992); J. A. Hendon, 'Having and holding: storage, memory, knowledge, and social relations', *American Anthropologist*, 102 (2000), 42–53; N. Merriman, 'Museum collections and sustainability', *Cultural Trends*, 17 (2008), 3–21.

81 MMCM vol. 1 (24 April 1891); *MMR* (1890–94); G. H. Carpenter, *A Short Guide to the Manchester Museum* (Manchester: Manchester University Press, 1933);

W. H. Edwards, 'An economical method of mounting shells and other small objects for museums', *Museums Journal*, 1 (1902), 251–4.

82 H. Miers, *A Report on the Public Museums of the British Isles (other than the National Museums)* (Edinburgh: Constable, 1928); R. U. Sayce (ed.), *Guide to the Manchester Museum* (Manchester: Manchester University Press, revised edn, 1957); W. M. Tattersall, *General Guide to the Collections in the Manchester Museum* (Manchester: Manchester University Press, 1915).

83 MMCM vol. 7 (3 March 1969); *MMRs* (1926–28); Stearn, *The Natural History Museum*.

84 MMCM vol. 5 (20 January1947); *MMR* (1953–54); Higgins, 'Life history groups'.

85 MMCM vol. 8 (29 October 1973); *MMR* (1908–9).

86 'Rectangular glass jars for museum purposes', *Museums Journal*, 21 (1922), 249–50.

87 MMCM vol. 5 (20 January 1941); C. Pearson, 'Curators, Culture and Conflict: The Effects of the Second World War on Museums in Britain, 1926–1965' (PhD dissertation, University College London, 2008).

88 MMCM vol. 5 (20 January 1947); *MMRs* (1950–56).

89 *MMRs* (1956–69); MMCA box DO3, typescript, C. W. A. Pettitt, 'The new zoology storage at the Manchester Museum: an opportunity for a new curatorial strategy'; Pettitt, Interviews with the author.

90 MMCM vol. 7 (29 January 1962).

91 MMCA box GB5, H. G. Cannon – A. P Wadsworth, 20 May 1949.

92 *MMR* (1967–68); Prag, Interview with the author, 2004, track 4.

93 Pearce, *Archaeological Curatorship*.

94 MMCM vol. 8 (24 May 1976); *MMRs* (1975–79); Building Design Partnership (Manchester Group), *Brief for New Extensions to the Manchester Museum* (Manchester: Building Design Partnership, 1972); A. Warhurst, 'New extension', *Communication* (Victoria University of Manchester newsletter) (October 1977), 10.

95 S. Moser, *Wondrous Curiosities: Ancient Egypt at the British Museum* (Chicago: University of Chicago Press, 2006), p. 2.

96 For recent contributions to the interdisciplinary historiography of display, see R. Hoberman, 'In quest of a museal aura: turn of the century narratives about museum-displayed objects', *Victorian Literature and Culture*, 31 (2003), 467–82; S. G. Kohlstedt, 'Masculinity and animal display in nineteenth-century America', in A. B. Shteir and B. Lightman (eds), *Figuring It Out: Science, Gender, and Visual Culture* (Lebanon, NH: Dartmouth College Press, 2006), pp. 110–39; C. Whitehead, 'Architectures of display at the National Gallery: the Barry Rooms as art historiography and the problems of reconstructing historical gallery space', *Journal of the History of Collections*, 17 (2005), 189–211.

97 S. Forgan, 'The architecture of display: Museums, universities and objects in nineteenth-century Britain', *History of Science*, 32 (1994), 139–62.

98 *British Association for the Advancement of Science Report* 57 (1887); T. Greenwood, *Museums and Art Galleries* (London: Simpkin, 1888); E. Howarth, 'Museum cases and museum visitors', *Report of the Proceedings of the Museums Association*, 1 (1890), 88–94; S. M. Pearce, *Museums, Objects and Collections: A Cultural Study* (Leicester: Leicester University Press, 1992).

99 T. Bennett, 'Speaking to the eyes: museums, legibility and social order', in Macdonald (ed.), *The Politics of Display*, pp. 25–35; A. B. Meyer, 'A description of museum wall and

free-standing cases and desks made entirely of glass and iron', *Report of the Proceedings of the Museums Association*, 2 (1891), 112–19; Pearce, *Museums, Objects and Collections*.

100 *MMR* (1901–2), p. 12.
101 W. E. Hoyle, *General Guide to the Contents of the Museum* (Manchester: Cornish, 1892); K. Wonders, *Habitat Dioramas: Illusions of Wilderness in Museums of Natural History* (Uppsala: Almqvist and Wiksell, 1993).
102 Arnold, *Cabinets for the Curious*; Higgins, 'Life history groups'; R. Machin, 'Gender representation in the natural history galleries at the Manchester Museum', *Museum and Society*, 6 (2008), 54–67.
103 Howarth, 'Museum cases and museum visitors', p. 91.
104 V. E. M. Cain, 'Nature under Glass: Popular Science, Professional Illusion and the Transformation of American Natural History Museums, 1870–1940' (PhD dissertation, Columbia University, 2006); A. Griffiths, *Wondrous Difference: Cinema, Anthropology and Turn-of-the-Century Visual Culture* (New York: Columbia University Press, 2004); J. Insley, 'Little landscapes: dioramas in museum displays', *Endeavour*, 32 (2008), 27–31; Kohler, *All Creatures*; L. K. Nyhart, 'Science, art, and authenticity in natural history displays', in N. Hopwood and S. de Chadarevian (eds), *Models: The Third Dimension of Science* (Stanford, CA: Stanford University Press, 2004), pp. 307–35; S. C. Quinn, *Windows on Nature: The Great Habitat Dioramas of the American Museum of Natural History* (New York: Abrams, 2006); A. Reynolds, 'Reproducing nature: the museum of natural history as a non-site', *October*, 45 (1988), 109–27.
105 A. Bunney, 'It's not just a "children's playground". The influence of children on the development of the Science Museum, 1857–1973' (MSc dissertation, University of London, 1999); Markham, *Report on the Museums*.
106 C. M. Legge, 'Glass for dioramas', *Museums Journal*, 33 (1934), 352.
107 G. N. Swinney, 'The evil of vitiating and heating the air: artificial lighting and public access to the National Gallery, London, with particular reference to the Turner and Vernon collections', *Journal of the History of Collections*, 15 (2003), 83–112.
108 T. White, 'The lighting of museums', *Report of the Proceedings of the Museums Association*, 7 (1896), 148–54, p. 154.
109 *MMRs* (1897–99); W. E. Hoyle, 'The electric light installation in the Manchester Museum', *Report of the Proceedings of the Museums Association*, 9 (1898), 95–105.
110 F. J. Bell, 'On "good form" in natural history museums', *Museums Journal*, 3 (1903), 159–61; Howarth, 'Museum cases and museum visitors'; Moser, *Wondrous Curiosities*; E. R. Waite, 'The colouring of museum cases', *Report of the Proceedings of the Museums Association*, 3 (1892), 71–3.
111 *MMRs* (1934–42), (1961–62).
112 *British Association for the Advancement of Science Report* 57 (1887), p. 127.
113 *Ibid*, p. 127. On labelling, see Bell, 'Good form'; T. Bennett, *The Birth of the Museum: History, Theory, Politics* (London and New York: Routledge, 1995); E. S. Goodrich, 'Museum preparations', *Report of the Proceedings of the Museums Association*, 8 (1897), 80–4; E. Howarth, 'Report of Label Committee', *Report of the Proceedings of the Museums Association*, 2 (1892), 139–42; Museums Association, 'Report of the committee appointed to consider labelling in museums', *Report of the Proceedings of the Museums Association*, 2 (1891), 128–33.

114 *MMR* (1901–2), p. 12; MMCM vol. 2 (22 March 1901); N. Hopwood, *Embryos in Wax: Models from the Ziegler Studio* (Cambridge: Whipple Museum of the History of Science, 2002); Hopwood, 'Artist versus anatomist, models against dissection: Paul Zeiller of Munich and the revolution of 1848', *Medical History*, 51 (2007), 279–308; Kraft and Alberti, 'Equal though different'; A. M. Marshall, *Descriptive Catalogue of the Embryological Models* (Manchester: Cornish, 1891).

115 Museums Association, 'Report of the committee', p. 128; MMCM vol. 1 (23 January 1891).

116 E.g. Manchester Museum, *The Principal Divisions of the Lepidoptera* (Manchester: Manchester Museum, 1900); Manchester Museum, *The Principal Divisions of the Cœlenterata According to the 'Cambridge Natural History'* (Manchester: Sherratt & Hughes, 1907). Cf. H. Bolton, 'Descriptive labels for the geological department, Peel Park Museum, Salford', *Report of the Proceedings of the Museums Association*, 7 (1896), 69–91.

117 K. Hudson, *A Social History of Museums: What the Visitors Thought* (London: Macmillan, 1975); Miers, *Report on the Public Museums*; Markham, *Report on the Museums*.

118 MMCM vol. 5 (6 December 1948), p. 350. On redisplaying and labelling across the sector in this period, see Pearson, 'Curators, Culture and Conflict'; A. S. Wittlin, *Museums: In Search of a Usable Future* (Cambridge, Mass: MIT Press, 1970).

119 E. L. Seyd, 'A university museum and the general public', *Museums Journal*, 70 (1970), 180–2, p. 180.

120 *MMR* (1958–59), p. 1.

121 R. Fortey, *Dry Store Room No. 1: The Secret Life of the Natural History Museum* (London: Harper, 2008); K. A. Rader and V. E. M. Cain, 'From natural history to science: display and the transformation of American museums of science and nature', *Museum and Society*, 6 (2008), 152–71.

122 V. Airey, 'The past twenty years', *Journal of Education in Museums*, 1 (1980), 10–15; D. Moore, 'Thirty years of museum education: some reflections', *International Journal of Museum Management and Curatorship*, 1 (1982), 213–30.

123 S. W. Allison-Bunnell, 'Making nature "real" again: natural history exhibits and public rhetorics of science at the Smithsonian in the early 1960s', in Macdonald (ed.), *The Politics of Display*, pp. 77–97.

124 MMCM vol. 8 (11 May 1970). The Manchester Museum followed the example of the BM (NH), Leicester City Museums and the British Museum, which had appointed its first exhibitions officer, Margaret Hall, in 1964. Wilson, *The British Museum*.

125 A. Millward, 'Travelling exhibitions from the Manchester Museum', *Museums Journal*, 75 (1976), 171–2.

126 Manchester Museum, *The Manchester Museum* (Derby: English Life, 1985), p. 24; *MMR* (2002–3).

127 Horie, Interview with the author; on the importance of refreshment spaces to museum staff, see chapter 2 above; P. J. Smith, 'A Splendid Idiosyncrasy: Prehistory at Cambridge, 1915–50' (PhD dissertation, University of Cambridge, 2004).

128 Tansey, 'Keeping the culture alive'.

129 Pickstone, 'Working knowledges'.

6

Visitors: audiences and objects

So far this book has been largely concerned with those who worked in and around the Manchester Museum. Even including regular collectors and the many subaltern workers who remain invisible in the historical record, they numbered only a few hundred. But those who experienced the Museum, who visited to view, use and abuse the collections, were far more numerous. At a conservative estimate – accounting as far as possible for repeat visits – around ten million people passed through the Manchester Museum's doors in its first century.[1] Who were these visitors? How did they engage with and respond to the collections? How did museum staff address them, seek to control them, and interact with them?

To tackle these questions, this chapter draws from the established bodies of work in cultural theory, mass communication studies and book history that view the communication process from both sides. In museum studies, visitor theory and contemporary surveys are replacing the passive audience with active participants in the construction of meaning, but seldom has the historical visitor been awarded the same courtesy.[2] Rarely did those using museums leave any traces, but their constituency and agency can be inferred from the Museum's records – formal and informal – from associated ephemera, and from oral histories. Visitors were not vessels waiting to be filled, but autonomous agents with their own agendas. Just as reader-response theorists are seeking to recover not only the meaning of texts, but also the practices of reading, so this chapter explores not only the intentions of curators, but also the experience of visiting. It will come as no surprise that the two did not always tally. The 'public understanding of science' – with its connotations of a transmission of arcane knowledge from active expert to an inert public – can be complemented with accounts of the experiences of active audiences.

This final chapter thereby shifts the narrative of *Nature and Culture* from the movement of things and the processes enacted upon them to their use and audiences. Earlier chapters were concerned with the production of museum objects and knowledge – here we explore their consumption. Beginning by considering who visited the museum and in what numbers, we then move on to study the techniques used by museum staff to attract, assist and control them. Two significant audiences, schoolchildren and members of the university, are discussed in some detail.

Finally, we explore the ways in which visitors were involved in museum practice (as volunteers, for example), and unpack their sensory and emotional responses to the collections. This is not a comprehensive account of the whole century, but rather illustrations taken from key moments in the Museum's history, especially its first decade – when the groundwork was laid for audience engagement for the following half century – and the 1960s, which saw a marked change in approach to visitors.

The first task facing the would-be historian of museum visiting is to assess the access criteria and, where available, quantitative audience data. These factors, however ill-defined, can give an indication of broader demographic shifts in visiting, and if not the visitor constituency, then the intended audiences for the Museum: its addressees. At Peter Street, even though the collections that would form the core of the Manchester Museum were accessed principally by the members of the Manchester Natural History Society, up to 30,000 visits were made annually from the 1830s. In the mid-century, as discussed in chapter 1, the Society also sought to attract 'working classes and the young people of the district'.[3] By the 1860s, however, these numbers had dwindled, and there is no evidence that the citizenry of Manchester missed the collections as they sat in the Owens College attic for twenty years after the transfer from the Natural History Society.

And yet the late nineteenth century was a critical period in the construction of the public for museums.[4] On the one hand, public museums were attracting visitors from across the social spectrum on an unprecedented scale; on the other, collection-based scholars in universities and elsewhere were demarcating the natural science museum as an exclusive space for serious study, cleansed of its associations with the circus and fair. As part of the construction of a professional scientific community, Thomas Huxley and others advocated the 'new museum' idea, with distinct lay and expert audiences for museums. When the Owens College collections were once again made available in the new building from the late 1880s – at first only the lower floors but from 1890 the whole building – its audiences were explicitly bifurcated.[5] Although the architect Alfred Waterhouse did not strictly follow Huxley's recommendations for separate access for research and for public education, entry stipulations were different. The deed of gift by which the Natural History Society transferred the collection stipulated that 'The Collections were to be closed one day per week for cleaning, opened together with the Library for study for two days per week and open to the Public free, three days per week.'[6] Donors of other major university collections such as John Woodward (to Cambridge) and William Hunter (to Glasgow) had made similar stipulations regarding access.[7] In Manchester, general admission was through the door under the tower, but Owens College staff and students were able to enter directly from the Beyer Laboratories next door (see figure 2.1).

This explicit distinction between visiting groups was not to last. The Museum Committee, struggling on the monies the College allocated them, approached the Corporation in the early 1890s for an additional grant. To support their case, the Museum was opened for the general public all week long from May 1891.[8] Already,

many townsfolk were visiting, the Committee appealed, and the Museum was the only natural history collection available to them. Furthermore, the College had expended £70,000 since accepting the collections (the Committee conveniently ignored the monies the College had received from the Natural History Society and the Whitworth Trustees).[9] The appeal was presented to the Lord Mayor and city council, who passed it to the Free Library Committee, whose members visited the Museum. Eventually, an annual sum of £400 per annum was granted by the council on 11 October 1895 to be raised using powers afforded Manchester by the 1891 Museums and Gymnasiums Act.[10] From then until 1989 the Museum was funded by both the city and the University.

To render the Museum more accessible to the general public, the director, William Evans Hoyle, began to think about ways to open the galleries outside the working week – during evenings and on Sundays. Both were the subject of heated debate in the Museum profession in the late nineteenth century.[11] The principal reason for installing the electric lighting detailed in chapter 5 was to offer evening opening (see figure 5.4).[12] But access to the collections on a Sunday was subject not to technical challenges but rather religious objections. In an explicit effort to attract more working men, the Committee opened up the Museum on Sunday afternoons in 1895, as an alternative to the public house. The British Museum (Natural History), after decades of debate, followed suit the next year.[13] In Manchester, Hoyle was pleased with the result, reporting that 'the visitors were drawn from all classes of society, that great interest had been manifested in the collections and that information . . . had been well received', and further, that 'perfect decorum had been noticeable.'[14] Unlike evening opening, many townsfolk took advantage, with an average of more than four hundred visitors per Sunday. By the 1920s, however, this practice had become too successful. Echoing similar concerns elsewhere, the acting director 'reported that he had written to the Chief Constable about the unruly behaviour in the Museum on Sunday afternoons, and that the Constable on the beat had called in during the afternoon. This, however, had not proved efficacious.'[15] The Keeper George Carpenter also 'reported that the behaviour of a large proportion of the Sunday afternoon visitors to the Museum was unsatisfactory and caused annoyance to those who came for examination and study of specimens. He suggested it might be advisable to adopt admission on Sunday by ticket.'[16] Throughout the century, the tension between provision for researchers and other audiences is evident.

Nevertheless, both public and students gradually took advantage of the Museum in greater numbers. From an average of around 100 visitors per day in its early years, by the turn of the century it is likely that students, staff and public made up to 50,000 visits per annum, comparable with many provincial municipal museums.[17] Not until the completion of the larger extension in 1927 were more accurate visiting statistics compiled, by which time the Museum welcomed more than 150,000 visits including, as we shall see, more than 100,000 from schools. Wartime aside, then, non-school visits to the Manchester Museum numbered between 30,000

and 45,000 until the 1950s; a figure of around one tenth of the BM(NH), but four or five times that of the Pitt Rivers Museum.[18] Students numbered only in the low thousands throughout this period, so it is safe to assume that public visits were the most (quantitatively) significant.

In the decade after the Second World War, as students and University staff used the Museum less frequently, the Museum Committee began to readdress its audiences. Upon his appointment as director in October 1957, David Owen set about broadening the Museum's appeal with a marked emphasis on visitor services. If it was not to be central to the University's teaching, the Museum would become a jewel in the civic crown. 'It is quite clear', he argued, 'that a very large number of local people are still scarcely aware of the treasures within their reach.'[19] A Methodist lay preacher, Owen was zealous in his promotion of the Museum. He encouraged staff to participate in the mass media, not only on the radio (as some curators had since the 1930s) but also television.[20] His efforts were timely, as the University took custody of the Whitworth Institute (now Art Gallery) in 1958 and implemented a programme of modernisation there to render the galleries more attractive. The University was increasingly offering cultural assets to the townsfolk, he recognised, and the Museum could play a big role.

Owen was riding the crest of a national wave. During the 1960s, museums across the UK attracted many more visitors as economic prosperity generated more leisure time, and international tourism brought more visitors to London and other major cities.[21] Of the six million tourists to the UK in 1970 – ten times the estimated figure for 1950 – two thirds visited museums and galleries. The Museums Association estimated an overall increase in visits of around 80 per cent in the 1960s: the BM(NH) saw its visitor figures quadruple in the two decades from 1953, and visits to the British Museum itself nearly tripled.[22] Measured quantitatively, Owen's efforts were just as successful. In the fifteen years following his arrival, visits to the Manchester Museum increased by more than 350 per cent. Indeed, 'the museum galleries are almost too crowded for comfort', bemoaned Owen, 'we could often wish for more gallery space'.[23] Such expansion was not forthcoming, however, and in the 1970s visits per annum stabilised at around 200,000.

As well as seeking a quantitative shift in visiting, Owen began to think qualitatively about the visitor constituency. Aware that post-war slum clearances denied the Museum any immediately local audiences it may have had, he wanted to know from where visitors were coming. With this and other questions in mind, Owen commissioned a programme of visitor research. This was not the first to be undertaken at the Manchester Museum – reactions to the human anatomy displays had already been polled: in the late 1960s, the Manchester Museum was at the vanguard of visitor evaluation in the UK.[24] From the results, we gain a valuable snapshot into the visitor constituency of the Manchester Museum.[25] Only one third of visitors were from the city, but more than 90 per cent were from the surrounding county areas – which helped to persuade the GMC to fund the Museum, of which more

below. Two thirds had not visited London museums, which Owen took as powerful justification for national museums in the provinces – an ideal that would eventually be realised in Liverpool, but not Manchester. The visitors tended to be classified within the middle ranks of society, from skilled workers to professionals, which was a cause for concern:

> Certain of the manual worker occupations are not being attracted to the museum in the numbers one might hope for. It may be that in catering for the large student group of visitors and in cultivating contacts with the university, such sections of the visiting public have not been encouraged.[26]

This result mirrored general museum visiting patterns in the UK, and in his interpretation, Owen echoed similar concerns expressed by the Natural History Society a century earlier. The disparity between intended and actual audiences was a common feature of museums in both the nineteenth and twentieth centuries.

Organising the visitor

The same visitor research revealed that visits tended to last around two hours, although some for much longer periods. During this time, only a tiny fraction would directly come across a member of the curatorial staff. Rather, most would encounter the museum's 'voice' via a range of techniques employed to facilitate or regulate the visit: whether handbooks, museum lectures or temporary exhibitions. They were meant to show visitors how to see the Museum. Later I will contrast these with the motivations and interests of the visitors themselves, but first we should meet a crucial member of the Museum's staff.

While the curator was largely behind the scenes, the porter was more visible. Such personnel, so crucial in the experience of the visit and the maintenance of the collections, have rarely been afforded historical attention.[27] At the outset, the Museum employed a 'Commissionaire', soon replaced by an 'attendant', who monitored the entrance and occasionally strolled round the Museum.[28] The attendant made a rough head count, and kept out undesirables. He enacted the 1890s edict that 'children under the age of 12 be excluded from the Museum unless when in suitable charge'.[29] He was not always successful, finding rather that 'small children [had] taken advantage of his absence to make a playground of the entrance gateway'.[30] It soon became difficult for a single attendant satisfactorily to monitor the galleries; two were employed for Sunday opening, and the Chorlon-on-Medlock policemen also looked through the Museum as part of their beat.[31] The Museum reopened after the Second World War with four porters, and between six and eight were employed by the 1980s (see figure 6.1).

There can be no doubt that the attitude and aspect of the attendants had an impact on the visitor's experience. The first person most visitors saw was the porter at the entrance, in later years in a small booth next to the door. Like their peers in

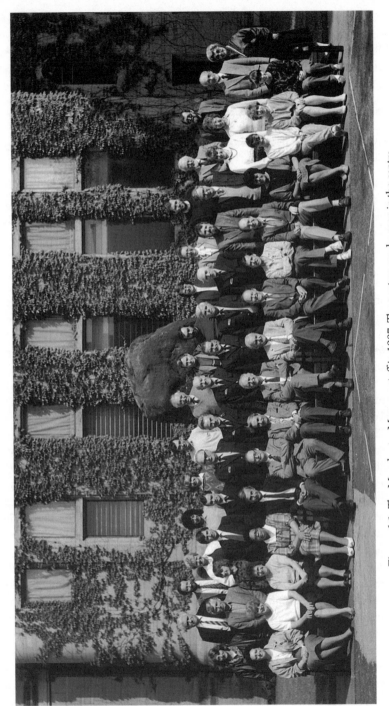

Figure 6.1 The Manchester Museum staff in 1987. The porters can be seen in the centre.

the BM(NH), porters dressed in a quasi-militaristic, police-style uniform – which reminded at least one colleague of a prison officer – instilling a behavioural code, a sense of order and quiet in the galleries.[32] The archaeologist John Prag remembered of one porter that he 'would have preferred there not to have been any public in the Museum at all', and like his peers, was 'much more there to say do not touch, do not run'.[33] Another 'had a marvellous presence. He could stand in the gallery, or proceed, in police parlance, through the galleries.'[34] One young visitor remembered 'security guards almost as terrifying as the mummies themselves'.[35]

Given that the porters were neither inclined nor expected to explain the exhibits to the visitors, and the keepers spent most of their time out of sight among the collections, different techniques assisted visitors' understandings of the layout and content of the Museum. Principal among these methods was the printed guide. The museum or art gallery guidebook had emerged as a genre in the nineteenth century, at first compiled by independent writers, and later by museums and galleries themselves.[36] The published outcomes of the cataloguing processes detailed in chapter 5 served not only to order and record the collections for staff and researchers, but also to make sense of them for those who visited the galleries. Together with the architecture, guidebooks served to shape the visit, to construct how the visitor moved and behaved. Text, arrangement and building worked together to condition the museum experience.

The authors of such publications intended to impose a particular reading of the displays, directing visitors to view them in a particular order, and in a particular way. The first *General Guide to the Contents of the Museum* in 1892 and other early pamphlets (sold from a table by the Museum boy) set out the exhibits as part of William Boyd Dawkins's evolutionary sequence of nature and culture.[37] They walked the visitor in a continuous path from mineralogy at the bottom of the Museum through to botany (and Egyptology) at the top. The segregation of audiences was reflected in subsequent publications: dense descriptive catalogues for students and naturalists, and for more general audiences *Handy Guides* 'intended merely to indicate in a cursory manner the principal objects in the Museum and its general arrangement, for the benefit of those whose time is limited'.[38]

As Dawkins's system began to fragment in the 1910s, the Keeper Walter Tattersall determined to issue discrete guidebooks for the different collections. Although his plan would not be realised for half a century, stricter divisions within the new *General Guide* during the First World War reflected and contributed to firmer divisions between nature and culture.[39] Enduring as these early publications were (variations of the 1933 *Short Guide* were used until 1970), their density may have deterred many visitors from using them on the galleries for a prolonged period. Accordingly, curators generated alternative ways of elucidating the collections, improvising a number of print techniques *in situ*. 'With regard to the typewritten guides which we have during the last few years provided for some of the exhibition cases,' reported the director in 1943, 'it is encouraging to find that as their number increases the public is

making more serious use of them; it is not uncommon now to find adults sitting at a case, studying the exhibits with the help of the guide, and making notes.'[40] Ephemeral typescript guides and additional cards available on the galleries fell between labels and catalogues on the spectrum of print communication with visitors.

The typescript guides were intended to presage separate publications, and finally during David Owen's tenure discipline-specific guidebooks were issued.[41] Like walking guidebooks issued at the Science Museum and elsewhere, they comprised short introductions to the separate disciplines, eschewing 'technical terms' and including illustrations of the objects or specimens as they would have been in life or use.[42] Gradually, however, the reprints ran out and the galleries changed to an extent that the publications no longer matched the displays, or the fields they purported to introduce. Finally, the director Alan Warhurst replaced them all with a single, glossily illustrated colour guidebook encompassing all the collections in 1985.[43] The principal printed mechanism of visitor guidance had thereby endured throughout the Museum's history: a single, brief but comprehensive guide to the collections. Like its predecessors, this guidebook served to construct a notional visitor in its tone and level, and to render the visit an experience of organised walking, for twentieth-century visitors as it had been for those in the nineteenth century.[44]

Guidebooks also served as proxy curators, given that the Manchester Museum did not generally provide guide-demonstrators, even when so vigorously advocated in the national arena by in the early century by Charles Hanbury-Tracy, fourth Baron Sudeley.[45] Such appointments at both the British Museum and the BM(NH) were applauded in Manchester, but not emulated. Only briefly did the Manchester Museum offer a series of regular 'guide-lectures'; rather, they continued with their principal mode of communication, the (stationary) 'Museum Lecture'. William Boyd Dawkins's were especially popular at the turn of the century, attracting 'mostly clerks, colliers and artisans with a few of the higher classes', leading the Museum Committee to boast that 'In this direction the Museum is becoming an important instrument in the general development of higher education in the district.'[46]

Attendance at lectures had been declining in the mid-century, when as part of his reforms David Owen reinvigorated their format and content. He enrolled university staff such as the radio astronomer Zdeněk Kopal to talk about the moon, and museum staff offered lectures on appealing topics such as the Loch Ness monster.[47] By the 1970s, lectures attracted peak audiences, complemented by a series of hugely popular day schools – attracting audiences of up to seven hundred – in collaboration with the University's extramural department.[48] By the 1980s, museum lectures held fresh significance, when 'High levels of unemployment, early retirement and the increase of available leisure-time create[d] exciting opportunities for museum education departments to capture the enthusiasm, and develop the individual interest, of members of the local community.'[49]

By this time it was clear that despite all the efforts at print communication the single most effective method of attracting new and larger audiences to the Museum

was the temporary exhibition. Small 'special exhibitions' had been staged since 1935, a practice the Museums Association had encouraged since the First World War. Temporary exhibitions then became a key part of the Manchester Museum offer in 1958, when David Owen converted the ground floor of the 1913 extension to a dedicated space for new displays. Each year between three and five (and sometimes as many as eight) exhibitions were staged. Owen was pleased with the results:

> The value of these temporary exhibitions is manifold. The museum shows a constant change and this encourages frequent visits. Complete collections can be brought out of store and seen in entirety. Interest can be focussed by publicity and we are indebted to the press for all the help they have given in bringing museum news before the public.[50]

From 1975, with the advent of the GMC-funded exhibitions team (see chapter 5 above), the Museum sent out touring exhibitions to the Greater Manchester region and beyond.

Three exhibitions in particular raised the Museum's profile (and visitor figures), involving respectively a moon rock, some mummies and a local 'bog body'. The first, as we saw in chapter 2, was the most dramatic: the hasty display of lunar soil barely two months after it had been collected by Neil Armstrong on the Apollo 11 mission in 1969.[51] A decade later, in advance of the long-awaited redisplay of the Egyptology galleries, Rosalie David oversaw a six-month exhibition, 'O! Osiris, Live Forever' (1979–80), in the basement of the Museum. Although like the moon rock the redisplayed mummies attracted unprecedented numbers of visitors, these crowds would be dwarfed by the Museum's most quantitatively successful exhibition ever.[52] In 1984, peat extractors on Lindow Moss near Wilmslow, Cheshire, came across what they first thought was a piece of wood. When a preserved human body emerged from the bog, they approached the police – a murdered woman's head had been found nearby the year before. It became apparent, however, that these human remains were ancient. The county archaeologist assembled a team to extract the body, which included the Manchester Museum keeper of conservation, Velson Horie. The coroner deemed 'Lindow Man' a national treasure, so his remains were transferred to the British Museum. After considerable regional dissatisfaction with this result in the North West, the British Museum collaborated to set up an extensive exhibition at the Manchester Museum in 1987, 'Lindow Man: The Discovery in the Moss'. Around 250,000 visits to the exhibition were recorded during the eight months it was staged.[53]

Temporary exhibitions embedded the Museum within its civic context, and to some extent compensated for the inertia of the permanent displays. But their principal function was to generate a larger numbers of visitors. They also attracted local and national attention: on the back of new exhibitions, the Museum won the coveted Museum of the Year Award in 1987. Not only had the techniques used to attract and guide visitors to the Museum changed in approach over the course of the century, they had also changed in scale. The guidebook offered to visitors

in 1990 was one tenth the length of that in 1890; but the Museum recorded ten times the visitors. Throughout, the keepers remained at a safe distance from most visitors, protected by the printed page, the lecture theatre stage and the uniformed porter. But there were other staff in the Museum who spent far more time with one especially numerous and demanding group of visitors: schoolchildren.

Educating the visitor

English museums, proclaimed the journal *Nature* in 1877, were 'the educational stock in trade of the nation'.[54] William Boyd Dawkins likewise considered them to be 'educators of the masses, offering them a means of culture which would otherwise be out of their reach'.[55] Accordingly, the Manchester Museum set out to be a primarily educational institution. And yet from the First World War the educational department of the Museum had an almost exclusive focus on primary schoolchildren. If the whole institution was ostensibly pedagogic in focus, why and how did 'museum education' come to be synonymous with school-level instruction, not only in Manchester but in the UK generally? To find out, we must examine the development of school-level education provision, the distinct staff involved, and its ambiguous place within the Museum as a whole.

Shortly after the Manchester Museum opened, a minor footnote appeared in the labyrinthine legislation relating to national compulsory elementary schooling that was to have a significant impact upon museum practice. The 1895 Day School Code stipulations as to what constituted school attendance decreed that 'visits paid during school hours under proper guidance to Museums, Art Galleries, and other institutions of educational value approved by the [Education] Department, may be reckoned as attendances'.[56] This development was seized upon by new museum professionals seeking to cement the museum's role in public life, and by the turn of the century many museums and schools were working closely together. Five principal mechanisms for this interaction were evident. The first and most involved mode of museum education was to devote the whole museum to school-level visitors, as at Thomas Horsfall's art gallery in neighbouring Ancoats and the Haslemere Educational Museum.[57] Second, by parity, there were those schools that built up extensive collections themselves; the school thus acting as museum. These two practices were rare in their pure form – more common were the extramural loan schemes of travelling cabinets, as established in Liverpool and later by Salford Museum.[58] Elsewhere, as for example at the Leeds Philosophical Museum, intramural instruction was provided for schoolteachers who then led their own classes around museum displays. Finally, a small number of museums provided direct in-house instruction for schoolchildren by their own curators, or dedicated educational officers. Although the Manchester Museum originally offered some teacher training and later set up a loan scheme, it became exemplary in this last approach.[59]

That the Museum offered intramural provision as its principal mode of school-

level education stemmed from local circumstances during the First World War. The onset of hostilities put an end to many museum activities, as the government closed the national museums and galleries (to save money, rather than collections), and encouraged municipalities to do the same.[60] In Manchester, however, school build-ings were required as military hospitals, so the town implemented a 'two-shift' system whereby classes from around twenty schools spent half the day outside school build-ings. Children spent as much time as possible outside; or otherwise at Belle Vue Zoo, swimming, at the cinema, or attending art galleries, including the City Art Gallery, the Ancoats Museum and the Whitworth Institute.[61] The Education Committee also approached the Manchester Museum for assistance, and together they constructed a scheme of classes in natural history and Egyptology, largely to be carried out by two teachers paid by the Committee.[62] This was not the first such scheme in the country, as it was to some extent prefigured by a plan for visiting schoolchildren initiated at the turn of the century at Leeds and by a formal scheme for the reception of school parties implemented by Newport Museum in 1912. Nevertheless, Manchester was heralded for years afterwards as the 'first really effective and lasting co-operation between museums and a local education authority'.[63]

The Manchester Museum continued to house local education authority (LEA) teachers after the First World War ended.[64] Nationally, the 1918 Education Act and the 1919 Public Libraries Act further encouraged education in museums and enhanced their public character.[65] However, museum professionals began to argue that although education was a vital part of museum activities, it was not their sum total. And so Manchester Museum was one of only a few museums across the country with externally resourced staff dedicated to educational activities.[66] After interrupting the service during the Second World War, the national context in which it relaunched in 1949 was very different. In the wake of the Education Act of 1944 giving LEAs more authority and finance, museum education thrived in Britain, and education services in various modes become commonplace.[67] Museum educators began to seek for themselves a professional identity distinct from curators on the one hand and teachers on the other, as for example in the formation of the Group for Children's Activities in Museums (forerunner of the Group for Education in Museums).[68] In Manchester, the post-war resurgence in museum education was marked by more informal activities, including the 'Children's Museum Club' from 1954; an extramural loan service set up in 1960; and especially, a coordinated city-wide system of courses and visits, the City Art Gallery and Manchester Museum Schools Service.[69]

By the 1970s, as the 'heritage industry' emerged in the UK, established museums found it politically expedient once more to increase their emphasis on school-level education; a tactic especially evident in Manchester.[70] With a record number of staff (six teachers, two clerical staff, a driver, a technician and a caretaker) and dedicated spaces spread across the Museum, the Manchester Museum Education Department thrived (see figure 6.2).[71] In 1981, the teachers moved to the basement, refurbished at a cost of £71,000 by the Manchester Education Committee after the University

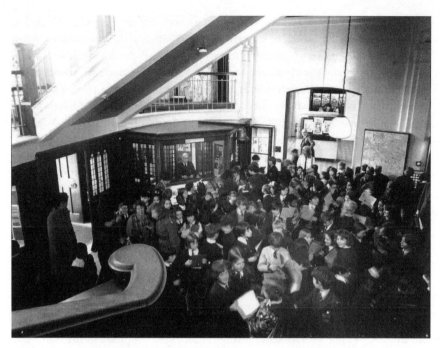

Figure 6.2 Schoolchildren in the entrance hall, 1973.

safety officer designated Waterhouse's spiral staircase in the tower unsatisfactory. Staff who had previously felt 'a bit out on a limb' were now more firmly embedded within the institution's practice.[72] Even as the new teaching space opened, however, funding cuts by the new LEA began to impact upon the Department.[73] By the end of the decade it faced an uncertain future.

In April 1993 the City of Manchester ceased to fund the Manchester Museum Education Department after eight decades, to be replaced by a self-funding system in which schools were charged for their visits.[74] Schoolchildren remained a key audience for the Museum, and the character of their visits remained strikingly constant, but the arrangements surrounding their attendance shifted in response to a changing political climate. Different aspects of that same climate, both local and national, impacted upon another significant audience for the museum – University students. For although 'museum education' in the UK principally refers to school-level delivery, the Manchester Museum also played an educational role in the University of Manchester, its parent institution.

Town and gown

In its education service and otherwise, the Manchester Museum functioned as a municipal museum. Indeed, I have argued that its intramural programme was

more embedded within civic life than the services provided by many municipal institutions elsewhere. Nevertheless, the Manchester Museum was a university collection. As such, it was part of a long and esteemed tradition (or so its directors claimed) – some of the earliest collections that we might now class as 'museums' were held by universities. Various Oxbridge colleges gathered paintings as early as the fifteenth century, and the Ashmolean in Oxford was opened as the first ostensibly 'public' museum in 1683.[75] In the centuries that followed, large collections were endowed or donated to British universities by John Woodward (Cambridge, 1727), Fitzwilliam (Cambridge, 1816), William Hunter (to Glasgow University, posthumously in 1807), General Pitt Rivers (to Oxford University, 1883) and Flinders Petrie (University College London, 1913). The new university colleges founded in the English provinces in the wake of Owens College's foundation in 1851 all included museums, ranging from small departmental teaching collections to sizeable art galleries.[76]

Coincident with the construction of the Manchester Museum was a series of new buildings for the older collections, including the Hunterian (1870), the Ashmolean (1894) and the Sedgwick (1904, based on Woodward's collection in Cambridge). These grand new premises rendered the museums more visible and accessible than ever before, and made a significant impact upon the civic built environment. This provoked a tension in governance and display evident throughout the twentieth century: how could a single institution simultaneously satisfy the needs of university and 'general' audiences? 'The problem', as identified in the Wright report on provincial museums in 1973, 'is that a university under pressure for resources cannot reasonably be expected to develop and display such collections to serve purposes beyond its own functions.'[77] How, then, did the Manchester Museum function in its higher educational and civic contexts? Where was it positioned relative to university and to city, as enacted though governance and funding, and how did this impact upon the status of the staff, exhibitionary strategies and the built environment?

The Manchester Museum is a particularly interesting case study in this respect, given its unusual town-gown funding arrangement.[78] For nearly a century, it functioned as both a municipal and academic collection, governed by both University and city, an arrangement unique in the UK. The Museum Committee, which included seats not only for professors but also for local government, reflected this hybrid character.[79] Its duality was not always evident to the townsfolk, however. At the Museum's silver jubilee celebrations,

> Opportunity was taken to impress on those who attended that the Museum is a public institution open freely to the public daily, a fact that is even yet not generally understood. . . . The administration of an important public Museum by an academic corporation is not in accordance with the usual practice either in England or abroad. Those who have had the privilege of serving the Manchester Museum in any capacity are convinced that here the system has been fully justified by its results; they are able to look forward confidently to the increasing usefulness of the University with

the Museum to the City and its regional area, by the promotion of a real interest in those specimens and objects, whether rare or familiar, which can be displayed so as to increase knowledge and to help understanding.[80]

Twenty years later, the Chair of the Museum Committee still found cause to complain, 'The trouble is that the Museum falls between two stools: the city considers it an entirely University affair – although they must be acquainted with museums in other cities – and the University can only develop it in relation to its finances, and you cannot expect the University Grants Committee to finance a city museum.'[81]

Staff also felt this tension. Although they were University employees, their duties reflected the demands of both stakeholders. Their standing in relation to other university staff was indicative not only of the place of the Museum but also the status of museum-based disciplines such as systematic biology in an era when laboratory science and field-based anthropology were emerging as hegemonic practices within academia. Other university collections, including for a period the Whitworth Art Gallery, were embedded within faculty structures and/or run by departmental chairs. At the Manchester Museum the Keeper and his staff were not members of faculty but were nonetheless ostensibly supervised by the relevant professors as 'scientific supervisors'. In the Museum's early years, the supervisors exercised hands-on management of the collections, a relationship that as we have seen did not always run smoothly.[82] As the focus of many academic disciplines shifted away from material culture and therefore museums, so the relationship between the collection and the departments became increasingly distant. Even geology and zoology, which retained their focus on specimens, set up their own teaching collections separate from the Museum. The scientific supervisors became less involved with the day-to-day running of the Museum as its collections became more peripheral to their teaching and research.[83]

How, then, was the Museum to attract and to cater for diverse audiences, student and public, in its exhibits? Whereas university collections in towns that also had a municipal museum with a similar remit felt little need to render their displays inclusive, the Manchester Museum, like the Hancock Museum in Newcastle, functioned as the civic natural history collection. From Huxley's involvement onwards its staff struggled to render its galleries not only legible to the general visitor but also useful for university teaching. In the 1970s, one solution implemented by the Manchester Museum zoologists 'to reconcile the inevitable conflict which results from our being an institutions used by both town and gown' was to display thematic, accessible exhibitions in the uprights of the table cases, and taxonomic arrangements in the horizontal.[84] Panels for students were blue, and those for 'public display' orange.

The Museum's physical location within the urban landscape was fundamental in its relation to town and gown (see figure 6.3). When Owens College moved out to new premises in suburban Chorlton-on-Medlock, it became removed from the centre of Manchester, a short but crucial distance that to this day impacts upon the Museum's attendance. The collections attracted few visitors from its immediate

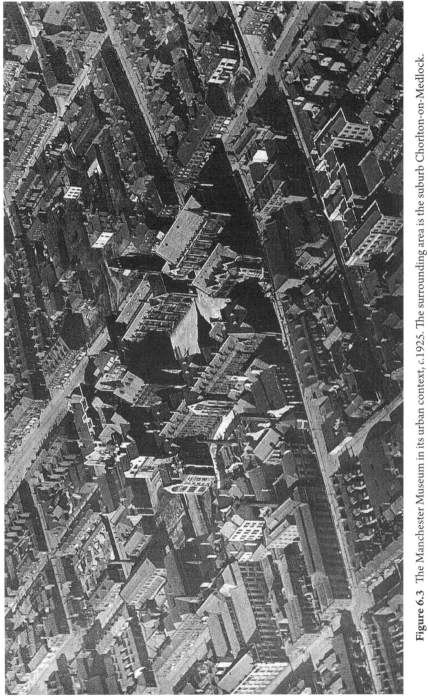

Figure 6.3 The Manchester Museum in its urban context, c.1925. The surrounding area is the suburb Chorlton-on-Medlock.

neighbourhood, and even fewer after Chorlton-on-Medlock disappeared under a sea of University concrete in the 1960s. As Owen lamented, 'the enormous slum clearance programme began to reduce the immediate local population and the casual visitors became fewer . . . the University is surrounded by hundreds of acres of cleared land'.[85] Local families with children who had once played in the galleries were removed to Withington, Wythenshawe and other suburbs, and no longer visited on such a casual basis.[86] The neighbouring streets were replaced by new buildings for the sciences on the east side of Oxford Road (but not, as discussed in chapter 2, for the Museum). In the wake of the Robbins Report on UK higher education in 1963, the University then embarked on an even larger construction programme that fundamentally altered the Museum's built environment. No longer the University's flagship building, the Museum became dwarfed by new buildings such as the Medical School down the road and the Maths Tower opposite (see figure 7.2). The Museum, once the physical town-gown interface, was now embedded within the University campus, removed from the general civic landscape.

Conscious of this galloping growth, the University, the corporation and the hospitals jointly set about shaping a coordinated 'Manchester Education Precinct'.[87] More than 280 acres were to be landscaped, and connected with overhead walkways. The planners were especially keen that the area should be not only educational but residential, and intended that 43,000 staff, students and general public should live on site. Central to this (unrealised) vision was the notion of a 'town centre' on Oxford Road, boasting cultural amenities including the Royal Northern College of Music, the Phoenix Pub, and the Museum. Although the education precinct stalled, and a mooted new building for the Museum never materialised, the Museum benefited by expanding into the neighbouring building, originally the Dental School and latterly housing the Department of Metallurgy.[88] At a time when the University Grants Committee was loath to fund capital projects for museums, the University and the GMC jointly provided the £250,000 necessary.

This would be the last capital injection of its kind. The 1980s marked a distinct shift in the climate for British university museums. Already the Standing Commission on Museums and Galleries had noted that natural science students were neglecting museum collections.[89] This concern was echoed in an influential 1979 report:

> It is clear that the university museums are in many disciplines used less today for teaching purposes that when they were originally formed . . . But the public interest in their contents is growing and some re-assessment of their function and potential may therefore be necessary.[90]

As its diminishing revenue proved inadequate to effect change on the out-of-date galleries, the Manchester Museum moved to a model of fund-raising that drew on corporate sponsors and one-off grants.[91] Its income suffered a further blow in 1986 when the abolition of the GMC cut half the Museum's funding at a stroke. After a

desperate campaign, Warhurst secured short-term funding directly from the Office of Arts and Libraries.[92] No longer anchored by local government monies, over the following decades the Manchester Museum rode the waves of higher education collection funding in Britain.

At the end of the twentieth century, then, the Museum apparently returned to its origins as a collection funded from within the higher education sector. Did ninety years of collaboration with the local authority have any impact? The result was a university collection that fulfilled the function of a municipal museum. The town's demands gave the Manchester Museum impetus and motivation in a century when the relationship between academic disciplines and material culture waxed and waned. The link with the town provided funding for extensions, brought visitors through the doors and stimulus, if not means, for gallery development. Even as the concrete University enveloped it, the Museum remained rooted in civic culture, even to the extent that (until recently) the collection's connection with the University have not always been clear. Serving two apparently disparate stakeholders and audiences was no doubt a headache for generations of keepers; but to assume such a simple dichotomy, a straightforward tension between two polar opposites, is to ignore the heterogeneity of both student and lay audiences; contingent local factors such as the development of other museums and slum clearances; and the shifting relationship between museums and universities.

Involving the visitor

Schoolchildren and University students alike engaged with the Museum in quite a hands-on way, gaining closer contact with objects than they might have on a casual visit. But they were by no means unique in this respect. Analysts of audiences and the public engagement with science have discounted models of cultural consumption that cast viewers, readers and visitors as passive vessels.[93] All those who passed through the doors of the Museum engaged in some way with the space and the collections, although for the majority of visitors this was on a private, affective level, discussed in the following section. Here, however, I am concerned with four especially visible modes of interaction in order to demonstrate the active nature of museum visiting: enquiring, researching, learned society involvement, and volunteering. Those who participated in the Museum in these ways have rarely been accounted for in the study of museum visitors, and yet they were ever-present in the day-to-day life of the Museum – whether the curators liked it or not.

Label texts, catalogues and guides could never answer all the questions visitors might have. As soon as the Museum opened, a steady series of enquiries were aimed at the staff, whether related to the collections, the disciplines they represented, or utterly unrelated to anything. 'The staff are frequently asked for information on their special subjects,' reported director George Carpenter in 1933, 'particularly in regard to matters of economic bearing.'[94] Fiscal interests dictated a significant proportion

of the queries directed at each collection and by 1970, up to 100 valuation requests were made per year. Many others asked for images, and members of staff became expert photographers as a result; eventually the Museum included a photographic studio in the basement. Requests for identification were also common, especially in numismatics and entomology.[95]

Certain visitors wanted to engage more closely with the collections. From the outset, the staff gave careful thought to the anticipated needs of those who came to the Museum to study particular items. These visitors – 'students' in the old-fashioned sense – were especially valued, to be sheltered from the general hubbub of the galleries, and so dedicated space was set aside:

> It is anticipated that this arrangement will not only provide quieter surroundings for the serious students of Zoology than have been hitherto available in the open Museum, but it will also have the advantage of enabling the Committee to keep the collection of specimens exhibited to the general public undisturbed.[96]

A small but steady stream of specialists passed through the Museum – some two dozen per annum used the herbarium in the 1930s, for example – studying the specimens closely, their research facilitated by the keepers. In return, the Museum staff learned more about their own collections, and the status of both staff and collections was reinforced. Esteemed visitors were listed in Museum publications, lending the collection kudos and echoing the earlier practice of recording notables in the visitors' autograph book.[97]

Such interaction with groups and individuals demonstrated the dynamic network of organisations and institutions in which the Museum was embedded.[98] The very first visitors to the Museum were members of scientific societies including, as we have seen, the British Association for the Advancement of Science during its annual meeting in 1887. Especially closely involved in its early years were the Conchological Society of Great Britain and the Manchester Geological Society (after 1904, the Manchester Geological and Mining Society). As the cultural collections grew, so cognate organisations such as the Manchester Egyptian Association (later the Manchester Egyptian and Oriental Society) also became closely involved with the Museum. Staff were well represented in the upper ranks of these organisations: Winifred Crompton was central to the Egyptian Society, and curators served as presidents or secretaries of many local (and some national) societies devoted to anthropology and archaeology, microscopy, entomology, conchology, natural history, numismatics and antiquarianism. In 1925 the importance of such bodies to the governance of the Museum was reflected in the invitation to nominate representatives to sit on the Museum Committee. Members of local clubs and societies were keen and regular attendees at Museum lectures and events, and many held their meetings in the Museum.[99] They visited in groups on weekends, prompting the staff to print tailored guides for them; as evidence of the symbiotic relationship, 'Such visitors frequently present[ed] valuable specimens to the Museum'.[100]

The Museum was also embedded in national and regional museum networks, including the Museums Association and the North West Federation of Museums and Galleries.[101] In this respect the Museum was significant not only as an organisation but also as a venue. Never was this more apparent than during various 'conversaziones' – for example held by the Manchester Geological Society – and at the Museum's own annual soiree, the latter hosted by the vice-chancellor (eventually discontinued because its popularity rendered it prohibitively expensive).[102] Just as natural knowledge had been part of the coffee-house culture in the eighteenth century, so in the nineteenth and twentieth centuries, science operated in the public gaze in social events of this kind.[103] The great and the good rubbed shoulders with the Museum staff, viewing the latest acquisition and maintaining the Museum's place in the cultural make-up of the University and the city. Attendees, like members of learned societies, were not passive audiences members but rather active participants in the social construction of the Museum in their engagement with personnel and objects alike. The same notable citizenry came to see and be seen in the Museum as they did in the Art Gallery, the Town Hall and at the Hallé Orchestra.

The soirée attendee, the learned society member, the enquirer and even the researcher were only to a certain extent active participants in the Museum. Another community transgressed the boundary between staff and curator to a far greater degree. Volunteers were a constant feature of museum life throughout the century, from schoolchildren and students to experts and retired members of staff.[104] For some, long-term involvement was formalised with an honorary appointment, as discussed in previous chapters. The character of their involvement and their relationships with the paid staff is evidence of the shifting status of amateurs and professionals in the sciences and humanities.[105] The construction of professional communities in the late nineteenth century involved the recasting of the relationship between professional curators and amateurs, and especially women. Museum volunteers were often female, as women worked with museum collections in a voluntary capacity in order to circumvent the male dominance of paid positions. This sometimes reaped rewards: for Winifred Crompton (who catalogued in her own time in conjunction with her paid role as the Museum's printer) and her successor Mary Shaw, years of unpaid labour eventually bore fruit in their successive appointments as assistant keepers for Egyptology.

Volunteer involvement was not without its problems. The security of the collections was an issue, and the relationship between paid and unpaid staff relied on trust – especially in numismatics, with such (financially) valuable objects. When this trust was transgressed, and relations deteriorated, the results were complex and protracted.[106] Furthermore, in the 1960s, the technicians were concerned that reliance on volunteer labour might prejudice further appointments.[107] Nonetheless, the Museum continued to involve volunteers and in the 1980s, in conjunction with the Manpower Services Commission, museums relied on a large informal workforce. The volunteers' ambiguous position in this arrangement, between curator

and visitor, indicates the complexity of mapping the communities of practice in and around the Museum. Even more challenging for the historian, however, is assessing the motivations and responses of its users.

The visitor experience

Having begun to differentiate the communities of users in the Museum, in closing this chapter, I want to unpack the experiences of the visitors themselves. Drawing on the limited sources available, one can explore their motivations, the senses engaged in the Museum, and their responses to the collections. Although the latter are of course heterogeneous, the focus here is on the solemnity of the visit on the one hand and the awe generated by (some) objects on the other. In keeping with my approach throughout this chapter, I will contrast the Museum's early years with the decades following 1960 to illuminate change over time (or lack thereof).

Although they hoped that most visitors would use museums for educational purposes, curators also acknowledged other uses of the Museum space. At the British Association meeting that saw the Manchester Museum open for the first time, Henry Higgins of the Liverpool Museum categorised museum visitors as 'students', 'observers' or 'loungers'.[108] Here he acknowledged that for all the curator's efforts to render the museum edifying, visitors had their own motivations. In 1909, the Museum Committee noted with consternation 'an increase in number of students in the Museum, who were using it as a general reading room'.[109] By the time David Owen undertook visitor research in the Museum in the early 1970s, it was clear that two thirds of visitors were visiting the Museum for 'casual purposes'.[110] When asked of their reasons for visiting, 15 per cent of respondents were there to pass the time; 16 per cent were bringing others; a huge 28 per cent came because they happened to be passing; and a quarter had come to see a specific exhibit.[111]

This was despite a century of curators seeking to instil museum visiting as a habit. The museum and library advocate Thomas Greenwood's advice was to 'Visit the nearest Museum periodically, and let it be to you an advanced school for self-instruction.'[112] It is clear that a small core of visitors, especially those that had visited as children, came back time and again. This was to be encouraged: 'it takes a long time to build up a habit of museum visits' recorded David Owen as he began to campaign for more visits, 'so many people, on hearing the word "museum" exclaim, "Oh, I haven't been there since I was a child"! Once it is recognised, however, that a trip to the museum is rewarding, people plan frequent visits and watch the papers for items of museum interest.'[113] It is unclear how many visits resulted in 'playing hide and seek around the cases', as Hoyle expressed the common fear of curators.[114]

Whether motivated by education or entertainment, it is clear that for some, visiting the Manchester Museum was not an isolated habit, but rather part of their wider leisure patterns. Libraries, theatres and galleries were part of the same cultural portfolio, such as that of one visitor who reported proudly that she was 'interested

in everything'.[115] 'It is thus clear', maintained David Owen, 'that the majority of our visitors look to us for their cultural heritage and not to London.'[116] Some of the visitors and most of the staff considered the Manchester Museum to be a jewel in the city's cultural crown. We can assume that during the rest of the Museum's history, as in 1970, the majority of the Museum's visitors were from the surrounding areas. For these suburban residents, central Manchester's function was not only corporate and commercial, but also cultural.[117] Its collections may have arrived from far-flung, exotic spaces, but they nevertheless became absorbed into Manchester's civic identity. Cultural assets such as the Manchester Museum contributed to visitors' sense of belonging to place.[118]

Visitors therefore felt a powerful sense of ownership: one telling visitor response to the proposed changes at the end of the twentieth century was simple – 'don't spoil it' – which prompted the Director to reflect, 'there are many people who care about the Manchester Museum and feel it to be *their* museum. They grew up with it, and want to return to it, perhaps with their children and even grandchildren.'[119] Iconic specimens became identified with Manchester rather than with their provenance – Maharajah was 'the elephant who walked to Manchester' (not 'the elephant who walked from Edinburgh' nor 'the elephant who spent several decades walking the country with Wombwell's Royal Number One Menagerie'); likewise the Manchester moon rock; and, especially, the Manchester mummies.[120] Nowhere was this fierce sense of protection more evident than when Lindow Man was 'removed' to London, for although it was the Manchester Museum's most popular exhibit, he belonged to the British Museum.[121]

Among the motivations that brought people to the Museum, then, were education, entertainment and a sense of civic identity. So far, so unsurprising. But what happened once they encountered the collections? What senses and emotions were involved in the visit? It appears from even the few traces of visitors' responses that their experiences were highly varied, far beyond that which curators intended. For much of the nineteenth century, museum professionals sought to render the museum a purely scopic site, for hands-off contemplation. Like others promoting science to new publics, Thomas Huxley emphasised the importance of the visual.[122] In the expanding public museum sector in the late Victorian period curators tried to construct transparent, ordered displays and clear labelling, which were constituents of particular ways of displaying and viewing. Natural history displays, like General Pitt Rivers's archaeological exhibits, were intended to 'speak to the eyes'.[123] Looking was the fastest and most effective way to learn – simply to place an object in view would be sufficient to embed it within the memory and understanding of the museum visitor. They were intended to gaze intently upon the objects, in calm contemplation. Beatrix Potter, then a budding naturalist, visited the Museum in 1895. 'Went to Owens College Museum in afternoon', she recorded in her diary, 'very cool and quiet among the fossils'.[124]

Not all visit(or)s were so quiet. Whether from personal tours, museum lectures,

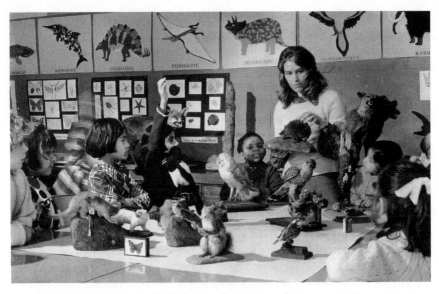

Figure 6.4 A school group in the Museum classroom, *c.*1980.

or the noisy bustle of the audience, the visit was an aural as well as a visual experience. The twentieth-century museum was still a site for sociability, as its Enlightenment forebears had been. Rather than social equals conversing with the collector, however, visitors were talked *at* in the museum. No doubt they nevertheless continued to share their responses with each other: as James Secord demonstrates, conversation was a crucial component in the experience of science.[125] And if the aural experience has been too often ignored in the history of museums, so too has the tactile.[126] Victorian collections had been gradually removed from the visitors' haptic range as the use of formal vitrines increased, distancing the observer and specimen. Although many of the specimens in the Peter Street Museum had been out in the open, in the new Oxford Road premises they were all encased: objects were thereby reified, rendered sacrosanct.

Gradually over the course of the twentieth century, however, visitors were able once more to enjoy more haptic engagement with the collections. From the interwar period, science museums such as those in London and Munich began to offer hands-on experiences.[127] The importance of the tactile was embedded in the experience offered by the Manchester Museum Education Service in particular (see figure 6.4):

> When children visiting a Museum are able to handle actual Museum objects the use of tactile as well as visual senses stimulates them to produce a wide variety of creative work. The fact of being able to touch an owl, for example, to feel the incredible softness of its down feathers, to look closely at the complex pattern of its colouring and to turn it round and study it from all angles, is so inherently exciting that all children are stimulated towards creativity.[128]

Figure 6.5 Drawing birds on the gallery, *c.*1950.

By contrast, on the gallery, as one visitor who remembered coming to the Museum as part of a school group in 1925, 'everything was in glass cases – you couldn't touch anything' (see figure 6.5).[129]

The museum visit, then, was a varied, multi-sensory event. And it also had the potential to be a profoundly affective experience. William Boyd Dawkins was highly critical of the curiosities in the old Natural History Society Museum – intended as he saw it to incite wonder, horror and disgust – as opposed to the serious, scholarly collection that he retained.[130] If Dawkins and his successors wanted the displays to educate and to engage, and perhaps at times to astound, these only accounted for a fraction of visitors' responses. But as Sharon Macdonald found in her recent study of late twentieth-century visitors, 'amidst the variety were also certain patterns which . . . could be seen as part of a repertoire of prevalent interpretations'.[131] Among the scant recorded and remembered responses to the Manchester Museum's displays, some groups of common experiences, certain regimes of value, are discernible. Particular aspects of the experience were privileged, and certain ways of expressing the visiting experience were afforded more validity than others. Here I want to concentrate on two apparently contradictory attitudes to the Museum – that it was a forbidding space, but that the objects within it were awe-inspiring. These responses were a combination of that which was elicited by the

display and that which came from the visitors themselves, which I have elsewhere dubbed the 'museum affect'.[132]

The memories many visitors took away with them was that of a sombre, subdued experience.[133] This response was associated especially with the uniformed porters patrolling the galleries and with Waterhouse's cathedral-like architecture. The responses to the building support recent sociological research into audiences, which posits that visitors to urban cultural assets viewed them as 'a series of physical interventions in the built environment' so that the 'city becomes its buildings'; often the architecture had as much an impact as the contents of the institutions.[134] One visitor recalled that entering the Museum in the 1960s, wearing Sunday best, was like walking into a church.[135] Another remembered from visiting in the mid-century 'the staircases and the stuffed animals' in particular, and that one 'had to be very quiet, like libraries. . . . It would be quite hushed, I think. You'd have had to be a brave person to come in on your own. . . . You didn't touch things, and you didn't ask.'[136] The same visitor remembered the dustiness of the animals – an impression that Owen acknowledged: 'the name "museum" . . . denotes to many people a dry, dusty, dead collection of antiquities and freaks of nature housed in unlit cases of glass and ebony.'[137]

Some visitors may have been intimidated, but it did not seem to impinge upon their fascination with particular objects. A small number of especially iconic specimens instilled particular awe. Size especially invoked a powerful sense of wonder in the visitor and throughout the century, visitors of all qualifications relayed their fascination with the gigantic. Upon entering the natural history gallery, the attention of visitors was often drawn to the sperm whale hanging from the ceiling, as it was for visitors in Hull, which had a Sibbald's Rorqual similarly suspended. Other mammals caught visitors' attention, especially children's. Curiosity and the appeal of the exotic was a factor for many: 'There would be stuffed animals', remembered one visitor, 'that I would never have seen in the flesh, only in picture books.'[138]

These iconic specimens were almost always mammals, with two notable exceptions: an enormous spider crab and the living reptiles. From the year after it opened in 1964, the vivarium accounted for significant increase in attendance, and within a decade it was the most popular destination within the Museum.[139] Feeding time was especially popular, a performance that involved live rats (provided by local medical laboratories). Even the same visitor who complained, 'I didn't like the snakes in the vivarium,' nevertheless admitted, 'I quite liked the frogs.'[140] Some experiences were not so sanguine, such as the 'young sand blaster' who while working on the roof 'actually fell through a skylight onto a python's cage. Neither man nor snake was hurt but it is still not certain which was the more frightened.'[141] Periodically a serpent or crocodile would escape, but no (recorded) harm came to visitors or beasts.[142]

The popularity of the live animals was equalled only by the ancient Egyptian human remains, which like the vivarium were viewed by more than 80 per cent of those of visited in 1974 – just as the Egyptian mummies were arguably the most

popular archaeological items at the British Museum, so too in Manchester.[143] Kathleen Wright visited the Museum in 1924, and still remembered the mummies vividly more than eight decades later:

> I loved the mummies. . . . I was about eleven when [Lord Carnarvon and Howard Carter] opened [Tutankhamun's] tomb in Egypt [in 1922]. The *Daily Mail* made a lot of this. The pictures were marvellous. . . . It fascinated me. . . . In those days I thought the mummy section [in the Manchester Museum] was remarkable. I was fascinated by them, because I had been so interested. I do remember reading about this Tutankhamun . . . in the newspaper. Day after day, it was marvellous. So when I saw the actual mummies at the University, I thought it was wonderful. . . . To me, because I was so interested, remember, that was my favourite part. . . . To me, those mummies were very, very well displayed, and I remember being very impressed.[144]

Other visitors echoed her sentiment, remembering that 'Egyptology was fascinating . . . all the little figures, the little boats [from the Tomb of the Two Brothers], and the mummies.'[145] Although they were far fewer in number than the natural history specimens – and the Museum had only accepted them reluctantly in its early years – for many the Egyptian objects were the defining characteristic of the Manchester Museum.

The widespread fascination with these human remains should not lead us to make assumptions about essential responses to particular morbid objects, but rather that a particular combination of the exotic, the ancient, and the uncanny privileged the mummies in many visitors' memories and prompted such wondrous responses. I would argue that their local identification as the 'Manchester mummies' also contributed to this, as they became iconic and integral jewels in Manchester's cultural crown. These factors, and especially the latter, combined again to generate the highest visitor figures ever recorded for the Manchester Museum when Lindow Man was exhibited in 1987. The public reaction to the exhibition (and the subsequent retention of the remains by the British Museum) forcibly answers one journalist's query to Neil Hamilton, then Conservative MP for Tatton: 'Isn't it really a lot of fuss about what's basically a bag of bones?'[146]

One other object challenged the awe elicited by human remains, one which again despite its exotic provenance and brief spell in Manchester Museum did not prevent it from being absorbed into the civic consciousness: the briefly displayed 'moon rock' in 1969.[147] 'We came to see the moon rock,' remembered one visitor, 'of course it might have given us diseases, so it was in a dome-like thing.'[148] (The dome actually served to protect the tiny sample rather than the visitors.) And yet the fragments were not stunning objects, as even Jack Zussman, the mineralogist who brought the sample to the Museum, acknowledged. 'People filed in and looked at it, and they went away I think feeling that they were glad they came and saw it, so they could say, 'I've seen a bit of the moon', but I don't think it was terribly photogenic . . . I heard one lady say, 'I've seen something like that in our grate. It was a bit like cinders from

a coalfire.' Similarly, a member of staff at the time remembers the Director describing the sample as 'a little bit of cigarette ash'. Even Neil Armstrong had described moon soil as 'powdered charcoal'. Many visitors were nonplussed by its appearance: one later admitted, 'it meant nothing to me ... I was more into the tatty old mummy they had on display'.[149]

The disappointment of the moon rock notwithstanding, visitors generally reacted positively to at least some aspects of the Museum's displays, even if only one of these key iconic objects. There were a few notable exceptions, and these were a constant worry for the Museum authorities: vandals and thieves. The former included students staging sit-ins in the adjoining Council Chamber (who damaged doors) to 'Militant Suffragists' (who never appeared).[150] Among the objects that fell victim to those who sought to assist in the Museum in reducing its burdensome collection were twelve silver coins from the Hibbert collection in 1906; 200 Japanese objects in 1960; and a Dresser egg a decade later.[151] These objects tended to be portable and valuable. One example bucked this trend: a thief broke into a numismatics case, not for doubloons or silver, but rather to ransack one of the packets of recent decimal coins issued by the Royal Mint, presumably for bus fare.[152] Of around 4 million specimens, however, losing only a few hundred in this way was perhaps a decent record. And of the 10 million visitors, those who responded in such an extreme manner were very few.

Conclusion: expanding the history of museums

The history of the Manchester Museum, then, is not only a history of buildings, disciplines, acquisition routes and practices: it is also fundamentally a history of people, and how they related to objects. Curators and conservators arranged, cared for and displayed them – but to a greater or lesser extent, this was always with their use in mind. And these users have been the concern of this chapter: the different audiences for the Museum – whether working man, schoolchild, student or volunteer – how curators sought to attract, engage and/or control them, and how they in turn responded. Four themes have emerged during the course of this exploration that connect them to arguments in the chapters above: a marked shift in approach to visitor engagement; the enduring significance of class; the invisibility of certain categories of actors in the history of museums; and the active nature of museum visiting.

From this preliminary exploration of the variety of constituencies and experiences, we can see a pattern not so much of changing reactions to collections, but changing mechanisms for engagement between Museum (objects and staff) and the visitor. In its roots in the Victorian era, educators, curators and men of science seeking to construct professional communities were working to arrange collections – whether open or closed – as ordered and/or taxonomic. Haphazard private collections were eclipsed by regulated public museums and dedicated educational collections. Those that did not conform to these standards – the taxidermist's shop, the lurid anatomy

show – were deprived of credibility. By the end of the century, however, adrift from the University, the Museum was once again leaning towards these entertaining sites, with blockbuster exhibitions, colourful catalogues and brighter galleries. During the course of the century, the curators' attention expanded from seeking to control the quality of the visit to also attracting much larger quantities of visitors. In the 1870s and 1970s alike, museum advocates fretted over the class of visiting public – from Dawkins's appeal to the 'working classes and the young people of the district' to Owen's concern about the lack of 'certain manual worker occupations'.[153] Neither was terribly successful, and from what we can glean, the core of the Museum's visits comprised the ever-present school groups and repeat attendance from those whose background instilled or facilitated the habit of museum visiting.

We have also met particular users at the heart of the audience – researchers, learned societies and volunteers – whose efforts sustained the Museum and its collections. They and other visitors were not passive dupes, and approaching this study with an active audience model in mind has been profitable. Throughout this account there has been evident the tension between museum authorities controlling the visit and museum audiences constructing their experience and affective responses. Visitors chatted, touched things and complained about the smell. As curators well knew when they displayed whales and dinosaurs, mummies and skulls, visitors walked straight past carefully worded labels and gaped at the largest or ghastliest specimen. Thousands of specimens were on display, and millions in store – but only a select handful profoundly impacted on the visitors.

These reactions, and visitors' memories and imagination, were historically specific. Response theorists posit that reception is locally embedded within particular interpretive formations and social conditions.[154] The reverence and wonder felt by visitors in 1890 were different from those experienced by their counterparts a century later, in a different affective climate. By studying curatorial intention alongside audience response it has become clear that as didactic as displays may have become, the museum-visitor encounter was dialogic. The standardisation of the museum space, the educational schemes and guide books, were all constructed to police this enduring diversity of behaviours and the emotive reactions. Their success is debatable.

The encounter between visitor and specimen was not the last event in the object's life. The practices and processes detailed in the last chapter continued, and more objects arrived and departed, as we saw in chapter 4. Collections are dynamic entities, and ending this account with the visitor experience is not to imply that this was the end of the object's trajectory. Within these pages we have met the people who came into contact with museum things: collectors, curators, conservators, volunteers and schoolchildren. We have explored the spaces in which they were worked, stored and displayed. We have seen some of the uses to which they were put, and how they were used to build disciplines within a university museum. But most of all, we have seen how they enabled interactions between people, whether in knowledge production or otherwise.

Notes

1 Manchester Museum Central Archive (hereafter MMCA) *Manchester Museum Reports* (hereafter *MMR*) (1889–1986).

2 S. J. M. M. Alberti, 'The museum affect: visiting collections of anatomy and natural history', in A. Fyfe and B. Lightman (eds), *Science in the Marketplace: Nineteenth-Century Sites and Experiences* (Chicago: University of Chicago Press, 2007), pp. 371–403; G. Fyfe and M. Ross, 'Decoding the visitor's gaze: rethinking museum visiting', in S. Macdonald and G. Fyfe (eds), *Theorizing Museums: Representing Identity and Diversity in a Changing World* (Oxford: Blackwell, 1996), pp. 127–50; C. Haynes, 'A "natural" exhibitioner: Sir Ashton Lever and his *Holosphusikon*', *British Journal for Eighteenth-Century Studies*, 24 (2001), 1–14; E. Hooper-Greenhill, *Museums and their Visitors* (London: Routledge, 1994); Hooper-Greenhill, 'Studying visitors', in Macdonald (ed.), *A Companion to Museum Studies* (Oxford: Blackwell, 2006), pp. 362–76; K. Hudson, *A Social History of Museums: What the Visitors Thought* (London: Macmillan, 1975); B. Longhurst *et al.*, 'Audiences, museums and the English middle class', *Museum and Society*, 2 (2004), 104–24; Macdonald, 'Accessing audiences: visiting visitor books', *Museum and Society*, 3 (2006), 119–36.

3 Manchester Natural History Society (hereafter MNHS), *Report of the Council* (1857) in MMCA, CNH1/4, 7 January 1857, p. 2; S. J. M. M. Alberti, 'Placing nature: natural history collections and their owners in nineteenth-century provincial England', *British Journal for the History of Science*, 35 (2002), 291–311.

4 Alberti, 'The museum affect'; T. Bennett, *The Birth of the Museum: History, Theory, Politics* (London and New York: Routledge, 1995); Bennett, *Pasts beyond Memory: Evolution, Museums, Colonialism* (London: Routledge, 2004); Fyfe and Lightman (eds), *Science in the Marketplace*; T. H. Huxley, 'Suggestions for a proposed natural history museum in Manchester', *Report of the Proceedings of the Museums Association*, 7 (1896), 126–31.

5 MMCA, Manchester Museum Committee Minutes (hereafter MMCM) vol. 1 (10 January 1890).

6 MMCA, R. D. Darbishire, 'Memorandum on the Trust of the Manchester Museum', 2 May 1895.

7 L. Keppie, *William Hunter and the Hunterian Museum in Glasgow, 1807–2007* (Edinburgh: Edinburgh University Press, 2007); W. Whyte, S. Daultrey and L. Hide, *A Fitting Tribute: 100 Years of the Sedgwick Museum* (Cambridge: Sedgwick Museum of Earth Sciences, 2004).

8 MMCM vol. 1 (5 May 1891).

9 MMCM vol. 4 (19 February 1895); W. B. Dawkins, 'The organisation of museums and art galleries in Manchester', *Manchester Memoirs*, 62 (1917), 1–10.

10 MMCM vol. 1 (25 October 1895), (5 June 1896).

11 G. N. Swinney, '"I am utterly disgusted." – the Edinburgh Museum of Science and Art effecting moral decline?' *Review of Scottish Culture*, 16 (2003–4), 76–84.

12 MMCM vol. 2 (27 October 1898); *MMRs* (1898–1904).

13 W. T. Stearn, *The Natural History Museum at South Kensington: A History of the British Museum (Natural History) 1753–1980* (London: Heinemann, 1981).

14 MMCM vol. 1 (17 January 1896), p. 305.

15 MMCM vol. 4 (5 March 1923), p. 85; K. Hill, '"Roughs of both sexes": the working class in

Victorian museums and art galleries', in S. Gunn and R. J. Morris (eds), *Identities in Space: Contested Terrains in the Western City since 1850* (Aldershot: Ashgate, 2001), pp. 190–203.

16 MMCM vol. 4 (24 March 1924), p. 121.

17 Alberti, 'The museum affect'.

18 B. Blackwood, *The Origin and Development of the Pitt Rivers Museum* (Oxford: Pitt Rivers Museum, 2nd edn, 1991); Stearn, *The Natural History Museum*.

19 MMCM vol. (9 March 1959); 'Profile: David Owen', *Communication* (Victoria University of Manchester newsletter) (October 1976), p. 13.

20 MMCM vol. 5 (8 October 1945); vol. 6 (9 March 1959); *MMRs* (1932–42); Manchester Metropolitan University, North West Film Archive, RR 1005, Granada Television, 'From the North: Granada presents [the Manchester Museum]', television recording, 29 March 1968. In the 1970s, the Manchester Museum Mummy project enjoyed an especially high profile across the print and audio-visual media; see for example 'Revelations of a Mummy', *Chronicle*, BBC2, first broadcast 8 February 1977.

21 Department of Education and Science, *Provincial Museums and Galleries*, ed. C. W. Wright (London: HMSO, 1973); Standing Commission on Museums and Galleries, *Survey of Provincial Museums and Galleries*, ed. the Earl of Rosse (London: HMSO, 1963).

22 *MMR* (1969–70); G. I. McCabe, 'Museums in Education: The Educational Role of Museums in the United Kingdom' (MA dissertation, University of Sheffield, 1975); Stearn, *The Natural History Museum*; D. M. Wilson, *The British Museum: A History* (London: British Museum, 2002).

23 *MMR* (1969–70), p. 1.

24 *MMRs* (1962–64); D. E. Owen, 'Are national museums in the provinces necessary? A brief survey of Manchester visitors to London museums', *Museums Journal*, 70 (1970), 29. On visitor research in North America from the 1920s and Britain from the 1960s, see Hooper-Greenhill, 'Studying visitors'; Hudson, *A Social History of Museums*; G. Lawrence, 'Rats, street gangs and culture: evaluation in museums', in G. Kavanagh (ed.), *Museum Languages: Objects and Texts* (Leicester: Leicester University Press, 1991), pp. 9–32.

25 MMCM vol. 7 (26 January 1970); vol. 8 (20 May 1974); *MMRs* (1968–71); D. E. Owen, 'Presidential address', *Museums Journal*, 69 (1970), 97–9; Owen, 'Regionalisation of museums: what is a region?' *Museums Journal*, 71 (1971), 25–6.

26 T. Mason, 'The visitors to the Manchester Museum: a questionnaire survey', *Museums Journal*, 73 (1974), 153–7, p. 157.

27 S. Forgan, 'Bricks and bones: architecture and science in Victorian Britain', in P. Galison and E. Thompson (eds), *The Architecture of Science* (Cambridge, Mass.: MIT Press, 1999), pp. 181–208.

28 MMCM vol. 1 (5 May 1891); *MMR* (1890–94).

29 MMCM vol. 1 (25 April 1890), p. 38.

30 MMCM vol. 1 (28 October 1892), p. 173; MMCM vol. 5 (4 March 1939); *MMR* (1939–40).

31 MMCM vol. 2 (10 December 1906); *MMR* (1896–97).

32 R. Fortey, *Dry Store Room No. 1: The Secret Life of the Natural History Museum* (London: Harper, 2008).

33 A. J. N. W. Prag, Interview with the author, *Re-Collecting at the Manchester Museum* disc S19, 2006, MMCA, tracks 9–10.

34 *Ibid.*, track 10.
35 Manchester Museum Director's files, E. Stewart – N. Merriman, 10 September 2007.
36 A. Fyfe, 'Reading and visiting: natural history at the British Museum and the Pictorial Museum', in Fyfe and Lightman (eds), *Science in the Marketplace*, pp. 196–230; S. Koven, 'The Whitechapel picture exhibitions and the politics of seeing', in D. J. Sherman and I. Rogoff (eds), *Museum Culture: Histories, Discourse, Spectacle* (London: Routledge, 1994), pp. 22–48; C. S. Matheson, '"A shilling well laid out": the Royal Academy's early public', in D. H. Solkin (ed.), *Art on the Line: The Royal Academy Exhibitions at Somerset House 1780–1836* (New Haven: Yale University Press, 2001), pp. 38–54.
37 MMCM vol. 1 (4 April 1892); W. E. Hoyle, *General Guide to the Contents of the Museum* (Manchester: Cornish, 1892); A. M. Marshall, *Outline Classification of the Animal Kingdom* (Manchester: Cornish, 1891); F. E. Weiss, *Outline Classification of the Vegetable Kingdom* (Manchester: Cornish, 1892).
38 W. E. Hoyle, *Handy Guide to the Museum* (Manchester: Cuthbertson and Black, 1895), p. 3; e.g. J. C. Melvill and R. Standen, *Catalogue of the Hadfield Collection of Shells from Lifu and Uvea, Loyalty Islands*, 2 vols (Manchester: Cornish, 1895–97).
39 W. M. Tattersall, *General Guide to the Collections in the Manchester Museum* (Manchester: Manchester University Press, 1915).
40 *MMRs* (1942–43), p. 4; (1945–57). For example, MMCA Ethnology loan document box, typescript exhibit guide, Michael Eagar, 'Radioactivity', 1947.
41 T. Burton-Brown and J. Faulds, *Guide to the Ancient Egyptian Collections* (Manchester: Manchester Museum, 1962); R. M. C. Eagar and Faulds, *Record of the Rocks* (Manchester: Bates, 1960); J. Forde-Johnston and J. Whitworth, *A Picture Book of Japanese Art* (Manchester: Manchester Museum, 1965); E. L. Seyd, *Mammals* (Manchester: Manchester Museum, 1959); F. C. Thompson, *Common Coins* (Manchester: Manchester Museum, 1966); J. Whitworth, *The Cannon Aquarium* (Marple: Heap, 1968); F. Willett and G. Bridge, *Manchester Museum Ethnology* (Manchester: Bates, 1958).
42 Eagar and Faulds, *Record of the Rocks*, p. 2; A. Bunney, 'It's not just a "children's playground". The influence of children on the development of the Science Museum, 1857–1973' (MSc dissertation, University of London, 1999); J. van Riemsdijk and P. Sharp, *In the Science Museum* (London: HMSO, 1968).
43 Manchester Museum, *The Manchester Museum* (Derby: English Life, 1985).
44 T. Bennett, 'Figuring audiences and readers', in J. Hay *et al.* (eds), *The Audience and its Landscape* (Boulder: Westview, 1996), pp. 145–59; Bennett, 'Pedagogic objects, clean eyes, and popular instruction: on sensory regimes and museum didactics', *Configurations*, 6 (1998), 345–71; Bennett, 'Speaking to the eyes: museums, legibility and social order', in S. Macdonald (ed.), *The Politics of Display: Museums, Science, Culture* (London: Routledge, 1998), pp. 25–35; Bennett, 'Civic seeing: museums and the organization of vision', in Macdonald (ed.), *Companion to Museum Studies*, pp. 262–81.
45 *MMR* (1912–13); Fyfe, 'Reading and visiting'; C. Hallett, 'The work of a guide demonstrator', *Museums Journal*, 13 (1913), 192–202; J. H. Leonard, 'A museum guide and his work', *Museums Journal*, 13 (1914), 234–46; S. Moser, *Wondrous Curiosities: Ancient Egypt at the British Museum* (Chicago: University of Chicago Press, 2006); Stearn, *The Natural History Museum*.
46 *MMRs* (1899–1900), p. 25; (1902–3), p. 16.

47 *MMR* (1962–63).

48 *MMRs* (1973–82); MMCA box CA6, day school files; A. J. N. W. Prag, Interview with the author, *Re-Collecting at the Manchester Museum* disc S1, 2004, MMCA, track 14.

49 P. G. Carter, 'Educational services', in J. M. A. Thompson (ed.), *Manual of Curatorship: A Guide to Museum Practice* (London: Butterworths, 1984), pp. 435–47, p. 443.

50 *MMR* (1958–59), p. 3.

51 S. J. M. M. Alberti, 'Molluscs, mummies and moon rock: the Manchester Museum and Manchester science', *Manchester Region History Review*, 18 (2007), 108–32.

52 D. Kenyon and R. Neave, *Lindow Man: His Life and Times* (Manchester: Manchester Museum, 1987).

53 MMCM (2 November 1987); MMCA, 'Director's report for the period November 1987 – March 1988'. Lindow Man returned for to be exhibited in the Manchester Museum in 1991 and 2008.

54 'Local museums', *Nature*, 16 (1877), p. 228.

55 W. B. Dawkins, 'The value of natural history museums', *Nature*, 16 (1877), p. 98.

56 Committee of Council on Education (England and Wales), *Report; with Appendix* (London: HMSO, 1895), p. 314.

57 M. Harrison, 'Art and Philanthropy: T. C. Horsfall and the Manchester Art Museum', in A. Kidd (ed.), *City, Class and Culture* (Manchester: Manchester University Press, 1986), pp. 120–47; S. MacDonald, 'For "swine of discretion": design for living 1884', *Museums Journal*, 86 (1986), 123–30; E. W. Swanton, *A Country Museum: The Rise and Progress of Sir Jonathan Hutchinson's Museum at Haslemere* (Haslemere: Haslemere Educational Museum, 1947).

58 E. Howarth (ed.), *The Educational Value of Museums and the Formation of Local War Museums* (London: Wesley, 1918).

59 MMCM vol. 1 (4 April 1892), (9 December 1895); *MMRs* (1890–96); W. E. Hoyle, *Handy Guide to the Museum* (Manchester: Cornish, 3rd edn, 1903).

60 'The government and museums: the case for the provinces', *Museums Journal*, 15 (1916), 313–16.

61 Board of Education, *Memorandum on the Possibility of Increased Co-operation between Public Museums and Public Educational Institutions* (London: HMSO, 1931); L. Haward, 'Discussion in the relation of museums to art, commerce, welfare and education generally', in Howarth (ed.), *The Educational Value of Museums*, pp. 33–42; S. Hey, *Schools Working under the Two-Shift System: A Further Report Submitted on Scheme of Work in Connection with Museums, Art Galleries, Organised Games in the Parks, Teaching in the Parks, Walks in the Country, Etc.* (Manchester: City of Manchester Education Committee, 1917).

62 MMCA box CA5, pamphlet, A. L. Dawson, 'Manchester Museum Education Service', 1975; *MMR* (1914–15).

63 B. R. Winstanley, *Children and Museums* (Oxford: Blackwell, 1967), p. 30; see also S. F. Markham, *A Report on the Museums and Art Galleries of the British Isles (Other than the National Museums)* (Edinburgh: Constable, 1938); Standing Commission, *Survey of Provincial Museums*.

64 MMCA, typescript, F. Todd, 'Copy of memorandum and resolutions adopted at a conference on art education held at the [Manchester] Art Gallery on June 16th, 1920';

Board of Education, *Memorandum*; W. B. Dawkins, *The Opportunity of Manchester* (Manchester: Cuthbertson and Black, 1903).

65 J. A. Green *et al.*, 'Museums in relation to education – final report of committee', *Report of the British Association for the Advancement of Science*, 88 (1920), 267–80; E. Hooper-Greenhill, *Museum and Gallery Education* (Leicester: Leicester University Press, 1991); Standing Commission, *Survey of Provincial Museums*.

66 One other notable exception was Castle Museum in Norwich, which housed a museum demonstrator funded by the Norwich Education Committee from 1920, based explicitly on Manchester's example. E. Frostick, 'Museums in education: a neglected role?' *Museums Journal*, 85 (1985), 67–74; Markham, *Report on the Museums*; H. Miers, *A Report on the Public Museums of the British Isles (other than the National Museums)* (Edinburgh: Constable, 1928); Standing Commission, *Survey of Provincial Museums*.

67 McCabe, 'Museums in Education'; D. Moore, 'Thirty years of museum education: some reflections', *International Journal of Museum Management and Curatorship*, 1 (1982), 213–30; C. Pearson, 'Curators, Culture and Conflict: The Effects of the Second World War on Museums in Britain, 1926–1965' (PhD dissertation, University College London, 2008). Cf. Glasgow Art Gallery and Museums, *Educational Experiment: 1941–1951* (Glasgow: Corporation of the City of Glasgow, 1951); Stearn, *The Natural History Museum*.

68 Hooper-Greenhill, *Museum and Gallery Education*; Moore, 'Thirty years of museum education'; V. Woollard, '50 years: the development of a profession', *Journal of Education in Museums*, 19 (1998), 1–4.

69 MMCM vol. 6 (18 January 1954); *MMR* (1951–65); Carter, 'Educational services'; City of Manchester Education Committee, *The City Art Gallery and the Manchester Museum Schools Service* (Manchester: Manchester Education Committee, 1957); Department of Education and Science, *Museums in Education* (London: HMSO, 1971); B. R. Winstanley, 'School museum services in the British Isles', in Standing Commission, *Survey of Provincial Museums*, pp. 287–91.

70 D. C. Edinger, 'Education at the Field Museum, 1922–1970', *Bulletin of the Field Museum of Natural History*, 41:5 (1970), 15; D. Lowenthal, *The Heritage Crusade and the Spoils of History* (Cambridge: Cambridge University Press, 1997); Moore, 'Thirty years of museum education'; P. Wright, *On Living in an Old Country: The National Past in Contemporary Britain* (London: Verso, 1985).

71 MMCA box CA5, pamphlet, A. L. Dawson, 'Manchester Museum Education Service open day', 1985; North West Sound Archive (hereafter NWSA) 1982.6508(1).

72 T. Goss, Interview with the author, *Re-Collecting at the Manchester Museum*, disc S12, 2005, MMCA, track 9.

73 MMCA box CA5, Minutes of the Manchester Museum Senior Staff Meeting, 23 January 1980; *MMR* (1980–81).

74 T. Besterman, Interview with the author, *Re-Collecting at the Manchester Museum*, disc S16, 2005, MMCA.

75 M. C. Lourenço, 'Between Two Worlds: The Distinct Nature and Contemporary Significance of University Museums and Collections in Europe' (PhD dissertation, Conservatoire National des Arts et Métiers, Paris, 2005); A. MacGregor, *The Ashmolean Museum: A Brief History of the Institution and its Collections* (Oxford: Ashmolean

Museum, 2001); C. E. Mayer, 'University museums: distinct sites of intersection for diverse communities', *Museologia*, 3 (2003), 101–6.

76 S. J. M. M. Alberti, 'Civic cultures and civic colleges in Victorian England', in M. J. Daunton (ed.), *The Organisation of Knowledge in Victorian Britain* (Oxford: Oxford University Press, 2005), pp. 337–56.

77 Department of Education and Science, *Provincial Museums and Galleries*, p. 54.

78 Miers, *Report on the Public Museums*; D. Piper, 'Some problems of university museums', *Museums Journal*, 72 (1972), 107–10; Standing Commission on Museums and Galleries, *Universities and Museums: Report on the Universities in Relation to their own and other Museums* (London: HMSO, 1968); Standing Commission, *Report on University Museums* (London: HMSO, 1977).

79 MMCM vol. 1 (22 January 1889); vol. 8 (14 October 1974); MMR (1895–96), (1965–66); Department of Education and Science, *Provincial Museums and Galleries*; A. Warhurst, 'University museums', in Thompson (ed.), *Manual of Curatorship*, pp. 76–83.

80 *MMR* (1929–30), pp. 17–18.

81 MMCA box GB5, H. G. Cannon – A. P. Wadsworth, 20 May 1949.

82 MMCM vol. 1 (22 January 1889), (20 March 1889), (27 October 1899).

83 MMR (1970–71), 2; Mason, 'Visitors to the Manchester Museum'; B. Pullan and M. Abendstern, *A History of the University of Manchester*, 2 vols (Manchester: Manchester University Press, 2000–4); Standing Commission, *Universities and Museums*.

84 *MMR* (1968–69), p. 8; E. L. Seyd, 'A university museum and the general public', *Museums Journal*, 70 (1970), 180–2.

85 *MMR* (1963–64), p. 3.

86 I am grateful to Leslie Braine-Ikomi for this recollection.

87 R. Nicholas, *City of Manchester Plan: Prepared for the City Council* (Norwich: Jarrold, 1945); H. Wilson and L. Womersley, *Manchester Education Precinct: Interim Report of Planning Consultants* (Manchester: Victoria University of Manchester, 1964); Pullan and Abendstern, *A History of the University*.

88 *MMR* (1975–78); Building Design Partnership (Manchester Group), *Brief for New Extensions to the Manchester Museum* (Manchester: Building Design Partnership, 1972).

89 Standing Commission, *Universities and Museums*, p. 27.

90 Standing Commission on Museums and Galleries, *Framework for a System for Museums*, ed. A. Drew (London: HMSO, 1979), p. 26.

91 See e.g. *MMRs* (1981–83) on gallery sponsorship by Book Club Associates, NatWest and Ciba Geology.

92 *MMR* (1983–84); University of Manchester Archives, *Annual Reports of the Victoria University of Manchester* (1986–1990); MMCA, A. Warhurst – the author, 29 April 2005; MMCA box DO3, Letters of testimony supporting the Museum's claim for international status, 1983.

93 R. Cooter and S. Pumfrey, 'Separate spheres and public places: reflections on the history of science popularization and science in popular culture', *History of Science*, 32 (1994), 237–67; R. Darnton, *The Kiss of Lamourette* (London: Faber, 1990); D. Freedberg, *The Power of Images: Studies in the History and Theory of Response* (Chicago: University of Chicago Press, 1989); D. Hall, 'The history of the book: new questions? New answers?' *Journal of Library History*, 21 (1986), 27–36; Hay *et al.* (eds), *The Audience and its*

Landscape; J. L. Machor and P. Goldstein (eds), *Reception Study: From Literary Theory to Cultural Studies* (New York: Routledge, 2000); J. R. Topham, 'Scientific publishing and the reading of science in nineteenth-century Britain: a historiographical survey and guide to sources', *Studies in History and Philosophy of Science*, 31 (2000), 559–612.

94 G. H. Carpenter, *A Short Guide to the Manchester Museum* (Manchester: Manchester University Press, 1933), p. 16.

95 MMCM vol. 5 (21 October 1935); Thompson, *Common Coins*.

96 *MMR* (1908–9), p. 5.

97 At the turn of the century the Manchester Museum was graced by the presence of the writers Mary Kingsley and Beatrix Potter, the Duke and Duchess of Devonshire and a host of donors, politicians, men of science and curators. MMCA, manuscript ledger visitor book, 3 December 1889–24 August 1891; MMCA, manuscript ledger autograph book, 24 November 1897–9 September 1938, MMCA; Alberti, 'The museum affect'; P. Findlen, *Possessing Nature: Museums, Collecting, and Scientific Culture in Early Modern Italy* (Berkeley: University of California Press, 1994); Macdonald, 'Accessing audiences'.

98 C. Gosden and F. Larson, *Knowing Things: Exploring the Collections at the Pitt Rivers Museum 1884–1945* (Oxford: Oxford University Press, 2007).

99 S. Hey (ed.), *A Survey of the Facilities for Adult Education Available in Manchester* (Manchester: Manchester Education Committee, 1925); Miers, *Report on the Public Museums*.

100 *MMR* (1923–24), p. 7; (1937–38).

101 *MMR* (1932–33); G. Lewis, *For Instruction and Recreation: A Centenary History of the Museums Association* (London: Quiller, 1989). See also chapter 5 for a discussion of publication exchange networks.

102 MMCM vol. 3 (17 October 1910); *MMRs* (1938–51), (1982–83).

103 S. J. M. M. Alberti, 'Conversaziones and the experience of science in Victorian England', *Journal of Victorian Culture*, 8 (2003), 208–30; J. Burnett, 'The conversazione at the Edinburgh Museum of Science and Art, 1875', *Book of the Old Edinburgh Club*, 4 (1997), 145–8.

104 A. K. Daniels, *Invisible Careers: Women Civic Leaders from the Volunteer World* (Chicago: University of Chicago Press, 1988); J. Mattingly, *Volunteers in Museums and Galleries: The Report of a Survey into the Work of Volunteers in Museums and Galleries in the United Kingdom* (Berkhamsted, Hertfordshire: The Volunteer Centre, 1984); S. Millar, *Volunteers in Museums and Heritage Organizations: Policy Planning and Management* (London: HMSO, 1991).

105 A. Desmond, 'Redefining the X axis: "professionals", "amateurs" and the making of mid-Victorian biology', *Journal of the History of Biology*, 34 (2001), 3–50.

106 See for example the relationship between the ornithologist Robert Davison and the acting keeper Thomas Coward: MMCA box OMR5, directors' correspondence 1906–33; Manchester Museum Zoology Archive GB2875, R. R. Davison correspondence 1908–13.

107 MMCM vol. (11 March 1968); P. Prestwich, 'Museums, friends and volunteers – a delicate relationship', *International Journal of Museum Management and Curatorship*, 2 (1983), 171–5.

108 Cited in Swinney, 'I am utterly disgusted'.

109 MMCM vol. 3 (27 May 1909), p. 38.

110 Owen, 'Are national museums in the provinces necessary?'

111 Mason, 'Visitors to the Manchester Museum'.

112 T. Greenwood, *Museums and Art Galleries* (London: Simpkin, 1888), p. 388.

113 *MMR* (1958–59), p. 3.

114 Hoyle, *Handy Guide* (1903), p. 230; Bunney, 'It's not just a "children's playground"';
Hill, 'Roughs of both sexes'; Manchester Museum, *Guide to the Manchester Museum*
(Stockport: Dean, 1970).

115 B. Hethcott-Wood, Interview with the author, *Re-Collecting at the Manchester Museum*,
disc V3(1), 2005, MMCA.

116 *MMR* (1969–70), p. 1.

117 Owen, 'Are national museums in the provinces necessary?'; B. Longhurst *et al.*,
Globalisation and Belonging (London: Sage, 2005).

118 Longhurst *et al.*, 'Audiences, museums and the English middle class'.

119 *MMR* (1999–2000), p. 3, original emphasis.

120 Alberti, 'Molluscs, mummies and moon rock'; D. Barnaby, *The Elephant who Walked to
Manchester* (Plymouth: Basset, 1988); NWSA 1982.3619.

121 NWSA 2000.4033; 2000.3196.

122 T. Brennan and M. Jay (eds), *Vision in Context: Historical and Contemporary Perspectives
on Sight* (London: Routledge, 1996); J. Crary, *Techniques of the Observer: On Vision and
Modernity in the Nineteenth Century* (Cambridge, Mass: MIT Press, 1990); R. Hyde,
Panoramania! The Art and Entertainment of the 'All-Embracing' View (London: Trefoil,
1988); B. Lightman, 'The visual theology of Victorian popularizers of science: from rever-
ent eye to chemical retina', *Isis*, 91 (2000), 651–80; Lightman, *Victorian Popularisers of
Science* (Chicago: University of Chicago Press, 2007); I. R. Morus, *Frankenstein's Children:
Electricity, Exhibition, and Experiment in Early-Nineteenth-Century London* (Princeton:
Princeton University Press, 1998); A. S.-K. Pang, 'Visual representation and post-
constructivist history of science', *Historical Studies in the Physical and Biological Sciences*,
28 (1997), 139–71; A. Secord, 'Botany on a plate: pleasure and the power of pictures in
promoting early nineteenth-century scientific knowledge', *Isis*, 93 (2002), 28–57.

123 Bennett, *Pasts beyond Memory*; Greenwood, *Museums and Art Galleries*.

124 B. Potter, *The Journal of Beatrix Potter from 1881 to 1897*, ed. L. Linder (London:
Warne, 1966), p. 396.

125 J. A. Secord, 'How scientific conversation became shop talk', *Transactions of the Royal
Historical Society*, 17 (2007), 129–56; see for example Hallett, 'The work of a guide
demonstrator'.

126 But see F. Candlin, 'The dubious inheritance of touch: art history and museum access',
Journal of Visual Culture, 5 (2006), 137–54; E. Edwards *et al.* (eds), *Sensible Objects:
Colonialism, Museums and Material Culture* (Oxford: Berg, 2006); K. Hetherington,
'Spatial textures: place, touch, and praesentia', *Environment and Planning A*, 35 (2003),
1933–44; S. Stewart, 'From the museum of touch', in M. Kwint *et al.* (eds), *Material
Memories: Design and Evocation* (New York: Berg, 1999), pp. 17–36.

127 Bunney, 'It's not just a "children's playground"'; F. W. Cheetham (ed.), *Museum School
Services* (London: Museums Association, 1967); A. S. Wittlin, *Museums: In Search of a
Usable Future* (Cambridge, Mass.: MIT Press, 1970).

128 MMCA box CA5, leaflet, 'Manchester Museum Education Department', 1975, p. 3;
Dawson, 'Manchester Museum Education Service'.

129 K. Wright, Interview with the author, *Re-Collecting at the Manchester Museum* disc V4, 2006, MMCA, track 2.
130 MMCM vol. 4 (13 June 1927).
131 S. Macdonald, *Behind the Scenes at the Science Museum* (Oxford: Berg, 2002), p. 220.
132 Alberti, 'The museum affect'; Freedberg, *The Power of Images*.
133 D. Anderson and V. Gosselin, 'Private and public memories of Expo 67: a case study of recollections of Montreal's World's Fair, 40 years after the event', *Museum and Society*, 6 (2008), 1–21; Anderson and H. Shimizu, 'Recollections of Expo 70: visitors' experiences and the retention of vivid long-term memories', *Curator*, 50 (2007), 435–54.
134 Longhurst *et al.*, *Globalisation and Belonging*, p. 108, p. 112.
135 N. Gower-Jones, Interview with the author, *Re-Collecting at the Manchester Museum*, disc V1, 2005, MMCA.
136 Hethcott-Wood, Interview with the author, tracks 7, 14.
137 *MMR* (1969–70), p. 1.
138 Hethcott-Wood, Interview with the author, track 12; NWSA 1982.6508(2); E. Nightscales, 'A visit to the Hull Museum during the Xmas holidays. Essay II', *Hull Museum Publications*, 19 (1904), 30–1; S. Stewart, *On Longing: Narratives of the Miniature, the Gigantic, the Souvenir, the Collection* (Durham, NC: Duke University Press, 1993).
139 MMCM vol. 7 (10 May 1965), (26 January 1970); Mason, 'Visitors to the Manchester Museum'; NWSA 1962.6588.
140 Hethcott-Wood, Interview with the author, track 15.
141 *MMR* (1971–72), p. 1.
142 NWSA 1962.6588.
143 MMCM vol. 7 (26 January 1970); Mason, 'Visitors to the Manchester Museum'.
144 Wright, Interview with the author, track 2.
145 Hethcott-Wood, Interview with the author, track 13.
146 NWSA 2000.3196.
147 Alberti, 'Molluscs, mummies and moon rock'.
148 Hethcott-Wood, Interview with the author, track 10.
149 J. Zussman, Interview with the author, *Re-Collecting at the Manchester Museum* disc S8, 2005, MMCA; Prag, Interview with the author; R. Turnill, *The Moonlandings: An Eye Witness Account* (Cambridge: Cambridge University Press, 2003), p. 262; Gower-Jones, Interview with the author.
150 MMCM vol. 3 (22 June 1914), p. 241; vol. 8 (12 October 1970).
151 MMCM vol. 2 (15 October 1906), (10 December 1906); vol. 8 (10 January 1972); *MMRs* (1959–76). For museum theft in fiction, see R. Hoberman, 'In quest of a museal aura: turn of the century narratives about museum-displayed objects', *Victorian Literature and Culture*, 31 (2003), 467–82.
152 K. F. Sugden, Interview with the author, *Re-Collecting at the Manchester Museum* disc S4, 2005, MMCA, track 3.
153 MNHS, *Report of the Council* (1857) in CNH1/4, 7 January 1857, p. 2; Mason, 'Visitors to the Manchester Museum', p. 157.
154 Bennett, 'Figuring audiences and readers'; Machor and Goldstein (eds), *Reception Study*.

Conclusion: the museum in the twentieth century

'A museum is like a living organism', argued William Henry Flower, Director of the British Museum (Natural History), 'it requires continual and tender care. It must grow, or it will perish; and the cost and labour required to maintain it in a state of vitality is not yet by any means fully realised or provided for.'[1] These were prescient words at the turn of the nineteenth century for his institution and others. There are now over four million objects in the Manchester Museum (figure 7.1). They are no longer grouped within firm disciplinary boundaries, instead classed as 'natural environments' or 'human cultures'. They are cared for and deployed by a staff of nearly 100, ten times that of a century ago. Although acquisition is undertaken at a more measured pace than it once was, the collection is still growing. (Disposal and repatriations have been politically and museologically significant, but have made little quantitative impact.) Every one of the millions of objects has the capacity to tell a rich story – of its origins, of its place in classificatory schemes and, especially, of the museum itself.

Nevertheless, a museum is greater than the sum of its parts. Studying the collection as a whole has been beneficial. *Nature and Culture* is not a bundle of object biographies, but rather a work of museum history: a significant distinction, for objects have not been the main players in this story after all.[2] This has been the story of the relationship between objects and disciplines, the changing status of things in Western knowledge. Discipline construction, collecting, conservation and display were all carried out *by* people *with* objects. Awarding museum things too much agency would diminish the significance of the humans in the story. Objects did not act in their own right but rather material culture was acted *upon* and was a conduit for human intention.[3] People imbued things with value and significance, manipulating and contesting their meanings over time. Objects prompted, changed and channelled relationships but were nonetheless inanimate. Even when looking from the standpoint of the specimen we are looking at people, their practices and institutions.

Throughout their 'lives', museum objects were attributed varied meanings and values as collectors, curators and audiences encountered them in very different ways. They came to embody past and present practices. The challenge has been

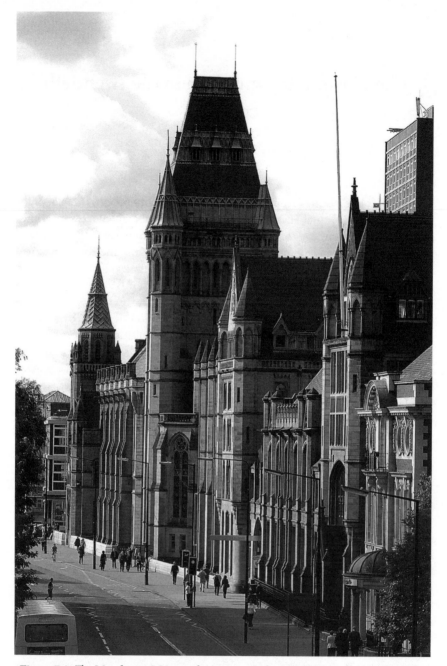

Figure 7.1 The Manchester Museum frontage on Oxford Road, 2003, from Whitworth hall on the left to the former Dental School (subsequently the Department of Metallurgy and since 1977 part of the Museum) on the right.

to recover these embodied techniques with the written word, to present in a book such as this the skills and processes that cannot be written down, to capture four dimensions in two, and to describe five senses only with sight (the smell and feel of this book notwithstanding). During my research I found that strolling the galleries of the Manchester Museum gave me a sense of place and studying the artefacts revealed much about them. But ultimately, *Nature and Culture* is a work of history, based on the historians' main fare: manuscripts, publications and oral history testimony. Cultural geographers, anthropologists and artists are interrogating museums and their objects in new ways with new tools, and it is to them that we should look for new approaches to sources.[4]

If this book's sources are traditional, the approach and outcome are innovative. Close attention to the historical record for the later chapters has uncovered a wealth of information concerning people who have been ignored in the history of museums. While accounting for the strategies of museum directors and prominent curators, *Nature and Culture* has also drawn attention to subaltern practitioners and their role in collecting objects, printing labels, sweeping floors and building displays. That many of their identities and backgrounds remain obscure should not deter us from accounting for general trends in the construction (or failure) of communities of practice. Only a few of the cataloguers, conservators and designers have been mentioned here by name, and any one of the processes explored warrants extensive further research, especially in comparative perspective. Beyond these museum workers, the importance of the visitor should by now be accepted by all museum historians. In particular, oral histories of museum and exhibition visiting will continue to be revealing.[5] The visitor constituencies of the Manchester Museum are especially interesting because of the institution's curious hybrid character as part municipal museum, part university collection. Like all museums, diverse people came through its doors over the course of a century, but in identifying specific groups and their priorities – students, schoolchildren, volunteers – we can begin to unpack the relationships between object and viewer, museum and audience.

This attention to invisible technicians and silent masses sets *Nature and Culture* apart from the germinal works of museum history mentioned in the introduction. The Foucauldian, post-structuralist and post-colonial approaches to museology adumbrated in the 1990s set the historiographical agenda and prompted a new generation of historically-informed museum studies. In writing this book, my aim had not been to extend these areas of scholarship, but rather to complement them. Where museum studies in the last two decades have addressed the role of museums in state-level governance, here I have explored an intermediary level of control, examining the various individuals and institutions at a local level in provincial England and their audience constituencies.[6] Many historians study museums as part of the imperial project, but here we have seen conversely the role of the material of empire in civic life. The objects in the collection became part of Manchester's civic identity, bringing with them traces of science, empire and the exotic. The

Manchester Museum was a component in a dynamic urban complex of institutions. Staff related not only to their international colleagues but also to fellow curators in neighbouring galleries and fellow scientists elsewhere in the University. These contexts set the Museum's objects not in a rigid frame of meaning but rather within a flexible system of intellectual and physical processes enacted on the individual, local and international level.

In tracing these meanings and processes the principal intention of the first part of this book was to understand the construction and development of disciplines and the boundaries between them. We saw how a collection based on palaeontology expanded and diversified, often acrimoniously. As William Boyd Dawkins's influence waned, zoology challenged geology's intellectual and physical place in the disciplinary hierarchy of the museum. Mapping this shift onto the wider politics of British science has been beyond the scope of this book, but parallels between the emphasis on evolutionary zoology in the Manchester Museum and the development of neo-Darwinism in biology more generally are suggestive. And from what we know of botany's fate in other collections, its subordinate role in Manchester (in exhibitionary terms at least) is representative.

The development of the humanities in the Manchester Museum is more unusual. Foisted upon an unwilling museum committee, the renowned Egyptology collection catalysed the architectural expansion of the Museum in the first half of the century and rendered the mummies the most iconic objects in what had been a natural history museum. In its wake, other archaeological and anthropological artefacts in the Museum acquired new significance, outgrowing the narrow evolutionary niche afforded them in the original scheme. Anthropogenic objects may still comprise only a tiny quantitative fraction of the total collection, but they occupy a disproportionate amount of staff time, gallery space and visitor attention. Objects collected under diverse intellectual auspices – palaeontological prehistory, aesthetic Hellenism or rescue excavations – are grouped together as 'archaeology', an apparently quasi-essential category that we have found is of recent origin in the Museum's organisation. The apparent stability of disciplinary boundaries can be deceptive.

This disciplinary fluidity in museums is paradoxical, given the inertia of material culture. As priorities and methods in cognate departments elsewhere in the University changed, the Museum and its staff remained wedded to the collection and to the kinds of questions that can be asked of objects. Museological ways of knowing were in the ascendant as the foundations for the Manchester Museum were laid at the heart of the new Victoria University. But what was the Museum to do half a century later, as the natural sciences and anthropology shifted their attention away from museum things? New strategies after the Second World War shifted the focus of the staff and the displays from within to outside the University. The Manchester Museum, always partly a civic collection, became emphatically so.

We have some indications that this shift in approach was mirrored elsewhere, that the middle of the twentieth century marked a change in direction for British

collections generally.[7] What we lack is a comprehensive history of museums in the twentieth century.[8] At the biographical level, there are analyses of nineteenth-century museum advocates, locally and nationally. William Boyd Dawkins in Manchester is reasonably well studied, just as General Pitt Rivers, Richard Owen and Augustus Wollaston Franks feature prominently in other histories. But what of their twentieth-century successors? Biographies of Lord Sudeley, Henry Miers, Arthur Drew and other prominent museum advocates could provide a handle for the national context, further fleshed out with accounts of some of the thousands of museum workers and further institutional histories. I have already indicated the rich scholarship on the relationship between museums and the imperial project: but what of displaying and collecting at the end of empire? A twentieth-century history would provide a sorely-needed historical context for the post-colonial turn in museology, filling the gap between imperial sources and contemporary approaches. Furthermore, I have only been able to hint at the role of museums in the Cold War and the fate of cultural institutions under Thatcher's government in the 1980s. The political history of UK museums in the twentieth century promises to be fascinating, and I hope that *Nature and Culture* provides a step in that direction.

In setting the chronological parameters of this project, however, I consciously avoided the last decade of the twentieth century, possibly the most significant and certainly the most turbulent decade in the history of the Manchester Museum and UK museums more generally. From 1994 the Heritage Lottery Fund provided a massive financial injection into the museum sector at the millennium, and the New Labour government elected in 1997 shifted the emphasis in museums from free market economics to social inclusion. Capital projects such as Norman Foster's Great Court at the British Museum (1994–2000) transformed the accommodation for the national heritage and the new government Department for Culture, Media and Sport encouraged audience inclusivity on an unprecedented scale. In this climate a new Director, Tristram Besterman, was appointed in 1994 to transform the Manchester Museum. He undertook a massive capital development project in tandem with significant personnel changes both to realign the museum as a public institution and to reintegrate it with the academic faculties from which it had become intellectually distant. Having secured funding (including £12 million from the Heritage Lottery Fund), in the first years of the new millennium Besterman orchestrated the most significant – and at times difficult – transformation in architecture and staff at the Manchester Museum since the 1920s, resulting in a new management structure, redisplayed galleries and a new entrance space (see figure 7.2).

Other museological changes were afoot in the 1990s. We have already seen that anthropology (and some archaeology) exhibitions were redisplayed along post-colonial lines. Natural history collections became key sites for public engagement with environmental issues and biodiversity and more recently as sites for exhibiting art. In concert with novel ways of showing objects, new ways of thinking about material culture have emerged since the 1990s. The highly theoretical character

Figure 7.2 The new Manchester Museum entrance set behind Oxford Road, part of the capital development project, opened in 2003. The redeveloped bridge can be seen on the right and the rear of the 1912 extension in the centre. The Maths Tower, now demolished, peers over the Museum.

of much of the latter work sometimes renders it redundant for museum practice, but it nevertheless indicates the refreshed significance of the object in academia. Furthermore, new approaches to material culture incorporate not only anthropogenic material, but also natural history specimens. Museum collections are as much part of the material cultures of science as the microscope, the textbook and the test tube. The taxidermic mount tells us as much about culture as it does about nature.[9]

In these closing remarks I have set the story of the Manchester Museum in its social, museological and political contexts. It is my hope that *Nature and Culture* will illuminate not only the collection but also our understanding of these contexts – the complex and fascinating relationships between people, objects and disciplines in the twentieth-century museum.

Notes

1 W. H. Flower, *Essays on Museums and Other Subjects Connected with Natural History* (London: Macmillan, 1898), p. 13; also partially cited in K. Arnold, *Cabinets for the Curious: Looking Back at Early English Museums* (Aldershot: Ashgate, 2006), p. 244.

2 Cf. S. J. M. M. Alberti, 'Molluscs, mummies and moon rock: the Manchester Museum and Manchester science', *Manchester Region History Review*, 18 (2007), 108–32;

C. Gosden and F. Larson, *Knowing Things: Exploring the Collections at the Pitt Rivers Museum 1884–1945* (Oxford: Oxford University Press, 2007).

3 S. J. M. M. Alberti, 'Objects and the museum', *Isis*, 96 (2005), 559–71; C. Gosden and C. Knowles, *Collecting Colonialism: Material Culture and Colonial Change* (Oxford: Berg, 2001); C. B. Steiner, 'Rights of passage: on the liminal identity of art in the border zone', in F. R. Myers (ed.), *The Empire of Things: Regimes of Value and Material Culture* (Oxford: Currey, 2001), pp. 207–31.

4 On the challenges and rewards of heterodox 'archives', see e.g. M. Patchett, 'Tracking tigers: recovering the embodied practices of taxidermy', *Historical Geography*, 36 (2008); C. DeSilvey, 'Observed decay: telling stories with mutable things', *Journal of Material Culture*, 11 (2006), 317–37.

5 See for example D. Anderson and V. Gosselin, 'Private and public memories of Expo 67: a case study of recollections of Montreal's World's Fair, 40 years after the event', *Museum and Society*, 6 (2008), 1–21; Anderson and H. Shimizu, 'Recollections of Expo 70: visitors' experiences and the retention of vivid long-term memories', *Curator*, 50 (2007), 435–54.

6 K. Hill, *Culture and Class in English Public Museums, 1850–1914* (Aldershot: Ashgate, 2005).

7 C. Pearson, 'Curators, Culture and Conflict: The Effects of the Second World War on Museums in Britain, 1926–1965' (PhD dissertation, University College London, 2008); cf. K. A. Rader and V. E. M. Cain, 'From natural history to science: display and the transformation of American museums of science and nature', *Museum and Society*, 6 (2008), 152–71.

8 Although see G. Lewis, *For Instruction and Recreation: A Centenary History of the Museums Association* (London: Quiller, 1989); A. S. Wittlin, *Museums: In Search of a Usable Future* (Cambridge, Mass.: MIT Press, 1970).

9 S. J. M. M. Alberti, 'Constructing nature behind glass', *Museum and Society*, 6 (2008), 73–97; S. J. Knell, 'Museums, reality and the material world', in Knell (ed.), *Museums in the Material World* (London: Routledge, 2007), pp. 1–28. On material culture studies more generally, see C. Tilley *et al.* (eds), *Handbook of Material Culture* (London: Sage, 2006). On natural history collections as the source and site for fine art, see M. Patchett and K. Foster, 'Repair work: surfacing the geographies of dead animals', *Museum and Society*, 6 (2008), 98–122. On museums, conservation and biodiversity see P. Davis, *Museums and the Natural Environment: The Role of Natural History Museums in Biological Conservation* (London: Leicester University Press, 1996); A. E. Leviton and M. L. Aldrich (eds), *Museums and Other Institutions of Natural History, Past, Present, and Future* (San Francisco: California Academy of Sciences, 2004).

Bibliography

Archives

Cheshire and Chester Archives and Local Studies Service
Churchill Archive Centre, Churchill College Cambridge
John Rylands University Library of Manchester:
 Special Collections
 The University of Manchester Archives
Manchester Central Library Archives and Local Studies
The Manchester Museum, University of Manchester:
 Archaeology Archive
 Central Archive (including recordings of *Re-Collecting at the Manchester Museum* Oral
 History Project 2004–6)
 Director's files
 Entomology Archive
 Egyptology Archive
 Herbarium
 Zoology Archive
North West Film Archive, Manchester Metropolitan University
North West Sound Archive, Clitheroe Castle, Lancashire

Printed sources

Abt, J., 'Disciplining museum history', *Museums and Galleries History Group Newsletter*, 4
 (2007), 2–3.
Adelman, J., 'Evolution on display: promoting Irish natural history and Darwinism at the
 Dublin Science and Art Museum', *British Journal for the History of Science*, 38 (2005),
 411–36.
Advisory Board for the Research Councils Review Group in Taxonomy, *Taxonomy in Britain*
 (London: HMSO, 1979).
Airey, V., 'The past twenty years', *Journal of Education in Museums*, 1 (1980), 10–15.
Alberti, S. J. M. M., 'Amateurs and professionals in one county: biology and natural history in
 late Victorian Yorkshire', *Journal of the History of Biology*, 34 (2001), 115–47.
——, 'Placing nature: natural history collections and their owners in nineteenth-century
 provincial England', *British Journal for the History of Science*, 35 (2002), 291–311.
——, 'Conversaziones and the experience of science in Victorian England', *Journal of
 Victorian Culture*, 8 (2003), 208–30.

———, 'Leopold Grindon', in B. Lightman (ed.), *Dictionary of Nineteenth-Century British Scientists*, 4 vols, vol. 2 (Bristol: Thoemmes, 2004), pp. 852–3.

———, 'Civic cultures and civic colleges in Victorian England', in M. J. Daunton (ed.), *The Organisation of Knowledge in Victorian Britain* (Oxford: Oxford University Press, 2005), pp. 337–56.

———, 'Objects and the museum', *Isis*, 96 (2005), 559–71.

———, 'Owning and collecting natural objects in nineteenth-century Britain', in M. Berretta (ed.), *From Private to Public: Natural Collections and Museums* (New York: Science History Publications, 2005), pp. 141–54.

———, 'Culture and nature: the place of anthropology in the Manchester Museum', *Journal of Museum Ethnography*, 19 (2006), 7–21.

———, 'Molluscs, mummies and moon rock: the Manchester Museum and Manchester science', *Manchester Region History Review*, 18 (2007), 108–32.

———, 'The museum affect: visiting collections of anatomy and natural history', in A. Fyfe and B. Lightman (eds), *Science in the Marketplace: Nineteenth-Century Sites and Experiences* (Chicago: University of Chicago Press, 2007), pp. 371–403.

———, 'Constructing nature behind glass', *Museum and Society*, 6 (2008), 73–97.

———, 'The status of museums: authority, identity and material culture', in D. N. Livingstone and C. W. J. Withers (eds), *Geographies of Nineteenth-Century Science* (Chicago: University of Chicago Press, forthcoming).

Alderson, L., *Rare Breeds* (Aylesbury: Shire, 1984).

Alexander, E. P., *Museums in Motion: An Introduction to the History and Functions of Museums* (Nashville: American Association for State and Local History, 1979).

Allen, D. E., *The Naturalist in Britain: A Social History* (Princeton: Princeton University Press, 2nd edn, 1994).

———, 'On parallel lines: natural history and biology from the late Victorian period', *Archives of Natural History*, 25 (1998), 361–71.

Allison-Bunnell, S. W., 'Making nature "real" again: natural history exhibits and public rhetorics of science at the Smithsonian in the early 1960s', in S. Macdonald (ed.), *The Politics of Display: Museums, Science, Culture* (London: Routledge, 1998), pp. 77–97.

Alpers, S., 'The museum as a way of seeing', in I. Karp and S. D. Lavine (eds), *Exhibiting Cultures: The Poetics and Politics of Museum Display* (Washington, DC: Smithsonian Institution Press, 1991), pp. 25–32.

Altick, R. D., *The Shows of London: A Panoramic History of Exhibitions, 1600–1862* (Cambridge, Mass: Belknap, 1978).

Anderson, D. and V. Gosselin, 'Private and public memories of Expo 67: a case study of recollections of Montreal's World's Fair, 40 years after the event', *Museum and Society*, 6 (2008), 1–21.

Anderson, D. and H. Shimizu, 'Recollections of Expo 70: visitors' experiences and the retention of vivid long-term memories', *Curator*, 50 (2007), 435–54.

Anderson, G., W. Price and R. Heard, 'Biographical Information – Walter Tattersall', http://tidepool.st.usm.edu/mysids, accessed 19 April 2006.

Andrei, M. A., 'Nature's Mirror: How the Taxidermists of Ward's Natural Science Establishment Reshaped the American Natural History Museum and Founded the Wildlife Conservation Movement' (PhD dissertation, University of Minnesota, 2006).

Appadurai, A. (ed.), *The Social Life of Things: Commodities in Cultural Perspective* (Cambridge: Cambridge University Press, 1986).

Archer, J. H. G., *Art and Architecture in Victorian Manchester: Ten Illustrations of Patronage and Practice* (Manchester: Manchester University Press, 1985).

Aristides, N., 'Calm and uncollected', *American Scholar*, 57 (1988), 327–36.

Arnold, K., *Cabinets for the Curious: Looking Back at Early English Museums* (Aldershot: Ashgate, 2006).

Arnold-Forster, K., *Held in Trust: Museums and Collections of Universities in Northern England* (London: HMSO, 1994).

Ashton, T., *Visits to the Museum of the Manchester Natural History Society* (Manchester: Manchester Museum, 1857).

Asimov, I., *Foundation and Empire* (New York: Doubleday, 1952).

Audubon, J. J., *The Birds of America: From Original Drawings*, 4 vols (London: privately published, 1827–38).

Axon, W. E. A., 'On a pewter plate, with figures of Christ and the twelve apostles, in the Manchester Museum', *Transactions of the Lancashire and Cheshire Antiquarian Society*, 25 (1907), 79–80.

Bailey, C., 'On the contents of a herbarium of British and foreign plants for presentation to the Victoria University, Manchester', *Manchester Memoirs*, 61:5 (1917), 1–13.

Bailey, P., *Leisure and Class in Victorian Britain: Rational Recreation and the Contest for Control, 1830–1885* (London: Routledge, 1978).

Bankes, G. H. A., 'Ethnology', in *The Manchester Museum* (Derby: English Life, 1985), pp. 11–13.

———, 'The manufacture and circulation of paddle and anvil pottery on the north coast of Peru', *World Archaeology*, 17 (1985), 269–77.

———, 'Introduction to the ethnology collections at the Manchester Museum', *Museum Ethnographers Group Newsletter*, 20 (1987), 76–83.

———, 'Photographing paddle and anvil potters in Peru', *Journal of Museum Ethnography*, 1 (1989), 7–14.

———, *Aotearoa: The Maori Collections at the Manchester Museum* (Manchester: Manchester Museum, 1990).

———, 'The ethnology collections of the Manchester Museum, 1900–2000', in A. A. Shelton (ed.), *Collectors: Individuals and Institutions* (London: Horniman Museum, 2001), pp. 311–21.

Baratay, E. and E. Hardouin-Fugier, *Zoo: A History of Zoological Gardens in the West*, trans. O. Welsh (London: Reaktion, 2002).

Barber, L., *The Heyday of Natural History 1820–1870* (London: Cape, 1980).

Barnaby, D., *The Elephant who Walked to Manchester* (Plymouth: Basset, 1988).

Barringer, T. and T. Flynn (eds), *Colonialism and the Object: Empire, Material Culture, and the Museum* (London: Routledge, 1998).

Barrow, M. V., 'The specimen dealer: entrepreneurial natural history in America's gilded age', *Journal of the History of Biology*, 33 (2000), 493–534.

Bather, F. A., 'How may museums best retard the advance of science?', *Report of the Proceedings of the Museums Association* (1896), 92–105.

Becher, T. and P. R. Trowler, *Academic Tribes and Territories: Intellectual Enquiry and the*

Culture of Disciplines (Buckingham: Society for Research into Higher Education and Open University Press, 2nd edn, 2001).

Belk, R. W., *Collecting in a Consumer Society* (London: Routledge, 1995).

Bell, F. J., 'On "good form" in natural history museums', *Museums Journal*, 3 (1903), 159–61.

Ben-David, J., *Scientific Growth: Essays in the Social Organization and Ethos of Science* (Berkeley: University of California Press, 1991).

Benjamin, W., 'The work of art in the age of mechanical reproduction', in *Illuminations*, ed. H. Ardent, trans. H. Zorn (London: Pimlico, 2nd edn, 1999), pp. 211–44.

Bennett, T., *The Birth of the Museum: History, Theory, Politics* (London and New York: Routledge, 1995).

——, 'Figuring audiences and readers', in J. Hay, L. Grossberg and E. Wartella (eds), *The Audience and its Landscape* (Boulder: Westview, 1996), pp. 145–59.

——, 'Pedagogic objects, clean eyes, and popular instruction: on sensory regimes and museum didactics', *Configurations*, 6 (1998), 345–71.

——, 'Speaking to the eyes: museums, legibility and social order', in S. Macdonald (ed.), *The Politics of Display: Museums, Science, Culture* (London: Routledge, 1998), pp. 25–35.

——, *Pasts beyond Memory: Evolution, Museums, Colonialism* (London: Routledge, 2004).

——, 'Civic seeing: museums and the organization of vision', in S. Macdonald (ed.), *A Companion to Museum Studies* (Oxford: Blackwell, 2006), pp. 262–81.

Benson, K., 'The emergence of ecology from natural history', *Endeavour*, 24 (2000), 59–62.

Bentham, G. and J. D. Hooker, *Genera Plantarum ad Exemplaria Imprimis in Herbariis Kewensibus Servata Definita*, 3 vols (London: Reeve, 1862–83).

Birley, A., 'Barri Jones', *Guardian* (23 July 1999), p. 22.

Bishop, M. J., 'Dr. J. Wilfrid Jackson (1880–1978): a biographical sketch', in M. J. Bishop (ed.), *The Cave Hunters: Biographical Sketches of the Lives of Sir William Boyd Dawkins and Dr. J. Wilfrid Jackson* (Buxton: Derbyshire Museum Service, 1982), pp. 25–48.

Black, B. J., *On Exhibit: Victorians and Their Museums* (Charlottesville: University Press of Virginia, 2000).

Blackwood, B., *The Origin and Development of the Pitt Rivers Museum* (Oxford: Pitt Rivers Museum, 2nd edn, 1991).

Blower, J. G., 'Ralph Dennell (1907–1989)', *The Linnean*, 5:3 (1989), 35–8.

Board of Education, *Memorandum on the Possibility of Increased Co-operation between Public Museums and Public Educational Institutions* (London: HMSO, 1931).

Boas, F., 'Some principles of museum administration', *Science*, 25 (1907), 921–33.

Bolton, H., *Catalogue of the Types and Figured Specimens in the Geological Department* (Manchester: Cornish, 1893).

——, *Supplementary List of Type and Figured Specimens in The Geological Department, Manchester Museum, Owens College* (Manchester: Cornish, 1894).

——, 'Descriptive labels for the geological department, Peel Park Museum, Salford', *Report of the Proceedings of the Museums Association*, 7 (1896), 69–91.

Bouquet, M. (ed.), *Academic Anthropology and the Museum* (New York: Berghahn, 2001).

Bowen, E. G., 'Roderick Urwick Sayce', *Montgomeryshire Collections* (1969–70), 168–70.

Bowler, P., *The Fontana History of the Environmental Sciences* (London: Fontana, 1992).

Boylan, P., 'Universities and museums: past, present and future', *Museum Management and Curatorship*, 18 (1999), 43–56.

Brears, P. and S. Davies, *Treasures for the People: The Story of Museums and Art Galleries in Yorkshire and Humberside* (Yorkshire and Humberside: Yorkshire and Humberside Museums Council, 1989).

Brennan, T. and M. Jay (eds), *Vision in Context: Historical and Contemporary Perspectives on Sight* (London: Routledge, 1996).

Brown, T., *Illustrations of the Fossil Conchology of Great Britain and Ireland, with Descriptions and Localities of all the Species* (London: Smith, Elder, 1839).

———, *The Taxidermist's Manual; or the Art of Collecting, Preparing, and Preserving Objects of Natural History* (London: Fullarton, 8th edn, 1849).

Building Design Partnership (Manchester Group), *Brief for New Extensions to the Manchester Museum* (Manchester: Building Design Partnership, 1972).

Bullock, W., *A Descriptive Catalogue of the Exhibition, Entitled Ancient and Modern Mexico* (London: Egyptian Hall, 1824).

Bunney, A., 'It's not just a "children's playground". The influence of children on the development of the Science Museum, 1857–1973' (MSc dissertation, University of London, 1999).

Burkhardt, R. W., 'The leopard in the garden: life in close quarters at the Muséum d'Histoire Naturelle', *Isis*, 98 (2007), 675–94.

Burnett, J., 'The conversazione at the Edinburgh Museum of Science and Art, 1875', *Book of the Old Edinburgh Club*, 4 (1997), 145–8.

Burton-Brown, T., *Excavations in Azarbaijan, 1948* (London: Murray, 1951).

———, *The Coming of Iron to Greece* (Wincle, Cheshire: the author, 1955).

———, *The Diffusion of Ideas*, 3 vols (Wootton, Oxfordshire: the author, 1971–83).

———, *Excavation at Kara Tepe 1957* (Wootton, Oxfordshire: the author, 1979).

———, *Barlekin* (Wootton, Oxfordshire: the author, 1981).

Burton-Brown, T. and J. Faulds, *Guide to the Ancient Egyptian Collections* (Manchester: Manchester Museum, 1962).

Butler, S., 'A transformation in training: the formation of university medical faculties in Manchester, Leeds, and Liverpool, 1870–84', *Medical History*, 30 (1986), 115–32.

Cain, A. M., 'Lloyd, Robert Wylie (1868–1958)', in *Oxford Dictionary of National Biography* (Oxford: Oxford University Press, 2004), www.oxforddnb.com/view/article/62497, accessed 19 April 2005.

Cain, V. E. M., 'Nature under Glass: Popular Science, Professional Illusion and the Transformation of American Natural History Museums, 1870-1940' (PhD dissertation, Columbia University, 2006).

Calman, W. T., 'A museum zoologist's view of taxonomy', in J. S. Huxley (ed.), *The New Systematics* (London: Oxford University Press, 1940), pp. 455–60.

Candlin, F., 'The dubious inheritance of touch: art history and museum access', *Journal of Visual Culture*, 5 (2006), 137–54.

Canney, M. A., 'Egyptology in Manchester', *Journal of the Manchester Egyptian and Oriental Society*, 18 (1933), 28–36.

Cannon, H. G., *The Evolution of Living Things* (Manchester: Manchester University Press, 1958).

———, *Lamarck and Modern Genetics* (Manchester: Manchester University Press, 1959).

Carpenter, G. H., 'On collections to illustrate the evolution and geographical distribution of animals', *Report of the Proceedings of the Museums Association* (1894), 106–44.

———, *A Short Guide to the Manchester Museum* (Manchester: Manchester University Press, 1933).

———, *A Short Guide to the Manchester Museum*, ed. R. U. Sayce (Manchester: Manchester University Press, revised edn, 1941).

———, *Guide to the Manchester Museum*, ed. R. U. Sayce (Manchester: Manchester University Press, revised edn, 1948).

Carson, R. A. G. and H. Pagan, *A History of the Royal Numismatic Society 1836–1986* (London: Royal Numismatic Society, 1986).

Carter, P. G., 'Educational services', in J. M. A. Thompson (ed.), *Manual of Curatorship: A Guide to Museum Practice* (London: Butterworths, 1984), pp. 435–47.

A Catalogue of the Valuable Collection of Paintings and Drawings, Prints and Etchings, Cabinet of Insects, &c. (The Property of the Late John Leigh Philips, Esq.) (Manchester: Aston, 1814).

Chalmers, J., *Audubon in Edinburgh: And his Scottish Associates* (Edinburgh: National Museums of Scotland, 2003).

Chalmers-Hunt, J. M. (ed.), *Natural History Auctions 1700–1972: A Register of Sales in the British Isles* (London: Sotheby Parke Bernet, 1976).

Chaloner, W. H., *The Movement for the Extension of Owens College Manchester 1863–73* (Manchester: Manchester University Press, 1973).

Charlton, H. B., *Portrait of a University, 1851–1951: To Commemorate the Centenary of Manchester University* (Manchester: Manchester University Press, 1951).

Charlton, W. A. and E. G. Cutter, *135 Years of Botany at Manchester* (Manchester: University of Manchester, 1998).

Cheetham, F. W. (ed.), *Museum School Services* (London: Museums Association, 1967).

Chun, D., 'Public display, private glory: Sir John Fleming Leicester's gallery of British art in early nineteenth-century England', *Journal of the History of Collections*, 13 (2001), 175–89.

Chung, Y. S. S., 'John Britton (1771–1857) – a source for the exploration of the foundations of county archaeological society museums', *Journal of the History of Collections*, 15 (2003), 113–25.

City of Manchester Education Committee, *The City Art Gallery and the Manchester Museum Schools Service* (Manchester: Manchester Education Committee, 1957).

Clark, J. F. M., *Bugs and the Victorians* (New Haven: Yale University Press, 2009).

Coleman, A. P. and H. W. Ball, 'An era of change and independence 1950–1980', in W. T. Stearn, *The Natural History Museum at South Kensington: A History of the British Museum (Natural History) 1753–1980* (London: Heinemann, 1981), pp. 333–85.

Collins, H., *Changing Order: Replication and Induction in Scientific Practice* (London: Sage, 1995).

Committee of Council on Education (England and Wales), *Report; with Appendix* (London: HMSO, 1895).

Conn, S., *Museums and American Intellectual Life, 1876–1926* (Chicago: University of Chicago Press, 1998).

Coombes, A. E., *Reinventing Africa: Museums, Material Culture and Popular Imagination in Late Victorian and Edwardian England* (New Haven: Yale University Press, 1994).

Cooper, A., 'The museum and the book. The *Metallotheca* and the history of an encyclopaedic natural history in early modern Italy', *Journal of the History of Collections*, 7 (1995), 1–23.

Cooper, M., *Robbing the Sparry Garniture: A 200 Year History of British Mineral Dealers* (Tucson, Arizona: Mineralogical Record, 2006).

Cooter, R. and S. Pumfrey, 'Separate spheres and public places: reflections on the history of science popularization and science in popular culture', *History of Science*, 32 (1994), 237–67.

Corfield, M., 'The reshaping of archaeological metal objects: some ethical considerations', *Antiquity*, 62 (1988), 261–5.

Corfield, R., *The Silent Landscape: In the Wake of HMS Challenger 1872–1876* (London: Murray, 2003).

Crane, S. A. (ed.), *Museums and Memory* (Palo Alto, CA: Stanford University Press, 2000).

Crary, J., *Techniques of the Observer: On Vision and Modernity in the Nineteenth Century* (Cambridge, Mass: MIT Press, 1990).

Crompton, W. H., 'Jesse Haworth: first president of the Manchester Egyptian Association', *Journal of the Manchester Egyptian and Oriental Society*, 9 (1921), 49–52.

———, 'William Evans Hoyle, M.A., D.Sc., M.R.C.S. (founder of the Manchester Egyptian Association)', *Journal of the Manchester Egyptian and Oriental Society*, 13 (1927), 65–7.

———, 'William Boyd Dawkins', *Journal of the Manchester Egyptian and Oriental Society*, 15 (1930), 12–13.

Crooke, E., *Politics, Archaeology and the Creation of a National Museum of Ireland: An Expression of National Life* (Dublin: Irish Academic Press, 2000).

Cunningham, C., *The Terracotta Designs of Alfred Waterhouse* (London: Natural History Museum, 2001).

Cunningham, C. and P. Waterhouse, *Alfred Waterhouse 1830-1905: Biography of a Practice* (Oxford: Clarendon, 1992).

Dance, S. P., *A History of Shell Collecting* (London: Faber, 2nd edn, 1986).

Daniels, A. K., *Invisible Careers: Women Civic Leaders from the Volunteer World* (Chicago: University of Chicago Press, 1988).

Darbishire, Barker, & Tatham (solicitors), *Plan and Particulars of a Very Valuable Freehold Plot of Land, Having an Extensive Frontage to Peter-Street* (Manchester: privately printed leaflet, 1872).

Darnton, R., *The Kiss of Lamourette* (London: Faber, 1990).

Darwin, C. R., *The Descent of Man, and Selection in Relation to Sex*, 2 vols (London: Murray, 1871).

Daston, L. (ed.), *Biographies of Scientific Objects* (Chicago: University of Chicago Press, 2000).

——— (ed.), *Things that Talk: Object Lessons from Art and Science* (New York: Zone, 2004).

David, A. R. (ed.), *The Manchester Museum Mummy Project* (Manchester: Manchester Museum, 1979).

———, *The Two Brothers: Death and the Afterlife in Middle Kingdom Egypt* (Liverpool: Rutherford, 2007).

Davis, P., *Museums and the Natural Environment: The Role of Natural History Museums in Biological Conservation* (London: Leicester University Press, 1996).

Dawkins, W. B., 'Darwin on the descent of man', *Edinburgh Review*, 134 (1871), 195–235.

———, 'The value of natural history museums', *Nature*, 16 (1877), 98.

———, 'The organisation of natural history museums', *Nature*, 16 (1877), 137–8.

——, *Early Man in Britain and His Place in the Tertiary Period* (London: Macmillan, 1880).

——, 'On museum organisation and arrangement', *Report of the Proceedings of the Museums Association*, 1 (1890), 38–45.

——, 'On the museum question', *Report of the Proceedings of the Museums Association*, 3 (1892), 13–24.

——, *The Opportunity of Manchester* (Manchester: Cuthbertson and Black, 1903).

——, 'The organisation of museums and art galleries in Manchester', *Manchester Memoirs*, 62 (1917).

——, 'The Manchester Museum: its place in education', *Old Owensian Journal*, 5 (1928), 142–4.

Dawson, W. R. and E. P. Uphill, *Who Was Who in Egyptology*, ed. M. L. Bierbrier (London: Egypt Exploration Society, 3rd edn, 1995).

De Peyer, R. M. and A. W. Johnston, 'Greek antiquities from the Wellcome Collection: a distribution list', *Journal of Hellenic Studies*, 106 (1986), 286–94.

De Quincey, T. P., *Autobiographic Sketches 1790–1803* (Edinburgh: Black, 1862).

Department of Education and Science, *Museums in Education* (London: HMSO, 1971).

——, *Provincial Museums and Galleries*, ed. C. W. Wright (London: HMSO, 1973).

DeSilvey, C., 'Observed decay: telling stories with mutable things', *Journal of Material Culture*, 11 (2006), 317–37.

Desmond, A., *Huxley: From Devil's Disciple to Evolution's High Priest* (London: Penguin, 1998).

——, 'Redefining the X axis: "professionals", "amateurs" and the making of mid-Victorian biology', *Journal of the History of Biology*, 34 (2001), 3–50.

Dimbleby, G. W. (ed.), *The Scientific Treatment of Material from Rescue Excavations: A Report by a Working Party of the Committee for Rescue Archaeology of the Ancient Monuments Board for England* (London: Department of the Environment, 1978).

Douglas, A. S. and E. G. Hancock, 'Insect collecting in Africa during the eighteenth century and William Hunter's collection', *Archives of Natural History*, 34 (2007), 293–306.

Down, R., '"Old" preservative methods', in C. V. Horie (ed.), *Conservation of Natural History Specimens: Spirit Collections* (Manchester: University of Manchester, 1989), pp. 33–8.

'Dr Alcock's diary . . .', *Cheshire Archives and Local Studies Newsletter*, 27 (2005), 2.

Dresser, H. E., *Eggs of the Birds of Europe, Including all the Species Inhabiting the Western Palæarctic Area*, 2 vols (London: Royal Society for the Protection of Birds, 1905–10).

Dresser, H. E. and R. B. Sharpe, *A History of the Birds of Europe, Including all the Species Inhabiting the Western Palaearctic Region*, 9 vols (London: published by the author, 1871–96).

Drower, M. S., *Flinders Petrie: A Life in Archaeology* (London: Gollancz, 1985).

Duncan, C., *Civilizing Rituals: Inside Public Art Museums* (London: Routledge, 1995).

Society of Museum Archaeologists, *Dust to Dust? Field Archaeology and Museums* (n.p.: Society of Museum Archaeologists, 1986).

Eagar, R. M. C., 'The moon in a geological gallery', *Museums Journal*, 64 (1964), 132–7.

——, *The Geological Column* (Manchester: Manchester Museum, 1965).

Eagar, R. M. C. and J. Faulds, *Record of the Rocks* (Manchester: Bates, 1960).

Eagar, R. M. C. and D. E. Owen, 'Moon rock in Manchester', *Museums Journal*, 69 (1970), 159–60.

Eagar, R. M. C. and R. Preece, 'Collections and collectors of note 14: the Manchester Museum', *Newsletter of the Geological Curators Group*, 2:11 (1977), 12–40.

'Eagar's endeavour', *Communication* (Victoria University of Manchester newsletter) (February 1977), p. 13.

Earl of Rosse, *Survey of Provincial Museums and Galleries* (London: HMSO, 1963).

Edge-Partington, J. and C. Heape, *An Album of the Weapons, Tools, Ornaments, Articles of Dress, etc., of the Natives of the Pacific Islands*, 3 vols (Manchester: privately printed, 1890–98).

Edinger, D. C., 'Education at the Field Museum, 1922–1970', *Bulletin of the Field Museum of Natural History*, 41:5 (1970), 15.

Edwards, A. B., *A Thousand Miles up the Nile* (London: Longmans, 1877).

Edwards, E., C. Gosden and R. Phillips (eds), *Sensible Objects: Colonialism, Museums and Material Culture* (Oxford: Berg, 2006).

Edwards, J. J. and M. J. Edwards, *Medical Museum Technology* (London: Oxford University Press, 1959).

Edwards, S. R., 'Spruce in Manchester', in M. R. D. Seaward and S. M. D. FitzGerald (eds), *Richard Spruce, 1817–1893: Botanist and Explorer* (London: Royal Botanic Gardens, 1996), pp. 266–79.

Edwards, W. H., 'An economical method of mounting shells and other small objects for museums', *Museums Journal*, 1 (1902), 251–4.

Elliot Smith, G., 'Winifred M. Crompton', *Journal of the Manchester Egyptian and Oriental Society*, 18 (1933), 25–6.

——, *Catalogue Générale des Antiquités Égyptiennes du Musée du Caire: The Royal Mummies* (London: Duckworth, facsimile edn, 2000).

Elliott, P., 'Provincial urban society, scientific culture and socio-political marginality in Britain in the eighteenth and nineteenth centuries', *Social History*, 28 (2003), 361–87.

Ellis, R., R. Grove-White, J. Vogel *et al.*, *Nature: Who Knows?* (Lancaster: English Nature, Lancaster University and the Natural History Museum, 2005).

Elsner, J. and R. Cardinal (eds), *The Cultures of Collecting* (London: Reaktion, 1994).

Eltringham, H. and H. Britten, *Histological and Illustrative Methods for Entomologists* (Oxford: Clarendon, 1930).

Faraday, F. J. and W. B. Faraday, 'Selections from the correspondence of Lieut.-Colonel John Leigh Philips of Mayfield, Manchester', *Memoirs and Proceedings of the Manchester Literary and Philosophical Society*, 3, 44, 45 (1890–1901), 13–56, 1–51, 1–59.

Farber, P. L., *Finding Order in Nature: The Naturalist Tradition from Linnaeus to E. O. Wilson* (Baltimore: Johns Hopkins University Press, 2000).

Fiddes, E., *Chapters in the History of Owens College and of Manchester University, 1851–1914* (Manchester: Manchester University Press, 1937).

'Finalists for the 1980 Museum of the Year award', *Illustrated London News*, June (1980), 47–9.

Findlen, P., *Possessing Nature: Museums, Collecting, and Scientific Culture in Early Modern Italy* (Berkeley: University of California Press, 1994).

——, 'Mr. Murray's Cabinet of Wonder', in D. Murray, *Museums: Their History and Their Use*, vol. 1 (Staten Island: Pober, reprinted edn, 2000), pp. i–xii.

Finnegan, D. A., 'The spatial turn: geographical approaches in the history of science', *Journal of the History of Biology*, 41 (2007), 369–88.

Fish, T., *The 'Behrens' Collection of Sumerian Tablets in the Manchester Museum* (Manchester: Manchester University Press, 1926).

Fisher, C. (ed.), *A Passion for Natural History: The Life and Legacy of the 13th Earl of Derby* (Liverpool: National Museums and Galleries on Merseyside, 2002).

Fisher, N., 'The classification of the sciences', in R. C. Olby, G. N. C. Cantor, M. J. S. Hodge *et al.* (eds), *Companion to the History of Modern Science* (London: Routledge, 1990), pp. 853–68.

Fleure, H. J., 'Alfred Cort Haddon 1855–1940', *Obituary Notices of Fellows of the Royal Society*, 3 (1941), 448–65.

Flower, W. H., 'Address', *Report of the Meeting of the British Association for the Advancement of Science*, 59 (1889), 3–24.

——, *Essays on Museums and Other Subjects Connected with Natural History* (London: Macmillan, 1898).

Forde-Johnston, J., 'The excavation of a round barrow at Gallowslough Hill, Delamere Forest, Cheshire', *Transactions of the Lancashire and Cheshire Antiquarian Society*, 70 (1960), 74–83.

——, *Great Medieval Castles of Britain* (London: Bodley Head, 1979).

Forde-Johnston, J. and J. Whitworth, *A Picture Book of Japanese Art* (Manchester: Manchester Museum, 1965).

Forgan, S., 'Context, image and function: a preliminary enquiry into the architecture of scientific societies', *British Journal for the History of Science*, 19 (1986), 89–113.

——, 'The architecture of display: museums, universities and objects in nineteenth-century Britain', *History of Science*, 32 (1994), 139–62.

——, 'Museum and university: spaces for learning and the shape of disciplines', in M. Hewitt (ed.), *Scholarship in Victorian Britain* (Leeds: Trinity and All Saints, 1998), pp. 66–77.

——, 'Bricks and bones: architecture and science in Victorian Britain', in P. Galison and E. Thompson (eds), *The Architecture of Science* (Cambridge, Mass: MIT Press, 1999), pp. 181–208.

Fortey, R., *Dry Store Room No. 1: The Secret Life of the Natural History Museum* (London: Harper, 2008).

Franks, J. W., *Herb. Manch: A Guide to the Contents of the Herbarium of Manchester Museum* (Manchester: Manchester Museum, 1973).

Freedberg, D., *The Power of Images: Studies in the History and Theory of Response* (Chicago: University of Chicago Press, 1989).

Frere, S., *Principles of Publication in Field Archaeology* (London: Department of the Environment, 1975).

Friedman, R., 'Elise Jenny Baumgartel 1892–1975', www.brown.edu/Research/Breaking_ Ground/, accessed 18 April 2006.

Frost, C., *A History of British Taxidermy* (Lavenham: Lavenham Press, 1987).

Frostick, E., 'Museums in education: a neglected role?' *Museums Journal*, 85 (1985), 67–74.

Fyfe, A., 'Reading and visiting: natural history at the British Museum and the *Pictorial Museum*', in A. Fyfe and B. Lightman (eds), *Science in the Marketplace: Nineteenth-Century Sites and Experiences* (Chicago: University of Chicago Press, 2007), pp. 196–230.

Fyfe, A. and B. Lightman (eds), *Science in the Marketplace: Nineteenth-Century Sites and Experiences* (Chicago: University of Chicago Press, 2007).

Fyfe, G. and M. Ross, 'Decoding the visitor's gaze: rethinking museum visiting', in S. Macdonald and G. Fyfe (eds), *Theorizing Museums: Representing Identity and Diversity in a Changing World* (Oxford: Blackwell, 1996), pp. 127–50.

Galison, P. and B. Hevly (eds), *Big Science: The Growth of Large-Scale Research* (Stanford, Calif.: Stanford University Press, 1992).

Gange, D., 'Religion and science in late nineteenth-century British Egyptology', *The Historical Journal*, 49 (2006), 1083–103.

Gardiner, J. S., 'Sydney John Hickson 1859–1940', *Obituary Notices of Fellows of the Royal Society*, 3 (1941), 383–94.

Garnett, A., 'Herbert John Fleure 1877–1969', *Biographical Memoirs of Fellows of the Royal Society*, 16 (1970), 253–78.

Gieryn, T. F., 'Boundary work and the demarcation of science from non-science: strains and interests in professional interests of scientists', *American Sociological Review*, 48 (1983), 781–95.

———, *Cultural Boundaries of Science: Credibility on the Line* (Chicago: University of Chicago Press, 1999).

———, 'What buildings do', *Theory and Society*, 31 (2002), 35–74.

Girouard, M., *Alfred Waterhouse and the Natural History Museum* (New Haven: Yale University Press, 1981).

———, *Town and Country* (New Haven: Yale University Press, 1992).

Glasgow Art Gallery and Museums, *Educational Experiment: 1941–1951* (Glasgow: Corporation of the City of Glasgow, 1951).

Golinski, J., 'The theory of practice and the practice of theory', *Isis*, 81 (1990), 492–505.

———, *Making Natural Knowledge: Constructivism and the History of Science* (Chicago: University of Chicago Press, 2nd edn, 2005).

Goodburn, R., M. W. C. Hassall and R. S. O. Tomlin, 'Roman Britain in 1978', *Britannia*, 10 (1979), 267–356.

Goodrich, E. S., 'Museum preparations', *Report of the Proceedings of the Museums Association*, 8 (1897), 80–4.

Goodyear, F. H., *Archaeological Site Science* (London: Heinemann, 1971).

Gordon, I. and S. W. Kemp, 'Walter M. Tattersall and Olive S. Tattersall: 7 decades of Peracaridan research', *Crustaceana*, 38 (1980), 311–20.

Gosden, C., *Anthropology and Archaeology: A Changing Relationship* (London: Routledge, 1999).

Gosden, C. and C. Knowles, *Collecting Colonialism: Material Culture and Colonial Change* (Oxford: Berg, 2001).

Gosden, C. and F. Larson, *Knowing Things: Exploring the Collections at the Pitt Rivers Museum 1884–1945* (Oxford: Oxford University Press, 2007).

Gosden, C. and Y. Marshall, 'The cultural biography of objects', *World Archaeology*, 31 (1999), 169–78.

'The government and museums: the case for the provinces', *Museums Journal*, 15 (1916), 313–6.

Green, J. A., H. Bolton, J. A. Clubb *et al.*, 'Museums in relation to education – final report of committee', *Report of the British Association for the Advancement of Science*, 88 (1920), 267–80.

Greenwood, T., *Museums and Art Galleries* (London: Simpkin, 1888).

Griffith, A. S., *Catalogue of Egyptian Antiquities of the XII and XVIII Dynasties from Kahun, Illahun and Gurob* (Manchester: Sherratt & Hughes, 1910).

Griffiths, A., '"Journeys for those who can not travel": promenade cinema and the museum life group ', *Wide Angle*, 18 (1996), 53–84.

——, *Wondrous Difference: Cinema, Anthropology and Turn-of-the-Century Visual Culture* (New York: Columbia University Press, 2004).

Griffiths, T., *Hunters and Collectors: The Antiquarian Imagination in Australia* (Cambridge: Cambridge University Press, 1996).

Grindon, L. H., *Manchester Banks and Bankers: Historical, Biographical, and Anecdotal* (Manchester: Palmer and Howe, 1877).

Gruffudd, P., 'Back to the land: historiography, rurality and the nation in interwar Wales', *Transactions of the Institute of British Geographers*, 19 (1994), 61–77.

Gunn, S., *The Public Culture of the Victorian Middle Class: Ritual and Authority in the English Industrial City 1840–1914* (Manchester: Manchester University Press, 2000).

Gunther, A. E., *A Century of Zoology at the British Museum Through the Lives of Two Keepers, 1815–1914* (London: Dawsons, 1975).

Halbwachs, M., *On Collective Memory*, trans. L. A. Coser (Chicago: University of Chicago Press, 1992).

Hall, D., 'The history of the book: new questions? New answers?' *Journal of Library History*, 21 (1986), 27–36.

Hall, S. (ed.), *Representation: Cultural Representations and Signifying Practices* (London: Sage, 1997).

Hallett, C., 'The work of a guide demonstrator', *Museums Journal*, 13 (1913), 192–202.

Hamm, E. P., 'Unpacking Goethe's collections: the public and the private in natural-historical collecting', *British Journal for the History of Science*, 34 (2001), 275–300.

Handbook of Manchester. Prepared by the Local Committee for the Members of the British Association (British Association for the Advancement of Science) (Manchester: Sowler, 1887).

Handley, E., 'Thomas Bertram Lonsdale Webster', *Proceedings of the British Academy*, 120 (2003), 445–67.

Handley, N. (ed.), *Continuing in Trust: The Future of the Departmental Collections in the University of Manchester* (Manchester: Centre for the History of Science, Technology and Medicine, 1998).

Harbison, R., 'Contracted world: museums and catalogues', in *Eccentric Spaces* (New York: Avon, new edn, 2000), pp. 140–62.

Hardy, J. R., 'The macro-lepidoptera of Sherwood Forest', *Manchester Memoirs*, 45:12 (1901), 1–5.

Harrison, M., 'Art and Philanthropy: T.C. Horsfall and the Manchester Art Museum', in A. Kidd (ed.), *City, Class and Culture* (Manchester: Manchester University Press, 1986), pp. 120–47.

Hart-Davis, D., *Audubon's Elephant: The Story of John James Audubon's Epic Struggle to Publish The Birds of America* (London: Weidenfeld & Nicolson, 2003).

Hartwell, C., J. H. G. Archer and J. Holder, *Manchester* (New Haven: Yale University Press, 2002).

Haward, L., 'Discussion in the relation of museums to art, commerce, welfare and education generally', in E. Howarth (ed.), *The Educational Value of Museums and the Formation of Local War Musems* (London: Wesley, 1918), pp. 33–42.

Haworth, J., 'The progress of Egyptology in Manchester', *Journal of the Manchester Egyptian and Oriental Society*, 3 (1913), 12–18.

Hay, J., L. Grossberg and E. Wartella (eds), *The Audience and its Landscape* (Boulder, Col.: Westview, 1996).

Haynes, C., 'A "natural" exhibitioner: Sir Ashton Lever and his *Holosphusikon*', *British Journal for Eighteenth-Century Studies*, 24 (2001), 1–14.

Hayter, W. G., 'The Hayter Report and after', *Oxford Review of Education*, 1 (1975), 169–72.

Head, G., *A Home Tour through the Manufacturing Districts of England in the Summer of 1835* (London: Cass, facsimile edn, 1968).

Healy, J. F. (ed.), *Sylloge Nummorum Graecorum, VII, Manchester University Museum: The Raby and Güterbock Collections* (London: Oxford University Press, 1986).

Heape, C. and R. Heape, *Records of the Family of Heape, Staley, Saddleworth and Rochdale, from circa 1170 to 1905* (Rochdale: privately printed, 1905).

Henare, A., *Museums, Anthropology and Imperial Exchange* (Cambridge: Cambridge University Press, 2005).

Hencke, D., 'Severe blow dealt to museums policy', *Guardian* (20 April 1988), p. 3.

Hendon, J. A., 'Having and holding: storage, memory, knowledge, and social relations', *American Anthropologist*, 102 (2000), 42–53.

Hetherington, K., 'Spatial textures: place, touch, and praesentia', *Environment and Planning A*, 35 (2003), 1933–44.

Hey, S., *Schools Working under the Two-Shift System: A Further Report Submitted on Scheme of Work in Connection with Museums, Art Galleries, Organised Games in the Parks, Teaching in the Parks, Walks in the Country, Etc.* (Manchester: City of Manchester Education Committee, 1917).

—— (ed.), *A Survey of the Facilities for Adult Education Available in Manchester* (Manchester: Manchester Education Committee, 1925).

Hickson, S. J., *Outline Classification of the Animal Kingdom* (Manchester: Manchester University Press, 4th edn, 1911).

——, *Outline Classification of the Animal Kingdom* (Manchester: Manchester University Press, 5th edn, 1924).

Higgins, H. H., 'Life history groups. Suggestions on the desirability of exhibiting in museum drawers of unmounted skins of birds', *Report of the Proceedings of the Museums Association*, 2 (1891), 49–56.

Hill, K., '"Thoroughly embued with the spirit of ancient Greece": symbolism and space in Victorian civic culture', in A. Kidd and D. Nicholls (eds), *Gender, Civic Culture and Consumerism: Middle-Class Identity in Britain 1800–1940* (Manchester: Manchester University Press, 1999), pp. 99–111.

——, '"Roughs of both sexes": the working class in Victorian museums and art galleries', in S. Gunn and R. J. Morris (eds), *Identities in Space: Contested Terrains in the Western City since 1850* (Aldershot: Ashgate, 2001), pp. 190–203.

——, *Culture and Class in English Public Museums, 1850–1914* (Aldershot: Ashgate, 2005).

Hincks, W. D., 'Dr. Franz Spaeth and the Cassidinae', *Coleopterists' Bulletin*, 5 (1951), 55–7.

Hoage, R. J. and W. A. Deiss (eds), *New Worlds, New Animals: From Menagerie to Zoological Park in the Nineteenth Century* (Baltimore: Johns Hopkins University Press, 1996).

Hoberman, R., 'In quest of a museal aura: turn of the century narratives about museum-displayed objects', *Victorian Literature and Culture*, 31 (2003), 467–82.

Holdsworth, P., 'The Greater Manchester Archaeological Unit', *Mamucium*, 28 (1981), 3–4.

Hooper-Greenhill, E., *Museum and Gallery Education* (Leicester: Leicester University Press, 1991).

——, *Museums and the Shaping of Knowledge* (London: Routledge, 1992).

——, *Museums and Their Visitors* (London: Routledge, 1994).

——, 'Studying visitors', in S. Macdonald (ed.), *A Companion to Museum Studies* (Oxford: Blackwell, 2006), pp. 362–76.

Hopwood, N., *Embryos in Wax: Models from the Ziegler Studio* (Cambridge: Whipple Museum of the History of Science, 2002).

——, 'Artist versus anatomist, models against dissection: Paul Zeiller of Munich and the revolution of 1848', *Medical History*, 51 (2007), 279–308.

Horie, C. V., 'Conservation and the specimen', *Newsletter of the Natural History Group of the ICOM Committee for Conservation* (1986), 4–5.

——, *Materials for Conservation: Organic Consolidants, Adhesives and Coatings* (London: Butterworths, 1987).

—— (ed.), *Conservation of Natural History Specimens: Spirit Collections* (Manchester: University of Manchester, 1989).

Hoskins, J., *Biographical Objects: How Things tell the Stories of People's Lives* (New York: Routledge, 1998).

Howard, M., *Up Close: A Guide to Manchester Art Gallery* (London: Scala, 2002).

Howarth, E., 'Museum cases and museum visitors', *Report of the Proceedings of the Museums Association*, 1 (1890), 88–94.

——, 'Report of Label Committee', *Report of the Proceedings of the Museums Association*, 2 (1892), 139–42.

—— (ed.), *The Educational Value of Museums and the Formation of Local War Musems* (London: Wesley, 1918).

Hoyle, W. E., 'The registration and cataloguing of museum specimens', *Report of the Proceedings of the Museums Association*, 2 (1891), 59–67.

——, *General Guide to the Contents of the Museum* (Manchester: Cornish, 1892).

——, *General Guide to the Contents of the Museum (Illustrated)* (Manchester: Cornish, 2nd edn, 1893).

——, *A Catalogue of the Books and Pamphlets in the Library Arranged according to Subjects and Authors* (Manchester: Cornish, 1895).

——, *Handy Guide to the Museum* (Manchester: Cuthbertson and Black, 1895).

——, 'The electric light installation in the Manchester Museum', *Report of the Proceedings of the Museums Association*, 9 (1898), 95–105.

——, *General Guide to the Natural History Collections* (Manchester: Cornish, 1899).

——, *Handy Guide to the Museum* (Manchester: Cornish, 3rd edn, 1903).

Hoyle, W. E. and H. Bolton, 'Classified cataloguing, as applied to Palæozoic fossils', *Report of the Proceedings of the Museums Association*, 5 (1894), 167–77.

Hudson, K., *A Social History of Museums: What the Visitors Thought* (London: Macmillan, 1975).

Hüllen, W., 'Reality, the museum, and the catalogue, a semiotic interpretation of early modern German texts of museology', *Semiotica*, 80 (1990), 265–75.

Huxley, L., *Life and Letters of Thomas Henry Huxley*, 2 vols (London: Macmillan, 1900).

Huxley, T. H., *Evidence as to Man's Place in Nature* (London: Williams and Norgate, 1863).

——, 'Suggestions for a proposed natural history museum in Manchester', *Report of the Proceedings of the Museums Association*, 7 (1896), 126–31.

Hyde, R., *Panoramania! The Art and Entertainment of the 'All-Embracing' View* (London: Trefoil, 1988).

Inkster, I. and J. Morrell (eds), *Metropolis and Province: Science in British Culture, 1780–1850* (London: Hutchinson, 1983).

Insley, J., 'Little landscapes: dioramas in museum displays', *Endeavour*, 32 (2008), 27–31.

Jackson, J. W., 'Preliminary report on the exploration of "Dog Holes" Cave, Warton Crag, near Carnforth, Lancashire', *Transactions of the Lancashire and Cheshire Antiquarian Society*, 27 (1909), 1–32.

——, *Shells as Evidence in the Migrations of Early Culture* (Manchester: Manchester University Press, 1917).

——, 'Obituary notice: Robert Standen', *Journal of Conchology*, 17 (1925), 41–5.

——, 'Obituary notice: William Evans Hoyle', *Journal of Conchology*, 18 (1926), 33–4.

——, *New Carboniferous Lamellibranchs and Notes on Other Forms* (Manchester: Manchester University Press, 1927).

——, 'Genesis and progress of the Lancashire and Cheshire Antiquarian Society', *Transactions of the Lancashire and Cheshire Antiquarian Society*, 49 (1933), 104–12.

——, 'The prehistoric archaeology of Lancashire and Cheshire', *Transactions of the Lancashire and Cheshire Antiquarian Society*, 50 (1934–35), 65–106.

——, *Contributions to the Archaeology of the Manchester Region* (Manchester: Manchester Museum, 1936).

——, 'Biography of Captain Thomas Brown (1785–1862), a former curator of the Manchester Museum', *Memoirs and Proceedings of the Manchester Literary and Philosophical Society*, 86 (1943–45), 1–28.

——, *Catalogue of Types and Figured Specimens in the Geological Department of the Manchester Museum* (Manchester: Manchester University Press, 1952).

——, 'Sir William Boyd Dawkins (1837–1929): a biographical sketch', in M. J. Bishop (ed.), *The Cave Hunters: Biographical Sketches of the Lives of Sir William Boyd Dawkins and Dr. J. Wilfrid Jackson* (Buxton: Derbyshire Museum Service, 1982), pp. 5–17.

Jankovic, V., 'The place of nature and the nature of place: the chorographic challenge to the history of British provincial science', *History of Science*, 38 (2000), 79–113.

Jenkins, I., *Archaeologists and Aesthetes in the Sculpture Galleries of the British Museum 1800–1939* (London: British Museum, 1992).

Johns, C. H. W., 'Some Babylonian tablets in the Manchester Museum', *Journal of the Manchester Egyptian and Oriental Society*, 3 (1913–14), 67–72.

Jones, B., *Past Imperfect: The Story of Rescue Archaeology* (London: Heinemann, 1984).

Jones, B. and P. Reynolds, *Roman Manchester: The Deansgate Excavations 1978* (Manchester: Greater Manchester Council, 1978).

Jones, D. R., *The Origins of Civic Universities: Manchester, Leeds and Liverpool* (London: Routledge, 1988).

Kargon, R. H., *Science in Victorian Manchester: Enterprise and Expertise* (Manchester: Manchester University Press, 1977).

Kavanagh, G., *Museums and the First World War: A Social History* (Leicester: Leicester University Press, 1994).

Kenyon, D. and R. Neave, *Lindow Man: His Life and Times* (Manchester: Manchester Museum, 1987).

Keppie, L., *William Hunter and the Hunterian Museum in Glasgow, 1807–2007* (Edinburgh: Edinburgh University Press, 2007).

Kidd, A., *Manchester: A History* (Lancaster: Carnegie, 4th edn, 2006).

King, D. Q., 'A checklist of sources of the botanical illustrations in the Leo Grindon Herbarium, The Manchester Museum', *Archives of Natural History*, 34 (2007), 129–39.

Kloet, G. S. and W. D. Hincks, *Check List of British Insects* (Stockport: privately printed, 1945).

Knell, S. J., *The Culture of English Geology, 1815–1851: A Science Revealed through its Collecting* (Aldershot: Ashgate, 2000).

———, 'Museums, reality and the material world', in Knell (ed.), *Museums in the Material World* (London: Routledge, 2007), pp. 1–28.

Kohler, R. E., *All Creatures: Naturalists, Collectors, and Biodiversity, 1850–1950* (Princeton: Princeton University Press, 2006).

Kohlstedt, S. G., 'Henry A. Ward: the merchant naturalist and American museum development', *Journal of the Society for the Bibliography of Natural History*, 9 (1980), 647–61.

———, '"Thoughts in things": modernity, history, and North American museums', *Isis*, 96 (2005), 586–601.

———, 'Masculinity and animal display in nineteenth-century America', in A. B. Shteir and B. Lightman (eds), *Figuring It Out: Science, Gender, and Visual Culture* (Lebanon, NH: Dartmouth College Press, 2006), pp. 110–39.

———, 'Exhibiting colonial science', in D. Livingstone and C. Withers (eds), *Geographies of Nineteenth-Century Science* (Chicago: University of Chicago Press, forthcoming).

Kohlstedt, S. G. and P. Brinkman, 'Framing nature: the formative years of natural history museum development in the United States', in A. E. Leviton and M. L. Aldrich (eds), *Museums and Other Institutions of Natural History, Past, Present, and Future* (San Francisco: California Academy of Sciences, 2004), pp. 7–33.

Kopytoff, I., 'The cultural biography of things: commoditization as process', in A. Appadurai (ed.), *The Social Life of Things: Commodities in Cultural Perspective* (Cambridge: Cambridge University Press, 1986), pp. 64–91.

Koven, S., 'The Whitechapel picture exhibitions and the politics of seeing', in D. J. Sherman and I. Rogoff (eds), *Museum Culture: Histories, Discourse, Spectacle* (London: Routledge, 1994), pp. 22–48.

Kraft, A., 'Building Manchester Biology 1851–1963: National Agendas, Provincial Strategies' (PhD dissertation, University of Manchester, 2000).

———, 'Pragmatism, patronage and politics in English biology: the rise and fall of economic biology 1904–1920', *Journal of the History of Biology*, 37 (2004), 213–58.

Kraft, A. and S. J. M. M. Alberti, '"Equal though different": laboratories, museums and the institutional development of biology in the late-Victorian industrial North', *Studies in History and Philosophy of Biological and Biomedical Sciences*, 34 (2003), 203–36.

Kuklick, H., *The Savage Within: The Social History of British Anthropology, 1885–1945* (Cambridge: Cambridge University Press, 1991).

Kuklick, H. and R. E. Kohler (eds), *Science in the Field* (*Osiris*, 11; Chicago: University of Chicago Press, 1996).

Lancashire and Cheshire Antiquarian Society, 'Saturday, October 6th, 1888. Visit to the Manchester Museum', *Transactions of the Lancashire and Cheshire Antiquarian Society*, 6 (1888), 233–7.

Lane Fox, A. H., 'On the principles of classification adopted in the arrangement of his anthropological collection, now exhibited in the Bethnal Green Museum', *Journal of the Anthropological Institute of Great Britain and Ireland*, 4 (1875), 293–308.

Larson, F., 'Anthropology as comparative anatomy? Reflecting on the study of material culture during the late 1800s and the late 1900s', *Journal of Material Culture*, 12 (2007), 89–112.

——, 'Anthropological landscaping: General Pitt Rivers, the Ashmolean, the University Museum and the shaping of an Oxford discipline', *Journal of the History of Collections*, 20 (2008), 85–100.

Larson, F. and A. Petch, '"Hoping for the best, expecting the worst": T. K. Penniman – forgotten curator of the Pitt Rivers Museum', *Journal of Museum Ethnography*, 18 (2006), 125–39.

Larson, F., A. Petch and D. Zeitlyn, 'Social networks and the creation of the Pitt Rivers Museum', *Journal of Material Culture*, 12 (2007), 211–39.

Latour, B. and S. Woolgar, *Laboratory Life: The Construction of Scientific Facts* (Princeton: Princeton University Press, 2nd edn, 1986).

Lawrence, G., 'Rats, street gangs and culture: evaluation in museums', in G. Kavanagh (ed.), *Museum Languages: Objects and Texts* (Leicester: Leicester University Press, 1991), pp. 9–32.

Leach, E. R., *Culture and Nature; or, La Femme Sauvage: The Stevenson Lecture* (London: Bedford College, 1969).

Lees, C. and A. Robertson, 'Early students and the "University of the Busy": the Quay Street years of Owens College 1851–1870', *Bulletin of the John Rylands University Library of Manchester*, 79 (1997), 161–94.

Legge, C. M., 'Glass for dioramas', *Museums Journal*, 33 (1934), 352.

Lemaine, G. (ed.), *Perspectives on the Emergence of Scientific Disciplines* (The Hague: Mouton, 1976).

Leonard, J. H., 'A museum guide and his work', *Museums Journal*, 13 (1914), 234–46.

Levell, N., *Oriental Visions: Exhibitions, Travel and Collecting in the Victorian Age* (London: Horniman Museum, 2000).

——, 'Illustrating evolution: Alfred Cort Haddon and the Horniman Museum, 1901–1915', in A. A. Shelton (ed.), *Collectors: Individuals and Institutions* (London: Horniman Museum, 2001), pp. 253–79.

——, 'The translation of objects: R. and M. Davidson and the Friends' Foreign Mission Association, China, 1890–1894', in A. A. Shelton (ed.), *Collectors: Individuals and Institutions* (London: Horniman Museum, 2001), pp. 129–61.

Leviton, A. E. and M. L. Aldrich (eds), *Museums and Other Institutions of Natural History, Past, Present, and Future* (San Francisco: California Academy of Sciences, 2004).

Lewis, C., *The Changing Face of Public History: The Chicago Historical Society and the Transformation of an American Museum* (DeKalb: Northern Illinois University Press, 2005).

Lewis, G., *For Instruction and Recreation: A Centenary History of the Museums Association* (London: Quiller, 1989).

Lightman, B., 'The visual theology of Victorian popularizers of science: from reverent eye to chemical retina', *Isis*, 91 (2000), 651–80.

——, *Victorian Popularisers of Science* (Chicago: University of Chicago Press, 2007).

Lindsay, W., 'Time perspectives: what "the future" means to museum professionals in collections-care', *The Conservator*, 29 (2005–6), 51–61.

Livingstone, D. N., *Putting Science in its Place: Geographies of Scientific Knowledge* (Chicago: University of Chicago Press, 2003).

'Local museums', *Nature*, 16 (1877), 228.

Longhurst, B., G. Bagnall and M. Savage, 'Audiences, museums and the English middle class', *Museum and Society*, 2 (2004), 104–24.

——, *Globalisation and Belonging* (London: Sage, 2005).

Loughney, C., 'Colonialism and the Development of the English Provincial Museum, 1823–1914' (PhD dissertation, University of Newcastle, 2005).

Lourenço, M. C., 'Between Two Worlds: The Distinct Nature and Contemporary Significance of University Museums and Collections in Europe' (PhD dissertation, Conservatoire National des Arts et Métiers, Paris, 2005).

Lowe, E. E., 'The registration and numeration of museum specimens', *Museums Journal*, 2 (1903), 258–66.

——, 'William Evans Hoyle, M.A., D.Sc.', *Museums Journal*, 25 (1926), 250–2.

Lowe, P. D., 'Amateurs and professionals: the institutional emergence of British plant ecology', *Journal of the Society for the Bibliography of Natural History*, 7 (1976), 517–35.

Lowenthal, D., *The Heritage Crusade and the Spoils of History* (Cambridge: Cambridge University Press, 1997).

Lucas, P., 'Charles Darwin, "little Dawkins" and the platycnemic Yale men: introducing a bioarchaeological tale of the descent of man', *Archives of Natural History*, 34 (2007), 318–45.

McAlister, M., '"The common heritage of mankind": race, nation, and masculinity in the King Tut exhibit', *Representations*, 54 (1996), 80–103.

McCabe, G. I., 'Museums in Education: The Educational Role of Museums in the United Kingdom' (MA dissertation, University of Sheffield, 1975).

McCarthy, C., *Exhibiting Maori: A History of Colonial Cultures of Display* (Oxford: Berg, 2007).

Macdonald, S. (ed.), *The Politics of Display: Museums, Science, Culture* (London: Routledge, 1998).

——, *Behind the Scenes at the Science Museum* (Oxford: Berg, 2002).

——, 'Accessing audiences: visiting visitor books', *Museum and Society*, 3 (2006), 119–36.

——, 'Collecting practices', in S. Macdonald (ed.), *A Companion to Museum Studies* (Oxford: Blackwell, 2006), pp. 81–97.

MacDonald, S., 'The Royal Manchester Institution', in J. H. G. Archer (ed.), *Art and Architecture in Victorian Manchester: Ten Illustrations of Patronage and Practice* (Manchester: Manchester University Press, 1985), pp. 28–45.

———, 'For "swine of discretion": design for living 1884', *Museums Journal*, 86 (1986), 123–30.

McGhie, H., 'Contextual research and the postcolonial museum: the example of Henry Dresser', *Annalen des Naturhistorischen Museums Wien* (forthcoming).

MacGregor, A., *The Ashmolean Museum: A Brief History of the Institution and its Collections* (Oxford: Ashmolean Museum, 2001).

———, *Curiosity and Enlightenment: Collectors and Collections from the Sixteenth to the Nineteenth Century* (New Haven: Yale University Press, 2007).

Machin, R., 'Gender representation in the natural history galleries at the Manchester Museum', *Museum and Society*, 6 (2008), 54–67.

Machor, J. L. and P. Goldstein (eds), *Reception Study: From Literary Theory to Cultural Studies* (New York: Routledge, 2000).

MacKenzie, J. M., *The Empire of Nature: Hunting, Conservation, and British Imperialism* (Manchester: Manchester University Press, 1988).

MacLeod, S., 'Making museum studies: training, education, research and practice', *Museum Management and Curatorship*, 19 (2001), 51–61.

McOuat, G. R., 'Species, rules and meaning: the politics of language and the ends of definitions in 19th century natural history', *Studies in History and Philosophy of Science*, 27 (1996), 473–519.

———, 'Cataloguing power: delineating "competent naturalists" and the meaning of species in the British Museum', *British Journal for the History of Science*, 34 (2001), 1–28.

Makepeace, C. E., *Science and Technology in Manchester: Two Hundred Years of the Lit. and Phil.* (Manchester: Manchester Literary and Philosophical Society, 1984).

Manchester Museum, *General Statement of the Work of the Museum* (Manchester: Manchester Museum, 1900).

———, *The Principal Divisions of the Lepidoptera* (Manchester: Manchester Museum, 1900).

———, *The Principal Divisions of the Cœlenterata According to the 'Cambridge Natural History'* (Manchester: Sherratt & Hughes, 1907).

———, *General Statement of the Work of the Museum* (Manchester: Manchester Museum, 1911).

———, *An Account of the Extension of the Museum* (Manchester: University of Manchester, 1912).

———, *Guide to the Manchester Museum* (Stockport: Dean, 1970).

———, *Guide to the Manchester Museum* (Stockport: Dean, 2nd edn, 1978).

———, *The Manchester Museum* (Derby: English Life, 1985).

Manchester Natural History Society, *Aves Britannicæ. A Systematic Catalogue of British birds* (Manchester: Council of the Natural History Society of Manchester, 1836).

———, *Catalogue of the Foreign Shells in the Possession of the Manchester Natural History Society* (Manchester: Council of the Natural History Society of Manchester, 1837).

Mandler, P., *The Fall and Rise of the Stately Home* (New Haven: Yale University Press, 1997).

Mangan, J. A. and C. C. McKenzie, *Militarism, Hunting, Imperialism: 'Blooding' the Martial Male,* (London: Routledge, 2009).

Markham, S. F., *A Report on the Museums and Art Galleries of the British Isles (Other than the National Museums)* (Edinburgh: Constable, 1938).

Markus, T. A., *Buildings and Power: Freedom and Control in the Origin of Modern Building Types* (London: Routledge, 1993).

Marshall, A. M., *Descriptive Catalogue of the Embryological Models* (Manchester: Cornish, 1891).

——, *Outline Classification of the Animal Kingdom* (Manchester: Cornish, 1891).

——, *Outline Classification of the Animal Kingdom* (Manchester: Cornish, 2nd edn, 1892).

——, *Outline Classification of the Animal Kingdom*, ed. S. J. Hickson (Manchester: Cornish, 3rd edn, 1897).

——, *Descriptive Catalogue of the Embryological Models*, ed. S. J. Hickson (London: Dulau, 2nd edn, 1902).

Mason, R., *Museums, Nations, Identities: Wales and its National Museums* (Cardiff: University of Wales Press, 2007).

Mason, T., 'The visitors to the Manchester Museum: a questionnaire survey', *Museums Journal*, 73 (1974), 153–7.

Matheson, C. S., '"A shilling well laid out": the Royal Academy's early public', in D. H. Solkin (ed.), *Art on the Line: The Royal Academy Exhibitions at Somerset House 1780–1836* (New Haven: Yale University Press, 2001), pp. 38–54.

Mattingly, J., *Volunteers in Museums and Galleries: The Report of a Survey into the Work of Volunteers in Museums and Galleries in the United Kingdom* (Berkhamsted, Hertfordshire: The Volunteer Centre, 1984).

Mauss, M., *The Gift* (New York: Norton, new edn, 1976).

Mayer, C. E., 'University museums: distinct sites of intersection for diverse communities', *Museologia*, 3 (2003), 101–6.

Mayr, E., *Systematics and the Origin of Species from the Viewpoint of a Zoologist* (New York: Columbia University Press, 1942).

——, *The Growth of Biological Thought: Diversity, Evolution and Inheritance* (Cambridge, Mass.: Harvard University Press, 1982).

Melvill, J. C., *A Brief Account of the General Herbarium Formed by James Cosmo Melvill, 1867–1904: And Presented by him to the Museum in 1904* (Manchester: Sherratt & Hughes, 1904).

——, 'List of molluscan papers (mostly dealing with the order Cephalopoda) by the late Dr. W. Evans Hoyle, D.Sc., F.R.S.E.', *Journal of Conchology*, 18 (1927), 71–4.

Melvill, J. C. and R. Standen, *Catalogue of the Hadfield Collection of Shells from Lifu and Uvea, Loyalty Islands*, 2 vols (Manchester: Cornish, 1895–97).

——, 'Report on the marine mollusca obtained during the first expedition of Prof. A. C. Haddon to the Torres Straits, in 1888–89', *Journal of the Linnean Society of London – Zoology*, 27 (1899), 150–206.

Merriman, N., 'Museum collections and sustainability', *Cultural Trends*, 17 (2008), 3–21.

Merriman, N. and H. Swain, 'Archaeological archives: serving the public interest?' *European Journal of Archaeology*, 2 (1999), 249–67.

Messer-Davidow, E., D. R. Shumway and D. J. Sylvan (eds), *Knowledges: Historical and Critical Studies in Disciplinarity* (Charlottesville: University Press of Virginia, 1993).

Meyer, A. B., 'A description of museum wall and free-standing cases and desks made entirely of glass and iron', *Report of the Proceedings of the Museums Association*, 2 (1891), 112–19.

Middlemiss, J. L., *A Zoo on Wheels: Bostock and Wombwell's Menagerie* (Burton-on-Trent: Dalebrook, 1987).

Miers, H., *A Report on the Public Museums of the British Isles (Other than the National Museums)* (Edinburgh: Constable, 1928).

Millar, S., *Volunteers in Museums and Heritage Organizations: Policy Planning and Management* (London: HMSO, 1991).

Millward, A., 'Travelling exhibitions from the Manchester Museum', *Museums Journal*, 75 (1976), 171–2.

Moffat, C. B., 'Obituary: George Herbert Carpenter, B. Sc. (Lond.), D. Sc. (Q. U. B.)', *Irish Naturalist's Journal*, 7 (1939), 138–41.

Moore, D., 'Thirty years of museum education: some reflections', *International Journal of Museum Management and Curatorship*, 1 (1982), 213–30.

Moore, P. G., *Marine Faunistics in the Clyde Sea Area: Fieldworkers in Cultural Context Prior to 1850* (Isle of Cambrae: University Marine Biological Station Millport, 2007).

Morrell, J., *John Phillips and the Business of Victorian Science* (Aldershot: Ashgate, 2005).

———, Review of A. J. Bowden, C. V. Burek, and R. Wilding (eds), *History of Palaeontology: Selected Essays*, Geological Society Special Publication 241 (London: The Geological Society, 2005), *British Journal for the History of Science*, 40 (2007), 447–8.

Morris, P. A., *Rowland Ward: Taxidermist to the World* (Ascot: MPM, 2003).

Morris, R. J., *Class, Sect and Party: The Making of the British Middle Class, Leeds 1820–1850* (Manchester: Manchester University Press, 1990).

———, 'Civil society and the nature of urbanism: Britain, 1750–1850', *Urban History*, 25 (1998), 289–301.

Morton, A. Q. and J. A. Wess, *Public and Private Science: The King George III Collection* (Oxford: Oxford University Press, 1993).

Morus, I. R., *Frankenstein's Children: Electricity, Exhibition, and Experiment in Early-Nineteenth-Century London* (Princeton: Princeton University Press, 1998).

Moser, S., *Wondrous Curiosities: Ancient Egypt at the British Museum* (Chicago: University of Chicago Press, 2006).

'Mr. Charles Heape. Fine gift to Manchester University. Collection of which illustrates the development of man', *Rochdale Observer* (2 June 1923), p. 5.

Muensterberger, W., *Collecting: An Unruly Passion: Psychological Perspectives* (Princeton: Princeton University Press, 1994).

Müller-Wille, S., 'Linnaeus' herbarium cabinet: a piece of furniture and its function', *Endeavour*, 30:2 (2006), 60–4.

Mulvaney, D. J. and J. H. Calaby, *'So Much that is New': Baldwin Spencer, 1860–1929; A Biography* (Melbourne: University of Melbourne, 1985).

Murray, D., *Museums: Their History and Their Use*, 3 vols (Glasgow: MacLehose, 1904).

Murray, M. A. (ed.), *The Tomb of Two Brothers* (Manchester: Sherratt & Hughes, 1910).

Museums Association, 'Report of the committee appointed to consider labelling in museums', *Report of the Proceedings of the Museums Association*, 2 (1891), 128–33.

Museums, Libraries and Archives Council, *The Museum Accreditation Scheme* (London: Museums, Libraries and Archives Council, 2004).

——, *A Pocket Guide to Renaissance* (London: Museums, Libraries and Archives Council, 2006).

Musgrave, J. H., R. A. H. Neave and A. J. N. W. Prag, 'The Skull from Tomb II at Vergina: King Philip II of Macedon', *Journal of Hellenic Studies*, 104 (1984), 60–78.

Myers, F. R. (ed.), *The Empire of Things: Regimes of Value and Material Culture* (Oxford: Currey, 2001).

Narkiss, I., 'Pass the Parcel: Archaeological Archives, Creators, Keepers and Beyond' (MA dissertation, Nottingham Trent University, 2003).

Natural Environment Research Council, *The Role of Taxonomy in Ecological Research* (London: NERC, 1976).

'Natural History Society', *Manchester Guardian* (25 October 1828), p. 2.

Naylor, S. (ed.), 'Historical Geographies of Science', special issue, *British Journal for the History of Science* 38 (2005), 1–100.

Neave, R. A. H. and A. J. N. W. Prag, *Making Faces: Using Forensic and Archaeological Evidence* (London: British Museum, 1997).

Newstead, R., 'The use of boric acid as a preservative for birds' skins, &c.', *Report of the Proceedings of the Museums Association*, 4 (1893), 104–6.

Nicholas, R., *City of Manchester Plan: Prepared for the City Council* (Norwich: Jarrold, 1945).

Nicholls, R., *The Belle Vue Story* (Manchester: Richardson, 1992).

Nightscales, E., 'A visit to the Hull Museum during the Xmas holidays. Essay II', *Hull Museum Publications*, 19 (1904), 30–1.

Nördlinger, C., 'A visit to Miss T. Mestorf, Directress of the Schleswig-Holstein Museum of National Antiquities at Kiel', *Report of the Proceedings of the Museums Association*, 7 (1896), 132–8.

——, 'The cleaning of museums', *Report of the Proceedings of the Museums Association*, 9 (1898), 108–11.

Nudds, J. R., *The R. M. C. Eagar Collection of Non-Marine Bivalves; Type and Figured Specimens of the Geological Department of The Manchester Museum* (Manchester: Manchester Museum, 1992).

——, 'Richard Michael Cardwell Eagar 1919–2003', *Geological Curator*, 7 (2003), 341–2.

Nyhart, L. K., 'Natural history and the "new" biology', in N. Jardine, J. A. Secord and E. C. Spary (eds), *Cultures of Natural History* (Cambridge: Cambridge University Press, 1996), pp. 426–43.

——, 'Science, art, and authenticity in natural history displays', in N. Hopwood and S. de Chadarevian (eds), *Models: The Third Dimension of Science* (Stanford, Calif.: Stanford University Press, 2004), pp. 307–35.

'Obituary. Mr. W. S. Ogden', *Manchester City News* (1 May 1926), p. 12g.

Oldroyd, D. R., *The Highlands Controversy: Constructing Geological Knowledge through Fieldwork in Nineteenth-Century Britain* (Chicago: University of Chicago Press, 1990).

Olson, S. L., 'Correspondence bearing on the history of ornithologist M. A. Carriker Jr. and the use of arsenic in preparation of museum specimens', *Archives of Natural History*, 34 (2007), 346–51.

Orna, E. and C. W. A. Pettitt (eds), *Information Handling in Museums* (London: Bingley, 1980).

Ostrower, F., *Why the Wealthy Give: The Culture of Elite Philanthropy* (Princeton: Princeton University Press, 1995).

Owen, D. E. (ed.), *Guide to the Manchester Museum* (Manchester: Manchester University Press, revised edn, 1965).

———, 'Are national museums in the provinces necessary? A brief survey of Manchester visitors to London museums', *Museums Journal*, 70 (1970), 29.

———, 'Presidential address', *Museums Journal*, 69 (1970), 97–9.

———, 'Regionalisation of museums: what is a region?' *Museums Journal*, 71 (1971), 25–6.

Owen, J., 'Collecting artefacts, acquiring empire: a maritime endeavour', *Journal of Museum Ethnography*, 18 (2006), 141–8.

Owens College Manchester, *Calendar for the session 1873–4* (Manchester: Sowler, 1873).

Pagan, H., 'The British Numismatic Society: a history', *British Numismatic Journal*, 73 (2003), 1–43.

Pain, S., 'Scientists to desert a million bird's eggs', *New Scientist* (28 April 1988), p. 29.

———, 'Love among the fossils', *New Scientist* (22 December 2007), pp. 74–5.

Pang, A. S.-K., 'Visual representation and post-constructivist history of science', *Historical Studies in the Physical and Biological Sciences*, 28 (1997), 139–71.

Parkinson-Bailey, J. J., *Manchester: An Architectural History* (Manchester: Manchester University Press, 2000).

Parry, R., *Museums in a Digital Age* (London: Routledge, 2006).

———, *Recoding the Museum: Digital Heritage and the Technologies of Change* (London: Routledge, 2007).

Patchett, M., 'Tracking tigers: recovering the embodied practices of taxidermy', *Historical Geography*, 36 (2008).

Patchett, M. and K. Foster, 'Repair work: surfacing the geographies of dead animals', *Museum and Society*, 6 (2008), 98–122.

Pearce, S. M., *Archaeological Curatorship* (London: Leicester University Press, 1990).

———, *Museums, Objects and Collections: A Cultural Study* (Leicester: Leicester University Press, 1992).

———, *On Collecting: An Investigation into Collecting in the European Tradition* (London: Routledge, 1995).

Pearson, C., 'Curators, Culture and Conflict: The Effects of the Second World War on Museums in Britain, 1926–1965' (PhD dissertation, University College London, 2008).

Pearson, W. H., *Catalogue of Hepaticæ (Anacroynæ) in the Manchester Museum. Arranged according to Stephani's 'Species Hepaticarum'* (Manchester: Sherratt & Hughes, 1910).

Peet, T. E., *The Stela of Sebek-khu: The Earliest Record of an Egyptian Campaign in Asia* (Manchester: Sherratt & Hughes, 1914).

Petch, A., 'Counting and calculating: some reflections on using statistics to examine the history and shape of collections at the Pitt Rivers Museum', *Journal of Museum Ethnography*, 18 (2006), 149–56.

Petrie, W. M. F., *Kahun, Gurob, and Hawara* (London: Kegan Paul, 1890).

———, *Illahun, Kahun and Gurob* (London: Nutt, 1891).

———, *Seventy Years in Archaeology* (London: Low, Marston, 1931).

Pettitt, C. W. A., 'The Manchester Museum Computer Cataloguing Unit: a STEP in the right direction?' *Museums Journal*, 80 (1981), 187–91.

——, 'People and data: managing the less predictable aspects of a museum computer system', in *Management of the Use of Automated Data* (Cambridge: Museum Documentation Association, 1988), pp. 12–19.

Pevsner, N., *Lancashire: The Industrial and Commercial South* (Harmondsworth: Penguin, 1969).

——, *A History of Building Types* (London: Thames & Hudson, 1976).

Philips, J. L., *Instructions for Collecting and Preserving Insects, &c.* (Manchester: Wheeler, 1808).

Pickstone, J. V., 'Museological science? The place of the analytical/comparative in 19th-century science, technology and medicine', *History of Science*, 32 (1994), 111–38.

——, *Ways of Knowing: A New History of Science, Technology and Medicine* (Manchester: Manchester University Press, 2000).

——, 'Science in nineteenth-century England: plural configurations and singular politics', in M. J. Daunton (ed.), *The Organisation of Knowledge in Victorian Britain* (Oxford: Oxford University Press, 2005), pp. 29–60.

——, 'Working knowledges before and after *circa* 1800: practices and disciplines in the history of science, technology and medicine', *Isis*, 98 (2007), 489–516.

Piper, D., 'Some problems of university museums', *Museums Journal*, 72 (1972), 107–10.

Planning and Policy Guidance 16: Archaeology and Planning (London: HMSO, 1990).

Plummer, H. and W. M. Tattersall, *Memorandum on the Manchester Museum* (Manchester: Manchester Museum, 1913).

Pocock, R. I. and N. Etherington, 'Selous, Frederick Courteney (1851–1917)', in *Oxford Dictionary of National Biography* (Oxford: Oxford University Press, 2004), www.oxforddnb.com/view/article/35017, accessed 14 Dec 2007.

Pomian, K., *Collectors and Curiosities: Paris and Venice, 1500–1800*, trans. E. Wiles-Portier (Cambridge: Polity, 1990).

Potter, B., *The Journal of Beatrix Potter from 1881 to 1897*, ed. L. Linder (London: Warne, 1966).

Poulton, E. B., 'The methods of setting and labelling Lepidoptera for museums', *Report of the Proceedings of the Museums Association*, 8 (1897), 30–6.

Prag, A. J. N. W., 'Archaeology at the Manchester Museum', *Mamucium*, 14 (1970), 18–20.

——, 'Greek vases in the Manchester Museum', *Mamucium*, 24 (1976), 28–34.

——, 'The Wellcome Collection and the Manchester Museum', *Mamucium*, 28 (1981), 4–6.

——, 'Archaeology alive at the Manchester Museum', *Museums Journal*, 83 (1983), 79.

——, 'Acquisitions by the Manchester Museum 1970–1987', *Journal of Hellenic Studies*, 108 (1988), 290–4.

——, 'Larger-than-life scholar and archaeologist [obituary of Theodore Burton-Brown, 1902–1988]', *Guardian* (14 June 1988), p. 39.

——, 'The Mediterranean in Manchester', *Minerva*, 5:3 (1994), 40–3.

Prestwich, P., 'Museums, friends and volunteers – a delicate relationship', *International Journal of Museum Management and Curatorship*, 2 (1983), 171–5.

Preziosi, D., *Brain of the Earth's Body: Art, Museums and the Phantasms of Modernity* (Minneapolis: University of Minnesota Press, 2003).

——, 'Art history and museology: rendering the visible legible', in S. Macdonald (ed.), *A Companion to Museum Studies* (Oxford: Blackwell, 2006), pp. 50–63.

'Profile: David Owen', *Communication* (Victoria University of Manchester newsletter) (October 1976), p. 13.

Pullan, B. and M. Abendstern, *A History of the University of Manchester*, 2 vols (Manchester: Manchester University Press, 2000–4).

Pye, E., *Caring for the Past: Issues in Conservation for Archaeology and Museums* (London: James and James, 2001).

Quinn, S. C., *Windows on Nature: The Great Habitat Dioramas of the American Museum of Natural History* (New York: Abrams, 2006).

Rader, K. A. and V. E. M. Cain, 'From natural history to science: display and the transformation of American museums of science and nature', *Museum and Society*, 6 (2008), 152–71.

Radford, T., 'Ornithologists' wings clipped', *Guardian* (27 April 1988), p. 4.

Rainbow, P. and R. J. Lincoln, *Specimens: The Spirit of Zoology* (London: Natural History Museum, 2003).

Rainger, R., *An Agenda for Antiquity: Henry Fairfield Osborn and Vertebrate Palaeontology at the American Museum of Natural History, 1890–1935* (Tuscaloosa: University of Alabama Press, 1991).

Ralston, J., *Views of the Ancient Buildings in Manchester*, ed. H. Broadbent (Salford: Printwise, facsimile edn, 1989).

Raybould, M. E., *A Study of Inscribed Material from Roman Britain: An Inquiry into Some Aspects of Literacy in Romano British Society* (Oxford: Archaeopress, 1999).

'Rectangular glass jars for museum purposes', *Museums Journal*, 21 (1922), 249–50.

Reynolds, A., 'Reproducing nature: the museum of natural history as a non-site', *October*, 45 (1988), 109–27.

Rhode, M. G. and J. Connor, 'Curating America's Army Medical Museum', in A. Levin (ed.), *Defining Memory: Local Museums and the Construction of History in America's Changing Communities* (Lanham, Md.: AltaMira, 2007), pp. 177–96.

Richardson, B. W., *The Health of Nations. A Review of the Works of Edwin Chadwick*, 2 vols (London: Longmans, 1887).

Riggins, S. H. (ed.), *The Socialness of Things: Essays on the Socio-Semiotics of Objects* (Berlin: Mouton de Gruyter, 1994).

Riggs, C., 'Jesse Haworth and the Manchester Museum', *Bulletin of the Association for the Study of Travel in Egypt and the Near East: Notes and Queries*, 24 (2005), 11–12.

Rodríguez, F. M., 'Consolidation and renewal: Otto Samson and the Horniman Museum', in A. A. Shelton (ed.), *Collectors: Individuals and Institutions* (London: Horniman, 2001), pp. 85–109.

Rothschild, M., *Walter Rothschild: The Man, the Museum and the Menagerie* (London: Natural History Museum, 2nd edn, 2008).

Rowley, F. R., 'Books and papers', *Museums Journal*, 10 (1911), 234–6.

Rudwick, M. J. S., *The Great Devonian Controversy: The Shaping of Scientific Knowledge among Gentlemanly Specialists* (Chicago: University of Chicago Press, 1985).

Russell, G., 'The Wellcome Historical Medical Museum's dispersal of non-medical material, 1936–1986', *Museums Journal*, 86: supplement (1986), 3–15.

'Sale of curiosities', *Manchester Guardian* (9 October 1868), p. 3.

Salmon, M. A., *The Aurelian Legacy: British Butterflies and Their Collectors* (Berkeley: University of California Press, 2001).

Sayce, R. U., *Primitive Arts and Crafts: An Introduction to the Study of Material Culture* (Cambridge: Cambridge University Press, 1933).

———, *The Museums and British Ethnology (North Western Federation of Museums and Art Galleries Presidential Address)* (Manchester: North Western Federation of Museums and Art Galleries, 1941).

——— (ed.), *Guide to the Manchester Museum* (Manchester: Manchester University Press, revised edn, 1957).

Scharff, R. F., 'On a dry system of macerating bones', *Museums Journal*, 10 (1911), 196–8.

Schlosser, J. R. von, *Die Kunst- und Wunderkammern der Spätrenaissance: Ein Beitrag zur Geschichte des Sammelwesens* (Leipzig: Braunschweig, amended edn, 1978).

Sclater, P. L., 'On the typical forms of vertebrated life suitable for exhibition in local museums', *Report of the Proceedings of the Museums Association*, 4 (1893), 95–9.

Secord, A., 'Science in the pub: artisan botanists in early nineteenth-century Lancashire', *History of Science*, 32 (1994), 269–315.

———, 'Botany on a plate: pleasure and the power of pictures in promoting early nineteenth-century scientific knowledge', *Isis*, 93 (2002), 28–57.

———, *Artisan Naturalists* (Chicago: University of Chicago Press, forthcoming).

Secord, J. A., *Controversy in Victorian Geology: The Cambrian-Silurian Dispute* (Princeton: Princeton University Press, 1986).

———, 'How scientific conversation became shop talk', *Transactions of the Royal Historical Society*, 17 (2007), 129–56.

Seebohm, H., *Classification of Birds: An Attempt to Diagnose the Subclasses, Orders, Suborders, and Some of the Families of Existing Birds* (London: Porter, 1890).

Sewter, A. C. and F. Willett, *Primitive Art from the Manchester Museum* (Manchester: Manchester University History of Art Department, 1952).

Seyd, E. L., *Mammals* (Manchester: Manchester Museum, 1959).

———, 'A university museum and the general public', *Museums Journal*, 70 (1970), 180–2.

Shanks, M., *Classical Archaeology of Greece: Experiences of the Discipline* (London: Routledge, 1996).

Shapin, S., 'The invisible technician', *American Scientist*, 77 (1989), 554–63.

Sheail, J., *Seventy-Five Years in Ecology: The British Ecological Society* (Oxford: Blackwell, 1987).

Sheets-Pyenson, S., *Cathedrals of Science: The Development of Colonial Natural History Museums during the Late Nineteenth Century* (Kingston, Ontario: McGill-Queen's University Press, 1988).

Shelton, A. A., 'Museum ethnography: an imperial science', in E. Hallam and B. Street (eds), *Cultural Encounters: Representing 'Otherness'* (London: Routledge, 2000), pp. 155–93.

——— (ed.), *Collectors: Expressions of Self and Other* (London: Horniman Museum, 2001).

——— (ed.), *Collectors: Individuals and Institutions* (London: Horniman Museum, 2001).

Sherborn, C. D., 'Memorandum on a catalogue of books and prints belonging to J. L. Philips', *Proceedings of the Manchester Literary and Philosophical Society*, 49 (1904–5), ii–iii.

———, *Where is the --- Collection?* (Cambridge: Cambridge University Press, 1940).

Shteir, A. B., *Cultivating Women, Cultivating Science: Flora's Daughters and Botany in England 1760 to 1860* (Baltimore: Johns Hopkins University Press, 1996).

Sitch, B., 'Thomas Sheppard, the Morfitts of Atwick and Allen coin number 223', *Yorkshire Archaeological Journal*, 65 (1993), 11–19.

Sloan, K., *J. M. W. Turner: Watercolours from the R. W. Lloyd Bequest to the British Museum* (London: British Museum, 1998).

Smith, J. E., 'Herbert Graham Cannon 1897–1963', *Biographical Memoirs of Fellows of the Royal Society*, 9 (1963), 55–68.

Smith, K. G. V., 'Grey, Thomas de, sixth Baron Walsingham (1843–1919)', in *Oxford Dictionary of National Biography* (Oxford: Oxford University Press, 2004), www.oxforddnb.com/view/article/35017, accessed 17 January 2008.

Smith, P. J., 'A Splendid Idiosyncrasy: Prehistory at Cambridge, 1915–50' (PhD dissertation, University of Cambridge, 2004).

Smyth, A. L., 'The Society's house, 1799–1840', *Memoirs and Proceedings of the Manchester Literary and Philosophical Society*, 126 (1986–87), 132–50.

Souder, W., *Under a Wild Sky: John James Audubon and the Making of The Birds of America* (New York: North Point, 2004).

Southwood, H., 'The history and wonder of the Marischal Museum's catalogues, 1900–2000', *Journal of Museum Ethnography*, 15 (2003), 94–107.

Staines, C. L., 'Franz Spaeth: publications and proposed taxa', *Zootaxa*, 1035 (2005), 1–49.

Standing Commission on Museums and Galleries, *Survey of Provincial Museums and Galleries*, ed. the Earl of Rosse (London: HMSO, 1963).

——, *Universities and Museums: Report on the Universities in Relation to Their own and Other Museums* (London: HMSO, 1968).

——, *Report on University Museums* (London: HMSO, 1977).

——, *Framework for a System for Museums*, ed. A. Drew (London: HMSO, 1979).

Star, S. L., 'Craft vs. commodity, mess vs. transcendence: how the right tool became the wrong one in the case of taxidermy and natural history', in A. E. Clarke and J. H. Fujimura (eds), *The Right Tools for the Job: At Work in Twentieth-Century Life Sciences* (Princeton: Princeton University Press, 1992), pp. 257–86.

Star, S. L. and J. R. Griesemer, 'Institutional ecology, "translations" and boundary objects: amateurs and professionals in Berkeley's Museum of Vertebrate Zoology, 1907–39', *Social Studies of Science*, 19 (1989), 387–420.

Starn, R., 'A historian's brief guide to new museum studies', *The American Historical Review*, 110 (2005), 68–98.

Stearn, W. T., *The Natural History Museum at South Kensington: A History of the British Museum (Natural History) 1753–1980* (London: Heinemann, 1981).

Steiner, C. B., 'Rights of passage: on the liminal identity of art in the border zone', in F. R. Myers (ed.), *The Empire of Things: Regimes of Value and Material Culture* (Oxford: Currey, 2001), pp. 207–31.

Stewart, S., *On Longing: Narratives of the Miniature, the Gigantic, the Souvenir, the Collection* (Durham, NC: Duke University Press, 1993).

——, 'From the museum of touch', in M. Kwint, C. Breward and J. Aynsley (eds), *Material Memories: Design and Evocation* (New York: Berg, 1999), pp. 17–36.

Stichweh, R., 'The sociology of scientific disciplines: on the genesis and stability of the disciplinary structure of modern science', *Science in Context*, 5 (1992), 3–15.

Stocking, G. W. (ed.), *Objects and Others: Essays on Museums and Material Culture* (Madison: University of Wisconsin Press, 1985).

——, *The Ethnographer's Magic and Other Essays in the History of Anthropology* (Madison: University of Wisconsin Press, 1992).

——, *After Tylor: British Social Anthropology 1888–1951* (Madison: University of Wisconsion Press, 1995).

Stopford, J. S. B., 'The Manchester period', in W. R. Dawson (ed.), *Sir Grafton Elliot Smith: A Biographical Record by His Colleagues* (London: Cape, 1938), pp. 151–65.

Sugden, K. F., 'The Department of Numismatics at the Manchester Museum', *Compte rendu*, 32 (1986), 41–4.

Swanton, E. W., *A Country Museum: The Rise and Progress of Sir Jonathan Hutchinson's Museum at Haslemere* (Haslemere: Haslemere Educational Museum, 1947).

Swinney, G. N., 'The evil of vitiating and heating the air: artificial lighting and public access to the National Gallery, London, with particular reference to the Turner and Vernon collections', *Journal of the History of Collections*, 15 (2003), 83–112.

——, '"I am utterly disgusted. . ." – the Edinburgh Museum of Science and Art effecting moral decline?' *Review of Scottish Culture*, 16 (2003–4), 76–84.

Swinney, G. N. and D. Heppell, 'Public and privileged access: a historical survey of admission charges and visitor figures for part of the Scottish national collections', *Book of the Old Edinburgh Club*, 4 (1997), 69–84.

Tansey, T., 'Keeping the culture alive: the laboratory technician in mid-twentieth-century British medical research', *Notes and Records of the Royal Society*, 62 (2008), 77–95.

Tattersall, W. M., 'On Mysidacea and Euphausiacea collected in the Indian Ocean during 1905', *Transactions of the Linnean Society of London – Zoology*, 15 (1912), 119–36.

——, 'The Schizopoda, Stomatopoda, and non-Arctic Isopoda of the Scottish National Antarctic expedition', *Transactions of the Royal Society of Edinburgh*, 48 (1914), 865–94.

——, *General Guide to the Collections in the Manchester Museum* (Manchester: Manchester University Press, 1915).

Thackray, A., 'Natural knowledge in cultural context: the Manchester model', *American Historical Review*, 79 (1974), 672–709.

Thomas, J. D., *Fifty Years of Whitleyism in the Inland Revenue, 1920–70* (London: Somerset House, 1970).

Thomas, N., *Entangled Objects: Exchange, Material Culture, and Colonialism in the Pacific* (Cambridge, Mass.: Harvard University Press, 1991).

Thompson, F. C., 'Obituary: Harold Raby, M.A.', *British Numismatic Journal*, 29 (1958–59), 196.

——, 'The coin collections in the Manchester Museum', *Spink and Son's Numismatic Circular*, 73 (1965), 1–2.

——, *Common Coins* (Manchester: Manchester Museum, 1966).

Thompson, J., *The Owens College: Its Foundation and Growth; and its Connection with the Victoria University, Manchester* (Manchester: Cornish, 1886).

Thompson, M. and C. Renfrew, 'The catalogues of the Pitt-Rivers Museum, Farnham, Dorset', *Antiquity*, 73 (1999), 377–93.

Tilley, C., W. Keane, S. Küchler *et al.* (eds), *Handbook of Material Culture* (London: Sage, 2006).

Tinniswood, A., *A History of Country House Visiting: Five Centuries of Tourism and Taste* (Oxford: Blackwell, 1989).

Tizard, H. T., 'Miers, Sir Henry Alexander (1858–1942)', in *Oxford Dictionary of National Biography* (Oxford: Oxford University Press, 2004), www.oxforddnb.com/view/article/35017, accessed 14 Dec 2007.

Topham, J. R., 'Scientific publishing and the reading of science in nineteenth-century Britain: a historiographical survey and guide to sources', *Studies in History and Philosophy of Science*, 31 (2000), 559–612.

Torrens, H., 'Mary Anning (1799–1847) of Lyme; "the greatest fossilist the world ever knew"', *British Journal for the History of Science*, 28 (1995), 257–84.

Trautmann, T. R., 'The revolution in ethnological time', *Man*, 27 (1992), 379–97.

Trew, A., *James Cosmo Melvill's New Molluscan Names* (Cardiff: National Museum of Wales, 1987).

Turfa, J. M., 'The Etruscan and Italic collection in the Manchester Museum', *Papers of the British School of Archaeology at Rome*, 50 (1982), 166–95.

Turnill, R., *The Moonlandings: An Eye Witness Account* (Cambridge: Cambridge University Press, 2003).

Tweedale, G., 'Geology and industrial consultancy: Sir William Boyd Dawkins (1837–1929) and the Kent Coalfield', *British Journal for the History of Science*, 24 (1991), 435–51.

——, 'Dawkins, Sir William Boyd (1837–1929)', in *Oxford Dictionary of National Biography* (Oxford: Oxford University Press, 2004), www.oxforddnb.com/view/article/62497, accessed 19 April 2005.

Tythacott, L., 'Trade, travel and trophy: a biography of the Ridyard collection at Liverpool Museum: 1895–1916', in A. A. Shelton (ed.), *Collectors: Expressions of Self and Other* (London: Horniman Museum, 2001), pp. 157–79.

Ucko, P. J., 'The biography of a collection: the Sir Flinders Petrie Palestinian Collection and the role of university museums', *Museum Management and Curatorship*, 17 (1998), 351–99.

United Kingdom Institute for Conservation of Historic and Artistic Works, *Guidance for Conservation Practice* (London: Tate Gallery, 1983).

Ure, J., 'Sir William Goodenough Hayter', in *Oxford Dictionary of National Biography* (Oxford: Oxford University Press, 2004), www.oxforddnb.com/view/article/62497, accessed 21 January 2008.

Urry, J., *Before Social Anthropology: Essays on the History of British Anthropology* (Reading: Harwood, 1993).

Van Riemsdijk, J. and P. Sharp, *In the Science Museum* (London: HMSO, 1968).

Van Riper, A. B., *Men among the Mammoths: Victorian Science and the Discovery of Human Prehistory* (Chicago: University of Chicago Press, 1993).

Vergo, P. (ed.), *The New Museology* (London: Reaktion, 1989).

Vernon, K., 'Desperately seeking status: evolutionary systematics and the taxonomists' search for respectability 1940–60', *British Journal for the History of Science*, 26 (1993), 207–27.

Vogel, S., 'Always true to the object, in our fashion', in I. Karp and S. D. Lavine (eds), *Exhibiting Cultures: The Poetics and Politics of Museum Display* (Washington, DC: Smithsonian Institution Press, 1991), pp. 191–204.

Waage, J., 'From the editor', *Antenna: Bulletin of the Royal Entomological Society*, 3 (October 1979), 121.

Waite, E. R., 'The colouring of museum cases', *Report of the Proceedings of the Museums Association*, 3 (1892), 71–3.

Waldron, H. A., 'The study of the human remains from Nubia: the contribution of Grafton Elliot Smith and his colleagues to palaeopathology', *Medical History*, 44 (2000), 363–88.

Wallace, I. D. and P. W. Phillips, 'The function of local natural history collections', *Newsletter of the Geological Curators Group*, 2:11 (1977), 7–9.

Ward, R. H., *Henry A. Ward: Museum Builder to America* (Rochester, NY: Rochester Historical Society, 1948).

Warhurst, A., 'University museums', in J. M. A. Thompson (ed.), *Manual of Curatorship: A Guide to Museum Practice* (London: Butterworths, 1984), pp. 76–83.

——, 'New extension', *Communication* (Victoria University of Manchester newsletter) (October 1977), 10.

Watson, J., 'One hundred and fifty years of palaeobotany at Manchester University', in A. J. Bowden, C. V. Burek and R. Wilding (eds), *History of Palaeobotany: Selected Essays* (London: Geological Society of London, 2005), pp. 229–57.

Webster, T. B. L., *Greek Vases in the Manchester Museum* (Manchester: Manchester University Press, 1933).

——, *Guide to the Greek Vases* (Manchester: Manchester Museum, 1946).

Weiner, A. B., *Inalienable Possessions: The Paradox of Keeping-While-Giving* (Berkeley: University of California Press, 1992).

Weiss, F. E., 'The organization of a botanical museum', *Report of the Proceedings of the Museums Association*, 3 (1892), 25–38.

——, *Outline Classification of the Vegetable Kingdom* (Manchester: Cornish, 1892).

——, 'James Cosmo Melvill (1845–1929)', *North Western Naturalist*, 5 (1930), 150–6.

——, *Three Manchester Botanists: Leopold Hartley Grindon, Charles Bailey, James Cosmo Melvill* (Manchester: Manchester University Press, 1930).

Wenger, E., *Communities of Practice: Learning, Meaning and Identity* (Cambridge: Cambridge University Press, 1998).

Wheeler, J., *Manchester, its Political, Social and Commercial History, Ancient and Modern* (Manchester: Whittaker, 1836).

White, T., 'The lighting of museums', *Report of the Proceedings of the Museums Association*, 7 (1896), 148–54.

Whitehead, C., 'Architectures of display at the National Gallery: the Barry Rooms as art historiography and the problems of reconstructing historical gallery space', *Journal of the History of Collections*, 17 (2005), 189–211.

——, *Museums and the Construction of Disciplines: Art and Archaeology in Nineteenth-Century Britain* (London: Duckworth, 2009).

Whitworth, J., *The Cannon Aquarium* (Marple: Heap, 1968).

Whyte, W., S. Daultrey and L. Hide, *A Fitting Tribute: 100 Years of the Sedgwick Museum* (Cambridge: Sedgwick Museum of Earth Sciences, 2004).

Wigglesworth, G., 'A new Californian species of *Sphaerocarpus*, together with an annotated list of the specimens of *Sphaerocarpus* in the Manchester Museum', *University of California Publications in Botany*, 16:3 (1929), 129–37.

Wilkinson, D. M., H. O'Regan and T. Clare, 'A tale of two caves: the history of archaeological exploration at Haverbrack and Helsfell in Southern Cumbria', *Studies in Speleology*, 14 (2006), 55–7.

Willett, F., *African Art: An Introduction* (London: Thames and Hudson, 1971).

Willett, F. and G. Bridge, *Manchester Museum Ethnology* (Manchester: Bates, 1958).

Willett, F. and T. Seddon, 'Excavations in Everage Clough, Burnley, 1951', *Transactions of the Lancashire and Cheshire Antiquarian Society*, 63 (1952–53), 194–200.

'William Smith Churchill', *Transactions of the Lancashire and Cheshire Antiquarian Society*, 32 (1914), 306–7.

Williams, N., 'Museum's staff in cuts walk-out', *Guardian* (25 April 1990), p. 3.

Williamson, W. C., *A Monograph on the Morphology and Histology of Stigmaria ficoides* (London: Palaeontographical Society, 1887).

———, *Reminiscences of a Yorkshire Naturalist* (London: Redway, 1896).

'Wills and bequests: Mr. William Sharp Ogden', *The Times* (13 September 1926), p. 15c.

Wilson, D., *Reconfiguring Biological Sciences in the Late Twentieth Century: A Study of the University of Manchester* (Manchester: University of Manchester, 2008).

Wilson, D. and G. Lancelot, 'Making way for molecular biology: institutionalizing and managing reform of biological science in a UK university during the 1980s and 1990s', *Studies in History and Philosophy of Biological and Biomedical Sciences* 39 (2008), 93–108.

Wilson, D. M., *The British Museum: A History* (London: British Museum, 2002).

Wilson, H. and L. Womersley, *Manchester Education Precinct: Interim Report of Planning Consultants* (Manchester: Victoria University of Manchester, 1964).

Wingfield, C., '(Before and) after *Gallery 33*: fifteen years on at the Birmingham Museum and Art Gallery', *Journal of Museum Ethnography*, 18 (2006), 49–62.

Winstanley, B. R., 'School museum services in the British Isles', in Standing Commission on Museums and Galleries, *Survey of Provincial Museums and Galleries*, ed. the Earl of Rosse (London: HMSO, 1963), pp. 287–91.

———, *Children and Museums* (Oxford: Blackwell, 1967).

Wittlin, A. S., *The Museum, its History and its Tasks in Education* (London: Routledge, 1949).

———, *Museums: In Search of a Usable Future* (Cambridge, Mass: MIT Press, 1970).

Witz, A., 'Patriarchy and professions: the gendered politics of occupational closure', *Sociology*, 24 (1990), 675–90.

Wolff, J. and J. Seed, *The Culture of Capital: Art, Power and the Nineteenth-Century Middle Class* (Manchester: Manchester University Press, 1988).

Wonders, K., *Habitat Dioramas: Illusions of Wilderness in Museums of Natural History* (Uppsala: Almqvist and Wiksell, 1993).

Wood, K., *Rich Seams: Manchester Geological and Mining Society 1838–1988* (Warrington: Manchester Geological and Mining Society Branch of the Institution of Mining Engineers, 1987).

Woollard, V., '50 years: the development of a profession', *Journal of Education in Museums*, 19 (1998), 1–4.

Worster, D., *Nature's Economy: The Roots of Ecology* (San Francisco: Sierra Club, 1977).

Wright, P., *On Living in an Old Country: The National Past in Contemporary Britain* (London: Verso, 1985).

Wyse Jackon, P. N. and M. E. Spencer Jones, 'The quiet workforce: the various roles of women in geological and natural history museums during the mid-1900s', *Geological Society of London Special Publications*, 281 (2007), 97–113.

Yanni, C., *Nature's Museums: Victorian Science and the Architecture of Display* (London: Athlone, 1999).

'The zoological family removing from the British Museum to their new house in South Kensington', *The Comic News* (18 July 1863), p. 3.

Index

Note: personal collections, literary works and reports can be found under collectors' and authors' names